W9-BXN-197

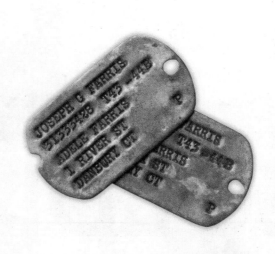

A SOLDIER'S

SKETCHBOOK

★★★ FROM THE FRONT LINES OF WORLD WAR II ★★★

★★★★★★★★★ JOSEPH FARRIS ★★★★★★★★★

NATIONAL GEOGRAPHIC

WASHINGTON, D.C.

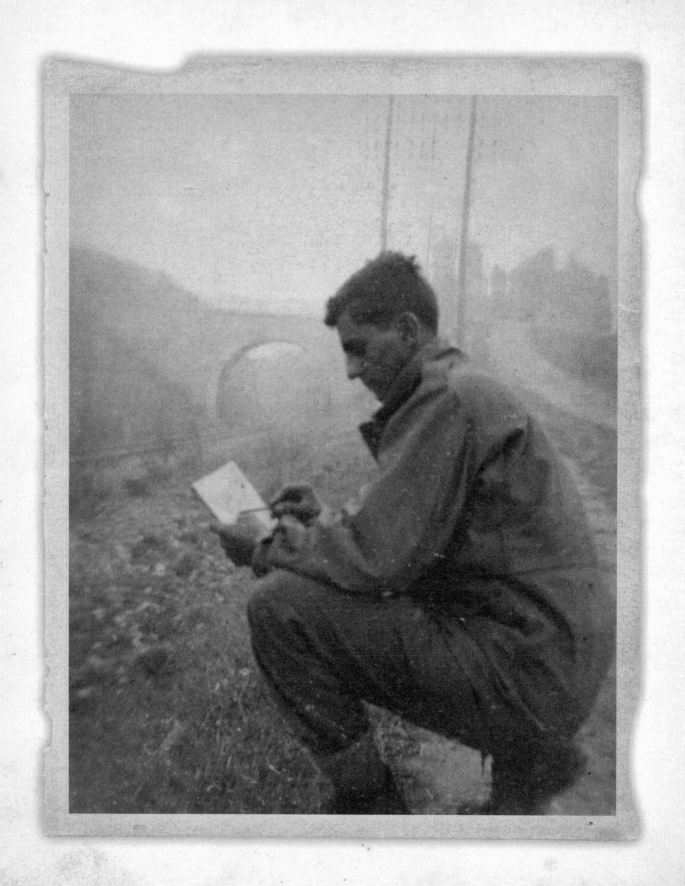

For my much loved family

This book is dedicated to my fellow soldiers in Company M,
3rd Battalion, of the 398th Infantry Regiment, 100th Infantry Division,
and to all the servicemen and women who served in World War II.

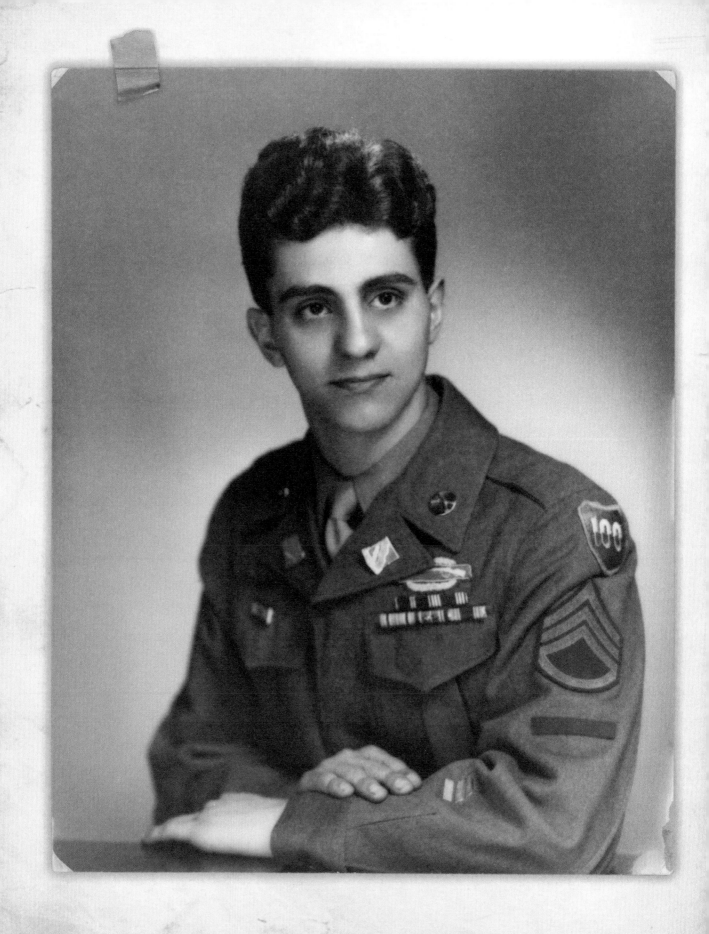

★
CONTENTS
★

Joseph Farris, age 21

FOREWORD:
THE CARTOONIST
AT WAR

The artist Joseph Farris made my pregnant wife cry. This is true. While I had a galley of *A Soldier's Sketchbook* spread across my worktable, she'd stop in occasionally and read his letters home and present-day commentary and stare at his art. One night I glanced up at her, and she was in tears. "Sweetheart," I said, "Are you OK?"

"I'm fine. The work is so powerful, so arresting. We witness the power of the image. These drawings show the darkness and fear that his letters could not. We see the artist educating himself. And now he's educating us."

War educates those that are touched by it. Often, perhaps always, the warring country's leaders don't learn its lessons, but the individuals touched by the bullets and the bombs usually do. And Joseph Farris had the crazily incomparable and wonderful happenstance of learning art at the end of a rough road of battle. With the Army's 100th Division, this young man from Danbury, Connecticut, would fight his way through the Maginot Line, one of the more treacherous and important battlefronts of the European Theater, and after V-E Day find himself in Biarritz, studying art for eight weeks.

This is one of the lovelier and more magical stories I have heard from a World War II GI. His story is like the story of Bigfoot, an improbable tale that keeps everyone hoping it might happen to him or that he might at least witness something epic and uncommon amid the aftermath and wreckage of war. Some GIs found love and booze. Farris concentrated on his sketching. (Like any young artist he might also have found love and booze, but the perfect gentleman, Farris never reveals.)

In his letters to his parents we whiff the naive but patient artist at work. From his postwar school in Biarritz he writes to his folks: "I really feel that I'll be able to make good in the art field and I'm working with all my might toward that end. I could have made these two months a snap and a fine rest, but I decided to get as much out of it as possible. I feel that if I work hard, especially the first years, I'll get up there."

Joseph Farris had always been an artist. He was a self-taught youth, and as a young boy took an art course with a *New Yorker* cartoonist. He had his first one-man show in his parents' confectionery

Joseph Farris and three fellow soldiers pose for a photograph in Plüderhausen, Germany, in May 1945.

shop. He always knew he'd be an artist. And then happened this little war, this Pearl Harbor.

The boys of Danbury and Everywhere, America, lined up to do their duty, he among them. He trained. He got sent to college and was then ripped out of classes when the brass realized they needed more bodies. A friend died at Anzio. D-Day happened. The Army's 100th shipped across the Atlantic to advance the battle toward Germany and Hitler's nest. Joseph Farris was on one of those boats, serving with Company M heavy weapons company, Third Battalion, 389th Infantry Regiment.

And with him throughout training and battle the young soldier Joseph Farris carried his drawing supplies and wrote letters to the Dear Folks. He dreamed of the confectioner's shop and his mother's Lebanese cooking. He fought hard. And he wrote letters home and drew what he saw.

The paintings early in the book are full of vibrant, domestic greens: the shrubbery of a well-ordered American town and an even better ordered military college. Farris's buildings glow orange, burn with his need to study and see. He is both a soldier and a student. Part of what propels us through Farris's story is the privilege of seeing him realize the terrors of war—first through his drawings and then through his memory. As Joseph Farris moves on toward war and into battle, the vibrant natural greens subdue into Army green and are replaced with rusty browns and flat reds. Farris's trees don't have leaves. Often, they lack branches, becoming signposts for the dead. In the aftermath of battle, these demolished forests are the resting ground for the crucified. Farris's landscapes transform from places of learning and hope to bleak, barren, and burned places. The possibility of fear and death is drawn all over them.

But then greenery grows again in Farris's sketches. The war wears on, and as Farris hopes he might return to Danbury alive after all, his hope turns to more certainty. Yes, he will live. He will draw. Farris's green migrates from jeeps and helmets and ditches to fields and valleys. There is hope in green. It rolls in over distant hilltops, muted at first. By the end of the war it glows bright.

It isn't until about halfway through the book, in a succinct present-day note, that we know just how horrified our young soldier was: "I didn't mention in my letters how frightened my fellow soldiers and I were all the time."

The gentleman Farris, the Farris who constantly tells his folks that he is swell, that the chow is swell, that the fellows are swell, would never worry

his very fine parents and young brothers. This is currently an antiquated mode of communication for a soldier.

Today's email and Skype and blog soldiers return from a firefight, and within moments they tap out the particulars of their gory day on a keyboard and send the tale into the ether and back home to Wichita or wherever. Joseph Farris must have known with certainty that the audience for his letters was composed exclusively of his family—a hardworking Lebanese Christian family in which discretion was prized. Not so much today's soldier, whose email might be bandied about in cyberspace for hundreds to read.

Over the years of our current wars I've spent much time surfing blogs and electronic posts from today's combatants. The immediacy of electronic media feeds a public desire to know *everything* and to know it *now*. I sense these writers feel as though it is their duty to tell all, and to tell all at once. These kinds of posts might gratify the public with their pace and their gore, with their *nowness,* but I believe the slowness and thoughtfulness of an earlier generation's communications teach us more about the human hearts behind the weapons, cowering in fighting holes, watching their buddies die. The World War II soldier, letter writer, and—in Farris's case—artist seems to me a more complicated thinker about the vicissitudes and costs of combat.

The earnestness and, well, innocence of young Joseph Farris might sound silly and effete to today's professional, sculpted, ripped-up "warriors." Farris and his cohorts called each other doughboys—a much softer incarnation of today's warrior chomping a bloody bayonet between his teeth.

A Soldier's Sketchbook is at once a new kind of memoir, multi-narrative and richly visual, and a throwback to a time when national sacrifice at time of war was indeed national sacrifice. It is also a pleasure to inhabit, the kind of book the reader will on first contact push through from page one to the end, but will on subsequent visits drop into at his leisure, to spend some time with the artwork, with particularly moving letters, with the young idealistic soldier/artist Joseph Farris—the young man who would make good on his oath to his parents to "get up there" in the art world and become a career cartoonist for the *New Yorker,* the foremost home for America's cartoonists.

A Soldier's Sketchbook is an American story of war and striving and education and success, a story that just might make you cry.

—ANTHONY SWOFFORD
MAY 2011

★ PREFACE ★

started this memoir in 2004 for my family without thought of publication. But it really began 60 years ago, when my parents saved more than four hundred of my letters and drawings, in addition to newspaper clippings and memorabilia. I hadn't revisited the letters for all those years—I simply couldn't. When I finally did read them, I found myself immersed in war memories that had remained quiescent. They invaded my consciousness and dreams.

When Pearl Harbor was bombed on December 7, 1941, I was a senior in high school, and I, along with many others, felt our response would be swift and overwhelming and the war would soon be over. I didn't think I would be a part of it, but I did keep an attentive and wary eye on military developments.

I was drafted in 1943. I was then just 18 years old, and I served for almost three years.

I took basic training in Camp Croft, South Carolina, and then spent six months at The Citadel, the Military College of South Carolina, where they attempted to make an engineer out of me. The program was ended when they decided they needed infantrymen more than engineers, and I returned to the infantry at Fort Bragg, North Carolina.

The 100th Infantry Division, to which I belonged, left the United States in October 1944 on the U.S.S. *General Gordon*. None of us knew what was in store for us—whether we would return alive, or be horribly maimed if we did. I was certainly frightened, as I suspect all were, although we tried to appear cool. My fears didn't ease as time went on, but only increased in intensity. Every day I survived made me think that it was only a matter of time before it would be my turn.

River Street bordered my parents' store in Danbury. It was home to an interesting mix of African Americans and whites, and it had a lot of hat and fur shops. In those days, Danbury was known as "The Hat City of the World."

Young men like myself were desirable recruits for the armed services. Most of us were naïve and patriotic. This was especially true in World War II, which was considered a popular war. We had been attacked, and we fought back viciously and successfully. One wonders in retrospect, though, whether the war might have been avoided altogether if the world had acted earlier and more decisively.

After reading over these long-forgotten letters, I wanted my family to know what I had experienced and to help them understand what went into forming the present me. War, although never desirable, brings to the fore one's basic self. To me, the letters and drawings graphically show a frightened young man who, in spite of his outward bravado, was naturally curious, conscientious, and fairly brave in battle. While I certainly don't consider myself a hero, I did serve honorably and am proud of my service.

It is my hope that the letters, drawings, and documents of one common man will illuminate the experiences of other equally worthy soldiers who served and, in many cases, died in the service of their country.

ABOUT THIS BOOK

Unlike most memoirs, mine contains many different elements. First are the letters, which form the backbone of my story. I went through hundreds more letters than you see here, selecting the passages that showed who I was and what I was experiencing as an infantryman at the end of World War II. I have removed a lot, such as mundane openings or salutations, but kept the heart of many of my letters home. In each chapter, a few of my original letters have been reproduced in facsimile as well.

I have stitched together the letters with my memories of those days. For clarification, we distinguish these two voices—that of myself as young soldier, writing letters home, and that of myself later, reflecting on it all—with two different type fonts. Each chapter opens with a comment or observation, and occasionally a comment interrupts the sequence of letters, adding details or stories that didn't make it into my letters home, sometimes for good reason.

Soldiers' letters were subject to strict censorship. To serve as a counterpoint to what I was able to say in my letters, I have included notes called Company M Morning Reports in the margins of the book. I found these official military accounts of troop movements—cursory and almost matter-of-fact in their style—after the war ended, while I was on duty in company headquarters. They described our location and what happened in battle and indicated fatalities and wounded. Often when I wrote my parents saying that everything was "swell," the corresponding Company M Morning Report shows otherwise. These marginal notes throughout throw my representation of events into relief.

Besides the many letters I wrote, I made numerous drawings and paintings, took lots of photographs, and collected documents, newspaper items, and contemporary writings. I took the pictures with my 127 film camera, a simple point-and-shoot; some of these I sent home, but others I carried with me through my months abroad. Everything was carefully stored by my parents once I was back in Connecticut, and it sat unexamined for half a century. As I revisited my letters and the other saved material, the war became real again.

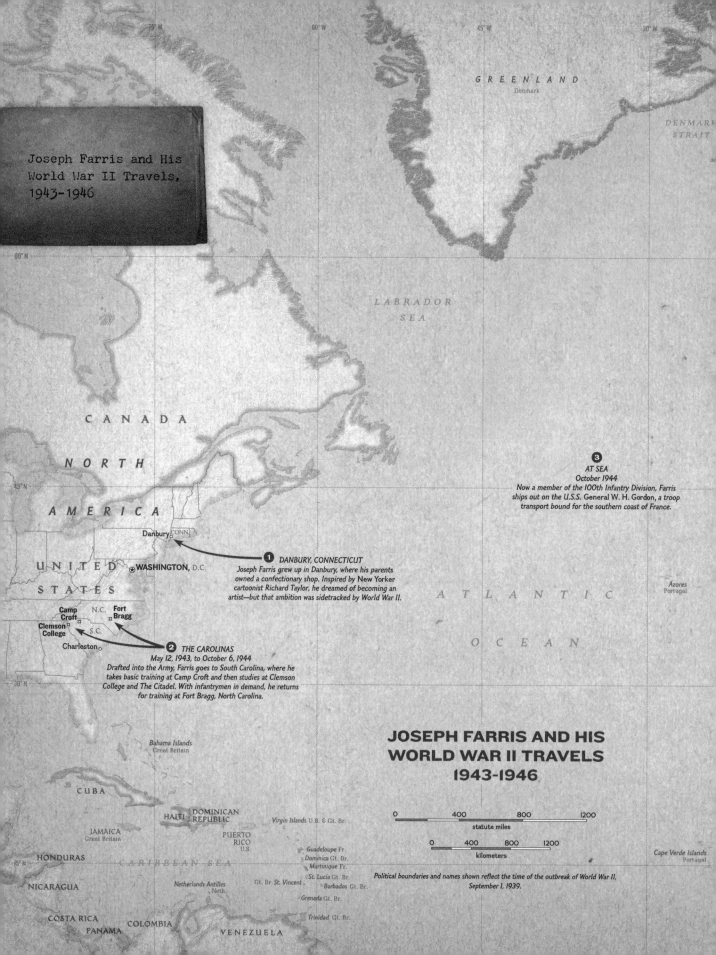

Joseph Farris and His
World War II Travels,
1943-1946

GREENLAND
Denmark

DENMARK
STRAIT

LABRADOR
SEA

CANADA

NORTH

AMERICA

❸
AT SEA
October 1944
*Now a member of the 100th Infantry Division, Farris
ships out on the U.S.S. General W. H. Gordon, a troop
transport bound for the southern coast of France.*

Danbury CONN.

❶ DANBURY, CONNECTICUT
*Joseph Farris grew up in Danbury, where his parents
owned a confectionary shop. Inspired by New Yorker
cartoonist Richard Taylor, he dreamed of becoming an
artist—but that ambition was sidetracked by World War II.*

⊛ WASHINGTON, D.C.

UNITED

STATES

Camp N.C. Fort
Croft Bragg
Clemson
College S.C.
Charleston

❷ THE CAROLINAS
May 12, 1943, to October 6, 1944
*Drafted into the Army, Farris goes to South Carolina, where he
takes basic training at Camp Croft and then studies at Clemson
College and The Citadel. With infantrymen in demand, he returns
for training at Fort Bragg, North Carolina.*

Azores
Portugal

ATLANTIC

OCEAN

Bahama Islands
Great Britain

**JOSEPH FARRIS AND HIS
WORLD WAR II TRAVELS
1943-1946**

CUBA

DOMINICAN
HAITI REPUBLIC
JAMAICA
Great Britain Virgin Islands U.S. & Gt. Br.

PUERTO
RICO
U.S.

HONDURAS Guadeloupe Fr.
 CARIBBEAN SEA Dominica Gt. Br.
 Martinique Fr.
NICARAGUA St. Lucia Gt. Br.
 Netherlands Antilles Gt. Br. St. Vincent Barbados Gt. Br.
 Neth.
 Grenada Gt. Br.

COSTA RICA Trinidad Gt. Br.
 COLOMBIA
PANAMA VENEZUELA

Cape Verde Islands
Portugal

| 0 | | 400 | | 800 | | 1200 |
statute miles

| 0 | | 400 | 800 | | 1200 |
kilometers

*Political boundaries and names shown reflect the time of the outbreak of World War II,
September 1, 1939.*

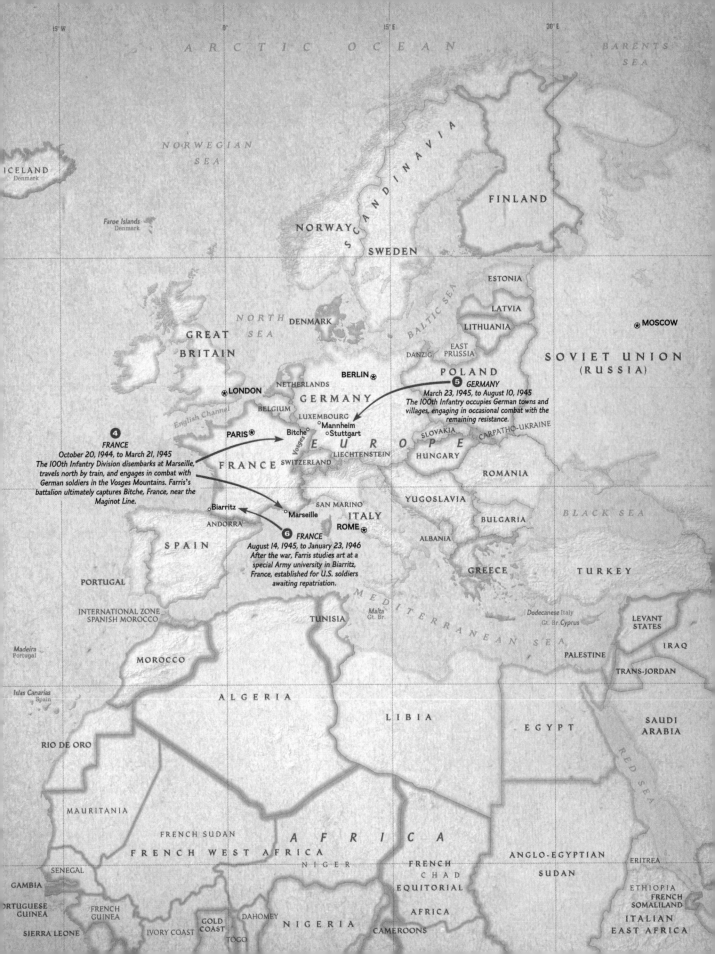

ARCTIC OCEAN

BARENTS SEA

NORWEGIAN SEA

ICELAND
Denmark

Faroe Islands
Denmark

FINLAND

SCANDINAVIA

NORWAY

SWEDEN

ESTONIA

LATVIA

LITHUANIA

⊛ MOSCOW

NORTH SEA

DENMARK

GREAT BRITAIN

DANZIG

EAST PRUSSIA

SOVIET UNION (RUSSIA)

POLAND

❺ GERMANY
March 23, 1945, to August 10, 1945
The 100th Infantry occupies German towns and
villages, engaging in occasional combat with the
remaining resistance.

⊛ LONDON

NETHERLANDS

BERLIN ⊛

GERMANY

BELGIUM

English Channel

LUXEMBOURG

Mannheim

PARIS ⊛

Bitche

Stuttgart

SLOVAKIA

CARPATHO-UKRAINE

❹ FRANCE
October 20, 1944, to March 21, 1945
The 100th Infantry Division disembarks at Marseille,
travels north by train, and engages in combat with
German soldiers in the Vosges Mountains. Farris's
battalion ultimately captures Bitche, France, near the
Maginot Line.

EUROPE

LIECHTENSTEIN

FRANCE

SWITZERLAND

HUNGARY

ROMANIA

YUGOSLAVIA

BLACK SEA

Biarritz

ANDORRA

San Marino

Marseille

ITALY

ROME ⊛

BULGARIA

❻ FRANCE
August 14, 1945, to January 23, 1946
After the war, Farris studies art at a
special Army university in Biarritz,
France, established for U.S. soldiers
awaiting repatriation.

SPAIN

ALBANIA

GREECE

TURKEY

PORTUGAL

INTERNATIONAL ZONE
SPANISH MOROCCO

Madeira
Portugal

MEDITERRANEAN SEA

Malta
Gt. Br.

Dodecanese Italy
Gt. Br. Cyprus

LEVANT STATES

IRAQ

TUNISIA

PALESTINE

Islas Canarias
Spain

MOROCCO

ALGERIA

LIBIA

EGYPT

SAUDI ARABIA

TRANS-JORDAN

RIO DE ORO

MAURITANIA

FRENCH SUDAN

FRENCH WEST AFRICA

NIGER

FRENCH CHAD

EQUITORIAL

ANGLO-EGYPTIAN

SUDAN

ERITREA

ETHIOPIA

GAMBIA

SENEGAL

PORTUGUESE GUINEA

FRENCH GUINEA

SIERRA LEONE

IVORY COAST

GOLD COAST

DAHOMEY

TOGO

NIGERIA

AFRICA

CAMEROONS

AFRICA

FRENCH SOMALILAND

ITALIAN EAST AFRICA

RED SEA

★ JOSEPH FARRIS AND WORLD WAR II

1943

FEBRUARY 8 U.S. forces defeat Japanese forces at the Battle of Guadalcanal.

FEBRUARY 11 Gen. Dwight D. Eisenhower selected to command Allied forces in Europe.

APRIL 13 Joseph receives his draft notice.

MAY 5 Joseph enters the Army at Fort Devens, Massachusetts.

MAY 12 Joseph is transferred to Camp Croft, South Carolina, for basic training; his score of 130 on the Army's intelligence exam raises the possibility of officer training school.

JULY 9 Joseph goes before the Army Specialized Training Program (ASTP) board; entering that program would keep him off the front lines.

JULY 10 The U.S. Army's 45th Infantry Division invades Sicily, marking the beginning of the Allied offensive against Axis-controlled Europe.

JULY 19 The Allies bomb Rome for the first time during the war.

JULY 22 The Nazis begin deporting Jews from the Warsaw Ghetto. Treblinka extermination camp is opened.

AUGUST 17 Allied forces take Sicily.

SEPTEMBER 3 Joseph completes basic training at Camp Croft.

SEPTEMBER 3 Allies invade mainland Italy.

SEPTEMBER 8 General Eisenhower announces the surrender of Italy to the Allies.

SEPTEMBER 16 Joseph arrives at Clemson College in South Carolina, where he takes exams to determine if he will be admitted to the ASTP; he does well and is subsequently enrolled in the program.

OCTOBER 4 Joseph arrives at The Citadel, Charleston, South Carolina, to begin the ASTP.

NOVEMBER 28 Roosevelt, Churchill, and Stalin meet in Tehran and begin discussing a planned June 1944 invasion of Europe, "Operation Overlord."

DECEMBER 24 Eisenhower becomes supreme Allied commander in Europe.

1944

JANUARY Joseph continues his ASTP classes at The Citadel.

JANUARY 22 Allies invade Anzio, Italy; unable to break through German lines, they hold their ground for four months. Joseph's friend Charlie Hajj is killed in the fighting here.

JANUARY 27 The two-year German siege of Leningrad is lifted.

FEBRUARY 3 U.S. forces capture the Marshall Islands in the Pacific.

FEBRUARY 8 Operation Overlord, the Allied plan to invade France, is confirmed.

MID-FEBRUARY Joseph learns the ASTP is being scaled back and that he likely will be reassigned to the infantry or the Army Air Forces.

EARLY MARCH After six months at The Citadel, Joseph receives his orders to return to the infantry.

APRIL Joseph takes infantry training at Fort Bragg, North Carolina.

MAY 8 The Allies set D-Day for Operation Overlord: June 5.

MAY 18 The long Battle of Monte Cassino ends with the Allies victorious.

JUNE 3 Joseph successfully passes the requirements to receive the Expert Infantryman's Badge.

JUNE 5 Rome falls to the Allies, the first Axis capital to be defeated.

JUNE 6 D-Day. Delayed by a day due to poor weather, Operation Overlord strikes with 155,000 Allied troops

landing on the beaches of Normandy, France, in the largest amphibious military operation in history.

AUGUST 15 Operation Dragoon, the Allied landing in occupied southern France, commences; the operation will push the Germans north to the Vosges Mountains, and this will be the route Joseph's infantry division follows after they arrive in France.

OCTOBER Soviet troops are pushing back the Germans in eastern Europe, entering Yugoslavia on the 1st and Slovakia by the 6th.

OCTOBER 6 Joseph and the 100th Infantry Division to which he belongs embark from the U.S. for the southern coast of France aboard the U.S.S. *General W. H. Gordon*, with 5,196 troops on board.

OCTOBER 14 The Allies liberate Athens.

OCTOBER 20 The 100th Infantry Division disembarks in Marseilles, France.

NOVEMBER 2 The 100th Infantry Division is moved by train to the area of St. Gorgon, France.

NOVEMBER 2 Belgium is entirely liberated with Canadian troops' capture of Zeebrugge.

NOVEMBER 7 Joseph's division encounters the Germans for the first time. They had been sent to relieve the 45th Infantry Division, which, with two other divisions, had fought the Germans all the way to the Vosges. Joseph is in Company M (Mike), Third Battalion, 398th Infantry Regiment of the 100th. Company M was a heavy weapons company: machine guns and mortars.

NOVEMBER 8 Company M suffers its first casualty.

NOVEMBER 19–20 Company M receives strong German resistance near Raon-l'Étape, a village in the Vosges region. One officer is killed as Joseph's division pushes back the Germans and takes what comes to be known as Hill 578.

NOVEMBER 24 French troops liberate Strasbourg.

NOVEMBER 24 Joseph receives the Combat Infantryman's Badge for the battle of Hill 578.

NOVEMBER 30 Joseph is allowed to write in his letters the names of towns his division has fought through, all to the south of Strasbourg: Raon-l'Étape, Épinal, Baccarat, and Rambervillers among them.

DECEMBER 4 The Germans continue to hold out in the Vosges, and Joseph and his company meet heavy resistance near the town of Rosteig.

MID-DECEMBER Heavy fighting continues between Joseph's battalion and German forces defending the Maginot Line at Bitche, near the German border.

DECEMBER 16 To the north of Joseph's division, in Belgium, German forces attempt to break through Allied lines in the Ardennes Forest, in what would become known as the Battle of the Bulge.

DECEMBER 18 Joseph's battalion captures Fort Freudenberg.

LATE DECEMBER Due to the efforts being redirected to the Battle of the Bulge, Seventh Army headquarters orders the 100th Division to hold defensive positions and delay their assault on the Maginot Line.

1945

JANUARY Joseph's battalion continues its offensive against German resistance in towns near the Rhine.

JANUARY 16 U.S. First and Third Armies link up following the Battle of the Bulge.

JANUARY 17 Warsaw is liberated by Russian troops.

JANUARY 27 Battle of the Bulge officially ends.

JANUARY 27 Soviet troops liberate Auschwitz.

FEBRUARY 4 Yalta Conference with Roosevelt, Churchill, and Stalin begins.

EARLY MARCH Joseph's unit is billeted in Lemberg and Echenberg, France; while in a state of semi-relaxation, receiving coffee and donuts from the Red Cross, they also continue to receive smatterings of German mortar shellings and aircraft strafings.

MID-MARCH The Seventh Army resumes its assault on the Maginot Line, and Joseph's battalion captures Bitche; the battalion had suffered 16 killed and 120 injured and subsequently was awarded the Presidential Unit Citation for this action.

MARCH 19 Joseph's company is relieved by another division's troops on the lines northeast of Bitche.

MARCH 22–23 Allied forces cross the Rhine into Germany.

MARCH 25 Joseph's company moves to Hochdorf, Germany

MARCH 29 The Russians enter Austria.

MARCH 30 The Russians enter Danzig.

APRIL 3 Joseph leaves for a scheduled rest period in Nancy, France. His company meanwhile begins moving into position to attack the Germans east of the Neckar River.

APRIL 4 The Allies liberate the Ohrdruf death camp.

APRIL 4 Joseph's company crosses Neckar River in assault boats, encountering intense resistance and heavy casualties; several soldiers were taken captive by the Germans. It was the "severest fighting of the war" for his unit, Joseph says in his memoir.

APRIL 7–10 Company M holds a position east of Neckargartach, Germany, still receiving artillery and mortar fire. Joseph returns from Nancy.

APRIL 10 Buchenwald concentration camp is liberated.

APRIL 12 Franklin Roosevelt dies. Harry Truman becomes President.

APRIL 14 Company M moves out to clear a series of German towns of remaining German resistance.

APRIL 15 Bergen-Belsen and Arnhem are liberated.

APRIL 21 Russians begin the assault on Berlin.

APRIL 30 Hitler commits suicide in his Berlin bunker.

MAY 2 Berlin falls to Soviet troops.

MAY 7 Germany unconditionally surrenders to the Allies. May 8 would officially be V-E Day.

MID-MAY Joseph's company enters a period of occupation duties in Germany amid concerns about if and when they might be sent to the Pacific Theater.

MAY 26 Word comes that all six soldiers from Joseph's platoon who had been captured were safe.

JULY 16 In the Trinity test, the U.S. explodes an atomic weapon in the New Mexico desert.

JULY 17 The Potsdam Conference begins, at which the Allies will determine Germany's future.

AUGUST 6 The atomic bomb "Little Boy" is dropped on Hiroshima, Japan.

AUGUST 9 A second atomic bomb "Fat Man," is dropped on Nagasaki.

AUGUST 14 Joseph is in Biarritz, France, to take art classes at the newly established Biarritz Army University.

SEPTEMBER 2 Japan officially surrenders to the Allies.

OCTOBER 17 Joseph departs Biarritz to return to Germany.

1946

JANUARY 31 Joseph boards the S.S. *Norway Victory,* bound for the U.S.

FEBRUARY 16 The *Norway Victory* arrives in New York harbor with Joseph and about 900 other servicemen aboard.

AL SOLDIERS

ON DECEMBER 7, 1941, Japan attacked Pearl Harbor. Four days later, Japan's ally Germany declared war on the United States, and soon U.S. troops were headed for both fronts—a total of 16.1 million U.S. men would serve during the war. By 1943, Germany had occupied most of Europe for nearly three years, but there were signals the tide was turning in the Allies' favor. In North Africa, at the second Battle of Alamein, the Allies defeated the Axis powers in November 1942, thus preventing Germany from access to the Suez Canal and vital Middle Eastern oil supplies. Further Allied victories continued in North Africa with the Allied capture of Tripoli in January 1943 and of Tunis in May 1943. In June, the Allies would invade Sicily, marking the initial Allied assault on Axis-controlled Europe. In September, Gen. Bernard Montgomery would lead an Allied force onto mainland Italy, and General Eisenhower would announce the surrender of Italy to the Allies. Having established a toehold in Italy, the Allies' next goal would be a free France.

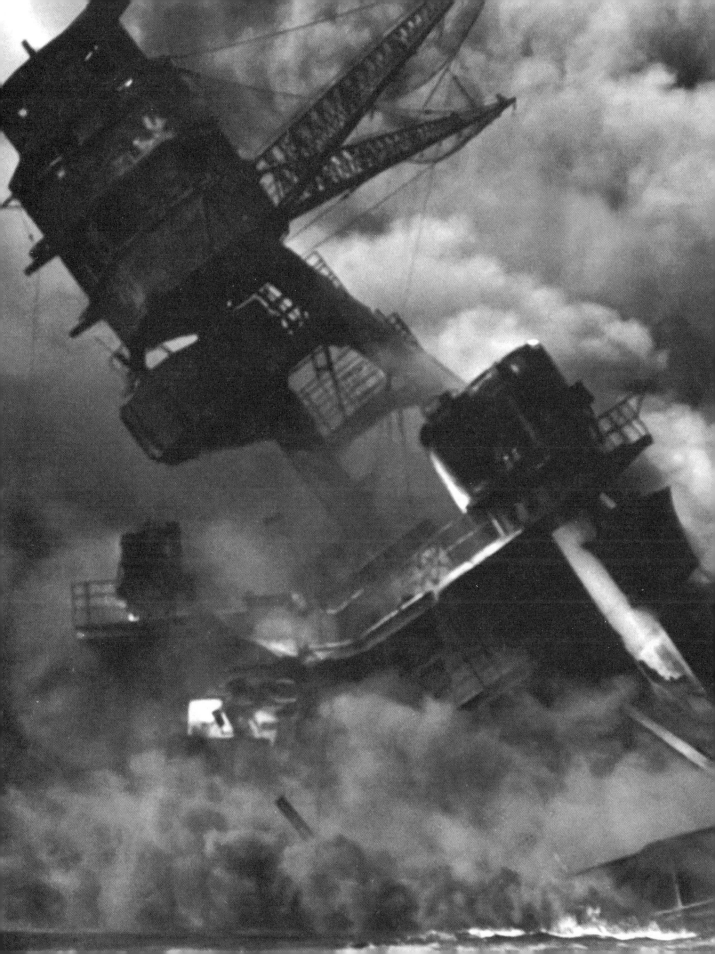

was born on May 30, 1924, in Newark, New Jersey. For a time, I was under the impression that Newark's Memorial Day parade was held in honor of my birth. My family lived in Newark until I was five or six, when we moved to Danbury, Connecticut, where I spent my school years.

Actually, I spent most of those years as an unpaid employee in the family mom-and-pop store at 59 Elm Street, which was named the Danbury Confectionery. The store sold a myriad of things—fruits, vegetables, canned goods, cold cuts, candy (we had the largest display of candy in the city and probably supported many of the area's dentists), tobacco of all sorts, and even condoms, which were sold surreptitiously since their sale was prohibited by Connecticut state law at the time.

My favorite section of the store was the soda fountain, where my creative instincts flourished. My banana splits were a wonder to be seen and devoured. We even had two pinball machines that we occasionally had to hide when we received word that the city was cracking down on them to save mankind from spending all their well-earned nickels. After a few weeks, they were brought out again and were probably responsible for all of mankind's sins.

Drawing became a passion with me at a very early age, and my first creative stirrings were copying the lead characters of the popular comic strips of the day. My efforts were rewarded with my first one-man show in the backroom of the store, which I curated and displayed. The art traffic on Elm Street was rather sparse, so I was the

Our family store was on Elm Street—a wonderful mix of many ethnicities, amid barbers, paint stores, bars, grocery stores, shoemakers, jewelry stores, and more. PREVIOUS SPREAD: *The U.S.S.* Arizona *burns after the Japanese attack on Pearl Harbor on December 7, 1941.*

primary admirer of the show. I was quite annoyed when customers, who had no respect for my time, interrupted my artistry to purchase some mundane food items.

When I was 12 or 13 years old, I noticed a story in the local paper saying that Richard Taylor, a famous cartoonist for the *New Yorker,* and some of his colleagues were giving a free art class in Bethel, an adjoining town. I promptly joined. This decision probably determined the direction my life would take. Taylor gave me and others our first formal art lessons and, more important to me, an awareness of a different lifestyle from my immigrant family's. I've never stopped drawing and painting since.

In 1942, I graduated high school with first honors, although I suspect that schoolwork wasn't as demanding in those days as it is now. My family and I didn't participate in the ritual of applying to colleges and universities. Why? In two words: Pearl Harbor!

I was 17 years old when my country went to war, and in my ignorance, I was convinced we would put an end to it quickly and I would get on with my life. After all, we were told, Japan was a country of wooden houses that we would easily conquer—and I had no reason to believe differently. I was quite unsophisticated about national and especially world affairs and didn't really understand what was going on. And I wasn't alone. Many of my friends and neighbors were in the same situation.

It didn't take long, though, before I realized I would be playing a part in the war, and I was going to find out how much I could handle in an unknown future. I didn't know what to expect, where I was going, and whether I would survive. My parents, particularly my mother, were deeply worried and concerned. I had spent most of my teenage years working in my parents' confectionery store and was extremely deficient in street smarts. But, although I didn't appreciate it at the time, my responsibilities in the store would aid me later when I was tested in combat.

In early 1943, I and almost two hundred others in the Danbury area received draft notices. My friends and I passed our examinations, physical and psychological, and came back to the store with great bravado.

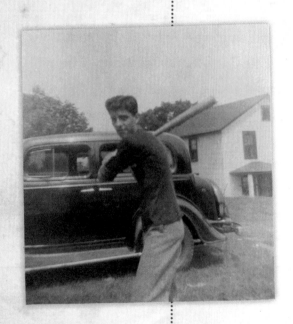

ABOVE: *The author at 16, a lover of baseball then as now.* OPPOSITE: *Draft order, April 13, 1943*

Prepare in Duplicate

Local Board No. 24A 11
Fairfield County 001
 241
County Court House
(LOCAL BOARD DATE STAMP WITH CODE)

APR 1 3 1943
(Date of mailing)

ORDER TO REPORT FOR INDUCTION

The President of the United States,

To _____ Joseph _____ George _____ Farris ____
 (First name) (Middle name) (Last name)

Order No. 12554 _____

GREETING:

Having submitted yourself to a local board composed of your neighbors for the purpose of determining your availability for training and service in the armed forces of the United States, you are hereby

notified that you have now been selected for training and service in the Land or Naval Forces ____
 (Army, Navy, Marine Corps)

You will, therefore, report to the local board named above at White St., Railroad Station ____
 (Place of reporting)

at 6:15 A. m., on the _____ 28th _____ day of _____ April _____, 19 43
(Hour of reporting)

This local board will furnish transportation to an induction station of the service for which you have been selected. You will there be examined, and, if accepted for training and service, you will then be inducted into the stated branch of the service.

Persons reporting to the induction station in some instances may be rejected for physical or other reasons. It is well to keep this in mind in arranging your affairs, to prevent any undue hardship if you are rejected at the induction station. If you are employed, you should advise your employer of this notice and of the possibility that you may not be accepted at the induction station. Your employer can then be prepared to replace you if you are accepted, or to continue your employment if you are rejected.

Willful failure to report promptly to this local board at the hour and on the day named in this notice is a violation of the Selective Training and Service Act of 1940, as amended, and subjects the violator to fine and imprisonment. Bring with you sufficient clothing for 3 days.

You must keep this form and bring it with you when you report to the local board.

If you are so far removed from your own local board that reporting in compliance with this order will be a serious hardship and you desire to report to a local board in the area of which you are now located, go immediately to that local board and make written request for transfer of your delivery for induction, taking this order with you.

Member or clerk of the local board.

D. S. S. Form 150
(Revised 6-15-42)

U. S. GOVERNMENT PRINTING OFFICE 16—18271-2

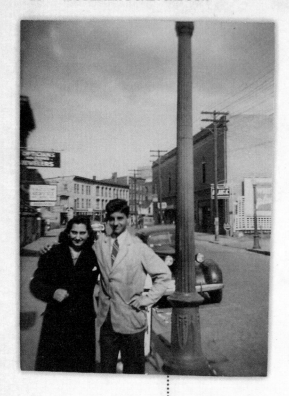

Anna Howard and the author on Elm Street

We marched in, holding imaginary rifles to our shoulders and yelling out in chorus, "Hup, toop, threep, four, hup, toop, threep, four . . ." We were masking our anxiety. My mother cried. I was 18. My childhood ended. Elm Street was about to become a place we hoped to return to alive.

My first taste of Army life was at Fort Devens, Massachusetts, where I gave up my civilian attire for GI clothing, and it was determined here where my military career would begin. As it happened, the need at that time was for infantry soldiers, and so I was assigned to Camp Croft, South Carolina, for 13 weeks of basic training in the infantry. To say the least, this wouldn't have been my first choice.

While still at Fort Devens, we recruits were given intelligence tests. Any score above 110 entitled the person to go to officer training school, and I was told mine was 130. It seems, however, that the schools were filled up at that time. But I did qualify for college in the Army Specialized Training Program (ASTP), so after basic training at Camp Croft, I found myself at Clemson University, awaiting placement as a prospective engineer of some sort. My life was probably saved because of the ASTP. If I hadn't qualified, I would have been shipped overseas along with my best Army friend, Charlie Hajj, who along with many soldiers was killed at the ferocious battle at Anzio, Italy. Life isn't fair.

★ FORT DEVENS, MA

MAY 5, 1943

Dear Mom & Dad, Georgie & Eddie—

I am now in the Army and everything is really swell. We arrived here at 1:45 in the afternoon, and boy they wasted no time. At about 3:00 we had everything that we needed to wear. About six or seven sets of clothing, two pairs of shoes, in fact the whole works. We have received one inoculation already. For typhoid I believe. Everyone's arms are now starting to feel a little numb.

UNITED STATES ARMY

May 5, 1943

Dear Mom + Dad, Georgie & Eddie

I am now in the Army and everything is really swell. We arrived here at 1:45 in the afternoon, and boy they wasted no time. At about 3:00 we had everything, that we needed to wear. About six or seven sets of clothing, two pairs of shoes, in fact the whole works.

We have received one

In about one and a half hours after we came we were assigned to barracks. The Sergeants and everyone here are really okay. They help us out whenever we ask.

We were ushered into the quartermaster building almost immediately after being assigned to barracks to receive our clothing. We were razzed by the recruits who had entered only minutes before and were called "rookies." As we turned the corner, we became the "veterans" and took it out on the rookies who were just entering. We all needed somebody to feel superior to.

MAY 8, 1943

Dear Folks—

We took our I.Q. test yesterday and I think I made out o.k. Then we went for the interview. I told him the whole works and showed him my Trade School papers. He seemed to be impressed more by my art training since it covered about five years.

Then I went to a sergeant who asks you what do you want. When he noticed I studied Art he handed me a small pad and pencil and told me to sit down and draw him. I took about 15 minutes sketching him. He seemed like a swell fellow and we were joking throughout. Many other Sergeants would come and take a look at how I was progressing.

It seemed a fellow earlier had said he was an artist, and the sergeant told him the same thing. The Sergeant showed me how it came out.

If you remember those very first drawings I used to do, this was worst. The Sergeant asked where I think he put him. "The infantry," I said. He said I was right. He was probably kidding about the infantry.

Any way the drawing didn't come out bad at all. He then asked me if I wanted the Air Corps. I told him yes and if I could also get drafting in it. He said he see would see what's what.

I've had only one inoculation so far and I'm waiting for shipping orders.

★ CAMP CROFT, SC

MAY 12, 1943

Dear Folks—

I hope sincerely that everyone is fine. I am feeling great. Naturally I really miss home and everybody and the store. But it won't long before we clean up on those things—the Japs and Germans—and everyone will be much happier.

The first chance I get I may try and call and in that case you'll know I am in Camp Croft in the Infantry. At first when I found out I was in the Infantry I was quite angry. By the way many Danbury Boys are here. In fact most of them.

As I was saying, at first I was quite angry with being in the Infantry. Now, I think I may be quite lucky. You see I just came back from Classification down here. In Camp Devens it doesn't mean a thing what you tell them or at most very little.

You see if a call comes from one of the camps South for 400 men for the Infantry, Camp Devens sends the first 400 men on their list regardless of who you are. Frank Repole, the teacher is also here.

I'll tell you what happened at the classification center here. He noticed I had Mechanical Drafting. I stand a good chance after Basic Training of 13 weeks is over to go to a trade school having something to do with Drafting.

Now for how I made out with the General Classification test. For Officers Candidate School you have to have 110 or over. Well I made 130. He didn't tell me this because he wasn't allowed to. He wrote in front of me though, knowing I wouldn't miss it. They have 5 classes of those who pass the I.Q. He did tell me I made Class One and I have a good chance for Officer's Training School, even though they were taking very few now.

It would be swell if you could send my art equipment. Send my box of water colors and the tubes of water color also. Do not send the oil paint

tubes. The watercolor tubes are small ones. Send me a couple of bottles of India Ink, about 5 pen points, some pencils, a small pencil sharpener, a ruler, some soap erasers.

Also if you can send separate my illustration board. If you cut them in halves it would be swell if you mail them that way. Also a sketch pad. Do not write with them and it won't cost much to mail them.

I myself feel perfectly fine. I'm in the air almost all the time. The interviewer said I would probably gain 20 pounds. I hope and think so.

It took us about 32 hours to get here. We went from Devens to Albany, N.Y., through Philadelphia–Maryland, Washington D.C.–Virginia, N. Carolina, and finally a few miles into South Carolina. We weren't permitted to leave the train.

This camp is rated as one of the best in the country. Third, I believe. There are about 25,000 men here. At Devens they could hold 80,000 . . . All the officers and non-coms have been quite swell. The food is still quite good.

The following letter was typical for the Army: They told us little and left us to speculate on our fate. The same awaited us when we went on line in combat. We never knew what was going on, who was on our left or right, or what plan the higher echelon, safely behind the lines, had devised for us—even though their decisions affected our lives and in many cases resulted in injury and death.

MAY 15, 1943

Dear Folks—

I hope everybody is healthy and well. Please dad and mom don't worry about me. I can take care of myself. I am thinking of you all every bit of the time.

As for going to school after training, please remember I am not certain. You know the army. I am almost sure though. They have, I believe some kind of a trade school or something. I always have a good chance for Officer's Candidate School because I got a high mark. They will be watching me and others so my worry now is being a good soldier and student. You see, we will have many lectures. We are learning in 13 weeks what previously took about 8 months.

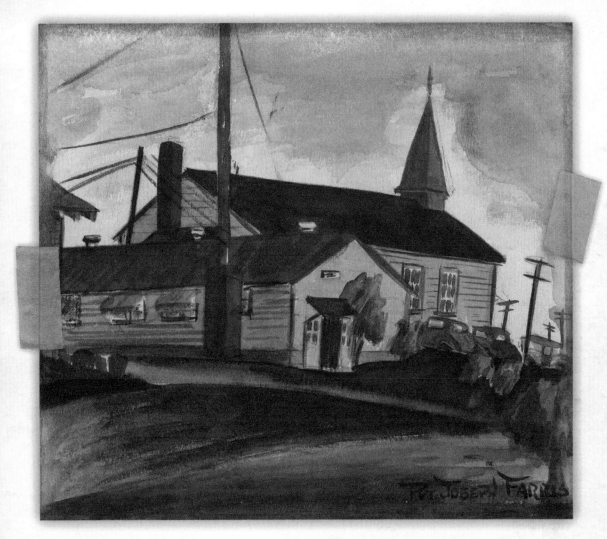

Today, we heard more lectures on military courtesy and air raid drill. They think of everything here. You should see us run into the nearby woods and scatter under trees etc. You can hardly make out anyone. You see, we wear green uniforms and they blend perfectly with the surroundings.

We get the latest news here before the public does. We hear the news every noon here.

We get mail call here every day including Sunday, so write every day. You don't know how nice if feels to receive mail. So far, I and Charlie haven't received anything but we know it will take awhile.

There are many fellows here from Danbury, about sixty. Many are in my barrack here. Charlie Hajj is here sitting next to me writing a letter also.

We have a lot of fun here. On Sunday, tomorrow, it's our day. As I said, we can sleep as long as we want. Charlie Hajj has said that when the Allies invade

Church at Camp Croft, South Carolina, 1943. There was a sameness in the architecture of the Army camps I trained in.

Europe, he is going to buy all the paper boys papers. This paper boy is here in camp just when we wake up. I don't know how he does it.

We took our rifles apart today. They are those famous Garands. We call them the M-1 and they are honeys.

Today we had our first real inspection. Man, what we didn't do. I never was so neat in all my life.

Today we went on our first obstacle course. It wasn't too bad . . . I ran the 50 yard dash in six seconds, which isn't bad.

I went hand over hand for 60 feet. That's as far as the obstacle went. I chinned myself only 3 times, though, which is my weakness. Later on about midway in the course, 6 weeks from now, we are going to go over the same course again and compare results. Then at the end of the 13 weeks we will again go over the course and again compare results . . . That way we can notice our improvement.

Yesterday we did calisthenics. Boy, they are going to build us up. I made out good in the broad jump and even better in the running broad jump and in the high jump. I didn't make the 12 foot wall though. Next time I will.

MAY 24, 1943

Dear Mom, Dad, Georgie & Eddie— […] I started writing this letter at noon. It is now 5:00 P.M. Man, all the things that happened in between. It all concerned chemical warfare. We were going to experience the effects of tear gas. The first time we put on our gas masks and were sent into the gas chamber. That wasn't bad because it proved our masks were o.k. We felt nothing. The second

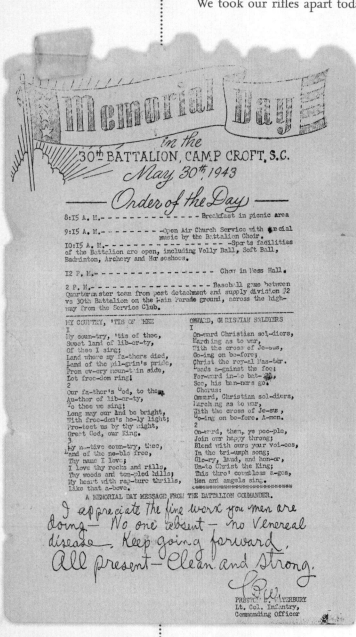

Memorial Day program, Camp Croft, South Carolina, May 30, 1943

time we went in with our masks and took them off in the chamber. When we came out we were really "crying." Tears flowed freely on all.

The third time we went in without our masks on and immediately put them on, which took about 15 seconds. Again tears flowed, but it did not irritate my throat at all since I held my breath.

Then as we gathered around outside listening to our instructor, someone threw a tear gas grenade at us and yelled "GAS!" Again we put the mask on like mad and again tears flowed. They were testing us to see if we were alert. I like to think we're ready for any gas attack the enemy might attempt.

Fortunately, we never had to experience gas warfare.

We had a similar experience when we were being instructed in the correct way to throw hand grenades. Hold the safety lever tightly and pull the pin, we were told. Once it is thrown, you have five seconds to duck into a hole or some other shelter before it explodes. The instructor was holding a grenade as he was talking, and suddenly he dropped it. The safety lever disengaged from the grenade, and we scrambled for our lives.

Nothing happened—it was a dummy. The instructor, who obviously had a sadistic streak, laughed uproariously. What one should do in such a circumstance, he explained, is to remain cool, take advantage of the five-second delay, and toss it out of harm's way. In actual combat, some infantrymen held the grenade, minus the lever, for two to three seconds before tossing it to prevent the enemy from doing just that.

Military-issued gas mask from World War II. Gas mask training was one of the more difficult and unpleasant exercises of basic training.

JUNE 23, 1943

Dear Folks—

We walked about 6 miles yesterday night with full backpack, etc. Then we pitched our tent in the dark and dug slit trenches. We had to keep absolutely still throughout the problem from 8:30 to 12:30 that night. We had a gas attack in between, and then we took down the tents and

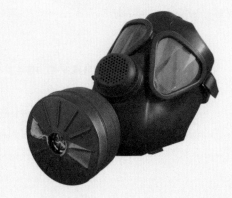

made up our packs, still in the dark. It's funny how doing things over and over enables one to complete tasks without sight to guide you.

Today we went on the combat range. We used the carbine rifle and had 16 rounds of ammunition. Then we started to run down the course. Every now and then, a target, such as a figure of a man would pop up and we would quickly pump a shot into it. The targets were pulled up 15 yards away by the coach who accompanied every man. I had to climb a fence and when I reached the top, a target popped out and I fired. Targets popped up from behind bushes, in windows etc. It was a lot of fun.

JUNE 24, 1943

Dear Folks—

A bunch of rookies moved in next door and made us feel like veterans, especially when we saw them learning how to salute. Almost six weeks of our basic training has been completed already.

A Soldier's Salary

Barron's reported in 1944 that the typical private first-class netted $3,600 a year, equivalent to about $45,000 in U.S. dollars today and more than many workers at the time.

JUNE 30, 1943

Dear Folks—

We fired the machine gun today for the first time using 300 rounds and I didn't do too badly. If they were for record, I would have qualified. We fire it at 1,000 inches away and in bursts of six. You can't fire it steady very long because the barrel would eventually burn out.

We got paid today and I got $36.25. They took out for insurance, war bonds and laundry. I'm going to keep it because I'm getting a little short.

JULY 6, 1943

Dear Folks—

We had more training on the machine gun yesterday. I shot for record and qualified easily. All we needed to qualify was 140 out of 200 and I got 171. Nearly everyone qualified. The guns aren't too good here and I sure hope they're better in combat!

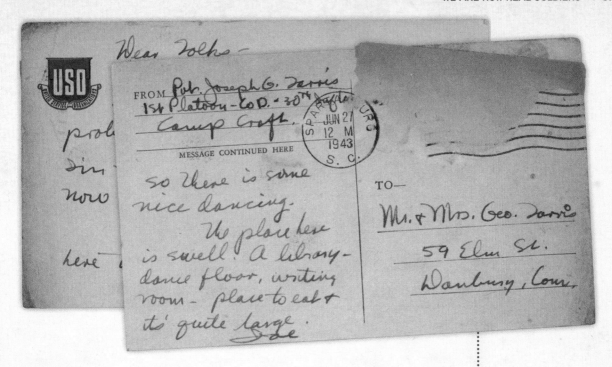

Dear Folks—

FROM Pvt. Joseph G. Jarris
1st Platoon—Co. D.—30th
Camp Croft.

SPARTANBURG S.C.
JUN 27 12 M 1943

MESSAGE CONTINUED HERE

so there is some
nice dancing.
The place here
is swell! a library—
dance floor, writing
room—place to eat &
it's quite large.
Joe

TO—
Mr. & Mrs. Geo. Jarris
59 Elm St.
Danbury, Conn.

JULY 9, 1943

Hi, dear folks—

Today we went before the board for the A.S.T.P.—the Army Specialized Training Program—which sends soldiers to college. There is a swell chance of my going. All we can do is wait. About six or seven in this platoon have a chance for it.

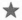

The ASTP was a program, instituted by the U.S. Army during World War II at a number of American universities, to provide officers and soldiers with needed technical skills. In order to qualify, recruits had to have an IQ score of at least 120, compared to the 110 score needed for Officer Candidate School applicants.

The soldiers in the ASTP received regular Army pay and had 59 hours of "supervised activity." This included 24 hours of classroom and lab work, 24 hours of required study, 6 hours of physical instruction, and 5 hours of military instruction. At its height in 1944, about 140,000 men were enrolled in the program. It was considered more demanding than either West Point or the Naval Academy.

In February 1944, the program was partially terminated as the need for combat soldiers grew, and most of the soldiers were returned to combat units. Some of the notable alumni of the ASTP were Senator Robert Dole,

Postcards like these from the USO (United Service Organizations) didn't require postage.

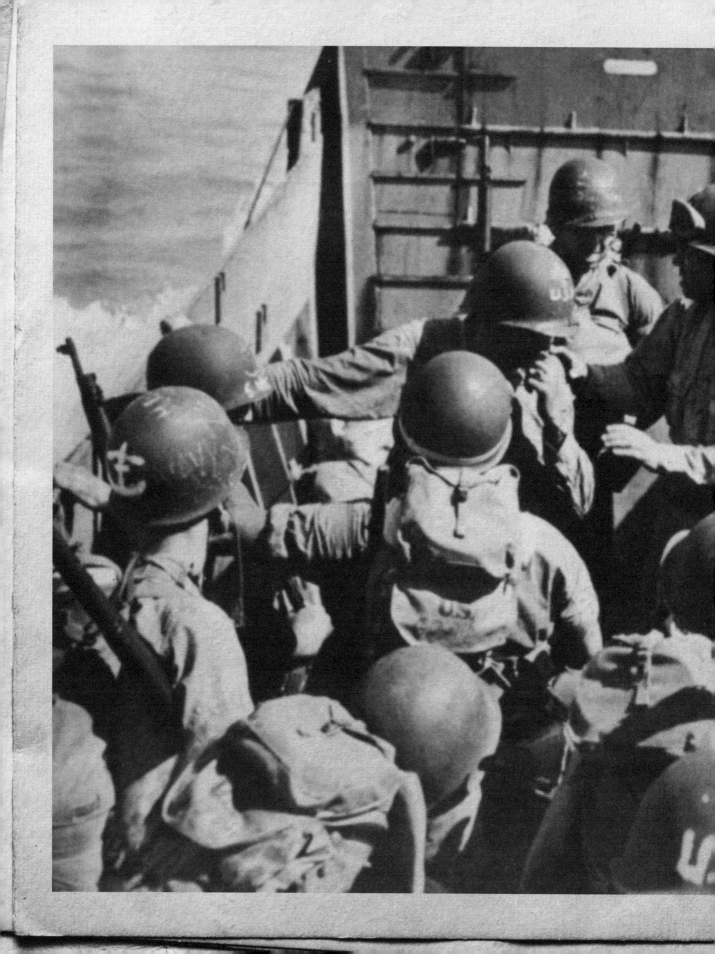

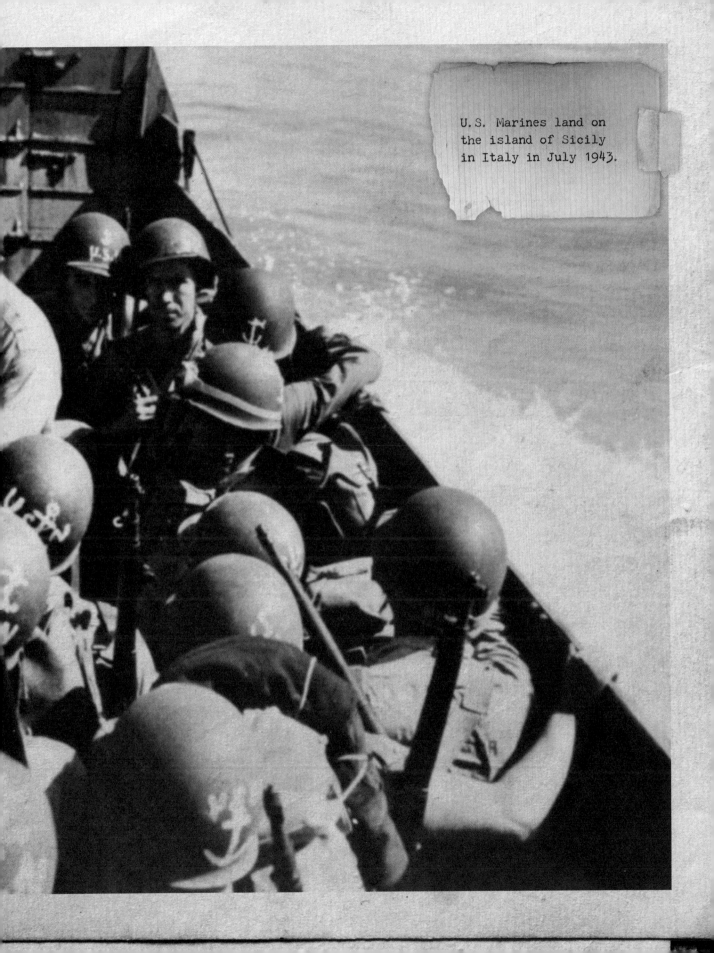

U.S. Marines land on the island of Sicily in Italy in July 1943.

Secretary of State Henry Kissinger, author Gore Vidal, journalist Andy Rooney, actor Mel Brooks, and many others.

At the time, I was more aware of the other significant benefit of becoming a member of the ASTP. It meant that, for the duration of the program, I would not be risking my life on the front lines. The anxiety of being accepted must have been palpable.

JULY 23, 1943

Dear Folks—

We've had quite a week, I must say. Wednesday we had one of hardest days of all. We were up at 4:15 and we walked for about 4 1/2 miles. Then we went through four courses. During one we "captured" a village where we used the carbine rifle with live ammunition. It was supposed to be a small German village. We all ended up charging the beer hall. Then had a session on explosives and how to make improvised grenades and Molotov cocktails. We threw hand grenades and then the worst of all, the infiltration course! We crawled under barbed wire for 60 yards under live machine-gun fire which was aimed 30 inches above the ground. Every now and then, buried dynamite explosives went off. What added to the difficulty was that it was hotter than hell. I'm telling you, we didn't even think about the bullets. We just dragged our rifles and pushed ourselves forward. Then we stayed in the trenches until everyone else crawled in. Next to the Cadre (corporals, sergeants, etc., who teach here), I was one of the first in. Don't start to worry about me, though. I want and like this training to be tough—it's doing me a lot of good. That was quite a day!

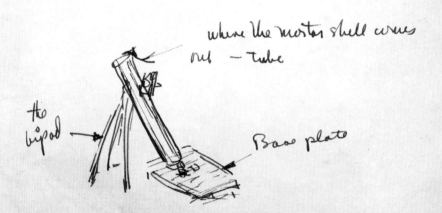

A rough sketch of a mortar. As a machine gunner, I envied the mortar squads. They remained well back of the front lines.

AUGUST 4, 1943

Dear Folks—

It's hard to believe that [my schoolmate] Jimmy Gould has made the supreme sacrifice. I remember Mr. Onerheim [our high school band leader] telling me about Jimmy. He would rather die rather than chance losing an arm because of his piano playing. For that reason, he joined the [Army] Air Force so as to not risk becoming an infantryman.

Yesterday we had our final physical training hike. We walked 17 miles with full pack and rifle, gas mask and the rest of our equipment. That shows how much better condition we're in now. We would never have made it at the beginning of our cycle.

Just two more weeks and our basic training will be over. As for ASTP, we won't know how we made out until after our seven-day maneuvers. That's the way it always is.

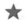

James Gould was, by far, the most popular member of our class at Danbury High School. He was a supremely gifted piano player and said that he practiced eight hours a day. I believe he was the first casualty among the people I knew well, especially from my high school class of 1942. It was very difficult to accept the fact of his death. He was such a vibrant and friendly personality that it was hard to believe he was gone. It certainly magnified the meaning of death and war in my psyche.

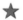

AUGUST 21, 1943

Dear Folks—

Tonight is the big night and probably the toughest of them all of the next two weeks. We've spent all day preparing for it and tonight we open it with a 30-mile hike. We're leaving about nine tonight. When we get to our destination—about five tomorrow morning—we will just lie down and sleep right on our packs.

Throughout the maneuvers, I'm going act as instrument corporal—that is, use the range finder to give the range, etc. I'll be with the platoon leader most of the time.

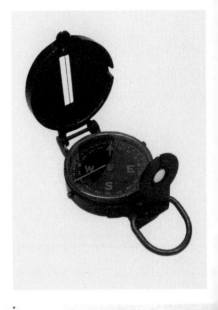

World War II U.S. compass

AUGUST 23, 1943

Dear Folks—

[. . .] Yesterday night we had quite a night. I think it was the most interesting night problem of them all. We were given a slip of paper with two compass directions on them and an army compass. I was squad leader—five of us altogether. Our objective was to get to the camp stockade without being captured by the enemy, which was Company C. We went through some of the

toughest wooded land I ever saw—completely in the dark with the compass as our only aid. Let me tell you, I sure got to trust that compass and I held on to it tight.

We started about 8:00 and finally pulled in about 11:30 p.m. without being captured. We were spotted by one guard but I maneuvered the fellows completely around him and that was the last we saw of him. He's probably still out there looking for us. We heard noise from guards on one field and waited about a half hour until it was quiet again.

Tonight we take Company C's place and act as guards and they will attempt to infiltrate through our defenses.

Today we had a problem on delaying the enemy with machine guns. Another company took the part of the enemy and made it quite interesting. I have had quite a racket, being instrument corporal. I eat with any squad, etc. (usually the first squad to eat).

When I mentioned we had a "problem," I was referring to an assignment given to us by headquarters that we then had to carry out. It concerned a military situation that we attempted to successfully complete.

I felt a great sense of pride, as indicated by the following letter. I was a young man, just turned 19, who had finished 13 weeks of grueling training with a reassuring feeling that I could handle anything sent my way. I was soon to learn that actual combat was going to test me even further—to my very core. At any moment, I could be dead.

One of Many

More than 16 million Americans served in the military during World War II; of that number, more than 11 million served in the Army, which included the Army Air Corps.

SEPTEMBER 3, 1943

Dear Folks—

Yup, we are now soldiers—real soldiers. Today we paraded out to the parade field and we really sparkled—the best we ever looked. The commander said we looked exceptionally good when we passed the reviewing stand.

SEPTEMBER 5, 1943

Dear Folks—

Many of the fellows from our platoon left a little while ago for their furloughs. They won't report back here but at their new camp upon completion of their twelve-day furlough. They were lucky to receive twelve days since they were only expecting seven and perhaps ten at the most.

As for ASTP, the rumors sound good. It's being passed around that we were all accepted and that we may leave here by Saturday.

It was something saying so long to the fellows that left today. I really felt bad, in fact we all felt bad. We had grown to know each other perfectly and they are a bunch that you can always count on for a laugh. [That was the last time I saw Charlie Hajj before he was killed.] We learned everything together, we worked hard together and we laughed together. I'm sure going to miss them but I hope that those that left stick together.

We all have a date to meet in Boston at the Met theater on July 4th, 1946. Save this letter so I'll have something to remind me of that important date. I'm getting most of their addresses so we can keep some kind of tab on each other.

Sadly, it never happened.

SEPTEMBER 8, 1943

Dear Folks—

Well—Italy surrendered! Man, but isn't that good! Everyone went nuts here. The 1st Platoon was the first to hear it—a cheer went up—then the 2nd Platoon—another cheer—then the 3rd—another cheer—I couldn't hear the 4th since they're farther away but it's been a great day!

SEPTEMBER 15, 1943

Dear Folks—

Well, folks, the big day has finally arrived. Four of us leave for Clemson College tomorrow, the 16th for classification in ASTP.

Clemson is about 70 miles from Camp Croft. There, I imagine, we'll be given tests to see what we're best suited for. Then we will be assigned to another college provided every thing's o.k. We hope they will send us north.

★ CLEMSON, SC

SEPTEMBER 16, 1943

Dear Folks—

Well, here I am at Clemson, S.C. The purpose of this university is to classify us. In other words here is where we'll know if we're in or not.

It seems that ASTP is rapidly filling up and they're rejecting quite a few, in fact 60% of the last group. What's got me worried is that I haven't had much math such as algebra, geometry and trig. They may overlook it since I'm only 19. In any case, I'm going to do my best to qualify.

SEPTEMBER 17, 1943

Dear Folks—

Today was a big day—we took three exams, the only ones I'll have to take. The next big thing is when I go before the board. I'm going to take all pertinent papers with me.

It seems we came in at a poor time. About three weeks earlier they were taking nearly everyone— but they may take most of us too. I don't know.

Fortunately my score on the Army General Classification Test, which was 130, is enough so I don't need any particular subjects such as algebra, geometry, etc., so I do meet all the requirements.

The town of Clemson is so small that if you blink, you miss it. The population is 425. We had to laugh when they said we had to take a 3 to 5 mile hike without any equipment. At Croft, we did 25 miles weighted down with equipment.

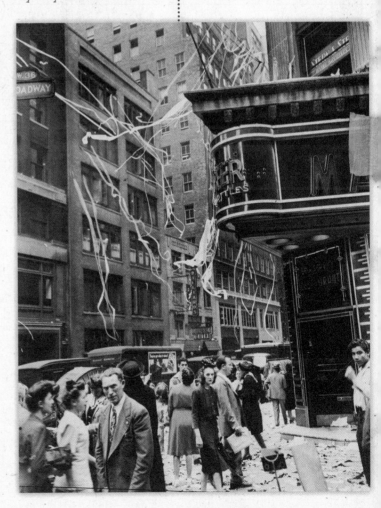

New Yorkers celebrate the surrender of Italy on September 8, 1943.

SEPTEMBER 20, 1943

Dear Folks—

I went before the board this morning—let me tell you, I didn't eat much breakfast either—I guess I realized what this meant.

Mine was a funny situation, as I told you I haven't had much math. There were between 50 and 60 fellows in our group and the names were in two lists. The first list men were accepted and the second questionable. I was in the second because of my math deficiency and plenty worried. The rumor had made the rounds that the first group was in—as for the second?

Well, I was the 16th fellow in from the second group and only one of the previous 15 was accepted. (He was one of the fellows who came in with our group and also was short in math.) Now you can see why I was worried. Well, what helped me was my 130 score in my general class, plus the good marks in the tests I took here Friday.

They told me at the board meeting that I was on the spot because I haven't had much math and I can expect to have to study on my own time—but that was something I expected.

The school they will presently send us to works something like this—twelve-week periods—starting with basic 1-2-3-4- and then advanced study. At the end of every period they have to decide whether you go on or not. Don't worry; I won't fail if it's completely up to me, so long as my math deficiency doesn't bother me too much. If I had arrived a couple weeks earlier, I might have been with the group that is leaving for Yale tomorrow. However, I'm thankful I'm in, so I won't complain.

SEPTEMBER 22, 1943

Dear Folks—

I've been studying algebra every chance I have and am coming along well. I think it will work out fine. I was on table waiter duty today. Our main function is to bring the food to the table and wait for seconds.

SEPTEMBER 27, 1943

Dear Folks—

I'm feeling rather bewildered. There are all kinds of rumors—I've never heard so many. One is we'll be going to Mississippi State University, one U.C.L.A., then M.I.T., and plenty more. Something is going to happen tomorrow—I can feel it.

Most of the fellows who were with Co. D-30th Infantry along with me are in Fort Meade, Md and expect to be overseas within thirty days. They've all made out their wills and all other necessary details. I really liked and cared for those fellows—I had the best time possible with them and I was plenty sad when I heard it. I only hope the fighting is over before they see action.

Schooling as Service
Starting in December 1942, both the Army and the Navy established training partnerships with a number of colleges and universities, whose student numbers were dwindling because of the war effort.

SEPTEMBER 28, 1943

Dear Folks—

There isn't much doing except for the uncertainty of where and when we too will be shipped. There were two more shipping lists today, one to Michigan for language students and one to M.I.T. for engineers. I would have liked very much to have been part of the group but that isn't up to me.

I saw Salute to the Marines with Wallace Beery and it's a darn good picture. One thing that is starting to get my goat is the continuous glory and praise the Marines are getting. We realize they have been doing a splendid piece of work but the real Queen is the Infantry—I and the rest of us know that.

I shall always hold respect for the infantry of any country and I can say I'm proud to say I'm from that service. All the fellows who have taken that training will agree with me that the infantry is the back bone of any army.

OCTOBER 2, 1943

Dear Folks—

Well, I got the final dope; I'm going to The Citadel Monday. Most of the fellows going are New Yorkers and a disappointed bunch but that's the army. I wasn't too lucky getting The Citadel. A bunch left yesterday for Boston University. Just two more names and I would have been with them. It's probably better that I'm not too near home since I'll probably study harder since I won't be able to go anywhere.

THE WEST POINT

OF THE SOUTH

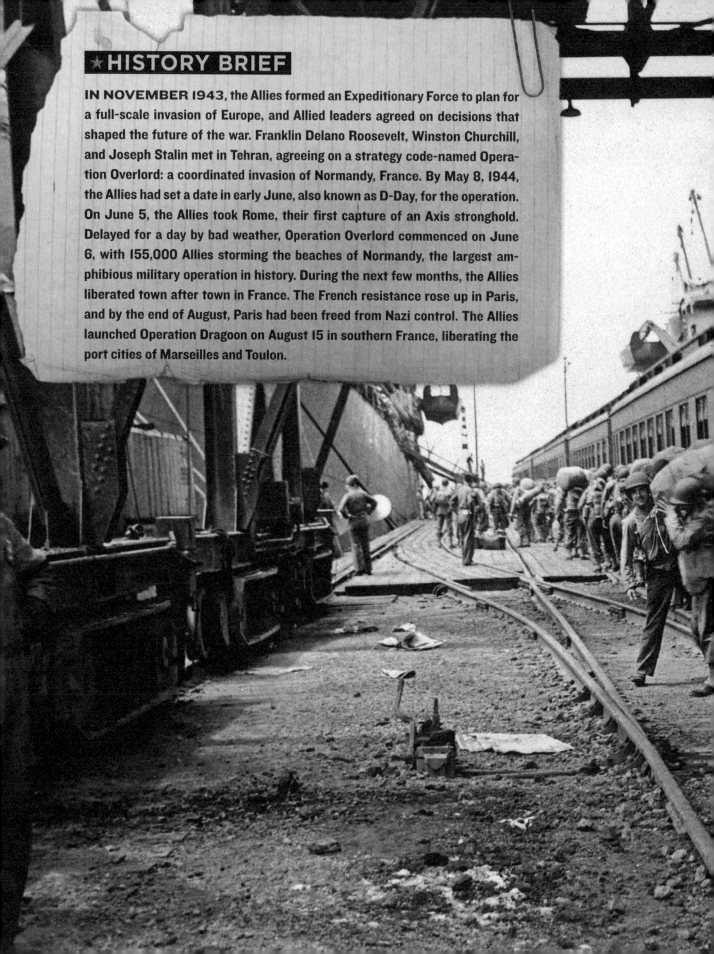

★HISTORY BRIEF

IN NOVEMBER 1943, the Allies formed an Expeditionary Force to plan for a full-scale invasion of Europe, and Allied leaders agreed on decisions that shaped the future of the war. Franklin Delano Roosevelt, Winston Churchill, and Joseph Stalin met in Tehran, agreeing on a strategy code-named Operation Overlord: a coordinated invasion of Normandy, France. By May 8, 1944, the Allies had set a date in early June, also known as D-Day, for the operation. On June 5, the Allies took Rome, their first capture of an Axis stronghold. Delayed for a day by bad weather, Operation Overlord commenced on June 6, with 155,000 Allies storming the beaches of Normandy, the largest amphibious military operation in history. During the next few months, the Allies liberated town after town in France. The French resistance rose up in Paris, and by the end of August, Paris had been freed from Nazi control. The Allies launched Operation Dragoon on August 15 in southern France, liberating the port cities of Marseilles and Toulon.

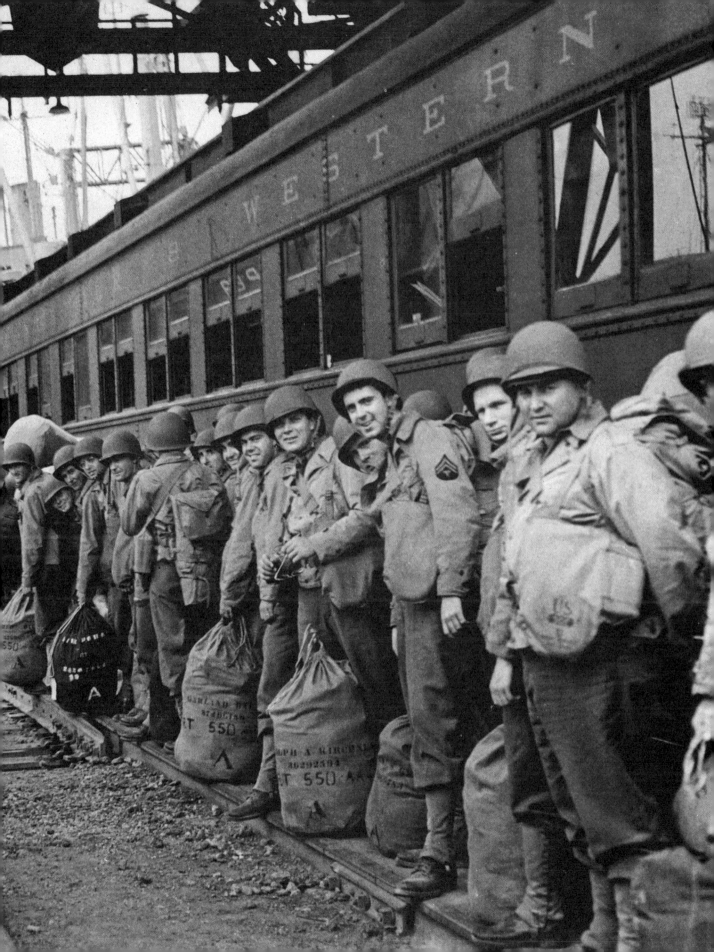

The Citadel is considered the West Point of the South, and the idea of going to a military school wasn't too inviting, especially when Yale, M.I.T., Harvard, and other prominent schools were in the mix. There was a favorable possibility that if I had pursued my Arabic heritage and opted to study Arabic, I might have been sent to Yale or to some other university more attractive to me, but I didn't. I mention Yale because New Haven, the home of the university, was only an hour or so from my home in Danbury, Connecticut.

In retrospect, I'm content with the way things worked out. But, at the time, I certainly wouldn't have opted to be on the front lines in the infantry. I was surprised to find out that I could handle the pressure and overcome my fear, and I ended up enriched by the experience. The reality was that my wishes weren't to be realized, and I was at The Citadel, where my main concern was the curriculum: Could I, with my limited math background, handle it?

Several of my fellow "students" were from New York City and way ahead of me in schooling, and I made a pest of myself asking to being tutored by them on mathematics, physics, and other subjects. I was severely challenged and worked intensely. When I reread these letters, I found myself pleasantly surprised to see how well I actually did. My hard work paid off.

Barracks at Fort Bragg, North Carolina, 1944. PREVIOUS SPREAD: *Troops waiting for overseas transport in Hampton Roads, Virginia.*

★ CHARLESTON, SC

OCTOBER 5, 1943

Dear Folks—

This letter is coming from The Citadel. Much to my surprise the place seems o.k. After the buildup it received at Clemson, that there were bars on the window and a nine foot wall around the whole thing, the place looks all right. There are no bars on the windows, instead a screen and there is no wall enclosing The Citadel, just a wire fence. The barracks look like a Bastille. They form a square around a stone floor. Classes start Monday so any chance for a furlough now is out.

Charleston is quite a big place in comparison to the other towns we've been in. It's called the "New York of the South." We noticed quite a few sailors in town yesterday when we passed through. Charleston is right on the coastline which accounts for the presence of the sailors. There is a P.O.E. (port of embarkation) where supplies and probably men are sent overseas.

We're in rooms which hold three men and have a sink with hot and cold running water. That is quite a luxury in comparison to Camp Croft and Clemson.

OCTOBER 8, 1943

Dear Folks—

We had our orientation lecture today where we got the lowdown. We are marked every month and one flunking grade and that's the end. Math and the rest of the schedule begin at college level, freshman year. In other words, I'm going to begin algebra, geometry, trig, physics and chemistry with no previous training. We also will have English, history and geography. I'm going to really have to work but you can bet I'm going to. If I flunk out it won't be because I didn't try.

OCTOBER 31, 1943

Dear Mom, Dad, George, and Eddie (Murphy [our cat] too) —

The inspections we have here are really strict and I do mean strict. They have worked out a gig system whereby after a certain number of gigs you lose your weekend pass. Our room was gigged this week for the room being out of place. However that didn't restrict us this week.

I hear that the restrictions for the dim-out have been lifted, especially in New York. That is a good sign.

We start our fourth week this Monday. Time is really moving on. This November fifth will mark the sixth month I've been in the army. It doesn't seem so long that I left home for Fort Devens in one way, maybe because I can vividly picture you folks so easily.

I love Sunday mornings, although I don't see why they make us get up for breakfast because we don't have to make up our beds or clean up. We just hop out of bed, go eat breakfast, come back and read the papers, write a few letters and just take it easy.

NOVEMBER 1, 1943

Dear Folks (and Murphy)—

I like going to school so much you'd never believe it—no fooling. It's a satisfied feeling a person has when he knows he goes to bed knowing he's learned something.

Taps has been blown about ten minutes ago but we've worked it out so we can continue right where we were before taps. Our room is in the corner of the barracks and hidden by big pillar and stairs. To complete the dim-out we put a shirt over the lamps and no one knows the difference. We use this underground system when we have an excessive amount of work to do.

Inside view of barracks at The Citadel, Charleston, South Carolina

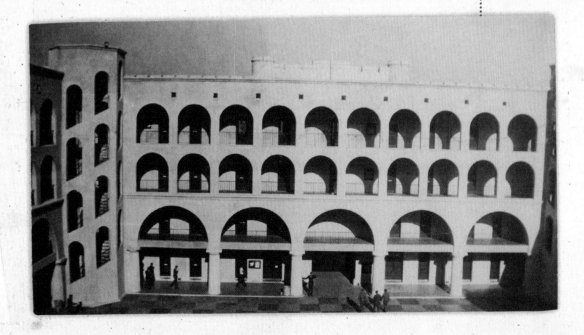

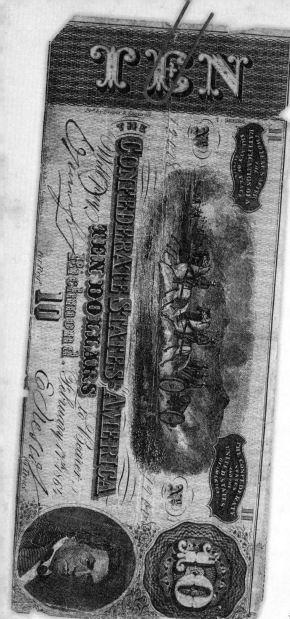

NOVEMBER 4, 1943

Dear Folks—

I was just looking at the Danbury News-Times and it was pleasant to see the picture of the High School band. It brought back pleasant memories and how! I think it is a wonderful tribute to Jimmy Gould and Mr. Onerheim. Let me know how the elections come out for the band, George.

George was my younger brother and was in the school band. I was the first president the band ever had.

NOVEMBER 7, 1943

Dear Folks—

The Confederate bill enclosed in the letter is one I bought down at Charleston last night. Imagine going into a store and buying money. Naturally though, they are worthless and you can buy all you want at 25 cents. The Confederacy produced the bills by the thousands with absolutely nothing to back them up, consequently it took a bushel full to buy anything with them.

NOVEMBER 14, 1943

Dear Folks—

We passed review for General Summerall all yesterday, cadets and all. There are about 500 cadets to our 1450 soldiers at The Citadel and coupled with the cadet band it was quite a spectacular affair.

They have a huge American flag which they flew from the mast the other day. It is the largest flag I've ever seen and it was quite a sight to behold. I must have stood in the road 10 minutes just looking at it.

Best to all salesmen, customers and friends. Does Pete the candy man come to the store anymore?

Confederate money. OPPOSITE: *Program for a chapel service at The Citadel.*

"REMEMBER NOW THY CREATOR IN THE DAYS OF THY YOUTH."

THE CITADEL

THE MILITARY COLLEGE OF SOUTH CAROLINA

CHAPEL EXERCISES

SUNDAY, NOVEMBER 14, 1943, 9 A. M.

Minister: The Reverend Heyward W. Epting
Pastor, Saint John's Lutheran Church
Organist: Mr. Princeton Dauer

PROGRAM

ORGAN PRELUDE: "Intermezzo" from "Cavaleria Rusticana" Mascagni

ADVANCING OF THE COLORS

DOXOLOGY

THE LORD'S PRAYER

SCRIPTURE LESSON: St. Matthew 7:15-29

HYMN: 116

RESPONSIVE READING: Selection 29

PRAYER, with response by Choir

ANTHEM: "Now Let Every Tongue Adore" (Bach) Citadel Choir

SERMON: "Building"

HYMN: 191

BENEDICTION, with four-fold Amem

RETIRING OF THE COLORS

POSTLUDE: Gower's Recessional

"—And let us with caution indulge the supposition that morality can be maintained without religion. Whatever may be conceded to the influence of refined education on minds of peculiar structure, reason and experience both fobid us to expect that national morality can prevail in exclusion of religious principle."

Washington's Farewell Address

NOVEMBER 17, 1943

Dear Folks—

They have started flunking out fellows already—about 20. Some were caught gambling, bad discipline and the remainder for failing to keep their marks up . . .

They have made it clear that since we were a selected group of the army, we would have more required of us.

Rules at The Citadel did not permit any contact with the bunk until after nine o'clock in the evening. We were supposed to be studying whenever we were in our rooms. I was caught taking a chance nap.

NOVEMBER 23, 1943

Dear Folks—

We were disappointed a little today. We found out we weren't going to get Thanksgiving Day off after all. We shouldn't kick, though, everyone else in the army is putting in a regular day and if we had gotten it, chances are we would have had to work harder making it up.

Guess what—they're playing "Jingle Bells" on the radio—sounds good.

DECEMBER 5, 1943

Dear Folks—

The results of the ASTP group before us showed the following: out of 222 ASTP units through the country (and that includes Yale, Harvard, Princeton, etc), we were first in history, 3rd in physics, 10th in math, 4th in English, and 6th in chemistry and 33rd in geography. That's not bad considering the lowest we placed was 33 out of a possible 222 in geography. I hope our bunch does as well.

General Summerall spoke to us yesterday for the first time and he came through with a splendid speech. As I have already told you, he was chief of staff in 1932. He covered the world situation and spoke with authority. He told us the army knew in 1918 that the peace wasn't a real peace. I wish you could have heard him, Dad.

DECEMBER 9, 1943

Dear Folks—

The train arrived in North Charleston at 8:45, an hour late. From there we caught a bus to the heart of Charleston and another bus from there into The Citadel.

I slept most of the way into Washington, where we had an hour-and-a-half layover. That gave us a chance to wash up and grab a bite to eat. We weren't so lucky (some of the fellows I met and me) from Washington to Charleston since we didn't get a seat, but we made ourselves comfortable in the aisle.

It was swell to get home. I'm sorry I didn't tell you swell folks how lucky I am—lucky to have a swell dad, swell mom and swell brothers—don't think I don't appreciate it—just remember I think you're tops—the very top . . . Gosh, it was swell, Dad, to have you with me until I was on the train.

I received a letter from Charlie Hajj today. He mailed it December 1st, 1943—I don't quite understand why it took so long. He was in the hospital when he wrote it. He misses the States, but he gets along swell with the Arabs and gets a kick out of hearing the Syrian programs over the radio.

I also received a V-Mail letter from one of the boys I was with in Croft. He is in England.

George, don't forget to send me the illustration board and a sketch pad or two.

Interior of The Citadel, 1943

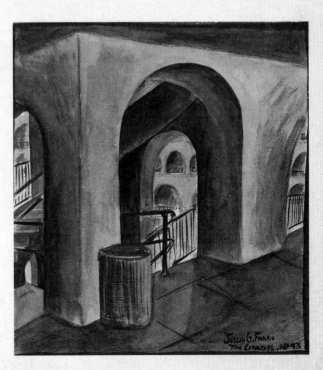

My cousin Al had enlisted in the air corps. One day while his outfit was having target practice, he was in the pits servicing the targets when someone fired prematurely and he was hit in one of his eyes. Sadly, he lost the eye and was discharged from the corps. I had just placed a call to him before writing the following letter.

DECEMBER 11, 1943

Dear Folks—

Al sounded swell, as did all the rest of you folks. From talking to him though, I received the impression that he cannot see out of his right eye. I hope it's not true.

The government exams come up the 22nd and 23rd of this month. Here's hoping I come out o.k. there. They usually give them at the very end of the term but for some reason or other, they're not waiting this time. My second-term marks covering the first eight weeks are as follows:

Geography C+	Math A
English B	Chemistry A–
Physics B	History A

I had a bad start in geography but I'm grasping it now. It's considered one of the easier subjects and for that reason, I guess, I haven't put enough time into it.

I enjoy reading history much more than when I was in high school—it's more important now, for I'm beginning to realize the old saying "What Price Freedom."

It seems as though they're fighting the Civil War all over again down here. The newspaper of Charleston—the News & Courier—is the big gun. I'd

discontinue subscribing to it if there was any other paper to replace it. Some of their editorials are the weakest arguments possible. For one thing, they aren't paying Negro teachers the equivalent of what white teachers get thereby causing friction. One editorial suggests making Danbury the Negro capital. I don't take that as an insult—hell, there's nothing wrong with a colored man but the most logical place is in Atlanta, Georgia, where there is a great colored population.

I cringe now when I see the word "colored" used, but that was the accepted use in my youth. Danbury, Connecticut, had a large African American population when I was growing up, and about half of the customers in our store were African American. Many became good friends.

JANUARY 15, 1944

Dear Folks—

The fellows in my section—72—hail from all over the States—Florida, South Carolina, Virginia, New York, Brooklyn (the Brooklyn fellows seem to think it's a separate state), Connecticut, Indiana, Nebraska, New Mexico, Ohio and many more states. It's really quite wonderful when you think of it. Our math teacher comes from Texas—and sounds it.

JANUARY 17, 1944

Say, George, send me my drawing book—George Bridgman's "Constructive Anatomy" and the illustration board. I've had quite a bit of free time lately and I'd like to take advantage of it.

Dad, you should hear the discussions we have in history class. We're supposed to be discussing ancient history but we're on modern affairs most of the time. If you get a chance, read Walter Lippmann's columns in the "New York Herald Tribune" editorial page. It appears every other day. That boy knows his stuff.

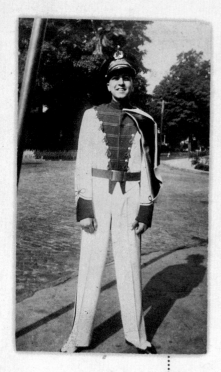

My brother, George Farris, was the drum major of the Danbury High School band in 1944.

JANUARY 19, 1944

George, try and get the art stuff I asked for as soon as you can—if you haven't already mailed.

I got my first mark back. I hit an A in history.

This Syrian fellow I was telling you about just got some baklawa and I still have a little of the sweets Aunt Mary gave me—we're going to have a little impromptu "party." The only thing holding us up is that he hasn't been able to find a can opener as yet.

We were assigned to give talks in front of the class. I couldn't think of a topic until I suddenly thought of art. So I prepared a talk on the human body and drew an illustration on the blackboard while I described the proportions—that was an easy way to knock off an oral speech.

FEBRUARY 10, 1944

Congratulations, George, on leading the band—give me the whole lowdown—how you felt and everything. I'm really proud of you, kid. I can picture you going to town up there. I'd sure liked to have seen you in action.

FEBRUARY 12, 1944

Dear Folks—

I wish you could see the cadet church services. It's been militarized and is quite effective. All visitors and soldiers sit on the sides while the center aisle is reserved for the cadets who come in as a unit. There are ushers (cadets) who take us to our seats. The general and colonel have an aisle reserved for them. We then all await the entry of the colors. The organist has chimes on the organ so when the flag comes in he uses the chimes and the result is tops. Everyone then snaps to attention. Then the regular church service proceeds. The same procedure takes place once more with the retiring of the colors. The general is the first one out of the chapel, followed by the remainder of visitors.

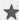

At this time, we found out that the ASTP was being severely reduced—almost eliminated—and most of us were being returned to the Army Ground Forces for duty with divisions and other units. The program probably saved my life, since I was removed from possible combat for six months or so. I decided to apply for the Army Air Forces—anything appeared better than returning to the infantry.

FEBRUARY 28, 1944

Dear Folks—

The big news concerns the aviation cadet applications. A ruling from Washington will not permit anyone but former air corps fellows to try for it. So this afternoon I went after my applications and now have them. I'm going to hold on to them just in case I may need them again. Anyway, you won't have to worry about my flying—I don't know what's what now—but don't worry.

Everything's coming along fine here—in fact, I hit 100 on my physics test without even trying hard. It makes me laugh to think how much I was worrying about physics the last term.

The author, James Farrell, and Gordon Foster, early 1944

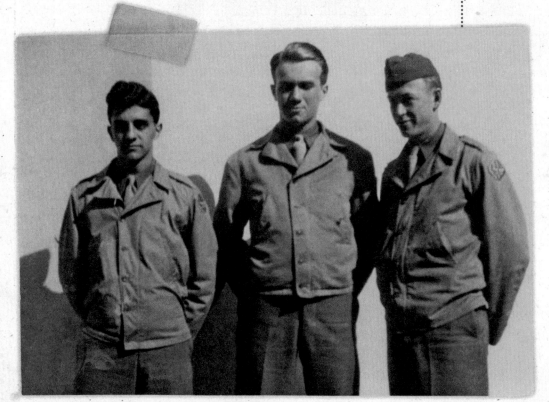

I had a swell time at the USO dance last Saturday night. After awhile you get to know the girls and meet them there quite regularly.

Tomorrow is payday but believe it or not, I still have money. That's quite unusual in the army.

We wrote a 500-word theme for English in class today and I took advantage of my art training and wrote about the process of making a cartoon.

Congratulations on making the boy scouts, Eddie [my youngest brother]—by now you should be a tenderfoot. Keep up the good work and I'll give you two months to be a second-class scout—don't disappoint me. Watch your spelling in your letters, Eddie. You're slipping just a little. Keep writing, as I really like to hear from you—you're a good kid, Ed.

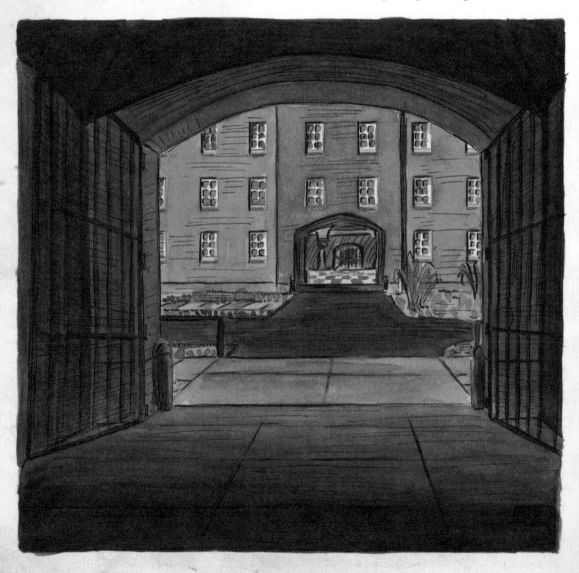

MARCH 1, 1944

Dear Folks—

I'm really sorry to have missed you when I called, Dad. Unless I get everyone, it kind of gets to me.

Everything is fine—I'm waiting for my date [to be transferred] now, which is the reason I had to call up early.

Alice Cornell is here tonight and is going to give a performance. She's a radio star—you may have heard of her. It's going to be broadcast over the radio. The Army Airbase Band is going to provide the music.

I'm glad to hear that you made Tenderfoot Scout, Ed—keep it up, kid.

I'm looking forward to receiving your pic, George. If it's anything like the one's you've taken previously it should be a honey. It's hard to believe that you're graduating in just a few months.

Everything is wonderful on this end.

I continuously tried to assuage the concerns of my family back home, even though I was experiencing much anxiety myself. In this case, it was what was going to happen to me when the ASTP was over.

MARCH 2, 1944

Dear Folks—

As yet no one has shipped out—that is, besides the boys that flunked out. The only office on the post nights is the O.D. (officer of the day). There are no non-coms or anyone from supper 'til morning. The whole organization is run practically by the G.I.s. We're not permitted to visit other rooms, lie on our bunks or have food in the room. The O.D. has to check at least one floor in each barrack, that is, go into each room and check up. As soon as the O.D. reaches our barrack, the word is passed around for everyone to get on the ball. This room has never been caught sleeping.

Pop Radio
Alice Cornell had her own talk-and-music show on WEAF, a popular New York City-based radio station that became WNBC in 1946.

OPPOSITE: *The Citadel, 1944. The architecture of The Citadel was an attractive subject for my watercolors. I've always been taken with drawing buildings.*

My days at The Citadel came to an end after six months when the ASTP was greatly reduced. My application to be transferred to the Army Air Forces was too late, because by then it was closed to all but those who had come to the ASTP from the air corps to begin with. Since I had originally been in the infantry, it was back to the infantry.

All told, my college experience was quite successful. I was able to overcome the severe handicaps caused by my high school studies being devoid of advanced subjects like algebra, geometry, trigonometry, and physics. I didn't flunk out and actually succeeded in receiving excellent scores. At first, physics was my greatest hurdle, but I ended up thoroughly enjoying it and had a final test score of 100.

★ FORT BRAGG, NC

APRIL 1944

Dear Folks—

My goldbricking job of sign painting is over but at least they know I paint. I completed about twenty signs all told besides painting some letters on a captain's footlocker. I got out of a night problem and bivouac.

I met another fellow I knew from Danbury last Saturday at the USO in Fayetteville [North Carolina] right after I finished writing to you. He was a high-school classmate of mine when I was a sophomore. The way we knew we were there was through a book where soldiers sign their names and addresses. His name's Charles Bettolotti and he's in field artillery taking basic. [Later in civilian life, he became my electrician.]

Say, Mom, take some of the money I sent home and buy Eddie a present. I'm pretty low in money so I'll not be able to send any from here. Payday is just around the corner, though.

APRIL 1944

Dear Folks—

A few of us are here for practice marksmanship with the pistol. We go out on the range tomorrow. Yesterday we were out on the Browning automatic water-cooled

OPPOSITE: *Temporary visiting pass for the author's father and uncle, Fort Bragg, North Carolina*

machine gun where we fired three belts of ammunition, one practice, the next also practice but called "jawbone" and the final one for record. There were about 150 rounds in a belt. Each round costs six cents, which makes $27 a man. That adds up to a lot of money. On the record, my score was 158 which rated the highest when I left. When I fired the machine gun at Camp Croft. I hit 171.

Around this time, my father and Uncle Abdoo came down to see me and spent a few days. One of my memories of the visit was the friendliness of the people. As we were walking in the community, everyone gave us a gracious "Good morning." We were experiencing Southern hospitality.

APRIL 25, 1944

Dear Folks—

Our whole company is on fire guard from 12 noon today 'til 12 noon tomorrow and we are restricted to the company area. One of our officers—you probably remember him, Dad—the small one who was before the company when you were across the street—a nice fellow—and bunch of the boys, including me, played volleyball—six games and were stopped only because it was too dark to see.

Please send me small pocketbooks once in a while. They slip into my pocket and I can take them out and read them during our spare time and during breaks.

This morning we went out on trucks and didn't have to hike to a range where we fired at radio-controlled airplanes. They have a wing span of six or seven feet and are operated

by a gas engine and controlled on the ground by radio. When it runs out of gas a parachute opens up and the plane lands safely. The operator on the ground brought it in toward us and then suddenly had it dive away simulating a real plane. Everyone took a crack at firing at it—sixty-five thousand rounds all together. Guess how many hits we made—nine, all told. That gives you an idea of what gunners are up against. Naturally we all weren't experienced at firing at aircraft and we shot only one hundred rounds at a time in each burst. There is a tracer bullet in every fifth cartridge to indicate where our shots were going. It was a lot of fun and I managed to fire twice before the captain came by. By the way—we walked back. All in all, I don't mind being with a line outfit.

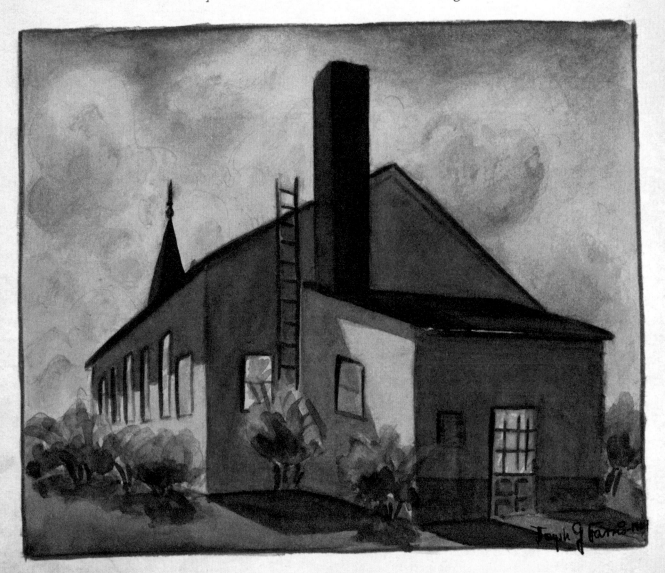

MAY 14 & 15, 1944

Dear Folks—

Here it is Mother's Day. It's too bad I wasn't able to be home this weekend but I guess I was quite lucky to be home as long as I was. [At the beginning of May, I went home to Danbury on an emergency leave for 10 or 11 days. I don't remember why.]

We just received the latest dope on the future of the division. There is a shipment coming up of the older fellows to P.O.E. (port of embarkment). We new boys are the replacements for them. The way I gather it is that the earliest we can ship out would be in August and if we do ship out it will probably be later than that. So don't worry about my shipping over for a while.

The company was out digging gun emplacements for a big exhibition we're going to give this Thursday for the Allied Press. Representatives from many countries are going to be on hand to look us over. Tomorrow we're going to go through a practice "wet run," which means we're going to use live ammunition. It should be a lot of fun. Tomorrow night we're going to go on a fifteen-mile hike. Then we're going to be off Wednesday 'til two o'clock. That never happened to us at Croft. We'd hike at night and go to work as usual the next morning.

The longer I'm here the better I like this place. I never have to worry about what to do in my off time. Tonight for instance, there was a quiz show at the service club and a concert at the amphitheater. Company M is in about the best location since we're located near the center of everything when it comes to entertainment.

MAY 19, 1944

Dear Folks—

We just got through with another easy morning—close order drill, calisthenics, cross country run, first-aid class and a reading of the articles of war. These articles relate to AWOL [absence without leave], desertion, etc., and must be read to us every six months—that comes to three times for me. As it is I've heard them about ten times, since many times I'm in with boys who haven't heard them before.

We pulled off the problem yesterday before the Allied war correspondents. I've never seen so much lead in the air at one time in all my life. We had heavy artillery behind us—at least eight miles back—240mm rifles! Our machine-gun platoon advanced at the ordered time while the second platoon protected our advance to new positions.

OPPOSITE: *Chapel, Fort Bragg, 1944*

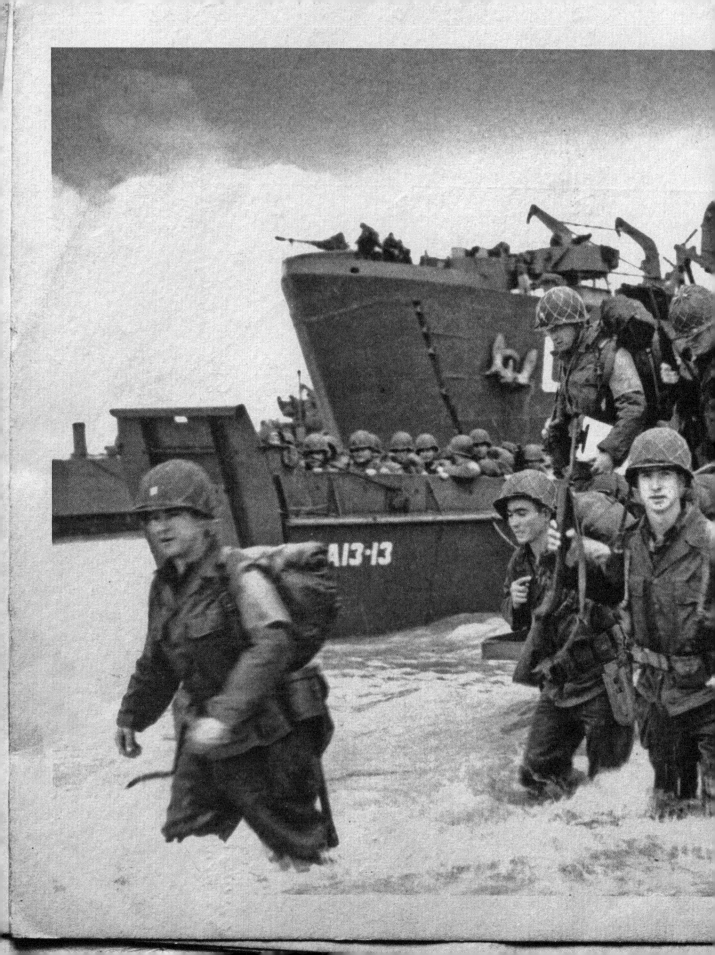

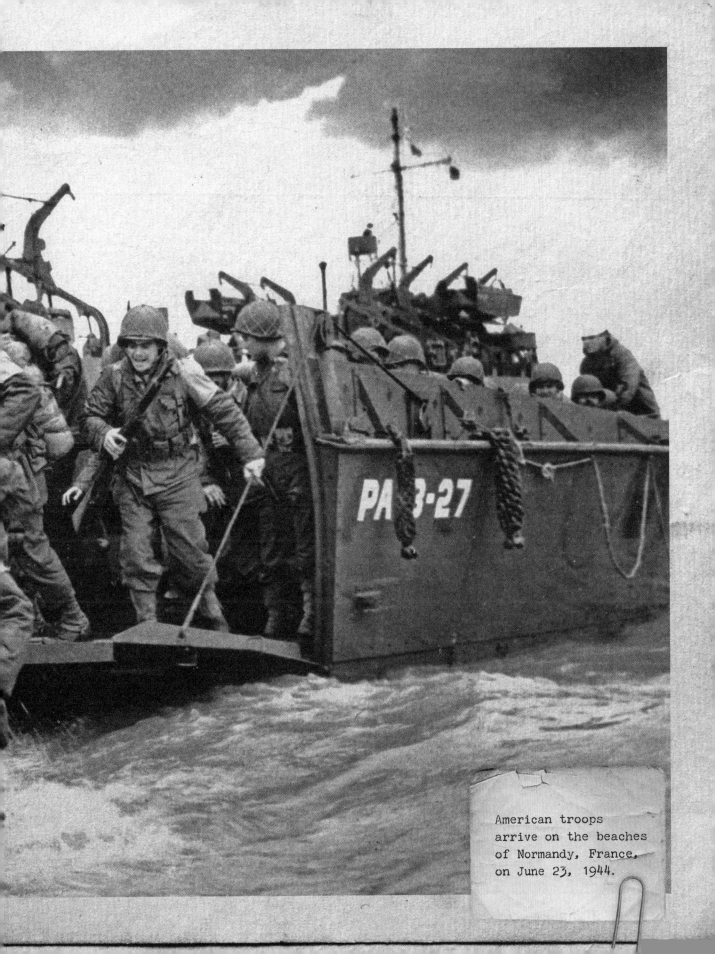

American troops
arrive on the beaches
of Normandy, France,
on June 23, 1944.

MAY 1944

Dear Folks—

Here it is nine o'clock in the morning and I just crawled out of bed. We have the morning off because we worked the infiltration course last night. No one was hurt although three fellows were knocked out, one from the heat and the other two from a big dose of smoke from the pots on the course. The machine guns we used weren't very good and they jammed on more than one occasion.

I still haven't received recent mail and am hoping Charlie Hajj is o.k.

The infiltration course was composed of heavy .30-caliber machine guns firing live ammunition 15 or 20 inches above the ground while the trainees crawled under it. One out of five cartridges had tracer bullets, which one could see whizzing above. There were buried explosives and pots emitting thick black smoke. As I remember, the course ran for about a hundred yards or so. It was very challenging and frightening, and I experienced it several times. At this point in my training, I was on the other end—doing the firing. The machine guns had a protective bar under the barrel to prevent them from firing too close to the ground. Unfortunately, on rare occasions the bar failed and there were casualties. No one was hurt during my times on the course, whether I was doing the crawling or the firing.

MAY 20, 1944

Dear Folks—

Yesterday we saw a swell demonstration of how the medical corps functions on the battlefield. It was a good show. They showed wounded cases which we followed up from the battlefield to hospital. The victims were painted up so that the wounds looked real. In the operating room they fixed one boy's arm so realistically it looked as though he had lost half of it. In the convalescing recovery tent there were a couple of boys acting as though they had lost their minds. They had us roaring in laughter.

Leadership

Maj. Gen. Withers A. Burress was the commanding officer of the 100th Infantry Division through September 1945, leading the Vosges Mountain campaign and the Battle for Bitche.

We went to an orientation lecture and became aware that our division commander Major General Burress had just walked in. We were discussing Russia and its government when he arrived and we switched to a regular gab session.

The rumor has it that we are to go on mountain maneuvers in July. The general said he was trying to get us out to the beach for ten days as sort of rest period. I hope it comes through. The mountain maneuvers would be swell since it's probably nice and cool up there. They would probably take place in West Virginia. Major General Burress looks like a regular fellow—he joked and acted like a G.I.

MAY 26, 1944

Dear Folks—

Yesterday was a snap of a day. In the morning we gave a demonstration of the effectiveness and use of the machine gun. In the afternoon, I got a big kick out of this—each one of us was put on a machine gun and acted as instructors for a group of non-coms. There were tech sergeants, staff sergeants and corporals in the group.

This morning we had our routine close order drill (marching—column left, column right, etc.) and calisthenics. Then we came in and cleaned our weapons and scrubbed the barracks. Right now we're just hanging around taking it easy. This afternoon we go out to fire transitions with the carbine rifle. Transitions means we fire at targets which pop up and then go down either when hit them or when the time is up.

Barracks, Fort Bragg, 1944. A typical barrack street at Fort Bragg, North Carolina. One day a truck full of watermelons appeared, and soon, as far as one could see, GIs on barrack porches down this street were devouring whole melons with great gusto.

MAY 30, 1944

Dear Folks—

It's now noon hour. The Memorial Day parade must be over by now. I'd have given a lot to have seen it. I'm feeling swell and hoping that all of you are feeling well. On my last birthday May 30, 1943, I was at Camp Croft in South Carolina. Now I'm a little farther north at least.

We had that big swing show last night. There were four bands in the contest and the two division bands also. The 399th has the best band outside of the division bands and last night they proved it. Our band didn't seem to have enough volume and power.

There is a rumor that we may move to another camp but it is purely rumor. I can use a sketch pad if you can get hold of one. The bigger it is the better.

I received your package yesterday and it's swell! Also your letters, George and Ed—thanks a lot. I also received a package form "the Committee of 100 Women." In it were cigarettes, cards, shaving cream, etc. It's pretty nice of them.

JUNE 3, 1944

Dear Folks—

Well, it's all over! By that I mean the test for the expert infantryman's badge, for me anyhow. It was pretty rough in places but I managed to come through with flying colors. That's the badge that I told you was first presented to a tech sergeant in our division—the first ever. It took about two and a half days to go through it. Wednesday we threw dummy hand grenades for record. I scored 95 out of a possible 100. Thursday morning we went through the physical fitness test and had to do at least 24 pushups, run 300 yards in 52 seconds (I made it in 47), do 8 burpees (a full-body exercise used in strength training and as aerobic exercise) in 20 seconds, run pick-a-back 75 yards in 27 seconds (I did it in 20), and run a zigzag course in 30 seconds (I did it in 29). The hardest part of it was that we went from one to the other without any rest to speak of. We had a first-aid test—the scorer wouldn't give us the results but said we had passed. In a field sanitation test I hit 95. Then we had a test in camouflage. We had to camouflage a foxhole so it would be invisible from above and from ground level. Then we had to dig a slit-trench under fire. We got pretty dirty doing that since we had to lie on our sides and dig away, ducking make-believe fire from a machine gun.

Yesterday we went onto a bayonet assault course. Since I don't carry a MI rifle and consequently no bayonet, I didn't have to go through that. My weapon as a machine gunner is a pistol. We came to a field-proficiency test where we had to cautiously advance firing at targets as they popped out. This had me worried most because I had to fire the pistol, and I never had before. I came out o.k., hitting six out of eight targets, which were silhouettes of a man from the stomach up. They were about fifteen yards away. You can't fire a pistol with much accuracy for more than twenty-five yards because one can't hold it steady for a long period of time.

Next was the big thing—scouting and patrolling which included two compass courses, one at day and one at night. We demonstrated how to creep, crawl, advance on houses, etc. We picked out day and night routes on a map and walked them. The day compass course was about 2,100 yards long, and we went through swampland for a little way. We were allowed to come within 75 yards of a stake and pass the test. I came about 50 yards away. Up to that point, I had passed everything. Now all I needed was to pass the night compass course which we covered last night. It was 2,400 yards long but through fairly good terrain. We had a maximum of two hours in which to complete it. The average was about one hour, which was my time. I almost fell over when I asked the umpire where the finish was. He pointed to the stake, which was about five feet in front of where I ended up! I was startled to have been able to get that close.

We've had the morning off today because of the taking the course last night. We're eventually going to receive the badge, which is a silver rifle against a blue background.

Digging Under Fire
Combat troops had to learn to dig a slit-trench—a narrow hole big enough to lie and hide in underground—even when in battle.

JULY 6, 1944

Dear Eddie—

Well, how're we doing, kid? I hope you're having a good time and since you're in Quincy [Massachusetts] I'm sure you are.

We have quite a few airplanes landing at the airport here now—B24s, B25s, B26s and many others.

A couple of days ago there was a pretty strong wind blowing. They took up the gliders anyway and eventually about ten of them missed the airport and a couple crashed. One of the fellows broke his back, but I believe the others

came through o.k. The gliders are towed by C47s. Sometimes they take up two gliders at a time, one on a little longer chain, then the other.

That's about it—have a good time, Eddie, and be good.

AUGUST 19, 1944

Dear Folks—

I'm now waiting for the call I placed to you to go through. The operator said that there would be a three- to four-hour delay so I'm now hoping that I catch you before you close the store.

We had an inspection today of all our G.I. equipment. No one has the faintest idea as to where we're going and that's keeping us in suspense. It's not going to be so bad since we're all going over together. We have a swell bunch of fellows and some good non-commissioned officers. Our platoon leader's name is First Lieutenant Gray and he's a darn good man.

I need some small tubes of watercolors—ivory black, cadmium yellow, crimson red, bright orange, and a tube of white if they have any.

I'm not sure if I'll be able to get a pass to see you like I hoped. They have cancelled all passes and furloughs. I got mine just in time. They may, however, eventually give us one and then again, they may not. That's the army!

The war news is pretty encouraging and kind of makes you feel good, especially to know that someday this will be all over.

Don't worry about me—everything's fine and I'll let you know what's what.

AUGUST 20, 1944

Dear Folks—

I just came back from the Service Club where a couple of us had some milk and ice cream. Before that we took in a movie—The Seventh Cross with Spencer Tracy. It was a good show. Later they held a swing concert with the division band, which was headed by a composer who previously was with a big band.

I believe we're going out for a three- or four-day problem staring tomorrow so you may not receive any letters for a few days. It was swell talking to you all last night. You sounded swell. We're not supposed to say anything about leaving and they're spot-checking some mail, but we don't know very much as to where or when we're going anyway. It'll be sometime in September, probably,

100th Division soldier sleeve insignia

before we leave Bragg and there's no telling how long we'll be at our next post. Everything's swell here, we're taking it easy and having a good time.

AUGUST 28, 1944

Dear Folks—

The lights are out now and I'm writing this in the latrine where the lights are on all the time. There is a big crap game in progress also. I guess a latrine—or bathroom, since you probably don't understand army talk too much—is a place for everything. It is about twice as large as our bathroom back home and that is large!

I was a prisoner chaser or guard today. We reported to the division stockade at 6:30 in the morning and were through at 5:00. This afternoon it was a goldbricker's job all the way. The detail I pulled was sitting outside of a fence-enclosed lot called "the bullpen," which was adjoining the stockade. For eight hours I sat with a carbine rifle and eyed the prisoner as he dug an immense hole. It was about twenty feet long or more both ways and I couldn't see the bottom. All these prisoners are from the 100th Division—fellows who went AWOL, etc. They are serving 50 years and a couple 20 years. I suspect they'll get out much sooner. Some of them think they're pretty tough.

Rear of a service club, Fort Bragg, North Carolina. Ordinary GIs and officers each had their own service clubs. The only time I visited an officers' club was when I was assigned to paint a mural.

SEPTEMBER 13, 1944

Dear Folks—

I sent a suitcase to you today by railroad express with some things I won't need. We weren't allowed to take our civilian shoes with us. Take good care of the paintings in the suitcase. The big ones are some I did at The Citadel and the rest at Fort Bragg.

That was the last letter I wrote from the States during the war.

ROWED TIME

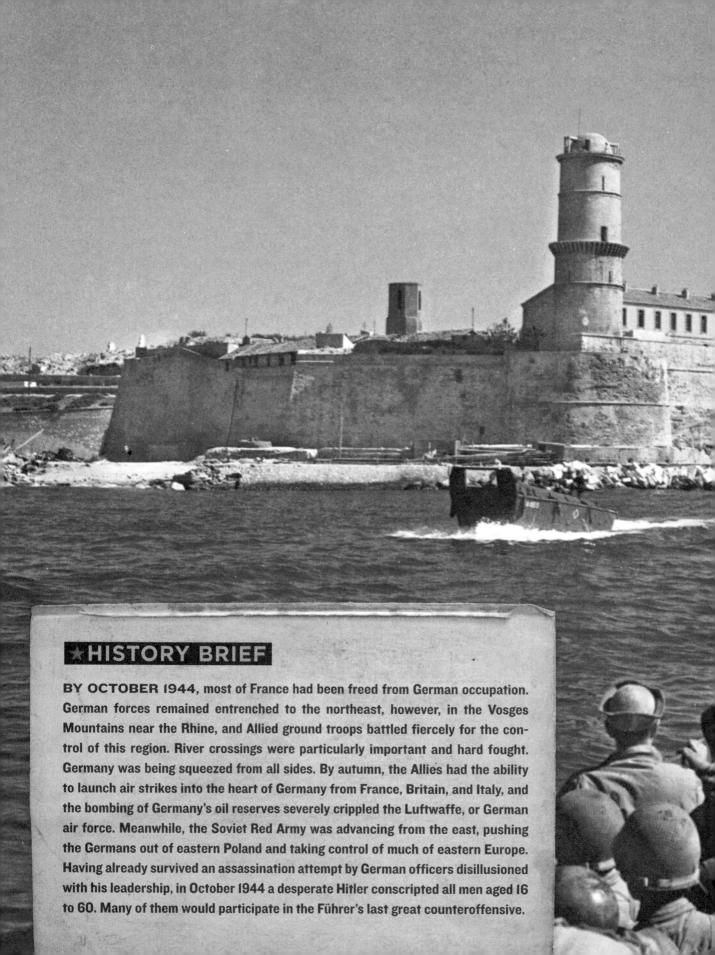

★ HISTORY BRIEF

BY OCTOBER 1944, most of France had been freed from German occupation. German forces remained entrenched to the northeast, however, in the Vosges Mountains near the Rhine, and Allied ground troops battled fiercely for the control of this region. River crossings were particularly important and hard fought. Germany was being squeezed from all sides. By autumn, the Allies had the ability to launch air strikes into the heart of Germany from France, Britain, and Italy, and the bombing of Germany's oil reserves severely crippled the Luftwaffe, or German air force. Meanwhile, the Soviet Red Army was advancing from the east, pushing the Germans out of eastern Poland and taking control of much of eastern Europe. Having already survived an assassination attempt by German officers disillusioned with his leadership, in October 1944 a desperate Hitler conscripted all men aged 16 to 60. Many of them would participate in the Führer's last great counteroffensive.

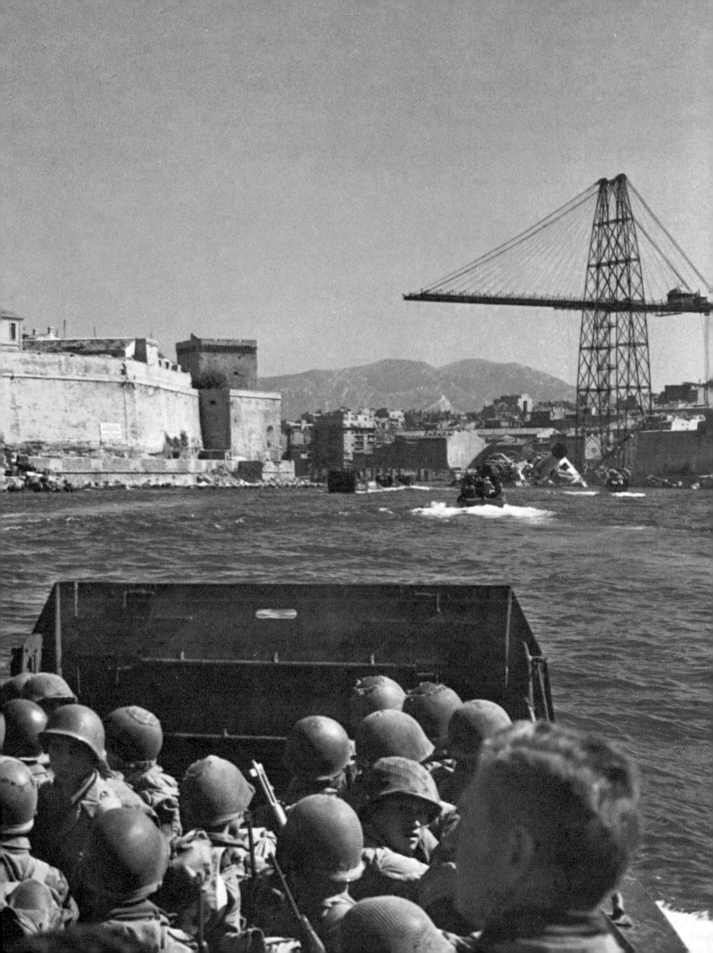

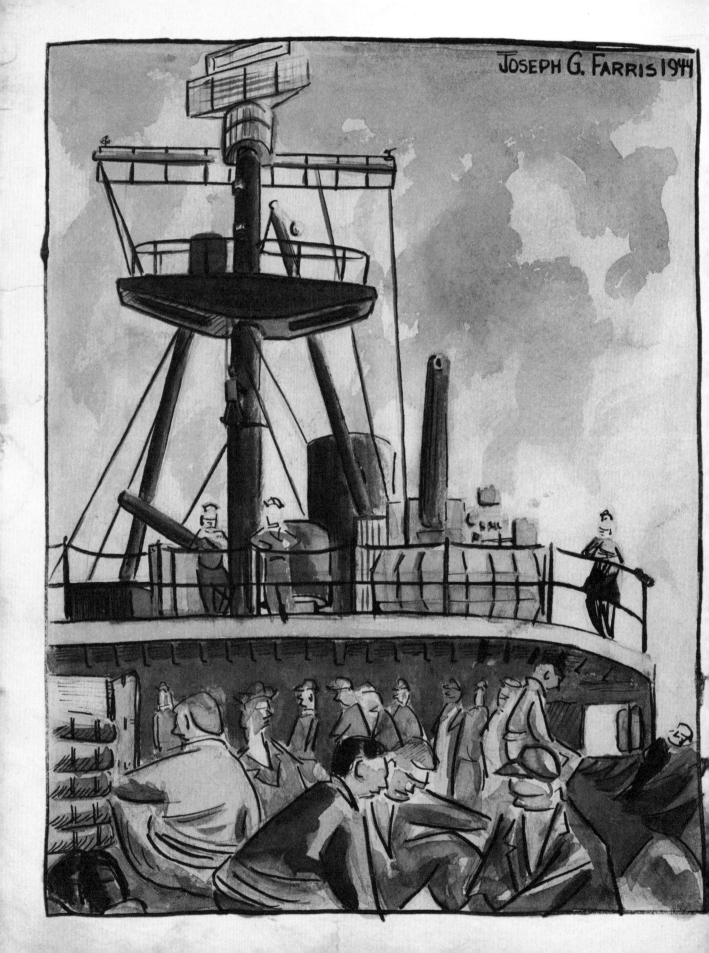

JOSEPH G. FARRIS 1944

The 100th Infantry Division, to which I belonged, left the United States in October 1944 on the U.S.S. *General W. H. Gordon,* which was operated by a U.S. Coast Guard crew. The ship was 622 feet long, displaced 17,833 tons, and was built in New Jersey, my birth state, in 1944. There were 5,196 troops aboard. I wondered then how many of us would return alive.

It didn't take long before seasickness overtook me as the ship rocked and rolled. Seasickness as a subject is often considered humorous, but I quickly found out otherwise. At first, I answered mess call, but after a while I couldn't stand the smell of food. We sat at long, planklike tables, and I would watch the food in my mess kit slide from left to right in cadence with the ship's rolling and make a stab at it as it whizzed by. Instead of eating the proffered food, I soon started going to the PX (post exchange) where I was able to buy saltines, which, it turned out, were almost the only food my stomach didn't reject. As long as the saltines held out, I managed to be fairly comfortable, though my nutrition suffered badly. Before long, the PX ran out of saltines, so I settled for M&Ms—small, oval-shaped candies I had never seen before. I ate so many of them for survival that to this day the idea of eating M&Ms makes me gag.

I frequently joined many of my fellow GIs at the railings throwing up. The fish must have been delighted with the strange but bountiful fare offered them. Whenever the weather permitted, I spent my time above deck commiserating with myself, but did manage to write letters and draw.

Aboard the U.S.S. General W. H. Gordon, *1944.* PREVIOUS SPREAD: *Allied soldiers arrive at the harbor in Marseilles, France, in August 1944.*

★ SOMEWHERE AT SEA

OCTOBER 1944

Dear Folks—

I'm writing this letter aboard a troop transport on our way over there. Our big day finally arrived. A few minutes ago we were told our destination, which as yet we aren't permitted to tell you.

I'm feeling fine much to my surprise, although yesterday I thought I really was going to get seasick.

Boarding the gangplank onto the boat from the pier was nowhere near as exciting or tense as we all expected it to be. When the ship left the pier no one was aware of the fact & when they gave us permission to go on deck we were all surprised to find ourselves out on the ocean already.

The ocean air is really wonderful especially since it's so pure. Whenever we feel a little seasickness coming over us we dash up to the deck & get in some of that air.

We get chow twice a day, in the morning for breakfast and in the evening. The food's really swell & we get plenty of it.

The Red Cross met us just before we boarded ship & gave us some very welcome coffee, donuts & candy. Then when we got aboard the ship here we each received a bag with this writing material here, a sewing kit, a pocketbook & several other items.

We have showers aboard ship and our particular sleeping quarters are about the best on the entire ship. The other quarters have chow lines passing through almost continuously. Before we boarded we were prepared to stand in line for chow for the greater part of the trip but they have a swell system worked out where we line up for rarely more than ten minutes.

We have a PX where we can get any necessary personal equipment besides candy that we may want.

It's a great thrill to go on deck and look around. As far as you can see it's water, 360 degrees through. This morning especially was nice, just after the sun had risen. The water is a deep blue, the bluest I've ever seen water. Flying fish occasionally pop out and go skimming along the surface & then just as suddenly disappear into the rising waves.

We have one luxury aboard that no one expected and that is a radio speaker in the mess hall. You can imagine how surprised I was when I suddenly heard the "Make Believe Ballroom" coming at me. It never sounded better, either.

Red Cross workers greet the troops with coffee and donuts in Germany, 1945.

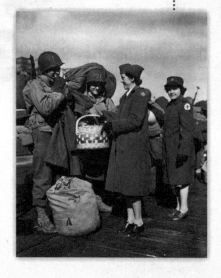

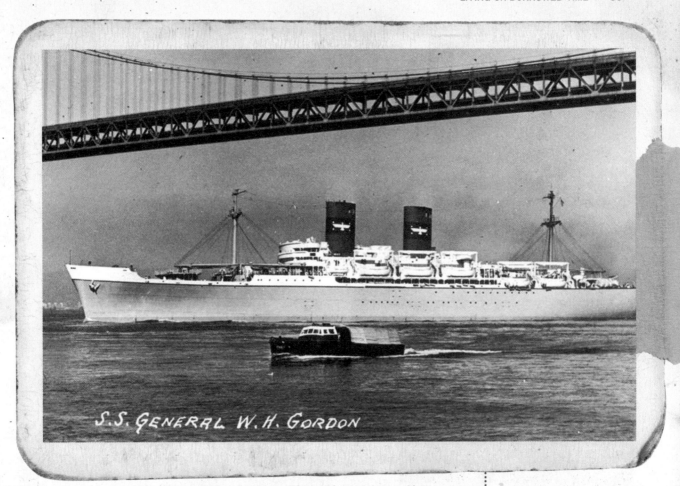

S.S. GENERAL W. H. GORDON

OCTOBER 1944

Dear Folks—

It's been some days since I wrote the first letter to you and not much has happened since then.

We had some experience with an ocean storm & it wasn't too pleasant. There were probably more men seasick on that day than men who were well. [Undoubtedly I was among the sick.] The waves really hit the deck that day & with the roaring wind that was enough to keep us restricted to the hold for the day. It gets pretty stuffy there after a while.

Right now the trip is pretty smooth & nearly everyone is feeling pretty well. I just came from chow & I feel exceptionally fine.

Yesterday I did my first sketching and I managed to finish a watercolor which didn't come out too bad. If you can get hold of some illustration board or illustration heavy paper it would probably come in handy. I couldn't bring all the board I had while we were at our last station & had to throw it away. I'm almost out of it now . . .

The U.S.S. General W. H. Gordon *left the New York Port of Embarkation on the way to Marseilles, France, in October 1944 with 5,196 troops aboard.*

I'm going to write a letter with V-Mail. You let me know how it compares. I'll send this letter by regular mail. That makes three letters, one air Mail, one V-Mail and one regular. When you get them let me know what the date was.

OCTOBER 1944

Dear Folks—

As I write this letter we have almost reached our destination. I'm feeling swell & doing o.k. I took in another movie today & this seemed to be a rather new one—Deanna Durbin in The Amazing Mrs. Holliday. Then we took in church service, which was a regular one today since it's Sunday.

It would be nice if I ran into Jimmy [Jimmy Carlo, a childhood friend] over here somewhere. You can never tell about those things. I was quite lucky in the States in seeing the fellows.

I've been doing quite a bit of reading & some sketching. There was a boxing tournament a couple of days ago—the Army vs the Coast Guard.

May the faith in God keep us close together.

OCTOBER 1944

Dear Folks—

I'm now sitting upon a hatch aboard ship and feeling very content. It's so peaceful & actually soothing right now, I think that it would take a sudden attack by planes to destroy that feeling.

The sea is wonderfully calm, so calm that it's hard to believe that the boat is moving. There is hardly any rocking to speak of. If it was like this all the time, I wouldn't mind going on indefinitely.

We were allowed on deck last night after all necessary precautions were taken. We caught our first glimpse of city lighting up the shore that we had seen in a long while.

I don't ever have to worry about something to do with all the reading material floating around and naturally this is a marvelous opportunity for sketching. There are so many fellows around that I'm bound to find someone with a good pose.

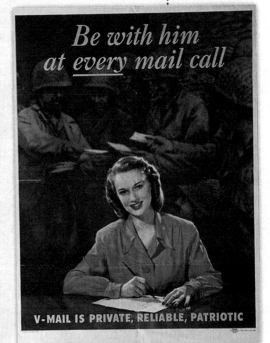

Be with him at *every* mail call

V-MAIL IS PRIVATE, RELIABLE, PATRIOTIC

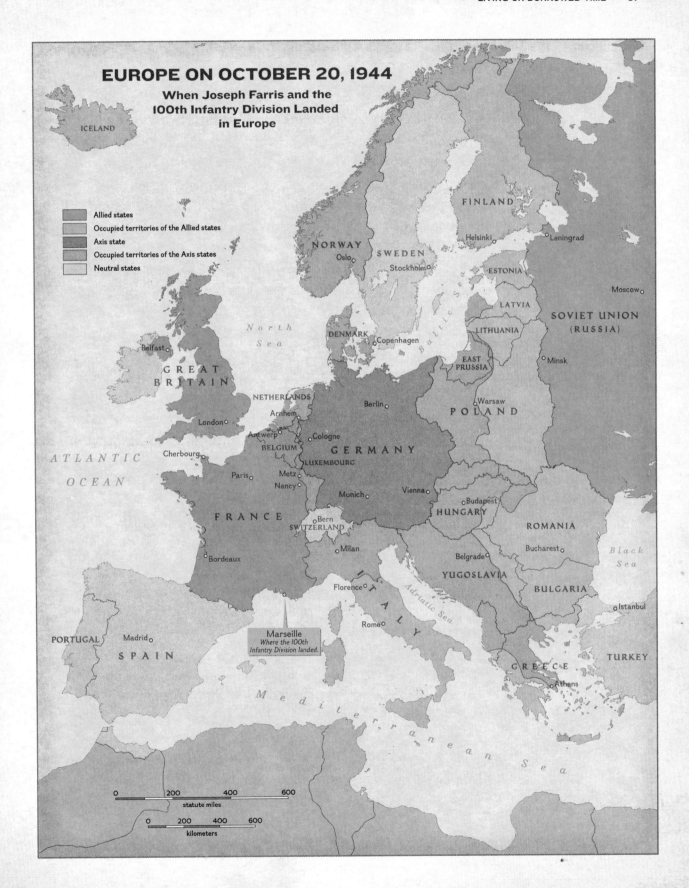

EUROPE ON OCTOBER 20, 1944

When Joseph Farris and the 100th Infantry Division Landed in Europe

ICELAND

Allied states
Occupied territories of the Allied states
Axis state
Occupied territories of the Axis states
Neutral states

NORWAY
Oslo

SWEDEN
Stockholm

FINLAND
Helsinki
Leningrad

ESTONIA
LATVIA
LITHUANIA

Moscow

SOVIET UNION
(RUSSIA)

North
Sea

DENMARK
Copenhagen

Baltic Sea

EAST
PRUSSIA

Minsk

Belfast

GREAT
BRITAIN

NETHERLANDS
Arnhem

London

Antwerp
BELGIUM

Cologne
Berlin

Warsaw

POLAND

Cherbourg

GERMANY

ATLANTIC
OCEAN

Paris
Metz
Nancy

LUXEMBOURG

Munich

Vienna

Budapest

HUNGARY

ROMANIA

Bucharest

Black
Sea

FRANCE

Bern
SWITZERLAND

Milan

Belgrade

YUGOSLAVIA

BULGARIA

Bordeaux

Florence

I
T
A
L
Y

Adriatic Sea

Istanbul

Marseille
*Where the 100th
Infantry Division landed.*

Rome

PORTUGAL
Madrid

SPAIN

GREECE

TURKEY

Athens

Mediterranean Sea

0 200 400 600
statute miles

0 200 400 600
kilometers

I believe these were all the letters I wrote on board ship on the way over to France. They were quite bland and could divulge nothing military. I suffered much more from seasickness and anxiety than the letters indicated. I didn't know what was in store for me.

After the conclusion of the war in Europe, I was assigned duty at Company M headquarters and noticed on the desk the Company M morning reports. Every morning during combat, the first sergeant, or someone he assigned, recorded concisely the previous day's events. They were filled with terse, short and matter-of-fact comments about each day's events. It was jarring for me to see how the first sergeant described each day, in words devoid of any emotion, whether the results were death, injuries, captures, or just the cleaning of equipment.

I surreptitiously made a copy of the entire set of reports and have placed the report for any given day, where there was one, just before the equivalent letter home, as in the case of this entry about our arrival in France. Some days there were no morning reports. The actual events are sometimes startling compared to my bland letters home—bland because of censorship.

Company M Morning Report
October 20, 1944
Reached and disembarked at Marseilles, France and proceeded by foot to Staging Area #1.

★ MARSEILLES, FRANCE

OCTOBER 23, 1944

Dear Folks—

I'm writing this letter from somewhere in France. We made it over here safely and are now in a bivouac area. I'm feeling swell, getting plenty of sleep and fresh air. We're sleeping in tents and since it gets dark early there's nothing to do but talk and then go to sleep. We get passes to small surrounding towns every other day where we can get some of that famous French wine, besides pears, grapes and weak beer.

I've developed quite an appetite from being out in the open and the rations taste good.

Point the complete address in ___ the pane ___ your ___
dress in the space provided on the right. Use typewriter, ___ ink, or dark pencil.
Faint or small writing is not suitable for photographing.

PASSED BY
U 45844 S
ARMY EXAMINER
(CENSOR'S STAMP)

TO: Mr. + Mrs. George Farris + George
59 Elm St.
Danbury, Conn
U.S.A.

SEE INSTRUCTION NO. 2

FROM Pfc. Joseph G. Farris - 31333428
6 M. 398th Inf. APO 447
90 P.M. New York, N.Y.
Oct. 23. 1944
(Sender's complete address above)

Dear Folks —

I'm writing this letter from somewhere in France. We
made it over here safely and are now in a bivouac area. I'm
feeling swell. getting plenty of sleep & fresh air. We're sleeping
in tents + since it gets dark early there's nothing to do but
talk + then go to sleep. We get passes to small surround
towns every other day. where we can get some of that
famous French wine besides pears, grapes, + weak bee

I've developed quite an appetite from being out
in the open. + the rations taste good

There are several German gun implacements
around the hillside. They put a lot of time in making
them.

The scenery is really beautiful + if I get
a chance I'm going to do some watercolors. The trains
that pass through are comical looking and pretty old
Every now + then they stop + shovel out some coal for
us + we all scramble to get some for our fires.

I'm slowly picking up some of the French language
Many of the words are easy to make out + all in all it's a
lot of fun. Don't worry about me everything's fine
God bless you all
Love Joe

HAVE YOU FILLED IN COM-
PLETE ADDRESS AT TOP?

REPLY BY
V···—MAIL

HAVE YOU FILLED IN COM-
PLETE ADDRESS AT TOP?

POST OFFICE DEPARTMENT PERMIT N

There are several German implacements around the hillside. They put a lot of time in making them.

The scenery is really beautiful and if I get a chance I'm going to do some watercolors. The trains that pass through are comical looking and pretty old. Every now and then they stop and shovel out some coal for us and we all scramble to get some for our fires.

I'm slowly picking up some of the French language. Many of the words are easy to make out and all in all it's a lot of fun. Don't worry about me—everything's fine.

OCTOBER 25, 1944

Dear Folks—

I've received two letters from you since I landed in France dated October 9th and 12th. Write as often as possible even if there isn't a lot to write about and I'll do better yet if possible.

It's rained three out of the last five days so we're getting a taste of the worst already. Living in the open gives me quite an appetite and believe me there's very little waste after chow.

I pulled a rather long detail yesterday unloading ships. I'm now qualified to be a stevedore.

I visited a town near our camping area where the business section is no larger if even as large as Elm Street. There are many wine shops, in fact nearly every other store. We went into one store and bought some pears and grapes which are about all you can purchase to eat. Then we spied a package of tea made in Japan and covered with quite a layer of dust. We bartered and got it for three small cigarette packs which contained 3 cigarettes. We stood in the store taking it easy and then as I was digging into a buddy's pocket for him to get some francs since his arms were quite full, I yelled out "God damn it!" because I couldn't find the francs. The French lady then yelled out in English "Jesus Christ!" and started shoving us out of the store because she thought we were just loafing. It was funny as hell and we roared out

laughing. They've picked up some English words such as "O.K., thank-you," etc.

I can always use some candy, cookies and canned stuff. I haven't received any packages yet and yours is the only air mail that has gotten through so far.

As I write this I know that you still don't know I'm in France and that you're probably worrying a lot. I wish I could somehow see you all and assure you that everything's o.k.

I had to ask for packages in writing in order to receive one. The post office clerk would be shown the request, which he in turn would stamp so that it couldn't be used again. I didn't receive any that first month on line because of the fighting. When the packages finally did arrive, I had nine or ten of them. One of them contained a six-pack of Coca-Cola and nothing else. I wasn't alone in my bounty—almost everyone was inundated with packages from home. We had quite a feast!

It also didn't stop raining for a month. We had no shelter during that period and never were able to remove our soaked clothing. Our young immune systems were quite stressed, but I never caught a cold. It was finally arranged for us to have a portable outside shower, and it's one that I'll never forget. It was followed by the luxury of a complete new set of dry clothing.

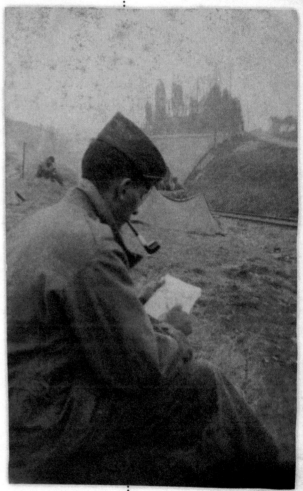

OCTOBER 26, 1944

Dear Folks—

I'm writing this by candlelight. Things are going swell here, much better than you'd think. The weather's not too cold right now. We're getting plenty to eat and the best (the infantry gets first choice when it comes to rations and we get fresh meat and everything else too). We aren't doing much just taking it easy. We pull details which are rather soft as a rule.

I carried watercolors, pads, pens, and pencils along with my 127 camera. My machine gun squad had its own jeep, in which I could safely store my material. Above, I sketch a scene near Septèmes and Marseilles, France, October 1944. The pipe smoking was an aberration for me. I tried it to look debonair, but I couldn't stand it after a while.

**NEAR MARSEILLES, FRANCE
BATTALION AID STATION**

Company M Morning Report
October 31, 1944
Left by rail for movement into combat area.

A couple of the boys and I went to town yesterday and had a swell time. I'm catching on to French fairly well and I sort of acted as interpreter even with what little French I know. By using sign language and some French from the little book we were issued we do o.k. In fact, by being slow to understand sometimes it's an advantage. We bought what looked like wheat cookies—one hundred francs worth (about $2.00). I stood there counting the cookies and trying to get them to come out even to divide up. The girl thought that I didn't trust her and that I was figuring it out. She then promptly gave us some change which she had tried to sly us on. We all got a big kick of it.

I just met a fellow who was in the same regiment as Charlie Hajj but in Company C while Charlie was in Company B. He didn't know Charlie, of course, but he said that they usually don't send dog tags home. One goes on the grave and one to the government. He was on Anzio and said usually what they report is true but I do hope they made a mistake this time. I'll keep an eye and ear open and see if I can meet anyone that was in Charlie's outfit and I'll let you know if I do.

I see where the Philippines were invaded by a great force of men. That's swell news and for a while I thought we'd have something to do with the invasion.

The train cars were called "forty and eights," meaning they could hold 40 men or 8 horses. They were extremely crowded, especially when trying to find a place to sleep. If you had to get up to answer "nature's call," you then had to wait for someone else to get up and take his place.

★ ST. GORGON, FRANCE

NOVEMBER 3, 1944

Dear Folks—

It's beautiful out here. The forests are slowly taking on a fall appearance. There are leaves all over the ground and they make a swell mattress. The green pine trees contrast against the reddish yellow of the leaves of other trees. In my mind I can see that big tree near Jack Dan's house across the street from the store. I suspect it's still a beautiful green.

Well, Dad, how about the store? Have you changed it around since I was last there? I bet something has been moved. And, Mom, what I'd give for a dish of taboule or fattoush but I guess I'd have to fight Georgie and Eddie for them. I imagine, Georgie, that you're quite a Romeo, and, Eddie, I imagine your garden is under some snow by the time this letter reaches you.

That's going to be about all for now. I'm o.k. though so don't worry please. I may not be able to write as often as I have because of conditions so don't let that fact worry you. I'll write as often as possible. Write as often as you can, George. A letter from home helps a lot.

Taboule, or tabbouleh, and fattoush are delicious Arabic salads, with flavors that represented family and home to me. Taboule is made with finely chopped vegetables—tomatoes, mint, romaine lettuce, scallions, parsley, and cracked wheat that has been soaked in water for about 30 minutes. Fattoush is a regular salad, with mint, parsley, tomatoes, cucumbers, romaine, scallions, and parsley, all chopped up; stale but edible Arabic bread, lightly toasted, is added

Company M Morning Report
November 2, 1944
Arrived at assembly area by train convoy at 1100 in the vicinity of St. Gorgon.

and softens when the dressing—which is composed of lemon juice, oil, garlic, allspice, and cinnamon—is added. The same dressing goes with taboule.

NOVEMBER 4, 1944

Dear Folks,

We had fresh milk today—one of the boys milked a cow in the barn near where we stopped and then boiled the milk to purify it.

I'm glad that I made out allotments on my pay to you. I wish I had them send more of it home and in fact I may soon send you more of my pay next payday. There's nothing here to spend the money on. I wish I could buy Xmas presents to send to you but we just aren't anywhere near a place where we can shop. I know it's not the gifts that show the real Xmas feeling anyhow. I hope and pray that next year I'm home and able to participate in Xmas with you.

On November 7, 1944, Company M, 398th Infantry Regiment, 100th Infantry Division, met the enemy for the first time. And we were scared as hell!

The day was particularly significant back in the States. The American people were at the polls reelecting Franklin Delano Roosevelt for his fourth term in office. The results of the election were, however, not at the top of our minds. We were at last going "on line." We had thought long and hard, wondering what we would face. At times, we felt we would never come back. Some of us didn't.

The 100th Infantry was relieving the crack 45th Infantry Division, which had, along with the 3rd and 36th Infantry Divisions, fought all the way to the Vosges Mountains after making the highly successful southern France invasion. In order to reach the unit of the 45th that we were to relieve, we had to climb a treacherously long and steep hill, which was a symphony of mud. It took expert handling on the part of the jeep drivers to ascend the trail without becoming engulfed by the mire.

When we got there, some members of the 45th mentioned an incident that had just occurred. Our planes had bombed some of our own troops and caused a number of casualties. That's all we needed, another enemy—our

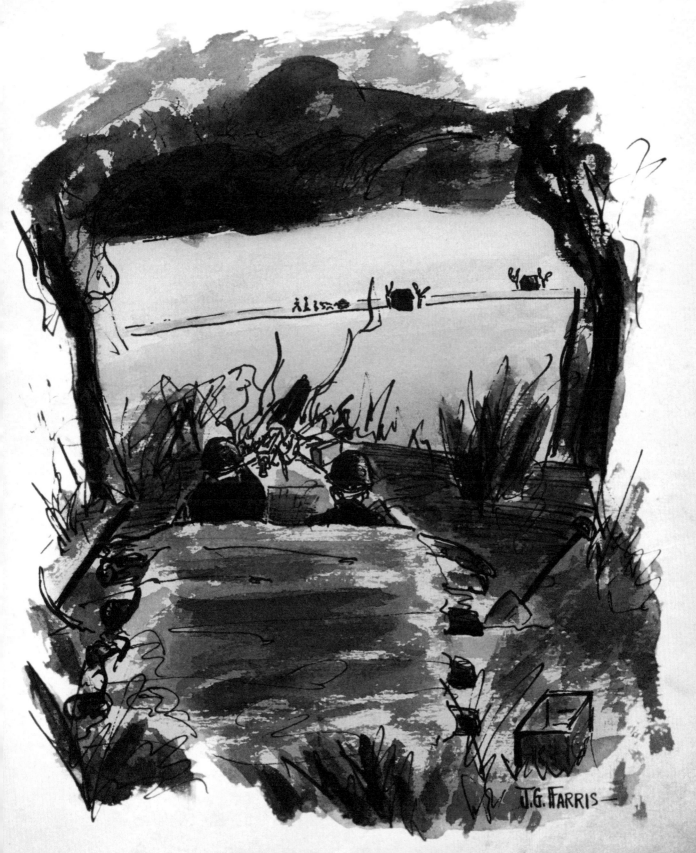

FIRST DAY ON LINE

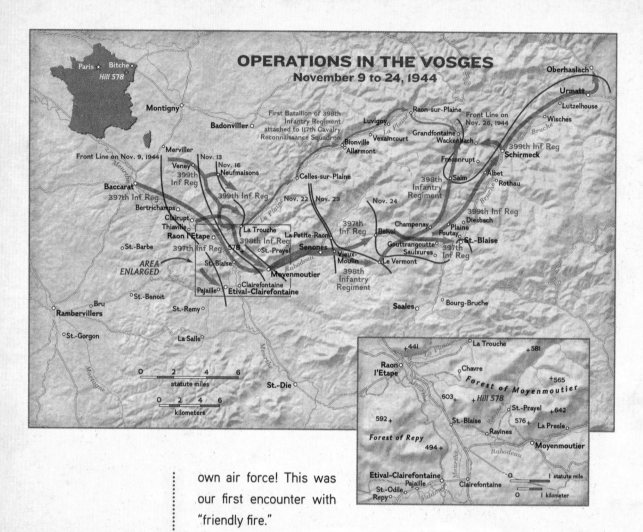

OPERATIONS IN THE VOSGES
November 9 to 24, 1944

own air force! This was our first encounter with "friendly fire."

It was quite a first day on line—the stories of friendly fire, the ever present mud, the consistent downpour of cold rain (which was to plague us the entire month of November), and the fear of meeting the enemy. As we labored toward the front lines, reports filtered back to us that there were large, comfortable foxholes awaiting us. The veteran 45th Division knew what the score was. One enthusiast termed the holes "hotels." Some hotels!

Company M, for "Mike" Company, to which I belonged, was composed of mortars and machine guns. I was assigned to a heavy machine-gun squad with a Browning .30-caliber water-cooled gun. The squad was composed of the squad leader, a first gunner, a second gunner, three ammunition bearers, and a jeep driver. For obvious reasons, our jeep transportation rarely approached too near the actual front. The first gunner carried the 50-or-so-pound tripod and had a .45-caliber pistol on his side. The tripod carved a painful valley into one's shoulders, as I was soon to learn firsthand when

I became first gunner. I had very little padding on my body for cushioning, weighing something like 125 or 130 pounds. The second gunner, which was my position at the beginning, carried the water-filled gun barrel on one shoulder; he fed the ammunition into the mounted gun as it was firing. The squad leader carried a carbine rifle, and the rest had the heavier M-1 rifles.

We finally got into position, without incident and wondering where the Germans were. The foxholes were three to four feet in depth and width and approximately six feet in length. It didn't pass our notice that, with a few more feet in depth, they would easily work as graves. For protection against tree bursts of mortar and artillery shells—that is, rounds that explode after hitting the tops of trees—stout tree trunks and branches covered the pits, and over these was the excavated dirt and sod. We soon would be digging our own foxholes, almost always after an exhausting long day's march. We used these initial foxholes that the 45th left for us as a model. Unfortunately, we often didn't have much time for a fancy cover—or any cover at all—and

Company M Morning Report
November 7, 1944
Left rear assembly area to engage with enemy at 1315.

It rained continuously the first month we were on the front lines. We hunkered down in a foxhole we inherited from the GIs replaced. We continually bailed out the hole with our helmets, which turned out to be a versatile piece of equipment.

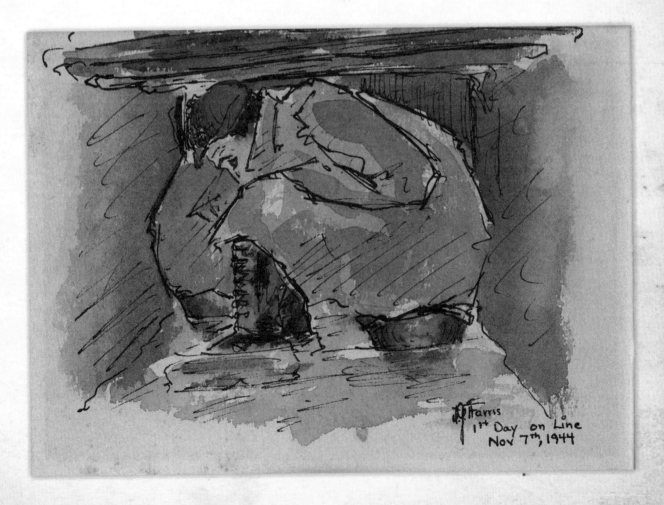

Harris
1st Day on Line
Nov 7th, 1944

I WANT **YOU** F.D.R.

STAY AND FINISH THE JOB!

INDEPENDENT VOTERS' COMMITTEE OF THE ARTS *and* SCIENCES *for* ROOSEVELT

OPPOSITE: *This watercolor depicts the morning of the first 24 hours on the front lines. The holes had been dug by GIs from the 45th Infantry Division. After digging the holes, they lined the tops with limbs and branches to deflect shrapnel. When we first saw them we thought they were great—until it started pouring rain and inundating us in our holes.*

just hoped for the best. Our "sleep" consisted of two hours on guard duty peering out of our holes, then two hours of sleep, two more hours of guard duty, two hours of sleep, and so on.

Our two machine guns flanked an inconspicuous dirt trail and overlooked a broad, wood-fringed valley that had a wide road passing through it. We noted two or three French farmhouses, which we promptly tagged as suspicious. But anything would have looked suspicious that first day! The 399th Regiment, we were told, was located in the distant wooded section to our left front.

We were now on the front lines! It was a frightening debut. Scattered among the foxholes were remnants of K rations, belts of machine-gun ammunition, wet blankets, and even M-1 rifles. Our holes appeared to be a dependable haven of protection, and perhaps they were, with respect to the enemy's mortar and light artillery (if we didn't get a direct hit). But they were, as we would quickly to learn, highly lacking when it came to protection from the persistent rain presented to us by Mother Nature.

We soon received our first look at the innocent victims of war. Crossing in front of our positions and nearly drawing our fire was a French peasant family and their livestock. The grandmother, who was too feeble to walk, was seated in the oxen-drawn cart along with their belongings. It was a pitiful sight. One of our men who could speak fluent French escorted the family back to battalion headquarters, where it was learned that the Germans had forced the people in the town to our right front to evacuate at once. Then one of the men spotted more people moving along the road down below us. After thorough binocular observation, it was determined that they were also victims of the German eviction.

At this point, we had been on line about three hours, and the silence had been broken only intermittently by the swishing of "screaming meemies." This was a weird sounding moan caused by the launching of German multiple-barreled mortars, which were directed at the 399th. All this time, we had brazenly strolled about in utter disregard of the shelter offered by our foxholes. Suddenly we heard a tremendous explosion, the volume of which attested to its nearness. We needed no further urging—into our holes we dove, and we didn't leave the protection of Mother Earth until dawn the following morning.

That night was to be among the most miserable 14 or 15 hours we were to spend during our entire stint on line. November means short days and long nights, and at 4:30 that afternoon, it commenced to become dusk. With enveloping night came the intrigue and tenseness of our first battle . . . with darkness.

My partner and I were a dejected and demoralized twosome in that forward machine-gun foxhole. Just a few weeks earlier, we had been in the comparative comfort and, even more important, safety of garrison life in the States. Now it was raining incessantly. The rain and its first cousin, mud—black, deep, and gooey—were to be constant companions for the next four or five weeks. We never took our clothes off or were in a building the entire month of November and were soaked thoroughly day after day.

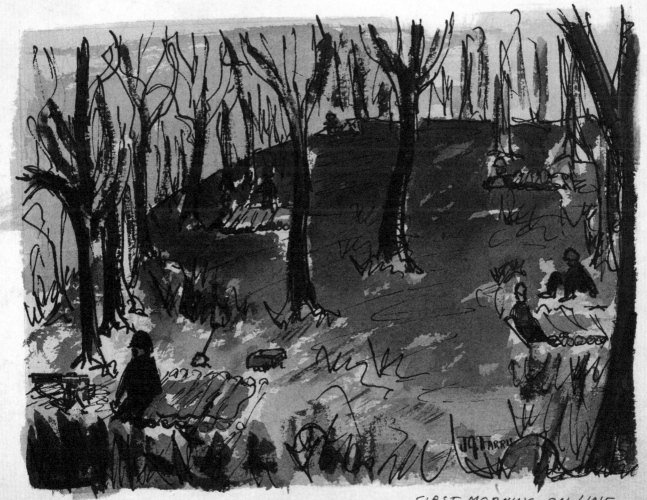

FIRST MORNING ON LINE

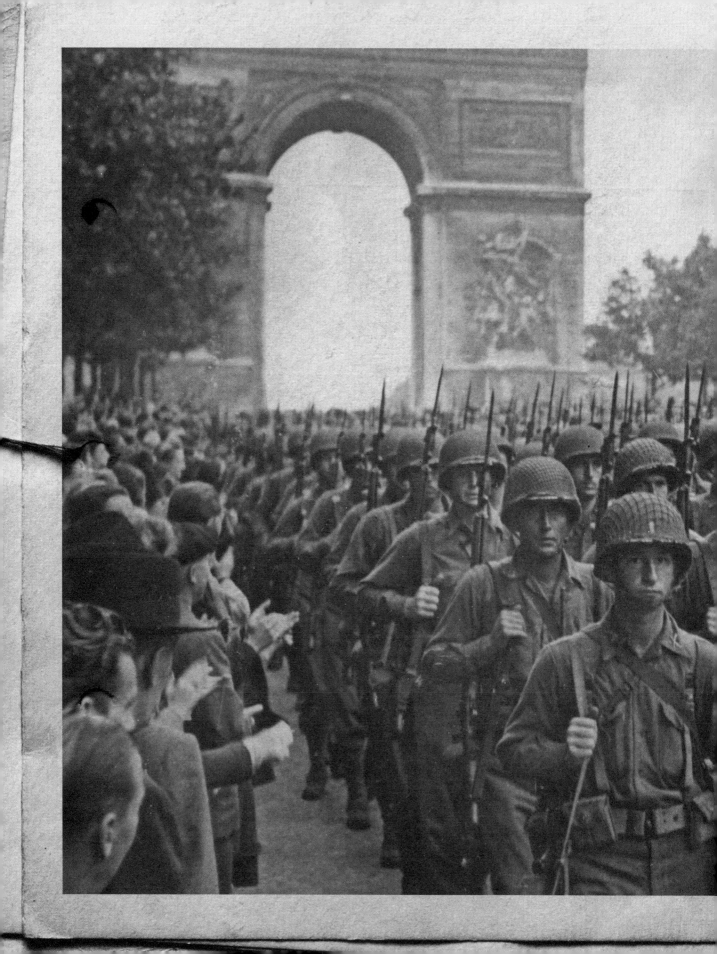

American troops march through the Arc de Triomphe and down the Champs Élysées during the liberation of Paris on August 25, 1944.

I remember the great luxury and pleasure our first shower gave us. It's only a slight exaggeration to say that when I took off my wet, muddy clothes, they almost stood at attention without me being in them. My standard outfit that winter consisted of heavy long underwear, two pairs of trousers, a shirt, two sweaters, a jacket, and a raincoat. I placed dry socks, two or three pairs, between my trousers and shirt ready to replace soaking wet socks to prevent trench foot, a painful disorder caused by extended exposure to cold, wet conditions. The wet ones went back under my shirt to dry from the heat of my body.

We faced severe censure, or worse, if we came down with trench foot. Yet, at least one member of our platoon actively courted this ailment as a way of escaping duty on the front line, and he succeeded. Jaundice, a buildup of yellow pigment in the skin and other parts of the body symptomatic of a number of serious disorders, was also a way out of fighting. I saw a number of young soldiers hoping for yellow urine as they peed. A cheer meant they got their wish. It may have led to serious problems later in life, but that was way off in time! Dying on the front lines was much more possible and immediate. There was another story that made the rounds of a lieutenant who raised one of his legs above the foxhole rim with the hope that an incoming bullet or fragment would hit it. He would then leave the front lines with a non-life-threatening leg injury.

That first night, the rain was heavy and steady. It seeped through what seemed like an impregnable cover into our foxhole, and before long we were sitting on our helmets. The water continued to rise and forced us to bail it out with our helmets as though we were in a sinking boat. I could see my hometown paper with the headline "Local Soldier Drowns in Foxhole on His First Day on the Front Lines"! The helmet had a plastic liner under it. The outer metal part provided protection, with luck, against shrapnel and bullets, but it also had other uses, all the way from cooking pot to portable latrine.

Our machine guns were left unattended, and if the enemy was in the vicinity, it would have been a cakewalk for them to overpower us or pass by unnoticed. Somehow, we survived our first day on line. We were now combat veterans.

Our morale couldn't have dropped much lower than on that fateful day of November 20. The Company M morning report coldly reported that Lieutenant

Gray had been killed in action (KIA). He was tall, slender, and handsome, probably in his 30s. We were all fond of him, and more importantly we had full confidence in his leadership.

"Hill 578" indicated a rise that was 578 meters (1,896 feet) in height. It was steep, thickly wooded, and the highest hill I had ever climbed. We were burdened with heavy equipment and trying hard to keep up with the much more mobile rifle company we were supporting. Earlier, our artillery had thrown a substantial barrage into the area to soften enemy resistance.

Before we reached Hill 578, we jumped off from a wooded section where our route of approach took us across a lumberyard and a wide field. The "Jerries"—as we referred to the German soldiers—could see this field nearly all the way, and they threw plenty of mortar fire at us. Fortunately, there was a ridge all the way across, and we advanced behind it without too many casualties.

It was on that field where I saw some of the bravery displayed by the medics, who were completely unarmed at all times. One of our boys was on the field wounded and under observation by the Jerries. Usually the enemy respected the Red Cross of Geneva that the medics prominently displayed on their uniforms and held their fire. Still, it takes a lot of courage on the medic's part to go out there, because all of us had seen cases where medics were fired upon. The wounded man was treated and carried to safety by the medic, a short, muscled Texan with more courage than almost anyone I came in contact with.

Portrait of Tech. Sgt. Ted Lederer by the author, November 1944. Tech. Sgt. Ted Lederer ably replaced our platoon leader, who was our first officer KIA (killed in action). Sadly, he died later in the fighting. I was extremely fond of him. It was a great loss.

We had heard that, when the Germans retreated, they left at least one out of every ten as a sniper hiding above in trees. This knowledge slowed us considerably as we were advancing, especially in wooded areas where we were constantly and nervously looking above us for snipers.

We had lost contact with the rifle company, which had moved considerably ahead of us, and our heavy machine gun squad was on the tail end of the

attack. We started up the hill with plenty of ammunition—seven belts of ammo (250 cartridges per belt). But we had only four belts when we finally reached the top of Hill 578—the fellows just couldn't carry any more. Up until then, it had been comparatively quiet, with occasional rifle shots and artillery rounds singing overhead.

We weren't too far up the hill when Lieutenant Gray told us to stay put. He went about 20 yards to our left front, where he knelt behind a tree and peered into the maze of woods for signs of the rifle company. A shot suddenly rang out, and the lieutenant slumped forward. A bullet had left a neat, almost inconspicuous hole in the side of his head. We had smiled at each other as he passed me only a few moments before. That was to be the last time I saw him alive. He was our company's first KIA. It left us all in a state of shock.

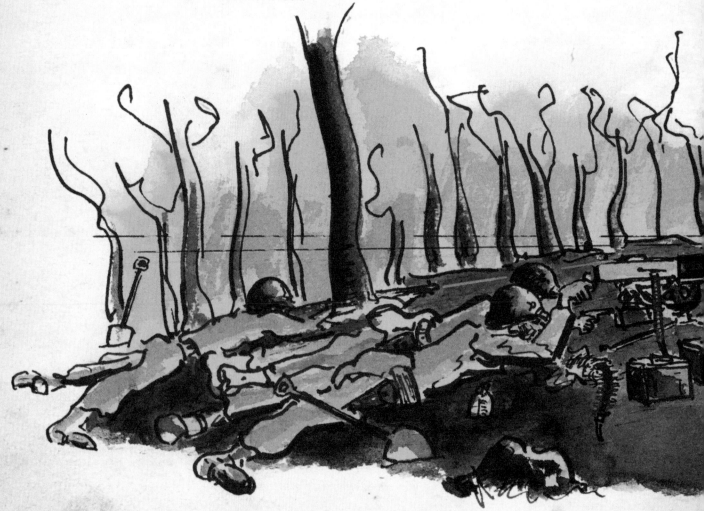

Tech. Sgt. Ted Lederer, a New Yorker with a friendly Bronx accent and considerable leadership qualities, quickly assumed command and led us to the top of the hill, where we established contact with the rifle company. They had almost completed digging into foxholes, and we started to do the same. We had just picked up our shovels when all hell broke loose, and we dove to the ground. German snipers, hiding in the trees, had been observing us with automatic weapons aimed at us. Their burp guns suddenly opened up at us. (They were called "burp" guns because they fired faster than our machine guns and that's exactly how they sounded.)

HILL 578, FRANCE, NOV. 1944

Company M Morning Report
November 19, 1944
Co. in support of attack from Campe DeVancances to vicinity of Raon L'Etape. Heavy enemy resistance from 0700 to 1545.

November 20, 1944
Co. continued supporting attack of Battalion S.E. of Raon L'Etape. One officer KIA (Lt. Gray-1st platoon). Weather rainy & cool.

The capture of Hill 578, near Bitche, France, November 1944. Hill 578 was our first major battle.

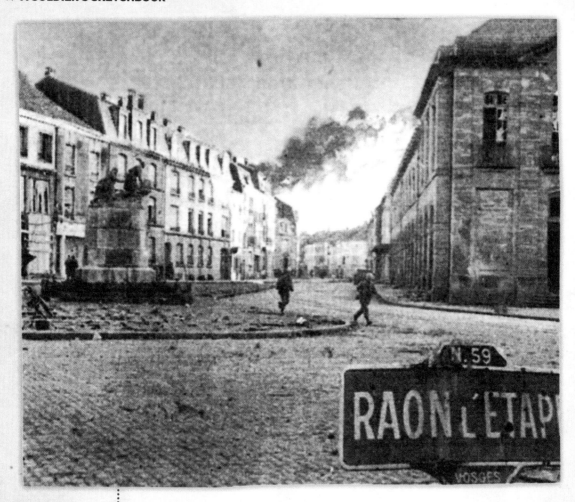

Scene from Raon-l'Étape, France, November 1944. OPPOSITE: *German railway guns outside Raon-l'Étape, November 1944*

Fortunately, we had half-loaded our machine gun, and it was facing in the general direction of the oncoming burp-gun fire. Bullets were whistling just above our heads, and we hugged the ground beneath us. We quickly full-loaded the machine gun and returned fire. It was the first time we were under enemy fire, and there was no mistaking the danger we were in. We were concerned about having enough firepower, as one of the four surviving ammunition belts had fallen out of its box and was covered with mud. One of the ammo bearers, who happened to have a shaving brush, attempted to clean the belt as the bullets were flying, in case it was needed. We were far out of reach of our supply line, and we knew it.

One of our riflemen had been digging a hole just below us, and when enemy fire commenced, he dove into the unfinished hole. Our first gunner, who was from Maine, panicked and started firing the machine gun wildly in the general direction of the Germans. As I was feeding the ammo belt into the gun, I looked up at him and was startled to see that he had covered

his eyes with one hand and was firing indiscriminately with the other! I quickly pushed him aside and took over control of the machine gun. Suddenly, one of our riflemen bravely stood up and emptied his submachine gun at the source of the incoming fire. That did it, and that sector threatened us no more.

My panicked first gunner, ashamed of his behavior, crawled down below us to the rifleman, who had left his backpack hanging on a branch and his rifle leaning against the tree trunk. They had both been decimated by the machine-gun fire. When the gunner reached the hole, he was startled to find that the rifleman, whom he had almost killed, was someone he knew from his hometown!

We had been on the forward slope of the hill when we were surprised by the heavy sniper fire and would have been easy victims of enemy hand grenades. We didn't expect to come out of this engagement alive, and when we did, we felt we were living on borrowed time.

We moved forward a few hundred yards after capturing Hill 578 and dug in for the night. Three snipers had been captured, and it was quite certain that one of them had fired the fatal shot at Lieutenant Gray. One of the rifle platoon leaders, a close friend of the lieutenant's, marched the three prisoners into the woods. We heard three shots. Lieutenant Gray had been avenged.

Our squad leader, who was not a draftee but belonged to the regular Army, had also lost control of himself during this first encounter with the enemy and was sent back behind the lines along with the first gunner. We never saw either again. I became squad leader. I was a seasoned 20-year-old.

Hill 578 helped me discover that I was capable under fire and was able to overcome fear and could be counted upon by my fellow men. I can't say that fear ever completely left me. It didn't. I just learned to live with it and hoped there wasn't a "bullet with my name on it."

Company M Morning Report
November 21, 1944
Co. supporting attack of bn. S.E. of Raon L'Etape from 0700 to 1200. At 1400 Co. moved to Moyenmoutier & slept in buildings for the nite.

November 23, 1944
Co. moved out of assembly area in vicinity of Sonnes at 0700 to support Battalion attack. Command post located in LeVermont.

★ SONNES, FRANCE

NOVEMBER 21, 1944

Dear Folks—

Today was a super day as days over here go. I received three of your swell packages, and boy they hit the spot [. . .]

Everything is fine with me. We're getting plenty to eat, and I believe we're going to shower up and get a new issue of clothes tonite [. . .]

We don't know too much of what is going on anyplace or how the war is coming out.

You know more than we do. I'm going to have a lot to tell you when I get home.

The fellows here get a pack of cigarettes a day not including the four cigarettes they get with each ration plus the ones we non-smokers give them. They actually throw away some because they get so many.

★ MOYENMOUTIER, FRANCE

NOVEMBER 23, 1944

Dear Folks—

I'm writing this letter from a deserted factory building in which we're putting up for the night. Everything's going along swell and I'm feeling great. We've been exceptionally lucky in that we've been sleeping in some kind of a building almost every night, at least for the last three days. Last night we took over a barn and although that may not sound extra, there is a lot of straw in a barn which makes a swell mattress.

The French people treat us swell—they're so thankful to us for liberating them. They give us coffee, bread and butter, apples, etc. We had a big day yesterday. As we were passing by a bakery the Frenchman who owned or took care of it started passing out whole loaves of bread to us. He must have passed out two or three hundred loaves and everywhere one looked you could see a doughboy munching on a whole loaf of bread. It was a funny sight. The bread was a big round loaf and I'll bet it weighed a good three pounds, that's how solid they were. The French use our white American bread, when they can get hold of it, for cake as dessert—that's how much they like it!

Tuesday
Nov. 21, 1944

Dear Folks —

Today was a super day as
days over here go. I received three of
your swell packages & boy they hit the
spot. Don't send any gum for awhile
because we get three sticks a day in our
rations & with what you have already
sent I'm plenty taken care of. Send
more Hersheys or any kind & five cent
candy bars when you send me a
package — also caramels.
Everything is fine with
me. We're getting plenty to eat,
& I believe we're going to shower up
& get a new issue of clothing tonite.
I think we're going to be issued waterproof
sleeping bags which are tops.

It hasn't been too cold
& the sun has been out almost all
the time the past few days.

We don't know too
much of what is going on, anyplace

ROSTEIG, FRANCE
1944

★ LEVERMONT, FRANCE

NOVEMBER 24, 1944

Dear Folks—

I guess it's o.k. for me to tell you that we're in the Seventh U.S. Army, which is commanded by Lt. General Patch. We're now entitled to wear one star on our overseas ribbon and if we reach Germany that will entitle us to wear another one. We've been presented with the Combat Infantryman's Badge also, so that when I finally get home I'm going to need a Mack truck to carry the decorations.

I had received the Infantryman's Badge after the grueling training in the States described in my June 3 letter, but the Combat Infantryman's Badge was given only to those who served in actual combat. I've noticed that many high-ranking officers often place the Combat Infantryman's Badge above all other decorations. Of all my decorations, I'm most proud of this one.

NOVEMBER 1944

Dear Folks—

I'm not certain of today's date but I believe it's Friday since yesterday was Thanksgiving. We're now in a little room all cleaned up, waiting for chow. We're receiving our Thanksgiving dinner today since we weren't able to get it yesterday.

It's funny how swell a feeling you get when you're all clean and have plenty to eat and a good place to sleep. I know that I feel like a million dollars.

The other day as we were riding along in our jeeps we had a momentary halt, one of many. One of the fellows spied some chickens along the road so he jumped out, made a quick bargain with the French owner and took out his pistol and took aim. He fired a couple of shots at one of the unfortunate chickens and finally

ABOVE: *Combat Infantryman's Badge.* OPPOSITE: *Our jeep was named "Connecticut Yankee" by the driver and me. We were both from Connecticut.*

Company M Morning Report
November 25, 1944
Main elements of Co. left LeVermont on foot at 0700. Remainder of Co. left on organic transportation at 0900. Co. located at Salm. Weather rainy & cold.

killed it. Then he gave the owner a pack of cigarettes as part of the bargain and hopped aboard the jeep. Then he cleaned it up and later boiled and fried it and had chicken to eat. Later on a couple of the boys caught a couple of chickens, wrung their necks and slipped them into a jeep and later had a chicken meal. Another fellow and I went into a garden, dug up some potatoes and beets, cleaned and cooked them and ate heartily.

We passed through some towns recently liberated from the Germans after four years of occupation. You'd never believe people could be so happy. They rushed out into the streets, giving us coffee, hugging and kissing us, crying because they were so happy. It was one of the most touching things I've ever witnessed. They were happy to let us sleep in their homes and they fed us and gave us more coffee. Old women cried a lot. They were so glad to see the Americans! When told, they couldn't believe we were finally coming! The night before, we passed through one of these towns and stayed at a textile mill for the night. There we picked up handkerchiefs, scarves and anything you can think of. One of the boys was flirting with one of the French girls and she noticed that his scarf was wet. She offered to trade hers for his and naturally the G.I. said o.k. so she ran home and picked up her scarf, a bright yellow one, and gave it to him. She took his scarf and said she would keep it as a souvenir from America. She didn't know that he got it from the town before this one and we didn't have the heart to tell her the truth so we kept her happy and let her think it came from America.

★ RAMBERVILLERS, FRANCE

NOVEMBER 30, 1944

Dear Folks—

We're now allowed to mention some of the towns we fought through—Raon-L'Étape, Epinal, Baccarat, Rambervillers, among others. These towns are near Strasbourg, which the Free French Armored Forces recently captured.

Refugees returning to their liberated homes near Raon-l'Étape, November 1944.
OPPOSITE: *GIs on line*

I took in another church service in the Catholic church that the Catholic priest kindly consented to let us use. This co-operation between Catholics and Protestants is an encouraging sign. I hope we have more of this friendly attitude. This morning I went up to the church, made a sketch of it and this afternoon I painted it.

★ ST. LOUIS, FRANCE

DECEMBER 6, 1944

Dear Folks—

Yesterday while we were firing our machine guns during a battle an Army Signal Corps photographer came up and took quite a few shots of us firing away. He is sending the reel to Washington where if they pass the shots are censored and then offered to any newsreel companies that may want them. Keep your eyes open when you go to the show, especially on the

Company M Morning Report
December 4, 1944
Co. supported Battalion attack North of Rosteig. Met heavy enemy resistance. Co. in Rosteig. Lt. Jerome wounded.

December 5, 1944
Co. continued supporting attack of Battalion North of Rosteig. Located in Rosteig. Weather rainy and cold. Bindel injured.

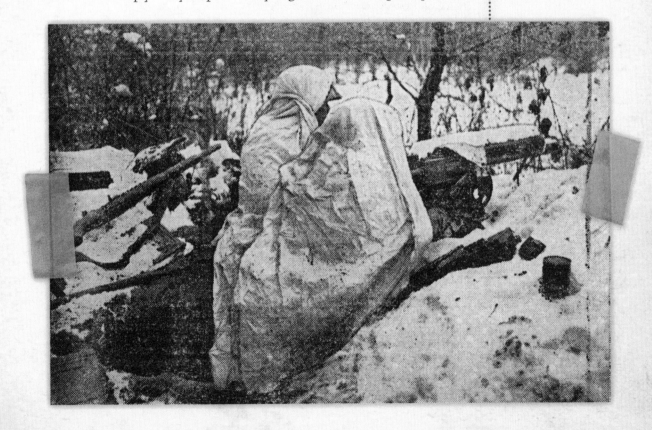

Thursday
Dec. 6th, 1944

Dear Folks —

Things are going along pretty fine here & I'm feeling great. We've been sleeping in houses almost every night & eating (& drinking like kings. We had an extra meal tonight — a chicken dinner which we caught, cooked & ate by ourselves with potatoes & gravy. Yesterday we found a cellar full of various bottles —— Vermooth wine, ~~anis~~ anisett, and —— champaign. Don't worry about my drinking — I do very little.

Yesterday while we were firing our machine guns an army signal corps photographer came up & took quite a few shots of us firing away. He is sending the reel to Washington where if they pass the shots are censored & then offered to any newsreel ~~companies~~ that may want ~~them.~~ Keep your eyes open when you go to the show especially on the newsreels for us. I'm firing the machine gun & have one man on either side of me. Also another photographer took some still shots of us that may appear in the papers — also of our machine gun crew. They may come out or already be out just about when you get this letter. Let me know if you should see anything. The still photographer took our names.

That's about it for now

Best to all love Joe.

newsreels for us. I'm firing the machine gun and have one man on either side of me. Also another photographer took some still shots of us that may appear in the papers [. . .] They may come out or already be out just about when you get this letter. Let me know if you should see anything. The still photographer took our names.

Company M Morning Report
December 8, 1944
Two machine gun sections
& 81 MM Mortar Platoon in
defensive positions about
2 km North of St. Louis.
Weather rainy & cool.

DECEMBER 7, 1944

Dear Folks—

You've probably heard that the Germans take everything they can get hold of before they leave a town. Well, in one town that we went into, we were talking to one of the Frenchmen and he told us how the Jerries took everything. He had an auto in his barn and when the Jerries saw it they wanted to take it along with them. Well, the Frenchman told them that the car wasn't running. The Jerries looked at the car and said, "Were not going to leave anything for the Americans." So they went and took two of the man's cows and hitched them up to the car and took the whole works with them.

DECEMBER 8, 1944

Dear Folks—

The more I see of a rifle company the more thankful I am that I'm in a heavy weapons company. Those boys have it the roughest of anyone. They walk almost anywhere they go, don't get to sleep under a roof as often as we do and are, I think, in more danger than anyone else. We get to ride a good part of the time since our weapons are heavy and each squad has a jeep.

DECEMBER 9, 1944

Dear Folks—

Here it's Saturday nite—five o'clock—and, as far as we're concerned, it's night. Back home it's twelve noon and I can clearly picture you all in the store. Mom, you're probably just finishing making dinner, and Dad, you're probably just finishing arranging the fruit in the window. Georgie is probably talking to some girl, and Eddie is outside playing. I wish I could say that I'm also working in the store—maybe it won't be too long.

OUR CHRISTM

AS ON THE LINE

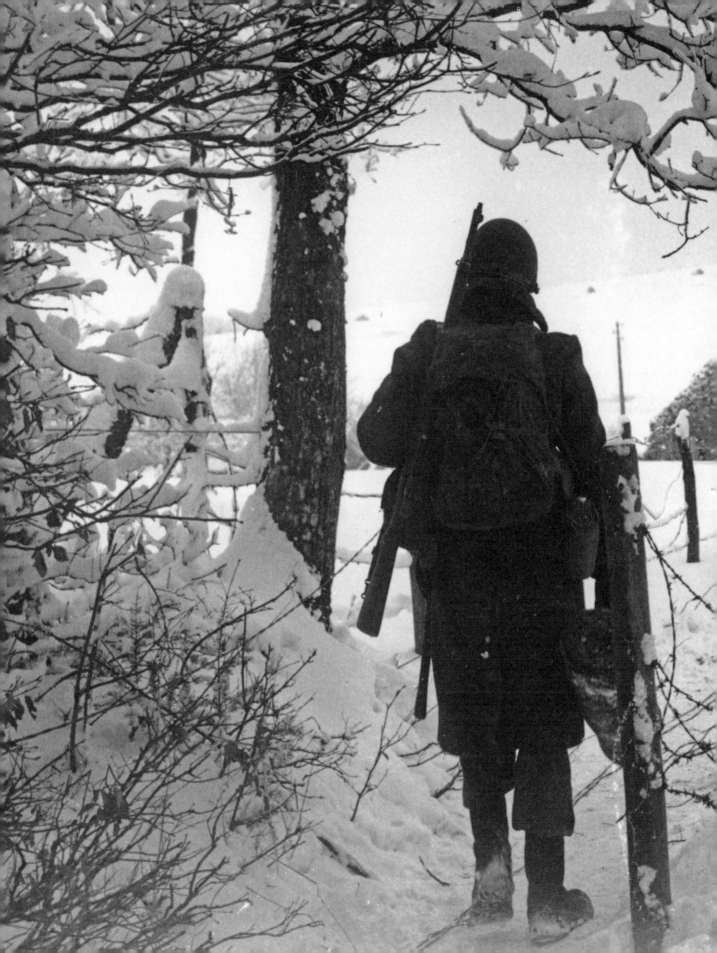

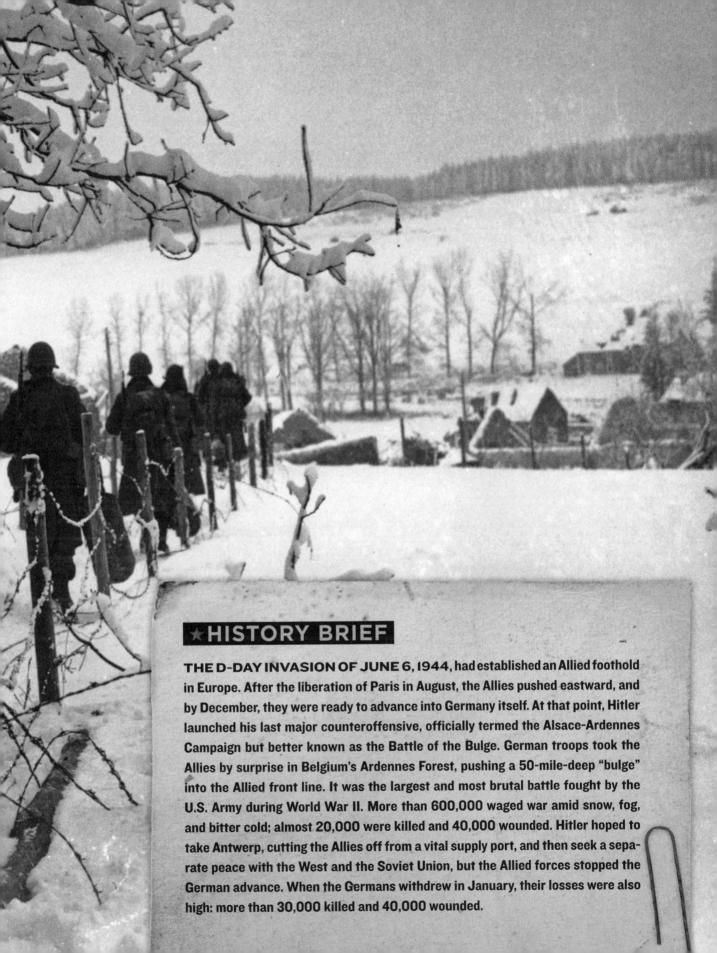

★ HISTORY BRIEF

THE D-DAY INVASION OF JUNE 6, 1944, had established an Allied foothold in Europe. After the liberation of Paris in August, the Allies pushed eastward, and by December, they were ready to advance into Germany itself. At that point, Hitler launched his last major counteroffensive, officially termed the Alsace-Ardennes Campaign but better known as the Battle of the Bulge. German troops took the Allies by surprise in Belgium's Ardennes Forest, pushing a 50-mile-deep "bulge" into the Allied front line. It was the largest and most brutal battle fought by the U.S. Army during World War II. More than 600,000 waged war amid snow, fog, and bitter cold; almost 20,000 were killed and 40,000 wounded. Hitler hoped to take Antwerp, cutting the Allies off from a vital supply port, and then seek a separate peace with the West and the Soviet Union, but the Allied forces stopped the German advance. When the Germans withdrew in January, their losses were also high: more than 30,000 killed and 40,000 wounded.

THE DASH TO FT FREUDENBERG - MAGINOT LINE
BITCHE, FRANCE. DEC. 1944

The capture of the Maginot Line at the northern French town of Bitche was, at first, a corps objective and later became our battalion's mission. Bitche had not been taken by the Germans when they captured France; they acquired it through the peace treaty imposed on France. The French people in the area never thought we could capture the fortresses or the city.

The Maginot Line was built between 1929 and 1940 to protect France from her longtime enemy Germany, defending the traditional invasion routes across her eastern frontier. It wasn't designed to defend itself against attack from the rear, or west. The line stretched from Switzerland to the Ardennes in the north and from the Alps to the Mediterranean in the south. For those times, it was state of the art, with an ultramodern defensive system. Much of it was underground, where interconnecting tunnels stretched for miles. Many thousands of men trained and slept within. In the end, Hitler decided to invade in the north through Belgium and the Ardennes Forest, bypassing the defenses. Some of the smaller forts of the Maginot Line were captured from the rear. It was only after France surrendered that the Germans took complete possession.

According to the schedule imposed on us, we were expected to take the Maginot Line at Bitche in, at most, one day. But we never got past Hill 419, which was between us and Fort Freudenberg, until later. The First Battalion took the first crack at it and was pinned down and suffered many casualties. The Jerries were in huge pillboxes with substantial gun power and a commanding position overlooking ground that was mostly bare and flat. We had no woods to hide in.

PREVIOUS SPREAD: *U.S. Army troops march toward the village of Lutrebois on January 25, 1945, during the Battle of the Bulge.*

When headquarters called on my Third Battalion to take over, we were extremely short of men. Put together, all the riflemen who were left from Companies I, K, and L barely made up one full rifle company. At full strength, Company M, my company, was a heavy weapons outfit composed of two machine gun platoons (eight machine guns) and one 81-mm mortar platoon (six mortars). However, because of casualties, we were able to make only one full machine gun platoon out of the two platoons we normally had. Our battalion went to battle for the Maginot Line with one rifle platoon and four heavy machine guns.

Besides having many casualties, a bug was making the rounds, and many of us were quite ill. I had a fever and chills and felt rotten. I was offered an opportunity to retreat back behind the lines until I recovered, but I knew our platoon was in bad shape and declined. I had the "GIs" (diarrhea), and a temperature of over 100°. I was given a stiff dose of some medication, 16 pills, and sent on my way! I was young, the war seemed just, patriotism was quite acceptable, and I had a strong sense of responsibility. Perhaps the years in helping my parents run their mom-and-pop confectionery store contributed to the latter.

Our target was Fort Freudenberg, while other troops attacked Fort Schiesseck. These were formidable fortifications of the Maginot Line west of Bitche. Fort Schiesseck, the larger of the two, had 11 adjacent units, each with a gun emplacement or a series of guns ranging from 47-mm to 135-mm that were mutually supporting and extremely difficult to attack. The walls of the fortifications were from three to ten feet thick and constructed of reinforced concrete. Some of the units had as many as five stories below ground level with underground railroads that were used for supply.

I was first gunner for the attack, which meant I had to carry the heavy tripod. Everyone was loaded down, so there was no complaining or shifting of burdens. Just as we started toward the first pillbox, we had our first casualty. One of our men lost part of his arm, blown off below the elbow. The soldier next to him panicked, unable to take it, and ran off to the rear with our medic chasing him. The rest of us sucked it up and kept going forward amid the chaos of explosions and bullets flying all around us. Suddenly I felt a jolt on the right side of my body and realized I had been hit with a piece of shrapnel. Fortunately, it had lost most of its velocity and didn't penetrate my body. I picked up the piece and quickly dropped it. It was still hot!

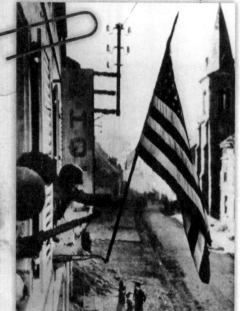

Capt. Thomas Garahan waves an American flag after the liberation of Bitche on March 17, 1945.

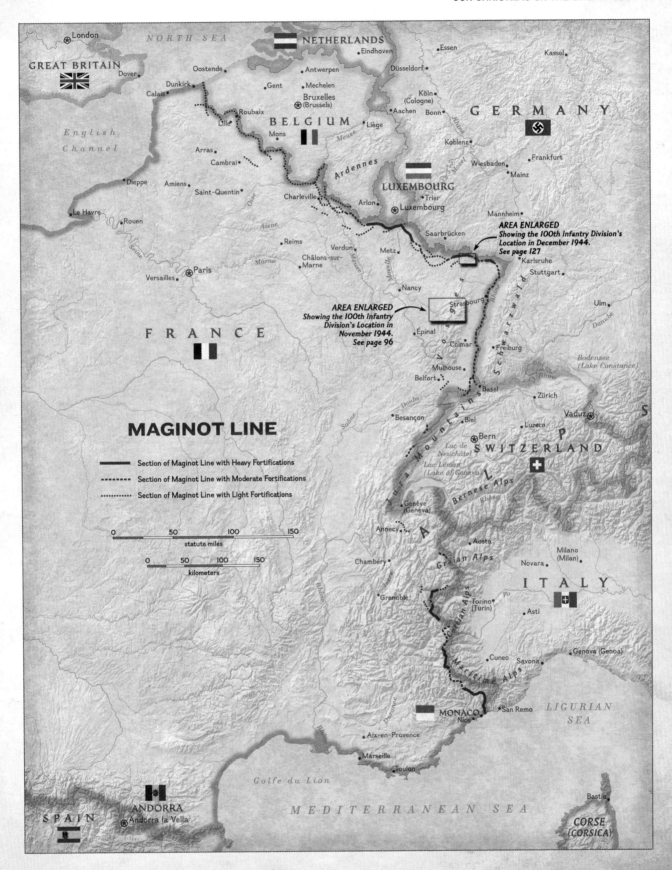

NORTH SEA

GREAT BRITAIN

London

Dover

Calais

Dunkirk

Oostende

NETHERLANDS

Eindhoven

Essen

Kassel

Düsseldorf

Antwerpen

Gent

Mechelen

Köln
(Cologne)

GERMANY

English
Channel

Dieppe

Le Havre

Rouen

Amiens

Arras

Cambrai

Roubaix

Lille

Mons

BELGIUM

Bruxelles
(Brussels)

Liège

Meuse

Ardennes

Aachen

Bonn

Koblenz

Wiesbaden

Mainz

Frankfurt

Saint-Quentin

Oise

Charleville

Arlon

LUXEMBOURG

Luxembourg

Trier

Mannheim

AREA ENLARGED
*Showing the 100th Infantry Division's
Location in December 1944.
See page 127*

Karlsruhe

Stuttgart

Paris

Versailles

Seine

Reims

Châlons-sur-
Marne

Marne

Verdun

Aisne

Metz

Mosel

Saarbrücken

Rhine

Meuse

Nancy

AREA ENLARGED
*Showing the 100th Infantry
Division's Location in
November 1944.
See page 96*

Strasbourg

Ulm

Danube

FRANCE

Épinal

Colmar

Vosges

Freiburg

Schwarzwald

Bodensee
(Lake Constance)

Mulhouse

Belfort

Rhine

Basel

Zürich

Vaduz

MAGINOT LINE

——— Section of Maginot Line with Heavy Fortifications

----- Section of Maginot Line with Moderate Fortifications

········· Section of Maginot Line with Light Fortifications

Besançon

Doubs

Biel

Jura Mountains

Lac de
Neuchâtel

Bern

Luzern

SWITZERLAND

0 50 100 150
statute miles

0 50 100 150
kilometers

Annecy

Genève
(Geneva)

Lac Léman
(Lake of Geneva)

Bernese Alps

Rhône

A
L
P
S

Chambéry

Aosta

Graian Alps

Milano
(Milan)

Novara

Grenoble

Cottian Alps

Torino
(Turin)

Po

Asti

ITALY

Isère

Durance

Maritime Alps

Cuneo

Savona

Genova (Genoa)

MONACO

Nice

San Remo

LIGURIAN
SEA

Aix-en-Provence

Marseille

Toulon

Golfe du Lion

MEDITERRANEAN SEA

SPAIN

ANDORRA

Andorra la Vella

Bastia

CORSE
(CORSICA)

MAGINOT LINE, BITCHE, FRANCE
DEC. 1944

We advanced toward the first set of pillboxes, which had us in their cross-hairs. To get away from the artillery fire they were bombarding us with, we dove into an unoccupied pillbox while our platoon leaders went on reconnaissance to see how we should approach Fort Freudenberg, our objective.

We hated to leave the safety of the pillbox when we had to make a move, but we had no choice. We left and went over a slight hill, which exposed us against the skyline. Then as we advanced toward Fort Freudenberg, I noticed our tanks to our right firing at the pillboxes. My immediate response was to get away from them, even though they were ours, since I had learned that they drew return enemy fire—and they surely did! To our right we could see the German 88-mm shells landing not more than 50 yards away! It felt like we were in a war movie. Although we were tired, we increased our speed and were really tearing toward the fort. As heavy as that tripod was, I ran as fast as I've ever run. When we reached a satellite pillbox, I threw down the tripod and quickly hopped into the fortification, which was still smoking. We took control of the pillbox with the help of the engineers, who placed huge demolition charges at strategic points while the riflemen covered them.

We moved forward again the next morning toward Fort Freudenberg, again at a gallop. Shells were bursting above us as we advanced after a 45-minute barrage by our artillery to the hill right above us where we dug in. I never saw so many shell holes in one field. The Germans threw artillery, mortar, automatic weapon, and small arms fire at us. Our riflemen, who were much more mobile than we heavy machine gunners were, had preceded us and were already at the fort. To our right were many light American tanks, ominously lined up at intervals of about 60 to 70 yards, employing direct fire upon the enemy pillboxes. In response, the Germans increased their artillery and mortar fire, forcing us to dig in.

We started with three men in our hole and before you knew it, there were six of us, all digging like mad, especially when an exploding shell came near us. Everyone was reluctant to raise their heads to see if anyone was approaching us, but I was frightened not to—I was concerned that some German might be crawling up in position to drop hand grenades into our position, which would have obliterated us. I put my helmet atop a rifle and raised it above the hole to see if it would draw fire. When there was no response, I quickly peeked out to see what was going on.

This watercolor shows one of the most dangerous moments in our battle for the Maginot Line. The Germans had bracketed our position, and we anxiously feared the next shell would zero in on us.

World War II Victory Medal

Suddenly, they threw the book at us. Their observation must have been excellent. One shell landed a few feet behind us and sprayed us with dirt. The next one was a few feet in front of us—they were bracketing us! We were sure the next shell would be right in our hole. We all crowded together trying to get under our steel helmets when for some fortuitous reason, the shelling stopped. Perhaps they had been taken out.

At 0930 hours the following morning, on December 18, 1944, we continued our attack behind a rolling barrage laid down by our artillery. In response, German artillery commenced firing again. It was remarkable how quickly we covered the remaining ground to the fort in spite of our tremendous burden. We could see the enemy shells exploding all around us, and it defied our imagination that we were not struck by the many flying pieces of shell fragments, let alone a direct hit. It's as close as we had come to being killed! There must have been an active element of fatalism embedded in our battle-weary minds and bodies, for no one commented with more than a passing remark on our latest brush with death. We had become battle-hardened combat soldiers.

We were now in Fort Freudenberg, which had once been a formidable adversary. It was now serving as our battalion command post, aid station, relief point, and whatever else was needed. Ironically, many armed Jerries were within 15 feet of us, sealed in the tunnel beneath us by our engineers. We sealed many pillboxes with the Germans running around inside. In Freudenberg, we had sealed them in on the second and third floors underneath us. In one of the other pillboxes that we sealed up, the Jerries had only one side open to them and were still firing at anybody who was in their limited field of fire. Therefore, we could move around three sides of the pillbox but not the fourth.

We were thoroughly worn-out, haggard men sprawled on the floor of the oblong cell. We could see two men arguing vehemently, yelling and gesturing angrily. One was the commanding officer of Company L and the other a light machine gunner. The gunner had just been ordered to return to his foxhole, which was about two hundred yards beyond the pillbox. He refused. He had been in the hole only a few minutes earlier when a German 88-mm shell had completely demolished his light machine gun right in front of him. He had miraculously escaped becoming a casualty and simply couldn't take it anymore. Developing in front of us was a case of "battle fatigue."

There were some amusing incidents. One of the fellows who was on the front lines for the first time was coming off the hill when a Jerry opened

up on him and the fellows he was with. The slugs were flying all around. Everybody else hit the ground and fast! But he just stood there, not realizing what was happening. Then he said, "What are they, birds?" When he saw everyone on the ground, he dove down as fast as he could. We still laugh whenever we think of it.

For the first couple of days in this battle, we had one or two C rations and later we got a sandwich and cold cup of coffee for breakfast and supper. The kitchen crew wasn't composed of the most courageous men I've known, and trying to get them to crawl up with our meals was an occasional event. Any movements had to be at night, which was the relatively safe time for crawling around, but even then we had to be cautious. There were mines and barbed wire strung all over the place. When we were in a hole, we still needed to answer nature's call. It was amusing to see a big GI sitting on a small C ration can for a toilet bowl. During the four days of this battle, all we had to cover ourselves with was a raincoat.

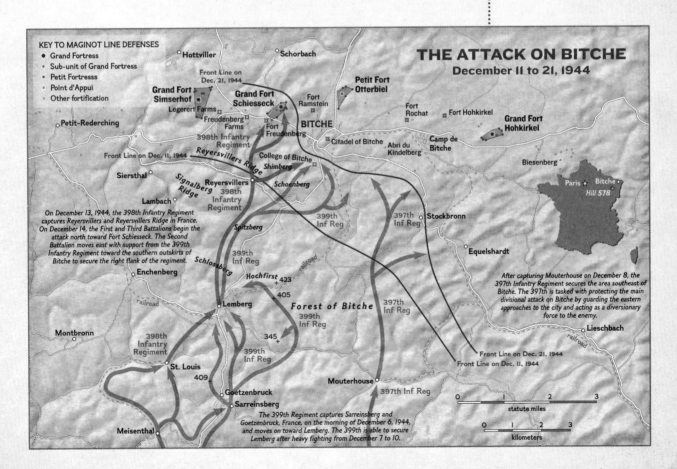

THE ATTACK ON BITCHE
December 11 to 21, 1944

KEY TO MAGINOT LINE DEFENSES
* Grand Fortress
• Sub-unit of Grand Fortress
• Petit Fortresss
• Point d'Appui
○ Other fortification

On December 13, 1944, the 398th Infantry Regiment captures Reyersvillers and Reyersvillers Ridge in France. On December 14, the First and Third Battalions begin the attack north toward Fort Schiesseck. The Second Battalion moves east with support from the 399th Infantry Regiment toward the southern outskirts of Bitche to secure the right flank of the regiment.

After capturing Mouterhouse on December 8, the 397th Infantry Regiment secures the area southeast of Bitche. The 397th is tasked with protecting the main divisional attack on Bitche by guarding the eastern approaches to the city and acting as a diversionary force to the enemy.

The 399th Regiment captures Sarreinsberg and Goetzenbruck, France, on the morning of December 6, 1944, and moves on toward Lemberg. The 399th is able to secure Lemberg after heavy fighting from December 7 to 10.

FT. FREUDENBERG, MAGINOT LINE
BITCE, FRANCE
1945

One fellow was hit in the helmet by a piece of shrapnel and slightly cut. He had a picture of his girlfriend in the helmet, which helped soften the blow. She could always claim she saved his life.

We took turns observing from one of the turrets, and on my shift I spotted Jerries jumping off trucks and moving toward our position. I gave the alarm, and we opened fire with our machine guns. A few minutes later, up came a white flag in surrender and 12 of them walked in. I saw them throwing away their equipment as they marched toward us. We made all our prisoners discard their helmets so that they couldn't grab them when their hands were up and use as weapons. We questioned them and found out they had just arrived from the Russian Front and were delighted to be our prisoners and out of combat.

Frank Burrola, one of our more dependable men, was, in size, the smallest member of the First Platoon but his courageous spirit far overshadowed his diminutive stature. After the hair-raising dash to the neutralized fort, Burrola's squad was assigned the mission of setting up to the right of the fort in a defensive position. The exhausted men started digging. How much of this they had done in the past six weeks! A foxhole was vitally important to a machine gunner—especially when he was firing his gun, since his position was immediately conspicuous and he became a target for return enemy fire. After digging a few feet, Burrola made a startling find: a bottle of schnapps, a potent German liquor. Evidently one or more of the Germans had cached the bottle, probably without the knowledge of their superiors, for use when a bit of courage was called for.

When we weren't on guard duty, we went to a small underground compartment that we shared with an unexploded 500-pound bomb. It had gone through a reinforced concrete wall at least four feet thick and demolished a 75-mm gun and now sat there ominously reminding us that war isn't a game. We tried to catch some sleep. Burrola with his powerful schnapps carefully stepped over our prone bodies as he made his way to the rear. He

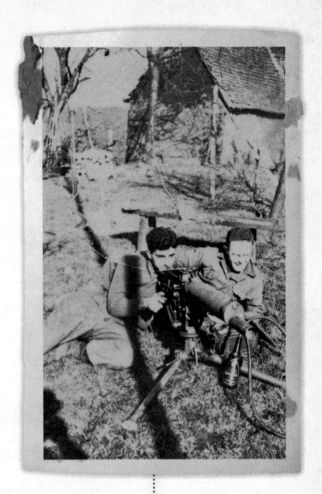

The author and his close friend Al Kaufman posing with a Browning 30-caliber water-cooled machine gun. OPPOSITE: *"Ft. Freudenberg, Maginot Line Bitche, France 1945." It depicts Frank Burrola getting drunk. He died the next day.*

ceremoniously set up a candle before he opened the bottle and proceeded to drown out his fears and anxieties. Sleep for us was soon an impossibility as the very inebriated Burrola commenced reciting passages from Shakespeare. Throughout his soliloquy, he kept repeating what turned out to be a prophetic phrase: "Not today, dear God, but tomorrow!" He died the next day.

This battle took place in December 1944, and we would have kept right on going were it not for Field Marshal Von Runstedt and the Battle of the Bulge, which was occurring north of us about the same time and took priority. Instead, we were forced to withdraw to defensive positions. Later, we returned and completed our mission.

During the battle for Bitche and the Maginot Line, our Third Battalion suffered 16 killed and 120 injured. For this action, our battalion was awarded the Presidential Unit Citation. We were the only battalion of the nine in the 100th Division that was honored with the citation.

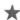

★ NEAR LEMBERG, FRANCE

DECEMBER 11, 1944

Dear Folks—

I just got off an hour and forty five minutes of guard duty and it's now almost two in the morning but I decided that I'd write you before going back to sleep. To our surprise (another fellow and I stood guard together) we found snow on the ground. This is the first real layer we've run across yet. It looks swell and peaceful and reminds me of home.

The sleeping bags we were issued really hit the spot and they're nice and warm, especially since I added a blanket to it. We were issued waterproof hoods also—so don't worry at all, we're well taken care of.

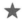

The following letter betrays very little about the circumstances in which it was written. My homesickness is palpable, though.

★ SOMEWHERE IN FRANCE

DECEMBER 23, 1944

Dear Folks—

I'm thinking very much of home as I write this, especially because it is so near to our greatest day of the year. I'd give a million dollars to be home with you all but that's being selfish on my part because there are so many other boys in the same predicament. Many of them haven't been home in a couple of years while I saw you all about three months ago.

I received my first letter from Jimmy Carlo and I got a kick out of one thing he said in it. He said he was in the "thick of things" in France. He's on an eight inch gun and probably about twenty miles behind the lines. He'd better not let an infantry hear him say he's in the "thick of things."

A buddy of mine and I spent Christmas Eve in a foxhole. It was an eerily quiet landscape—cold, snowy, and dark. In front of us was a grayish white expanse as far as we could see. We whispered to each other "Happy Christmas Eve," but it was anything but happy. We were looking for an unseen enemy, someone I had never met and didn't want to meet. I suspected that he or they felt the same.

The night was uneventful, and I spent much of it thinking of home and parents and two brothers. What was I doing here? I was feeling sorry for myself. I had been lucky in combat so far. "So far" was the operative phrase. I always feared what might come next. Each new day had me wondering if today there would be a bullet or shell with my name on it.

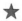

DECEMBER 25, 1944

Dear Folks—

Well here it is Christmas Day in France as well as in good ol' Danbury, which is where I'd like to be right now and always.

Company M Morning Reports

December 17, 1944
Company continuing supporting battalion attack on Maginot Line, encountered heavy enemy resistance. Co. advanced about 1000 yds. 1 EM killed R. Napie, 1 EM wounded-W. Reneau.

December 18, 1944
Co. continuing supporting battalion attack North of Reyersvillers. Encountered heavy enemy artillery & small arms fire from Maginot Line. I EM wounded-F. Burrola (later died in hospital).

December 19, 1944
Company continuing supporting battalion attack on Maginot Line under heavy artillery & small arms fire. Troops tired and worn out.

December 20, 1944
Co. continuing supporting battalion attack on Maginot Line. Progress slow, troops tired & worn out. 2 EM wounded R. Morris, R. Dolan

American soldiers walk down a war-torn street in Bastogne, Belgium, on December 13, 1945.

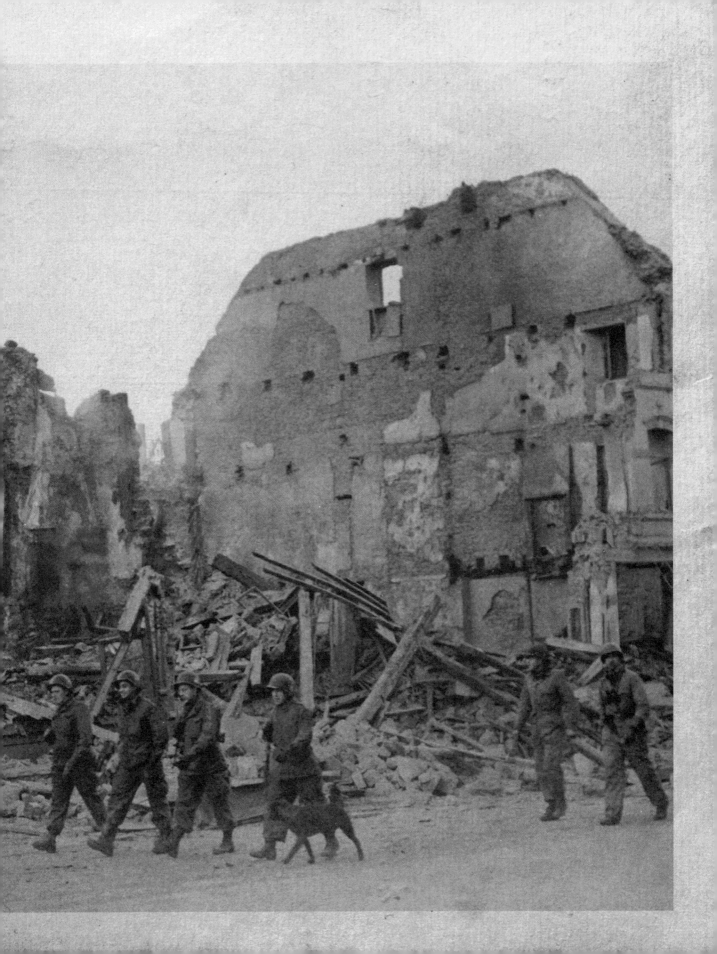

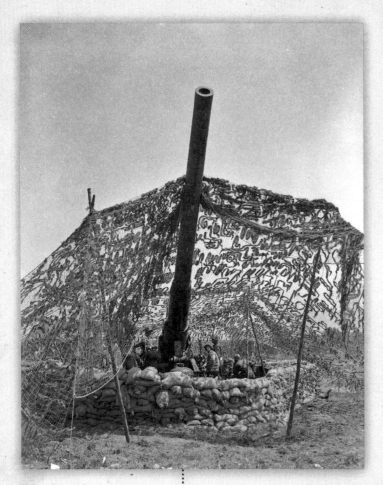

My company transported heavy artillery such as this eight-inch gun, which, together with its 240mm howitzer carriage, weighed almost 35 tons.

We've rigged up a little Xmas tree complete with ornaments and all—and to top it all, we decided something was still missing so we wound up some toilet paper around it. You'd be surprised how much better it looks with the toilet paper—leave it to Yankee ingenuity. One of the fellows got the ornaments from a nearby house. We didn't have any toys to put under the tree so we stuck the machine gun [under it . . .]

A belated Merry Christmas to you all—I'm with you in spirit all the time.

DECEMBER 27, 1944

Dear Folks—

Well, the Xmas holiday has passed by and everyone is probably starting to settle down to normal living again. I would like very much to be with you all, especially for New Year's Eve—we'd really welcome the New Year in right!

We had a fine Christmas dinner—plenty of turkey, potatoes, peas, carrots, cranberry sauce, cocoa, mince pie, two cans of beer, candy and a cigar—how about that? They held a movie for us Xmas Eve.

We've been issued new overcoats which would be quite a fad back home on a high school or college campus. They have a thick fur lining with a reversible topcoat to go over it. There is an attached hood and, with all the clothing I have on, it's a cinch—I'm not going to be cold.

DECEMBER 29, 1944

Dear Folks—

Hello, you swell people. Here's your soldier again. Things are going along swell here. I'm feeling great. We're in a house taking it easy, not doing very much. We're getting so much to eat that I that I'm almost afraid I'm going

France
Monday
Dec. 25th, 1944

Dear Folks —

Well here it is Xmas day in France as well as in good ol' Danbury, which is where I'd like to be right now and always.

We've rigged up a little Xmas tree complete with ornament + all — and to top it all we decided something was still missing so we wound some toilet paper around it. You'd be surprised how much better it looks with the toilet paper — leave it to Yankee ingenuity. One of the fellows got the ornaments from a nearby house. We didn't have any toys to put under the tree so we stuck the machine gun.

Things are going along swell — we're under a roof — in fact this building even has bunks — we're getting plenty to eat — in fact today

Company M Morning Report
December 29, 1944
Com. moved from defensive positions
in vicinity of Legerert Farms under
cover of darkness. Company now in
regimental reserve in Seirstal.

to eat too much—seriously. We're getting plenty of candy bars, donuts from the Red Cross & plenty more. We have C rations with us all the time & whenever we're hungry all we have to do is warm up a can of meat & spaghetti, or beans, stew, etc. Uncle Sam really takes care of our chow.

I've been receiving the Danbury News-Times regularly now & catching up on the old back copies.

You should be receiving the following from the government for me every month:

A $20 allotment

$10 war bond (costs me $7.50)

$25 war bond (costs me $18.75)

Money doesn't mean a thing over here—best thing we can possibly do is send it home & that's what I'm doing. I sent home thirty ($30) this payday—I can't use it here—let me know when you get it—it'll come straight from the government.

We have a movie coming up tonite—The Duke of West Point. I'm going to get set for it now.

DECEMBER 30, 1944

Dear Folks—

Well there are only two days left in 1944—and it's been quite a year. I've seen more & done more this year than any other year of my life.

The first thing I want to say is keep sending the air mail stamps & writing paper. I've been doing a lot of writing—almost every chance I get.

We're in a sort of rest period right now in a little town with a prewar population of about 600. It's a thrill to be able to walk through the town—a few houses—the roads are all dirt. There is no such thing as a theater or bowling alley. Much of the social life is centered on the church. The churches have a quaint old-world charm as does the village as a whole. The church, which is Catholic, in this little village, is surrounded by holy statues. There is a big rock which is hollowed out enough to have an altar installed—on each side of the altar is a holy statue.

These statues are all over the countryside. Almost every block in the little villages has a statue. An oddity is that almost regardless of all the shelling

& bombing the towns have taken, these holy statues are unharmed & in one piece.

You don't see any oil stoves or steam-heating systems around here—wood stoves supply almost all the heat they need. Of course, I imagine in big towns & cities modern conveniences are to be had. The little villages, however, are something out of the past. They still use old tools & methods to exist. Farming is about their main occupation.

The churches are open all the time naturally & the people go more than just on Sunday—probably a few times every day. I told you that they wear wooden shoes over slippers here. Well, when they go into the church they leave these wooden shoes outside—also when they go into their homes they leave their wooden shoes outside. I've often wondered what would happen if I went up & mixed them all over. Some day I'm going to try it.

DECEMBER 31, 1944

Dear Folks—

Here it is the last day of the year. I just came back from church services. This had to be our Xmas service as well since we couldn't have services Xmas Day. I took the Holy Communion—the first time in about two months.

When I asked you for a pocketbook I didn't mean a wallet—I was talking about a book to read.

I received two letters from you today dated the 11th & 12th of Dec. Keep writing steadily as you have been doing. You should be receiving my mail fairly regularly now—I've been writing three & four times a week at least.

There's snow on the ground—almost in time for Xmas. Everything looks nice and peaceful outside, except for the occasional roar of big guns having a duel.

Things are going along fine. In fact, I'm getting a little lazy at times. We're eating swell—getting plenty of rest.

I haven't received the gloves as yet. But maybe I will in the next few days. I'm getting plenty of airmail stamps over here now. Be good.

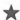

I didn't mention in my letters how frightened my fellow soldiers and I were all the time.

COFFEE, DONUTS, AND

RED CROSS GIRLS

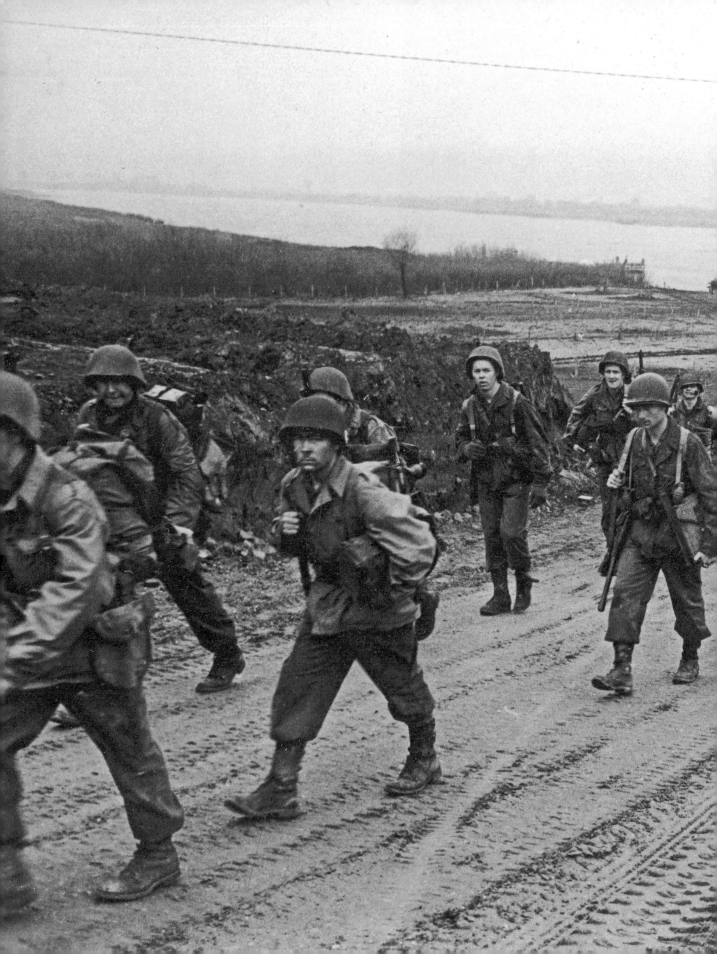

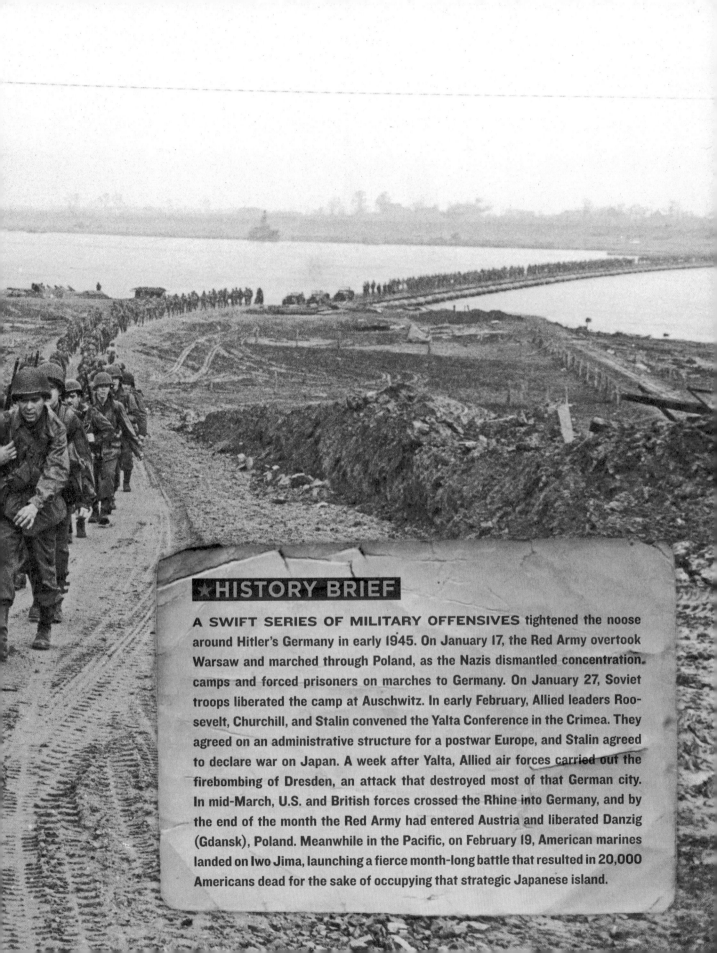

★ HISTORY BRIEF

A SWIFT SERIES OF MILITARY OFFENSIVES tightened the noose around Hitler's Germany in early 1945. On January 17, the Red Army overtook Warsaw and marched through Poland, as the Nazis dismantled concentration camps and forced prisoners on marches to Germany. On January 27, Soviet troops liberated the camp at Auschwitz. In early February, Allied leaders Roosevelt, Churchill, and Stalin convened the Yalta Conference in the Crimea. They agreed on an administrative structure for a postwar Europe, and Stalin agreed to declare war on Japan. A week after Yalta, Allied air forces carried out the firebombing of Dresden, an attack that destroyed most of that German city. In mid-March, U.S. and British forces crossed the Rhine into Germany, and by the end of the month the Red Army had entered Austria and liberated Danzig (Gdansk), Poland. Meanwhile in the Pacific, on February 19, American marines landed on Iwo Jima, launching a fierce month-long battle that resulted in 20,000 Americans dead for the sake of occupying that strategic Japanese island.

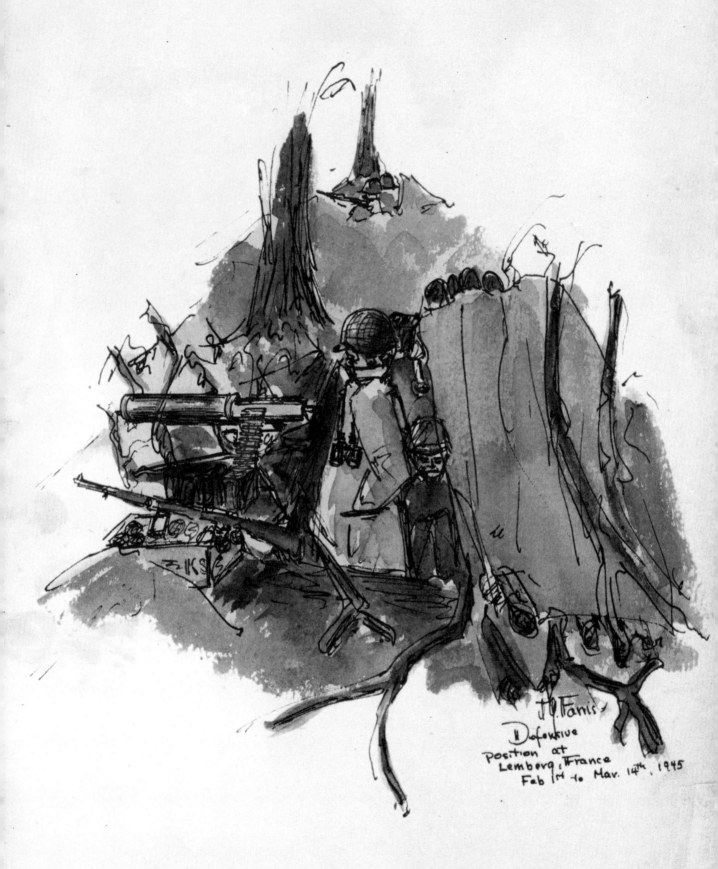

Defensive
Position at
Lemberg, France
Feb 1st to Mar. 14th, 1945

One would think that as time passed by, a person would become accustomed to combat, but the opposite is true. The truth is that we lived in anxiety, and it continually got worse. We had to be constantly vigilant, especially as we walked through thick, black, encompassing woods where there were likely to be German soldiers hidden in and behind trees as snipers. They were seasoned veterans, and many were crack shots.

Censorship was very much in evidence by the Allied Forces and what was really going on was quite different from the cheery "I'm o.k." letters I sent home. I tried hard to ease my family's concern about my safety, and for that reason many of my letters are quite bland and uninformative.

My parents were Syrian Orthodox Christians (both were from Lebanon, but at one time, Syria and Lebanon were one country). I entered the Army as a believer, and this belief gave me some comfort in a situation where my life was in constant danger of being ended. I carried a small copy of the New Testament in a pocket near my heart. We all heard stories of a bullet or shell fragment aimed at the heart being deflected by a small Bible or a bundle of photographs of loved ones. I could use all the help I could get. I would frequently read parts of the New Testament with the hope that a personal God would guide my path between bombs, shells, and bullets.

We were in Lemberg in a semi-state of rest part of February and March while we manned the front line a short distance away.
PREVIOUS SPREAD: *Soldiers of the 75th Division march toward Berlin after crossing the Rhine River, early 1945.*

★ SOMEWHERE IN FRANCE

Company M Morning Report
January 2, 1945
Elements of company moved NE of Sierstal to set up defensive positions under heavy enemy artillery fire on hill 402.5. Snow.

January 3, 1945
2 machine-gun sections 1 8 MM mortar section in defensive positions NE of Sierstal. Remainder of company in Sierstal. Enemy artillery very active in Sierstal, 2 direct hits on Company C.P. with 210MM Rockets. 4 men slightly wounded.

JANUARY 1, 1945

Dear Folks—

Here goes . . . my first letter of the New Year—a much happier year, I hope. I wasn't up last night to welcome 1945 in—I decided I'd rather have some sleep. I hit the hay about eight o'clock last night & slept through till seven this morning when I had to get up if I wanted any breakfast. When I found out we were having French toast I decided to crawl out of my sack.

My mail has been coming through fairly good—yesterday I received ten letters all at one crack. I'm just about caught up in my letter writing. I've been writing to you almost daily lately. I hope you've been receiving them as regularly.

We've got a swell bunch of fellows in our platoon. A good many of them are New Yorkers, some from Mass., from the South & from the Midwest.

We were just issued some tomato juice. All I can say is that Uncle Sam has quite a supply problem.

The house we're in now doesn't have any running water or a latrine in it. I don't see any rugs on the floor or anything. If some of the people were taken to the United States & shown around & be allowed to take over an average American home they would probably think they were getting a preview of heaven. I'll bet some of these people have never left their own little community—probably never saw a movie. A washing machine would be something.

JANUARY 3, 1945

Dear Folks—

Everything is coming along fine here & I do hope the same thing goes for all you swell people home.

There is snow on the ground outside, but we're fortunate in being in a house. You'd never dream that there was a war going on to look at the white, snow covered little village. I did a little sketching day before yesterday. The longer I stay over here and the more I want to go home and keep up my art studies. I'd sure like to be sitting next to our small radio in front of my drawing board

Jan 3rd, 1945

Dear Folks—

Everything is coming along fine here + I do hope the same thing goes for all you swell people home.

There is snow on the ground outside, but we're fortunate in being in a house. You'd never dream that there was a war going on to look at the white snow covered little village. I did a little sketching day before yesterday. The longer I stay over here + the more I want to go home + keep up my art studies. I'd sure like to be sitting next to our small radio in front of my drawing board in the kitchen right now. I'd switch on the radio, probably WABC + get some nice soft music + then proceed to do a little drawing. That would be after we closed the store, naturally.

in the kitchen right now. I'd switch on the radio, probably WABC & get some nice soft music & then proceed to do a little drawing. That would be after we closed the store naturally . . .

Those days were happy ones and I know it. I knew it then, too, & I was content. I heard some of the first music in a long time the other day at our movies. I'll bet if I heard the hit parade now I wouldn't recognize too many of the songs. The movies were old but still welcome. We saw The Man in the Iron Mask, The Duke of West Point & The Conquering Hero. I've seen them before but it was so long ago it was almost like seeing a new picture.

I'll send what few sketches I have all at once one of these days. I have to send them to the base censor first so they can be carefully checked, then they'll be sent to you.

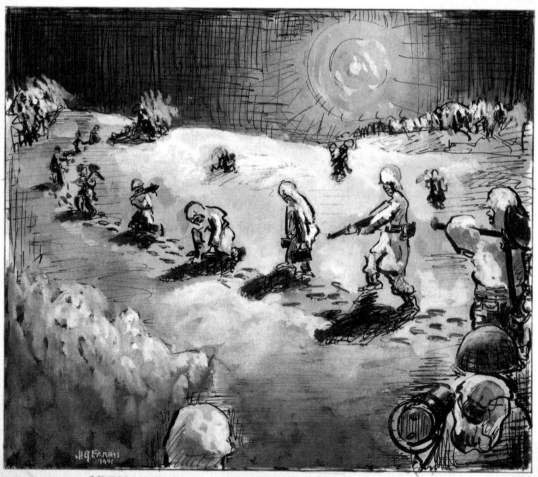

GERMAN FLARE NEAR GUISING, FRANCE JAN. 1945

Sad to say, I don't know what happened to those particular sketches.

JANUARY 4, 1945

Dear Folks—

I've been taking it pretty easy the past few days & have caught up on almost all my mail. We've been lucky in that we've been sleeping in a house for the past week or two almost every night. I'm feeling swell—I hope that you're not worrying too much because you know that I can take care of myself. I've found out that worrying just makes things worse so I'm not doing any. I'm letting the big boys do that.

The weather has been much more pleasant this past month than our first month overseas. It doesn't rain anymore just occasionally snow.

I can use some candles for light, some handkerchiefs, a little bottle of ink if you can pack it good & some candy and canned stuff. I haven't been able to get my films developed. I'll just hold on to them & sooner or later I'll find a place where I can get them developed. Then I'll rush them to you.

This watch you gave me, Dad, is a honey. Almost all the other fellows' watches have stopped from concussion of artillery while mine has kept right on ticking.

There isn't much more to report.

JANUARY 7, 1945

Dear Folks—

I'm writing this letter from my gun position. I got hold of the necessary supplies & time so here I am. We have a nice fire going & we are all gathered around it discussing everything that comes to mind. Right before chow, when we're all a little hungry, the talk drifts to food. We started talking about various kinds of snakes. Most of the boys want nothing to do with them. Then the talk drifted to seafood. I had to put in my two cents so I told the fellows how we used to catch shiners during the summer at the beach at night. I also mentioned how much I liked raw clams & only found one other fellow who ate them raw.

OPPOSITE: *We froze in place, hardly breathing, when the Germans fired flares.*

Back to snakes again, the Texas boy of our section said he saw snakes that curled up in a loop & rolled along. Then the fellows pounced on him telling him no such snake existed. We had quite an argument & couldn't reach any settlement.

With all this talk my mind wandered to the store with all you swell folks. I'd give a million to be with you. I couldn't think of anything better than working in the store & drawing in my spare time.

Today we got two cans of beer, candy, a cigar & some crackers. We got our mail yesterday & we have plenty to eat. Everything's going along swell & I have no kicks to make.

The other day as we were moving into position we met some of the fellows we were relieving. It was pitch-dark however & when one of the fellows said he was from Danbury all I could do was talk with him. We didn't dare use any light so I don't know what he looked like. He actually lives in Ridgefield but he hung out in Danbury quite a bit & his future wife lives in Danbury, I believe his girl's name is Emma Montesi but I didn't catch his name. I didn't know him, although you may, Georgie.

I have formed one habit which I've been able to keep right along—every nite after I get into my sack & zip it up I pull out my little book frame in which I have all of your pictures in & light my flashlight—then I say a little prayer & I find that I'm very close to you & the many thousand miles that separate us dwindle to nothing. Please try not to worry too much—everything will come out o.k.

JANUARY 8, 1945

Dear Folks—

Things are going along swell, we've been in one place for the last couple of days & have a roof over our heads. I'm feeling great & taking life easy.

A whole group of us are gathered together around a wood fire chewing the rag. We've got quite a bunch of fellows here. One has a nickname of "Fishhead & Meatball," another of "Ogie."

I drank one of my cans of beer last night—all that was missing was some of your French fried potatoes, sizzling steak, & your making it, Mom. Then Dad & I would get together to see who can eat the most. Georgie & Eddie somehow manage to get most of the French fries.

This is a very short note but I just want you to know everything's o.k.

JANUARY 9, 1945

Dear Georgie—

Hello, my brother, how're we doing? I think you know why you're getting this letter. This is the best I can do to extend you a happy birthday.

You're probably a little advanced in maturity over a lot of fellows seventeen years old, since you have already graduated school & are at work. Dad, Mom & I are exceedingly grateful, kid, that you are around to help out. Mom & Dad depend a helluva lot on you, so don't let them down. You may work a little harder than many other fellows your age but in the long run it's going to pay. You don't know how thankful I am for the training I got in the store, not only the business experience but the systematic method necessary. You're fortunate in having the swellest folks possible. If I can treat my future children half as good as Mom & Dad have treated us I'll feel that have done my job well. I wish I were home now to appreciate Mom & Dad more.

Don't get any ideas on joining up for a while, for at least eleven more months. I've never been more serious in all my life. I'm taking care of our share of the fight right now. If necessary your turn will come later. Meanwhile you cooperate all you can at home to help out the war effort & thereby not worry about your conscience.

I miss you a lot, Georgie, & I hope it won't be too long before we're together again. Meanwhile you do your best to make it a little easier for the folks.

Happy birthday to you, kid.

JANUARY 10, 1945

Dear Folks—

Hello, you swell folks, this is your wandering son again. Everything is going along swell & I'm feeling fine. I'm getting plenty of sleep & getting to be a bigger chowhound as the days go by. I'm sleeping under a roof & getting plenty of rest.

Even standing a little guard duty isn't bad. We have a little fire going all the time & nearby have some warm coffee whenever we want it. Usually we have some extra bread & make toast & then if we have any jam (which we have quite often) we're all set.

Company M Morning Report

January 11, 1945
Company moved out of defensive positions NE of Etting and now in defensive positions NW of Guising.

January 13, 1945
No change in location or situation. Enemy artillery and rocket fire nearby in vicinity of Guising. Direct hit on Company Command Post, causing 4 casualties.

I was made sergeant today so naturally my pay has been increased. I'm going to make a bigger allotment & I'll let you know just how much it is when I make the new allotment out. You should be receiving as $20 allotment & two war bonds—one for $25 & one for $10 now.

JANUARY 15, 1945

Dear Folks—

I had a swell surprise today. We came in from the cold to our place of sleep expecting a cold chow. Instead we walked into the warm kitchen & found the table all set out with chinaware & silverware. The food was set out awaiting us. Ordinarily we rush to get in line & there is very little courtesy shown. Today with the setting before us politeness was in order. "Thank you" & "please" were the terms used instead of "step on it," etc.

Yesterday the family here served us a homemade meal of mashed potatoes, sauerkraut & ham. They make coffee for us quite often. The meal really hit the spot. Tonite we sat around after our chow drinking our coffee & relaxing just like we all did back home.

I received another of your packages last night with Syrian sweets. They really hit the spot. Thanx a million folks. May God be with you all.

JANUARY 16, 1945

Dear Folks—

As sergeant, I'll be receiving $75 base pay, $15.60 overseas pay and

$10 combat infantryman's pay which totals a little over $103 a month. I'm paying $6.50 insurance a month so that leaves about $97. I've got about $26 out for war bonds and $20 as a straight allotment. That leaves about $50 which is too much for my needs over here. For that reason, I'm going to increase that $20 allotment to $50 or $55. That'll leave me $15 or $20, which is still more than I really need. Don't worry about me sending too much home. If ever the need for more money arises, I can cut the allotment anyway I see fit.

JANUARY 18, 1945

Dear Folks—

The people we're staying with here are treating us fine. They told us to make it our home while we were here & we are doing just that. I'm now sitting in the kitchen which is the warmest room in the house. We have a pot of hot coffee on the stove which we can dive into whenever we get the urging.

The people here do not have any electricity & haven't had since German occupation. I believe that if some of these people were taken to the States & shown our modern conveniences & luxuries they would think they were in another world. There is one old woman here that I believe hasn't ever seen a railroad or train. They're born and die in the same town & probably never venture far from it during their entire lifetime.

JANUARY 28, 1945

Dear Folks—

Well, my kid brother, Georgie, is now seventeen (and never been kissed?— never happen) & is starting on his eighteenth year. Here's hoping that it's a happy year for all of us. I guess you realize, George, that as you mature so do your responsibilities in the store. Also now that you're seventeen I realize that you're eligible to enter the navy. Well, listen here kid—if you talk about joining the navy, even think about it, within the next 10 or 11 months I'll get home some way, even if I end up in the guardhouse & beat your little — right up. Remember, George, your first duties are for Mom & Dad, then when you approach 18 years we'll talk about signing up. Be in no hurry. I'm enough for the folks to worry about for a while.

Company M Morning Report
January 23, 1945
Company moved from farm in vicinity of Guisberg at 1600 to relieve and take up defensive positions N and E of Lemberg under cover of darkness. Relief was completed by 2030. Receiving heavy barrages from enemy artillery and mortars.

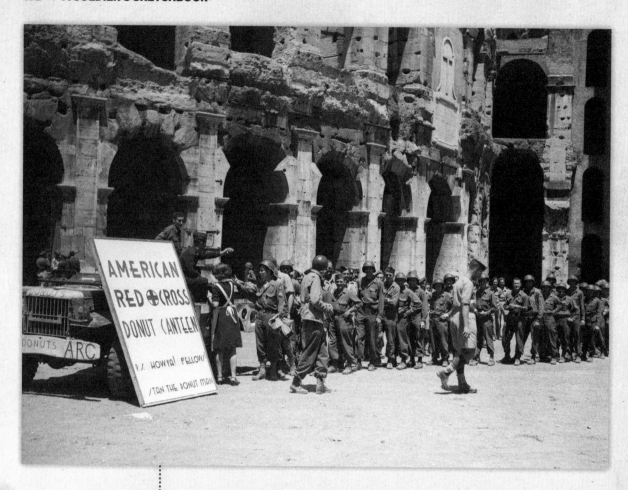

The appearance of the Red Cross girls, as we called them, was always an event we looked forward to. Attractive girls who could speak English! It was also an opportunity to do some creative flirting, even though we knew nothing would come of it.

I guess I should have addressed this letter to Geo. Jr instead of to all you folks. Everything's fine—I'm at a rest center for four days enjoying myself.

As the oldest, I always felt protective toward my brothers, George and Ed, even when we were quite young. If we were playing games with other kids, I tried to make sure they weren't taken advantage of.

JANUARY 29, 1945

Dear Folks—

On moving one day, I lost my pipe & gave the other one away. I can use a small one-with a small bowl. Try sending it in a small package first-class mail—I think you can. I have plenty of tobacco here, so don't send any.

From what I've been reading in the papers & from letters I take it that the cigarette shortage must really be something. Well, for the fellows over here, I can say that they're getting all they need & then some free of charge.

Yesterday I got some donuts from the Red Cross. Every now & then they send donuts up front to us.

Do you know that sometimes you get the news before we do? Quite often we can't get to a radio & naturally we don't have papers coming out all the time like in the States. The Stars and Stripes supplies just about all we know & we usually get that a day late at the front. Now with the Russians driving so furiously everyone's clamoring for the last-minute report.

You've probably read in the papers how they're trying to give the medics extra pay for being on the front line, such as infantrymen who receive the combat infantryman's badge, get ten dollars extra a month. Well, they deserve it. There is one aid man for each platoon (35 to 45 men). He goes wherever the infantry goes. When we attack, he's right there with us. Then when we have casualties, his work begins. There are times when he must go right into the open under observation of the Germans to get to the wounded man or men. The only protection he has is the Geneva Red Cross patch that he has on his sleeve. Medics are considered non-combatants and do not carry any firearms.

JANUARY 30, 1945

Dear Folks—

I saw a little French kid pulling double sleds up a hill so I told him to get on & I'd give him a ride up. I motioned for him to get on the sled & he quickly understood. As I was puffing up the hill, I noticed that the load was getting heavier. By the time I got up pulling like heck, I turned around to hand the rope to the kid. There was, it seemed, the whole French army on the two sleds. The kids just kept piling right on—they're not so dumb.

I've been having quite a time kidding the barber (French) who cut my hair. It seems everywhere I go I run into him. I soon knew his wife, dad & child through snapshots.

Company M Morning Report
January 29, 1945
Company remaining in defensive positions N & E of Lemberg. Making all possible improvements. Company's mortar platoon took a terrific shelling from enemy artillery & mortars. Red Cross passed out donuts and coffee at 1000 today. Company C.P. in same location in Enchenberg [France].

January 30, 1945
Company received 15 reinforcements for machine gun platoons.

FEBRUARY 1, 1945

Dear Folks—

The army has a fine medical system. With each platoon of men (twenty to forty-five) there is attached one medical aid man. So whenever we get a headache, are sick to our stomach, we tell our troubles to our aid man. Wherever we go, he's along with us. Since they usually take the same risks we do, most doughboys feel that these medics also deserve extra pay as combat infantrymen are getting. It looks as though Congress is going to do something for their cause—about time!

FEBRUARY 3, 1945

Dear Folks—

I just had a taste of some fine gin which our platoon leader graciously passed around. The officers get a monthly liquor ration (which they pay for). The German word for whiskey, that is liquor very similar to whiskey, is "schnapps." That's one German word nearly every G.I. knows.

The big topic of discussion among us, as probably it is with you, is the present Russian offensive. Upon returning to our house, our first question is "How close to Berlin are they?"

You're bowling o.k., kid, but wait until I get home, then we're really have some contests. One more thing, George—this is to the "General."

You say he "hates Russia." Well, you tell him the doughboys on the front line are giving all our prayers for Russian success. Not all of it is selfish either. All this talk about "fighting Russia after Germany" is straight from Berlin & just what Goebbels wants us to believe. Russia is making it a lot easier for a lot of us & saving a lot of American lives. When peace comes, it's only right that the Reds have a big say in boundaries, peace terms etc. I guess all this talk against Russia is my pet peeve & that's one way to get my temper up.

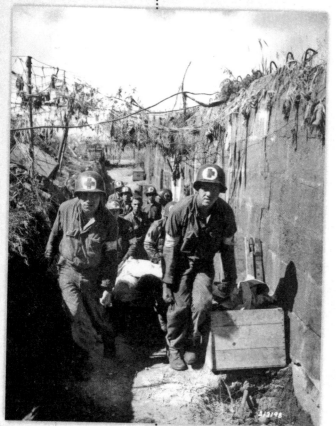

My admiration for the medics was unbounded. They carried no weapons but would at a moment's notice crawl out onto the battle field to treat and rescue a wounded GI. Our medic, "Doc" Hoover, was as courageous a person as I've ever met.

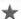

I was quite naïve then about world politics, but I did know that it was in our interest for Germany to be defeated, and the Russians had a great part in that—and that my life was at stake.

We called Al Hajj, the twin brother of Charlie, "General" because of his great interest in world affairs and the war. He had two other brothers fighting, and when his and Charlie's names came up for the draft, his family pleaded with the draft board to take only one so there would be a male left to help the family. Charlie volunteered to go, ending up in the same draft contingent I was in, and after basic training he was sent to Italy, where he died in Anzio.

The hollow remains of a building at Cherbourg show the devastation that followed in the wake of the Allied invasion.

FEBRUARY 6, 1945

Dear Folks—

Here it is another day—one day closer to the end of the war. There's a chicken in the pot right now boiling away. It seems that it was ambling along pecking away minding its own business. As long as it kept its distance it was o.k. In fact, a whole slew of them play around right across the street—but they're under observation of the owner. Anyway, this one visited us in the back yard is now doing its best to keep the boys happy.

I had me a toasted cheese sandwich just now. I got the cheese from a K ration & the bread was left over from one of the meals. Reminds me of the times we used to sit next to the toaster & eat them just as fast as they melted & toasted—pretty soon, again, I hope.

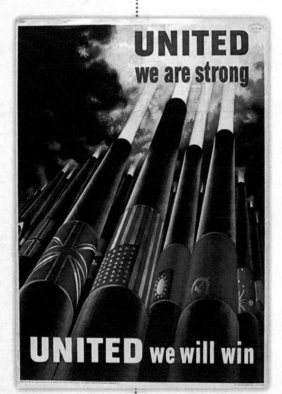

FEBRUARY 10, 1945

Dear Folks—

I think I've just about heard everything now. Not so long ago I was sitting in a foxhole listening to Woody Herman, Kate Smith & Xavier Cugat & standing guard. The Jerries were about three hundred yards to my front, dug in as we were & there's no telling how close they may have sent patrols to our positions. The reason I was able to listen in was that we had a field artillery observer in the hole directing shells during the day & naturally he had communication back to wherever he wanted it. Before he left that day he asked us if we would like to listen & we told him we would very much like to.

Standing guard that night was much more pleasant & passed by quite rapidly, although Jerry scared me a bit when I heard a noise—I held a hand grenade in my hand tensely waiting—if I had heard another noise, I would have thrown the grenade but all was quiet thereafter & I went back to listening to my music. You'd be surprised how dark it can get some nights—you can't see five feet in front of you & the only consolation is that neither can the Jerries.

As I ride around behind the lines & look around I notice what the war has done to the countryside—I get sort of a preview of what many European people are going to have to look & contend with. The hills are all pockmarked with foxholes where ever you look, shell holes in the same general area, some near the holes there's barbed wire placed in the most strategic positions. Here and there you see Jerry equipment, empty shell cases but the most prominent features are the wrecked buildings. There are many towns that do not have one whole building—some are ghost towns, not worth living in.

It was raining, hailing, snowing, raining again & now the sun is shining—all within an hour's time.

FEBRUARY 13, 1945

Dear Folks—

The houses around here are pretty uniform. Nearly all have a barn right in as part of the house. In it there is straw & hay for livestock, potatoes enough to last thru-out the winter. They are kept in the cellar where it is cool & damp & they keep quite well. Naturally the people grow their own vegetables during the summer & have enough over to last them through the winter.

The cellar in many cases is not below ground at all but is more of a first story affair.

Nearly everyone has his own livestock—cows, chickens etc. The people here are in a much better position to live without outside help than we at home. The people here are not accustomed to very many luxuries & therefore do not miss the movies, ice cream, or the ball game. Many people probably have seen very few movies & go to the larger cities where they do have movies much as we when we go to New York City.

The town which I am now in, which is a typical French village, has very few stores. In one town—there was only one store which was patronized by everyone in that town. It was something like a cooperative store—owned by the people themselves. The store manager is hired & paid by the townspeople. These stores are like our general stores in small Southern towns—they've got everything imaginable.

Company M Morning Report

February 13, 1945
Troops received donuts & coffee from Red Cross girls.

February 19, 1945
Enemy shelled Lemberg constantly for 1 hour this morning. (1st platoon located in Lemberg.)

February 22, 1945
Company received PX ration consisting of beer, candy, and cigars.

The Big Three
On February 4-11, 1945, the three chief Allied leaders—President Franklin D. Roosevelt of the United States, Prime Minister Winston Churchill of Great Britain, and Premier Joseph Stalin of the Soviet Union—conferred at Yalta on the southern shore of the Crimean Peninsula about the final defeat of Nazi Germany and the postwar plans for eastern Europe.

FEBRUARY 14, 1945

Dear Folks—

I see that the Big Three's conference [the Yalta Conference of Franklin Roosevelt, Winston Churchill, and Joseph Stalin] has come to a close & announced big things. I'm wondering if all this talk about what they're going to do to Germany isn't making them put up a stiffer fight. I don't know how the people back home feel about the war but we doughboys know it's not over until Jerry in front of us realizes it.

FEBRUARY 18, 1945

Dear Folks—

I took in church services today in the next town. Since today is Sunday, it was very appropriate—there are so many Sundays when it isn't possible to do that. While we were singing a hymn, in walked a huge black dog. At first the dog quietly listened & then it was too much for him. He started barking for all he was worth and we just kept on singing for all we were worth. Then one of the fellows got up & coaxed the hound out, came back, sat down & started singing again—peace once more reigned in the big shell-torn room.

FEBRUARY 19, 1945

Dear Folks—

I see that the Pacific war is coming along fine. Rumors really make the rounds around here—yesterday we heard that Yanks landed on Japan proper—I wish I could believe that—but I'm getting so that I believe very few rumors.

FEBRUARY 21, 1945

Dear Folks—

Yesterday a few of us went to a makeshift range & zeroed in our rifles. When we get a new rifle we're not sure how it fires because the way the manufacturer

Feb. 21st 1945

Dear Folks —

Hello everybody how're we all doing?
Here it is about seven in the morning
+ I've already washed, brushed my teeth,
+ combed my hair. You see my crop on my
head has grown almost to prewar length +
lately I've been spending almost as much
time on it as I did back home — how about
that?

Yesterday a few of us went to a
makeshift range + zeroed in our rifles. When
we get a new rifle we're not sure how it
fires because the way the manufacturer
makes it there may be a slight variation
to the sight etc. so we go to a known range
— yesterday 200 yards. We set up small
bottles + then carefully took aim + fired.
One of the boys had field glasses + coached us
telling where the shots went. Then by moving
the sight by a knob from right to left or up +
down we see what we need for a certain
range. I've got my rifle down pat.

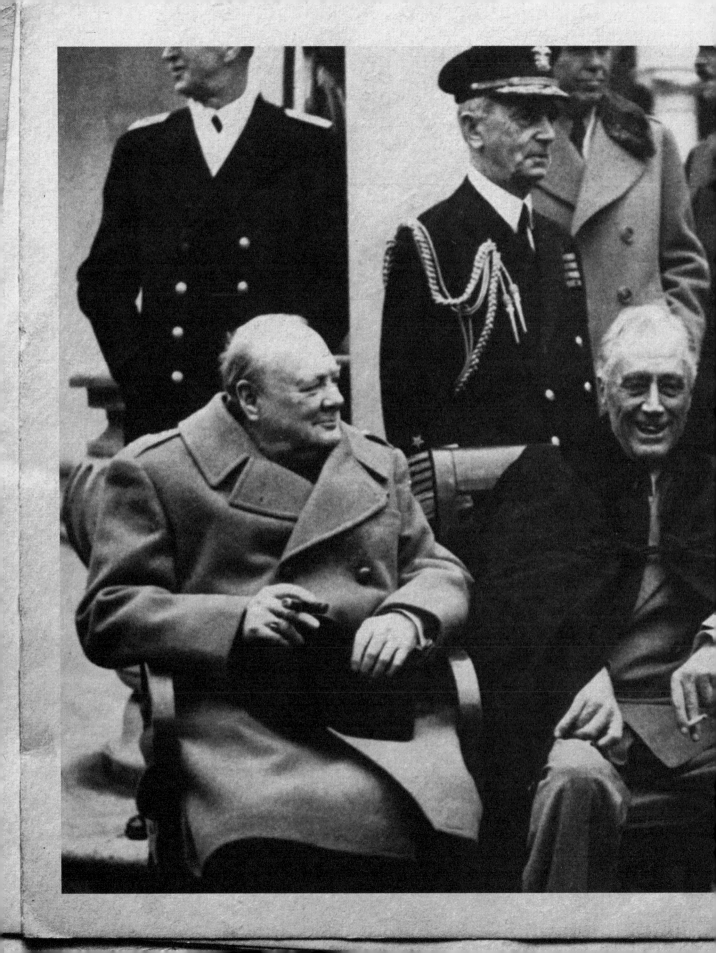

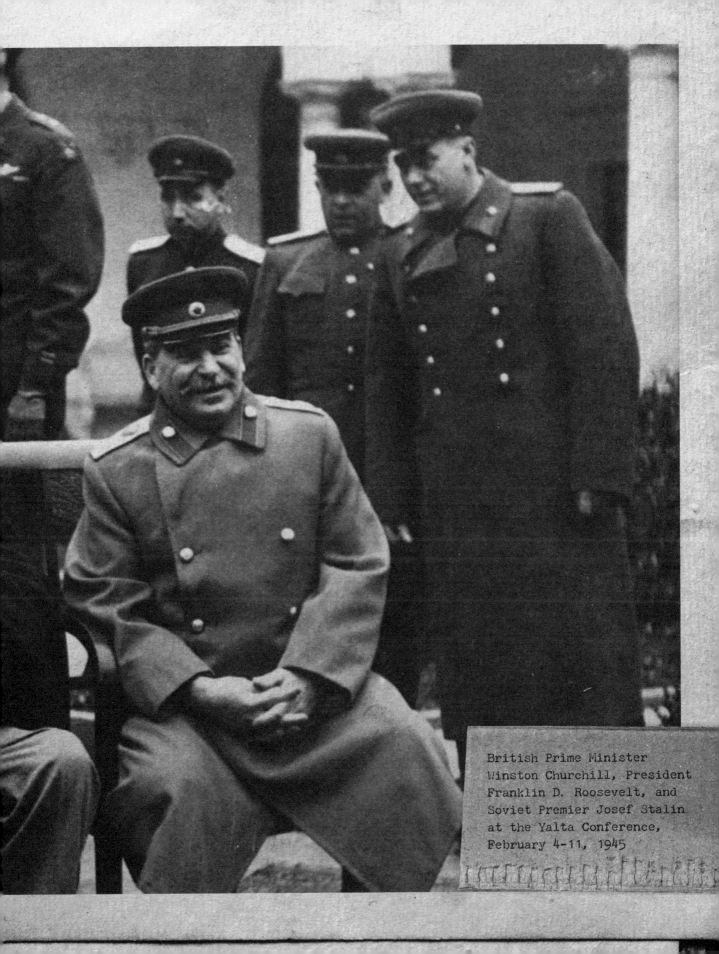

British Prime Minister
Winston Churchill, President
Franklin D. Roosevelt, and
Soviet Premier Josef Stalin
at the Yalta Conference,
February 4-11, 1945

makes it there may be a slight variation to the sight etc. so we go to a known range—yesterday 200 yards. We set up small bottles & then carefully took aim & fired. One of the boys had field glasses & coached us telling where the shots went. Then by moving the sight by a knob from right to left or up & down we see what we need for a certain range. I've got my rifle down pat.

On the way back here we went by this certain house & in the window were three fair gals waving at us. We went by them, suddenly realized it was us they were beckoning to. That jeep stopped on a dime & backed up so fast, the gals didn't have time to drop their hands. So we hopped out of the jeep, dropped our helmets, combed our hair & rushed in. We came out about an hour later with new friends—for the record, they were o.k., too.

FEBRUARY 22, 1945

Dear Folks—

Today is a fine day—sun shining away, everything nice & peaceful like. Yesterday was also a swell day so I went for quite a ride with one of the fellows who had to get something—about forty miles in all. One thing I've noticed quite a bit as I've traveled over the roads—almost all roads are lined with trees—one row on each side. This may be because most of the roads are dirt & the presence of the trees may prevent the dirt from eroding away. The roads wouldn't last long in a good rainstorm.

The grass is turning green now & the beauty of the countryside is becoming evident. I like to look at a little French village, nestled between high hills, from a distance. It's a peaceful scene. Winter, from what the people have told us, doesn't last very long—something we're all thankful for.

Not many people have running water into their homes—they have to go to the nearest pump, one of which supplies many families. I noticed straw around a few—probably to keep them from freezing.

One of the fellows was talking to some of the people & he said that they told him that many of the people have several families in one house owned by the group as a whole. One family may own the kitchen, another family one bedroom & maybe another family another bedroom. That's all these houses have—kitchens & bedrooms... Some of the homes did have electricity before

Company M Morning Report
February 24, 1945
Troops received hot coffee & donuts from Red Cross girls.

the war but have been without it for a long time. Almost all the windows have shutters—clumsy ones, though, nothing like ours at home. These homes seem to have been built for war—the walls are one & a half to two feet thick—sometimes thicker & almost always of stone. They can take several direct shell hits & survive. I can imagine what would happen to some of our buildings at home if they were hit a few times—"all would be kaput," a popular saying around here meaning no good etc.

Let me know how everything is at the store & with the houses. I can bet you're having quite a time getting a lot of stuff & probably a bigger headache from some unsympathetic customers.

FEBRUARY 25, 1945

Dear Folks—

I just came back from church services which were held just across the street in a little theater. There was a big turnout showing that when the fellows can attend services they do.

It's really something—here we were about 800 yards behind the lines attending worship as though nothing was wrong. The only suggestion that these were unusual times was the fact that everyone carried his weapon & gas mask in with him.

We sang many hymns first of all & I think sounded o.k. Many of the fellows had had previous training in music & were able to harmonize. Three of the boys got up & served as a lead trio for us. Singing hymns is about the only contact with music possible here.

The Red Cross was in town yesterday with donuts & coffee served by American girls.

We don't have to worry about a supply of wood to keep our stoves going. The civilians have cut a good winter's supply & neatly piled it up in a shed so all we have to do is carry it in.

We just heard that Russia declared war on Japan—we don't know how true it is but by the time you read this you'll know what the story is. I hope it's true.

The author's favorite part of a mess kit

FEBRUARY 26, 1945

Dear Folks—

Chow is swell, in fact almost civilian. We eat off chinaware & drink out of cups. I carry my silverware with me at all times—a spoon— the best eating utensil of all. I'd like to get hold of a Jerry combination fork & spoon. That's a good handy setup.

I don't know if I've told you what my rating calls for or not. I'm a squad leader of a heavy 30-caliber machine gun. I have under me a first and second gunner & three ammunition bearers, that is, when I have a full squad. Then there is one jeep & a driver naturally to each squad. My jeep driver is the Conn. fellow I've mentioned from Hartford & the name of our jeep is "Connecticut Yankee." He's a good boy & really takes good care of our stuff which we leave in the jeep & trailer. It's a swell setup.

I received a letter from Richard Taylor the other day. I think a lot of him & appreciate what he's done for me.

Richard Taylor was the renowned cartoonist for the *New Yorker* and other publications whom I met when I was first starting to draw. He was my mentor before I was drafted into the Army and was a strong influence on me, both in art and lifestyle.

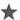

UNDATED

Dear Folks—

If the Germans see the Red Cross, they may or may not fire, depending how they feel. There are times when the Jerries see the Red Cross and will stop firing & wait for the medic to complete his aid but there are some who won't do that. As a rule, however, they do respect the Red Cross.

I was talking to some boys who were at Cassino in Italy during the heavy fighting. They told me that at one time they stopped the fighting for one half hour so that the medics could go out from both sides & pick up the dead & wounded. They said that the American & German medics were working side by side.

I know that when we capture a Jerry medic or when they capture ours, it's not unusual for them to work together caring for wounded—each usually caring for their own. After one German medic had worked in our aid room caring for captured German wounded the American doctor said the German really knew his stuff.

There's no doubt in any of the boys' mind over here that the medics deserve extra pay. They're doing a great job.

I just happened to notice that I'm the youngest sergeant in the company now. There are a couple of corporals who may be younger than I am.

Enclosed is a picture of a machine-gun nest to give you an idea of how it is with the snow. Right behind, those two fellows are standing in front of their hole. It's covered with heavy logs, dirt, firs & snow to protect it against tree bursts. A "tree burst" is a shell that hits a tree & explodes in the air, spraying the ground nearby with shrapnel. Those holes are fairly warm, too & when we're in our sacks & covered with blankets, we sleep o.k. Usually we have straw underneath us. Someone always has to be up & by the gun at all times naturally, especially at night when the Jerries usually try to infiltrate.

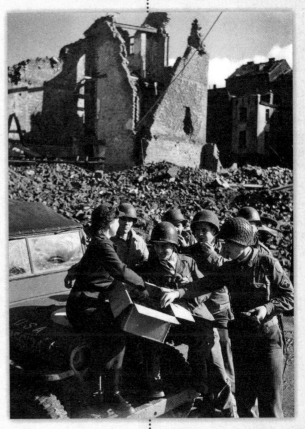

U.S. soldiers receive donuts from a Red Cross worker in Aachen, Germany.

FEBRUARY 27, 1945

Well, Dad, today you're uppermost in my mind because if you've noticed the date, you'll know that today you have reached your forty-seventh birthday.
I'll be able to be with you in spirit only & in prayer but I'm thankful that at least that is possible. I believe that Mom & you are the youngest parents represented here & I'm proud of that fact.

Georgie, I received your letter in which you said that you were going to include the address of one of our former customers (Feb. 19 airmail)—well you must have forgot to put it in. By accident, I met one fellow from Bethel.

I'm thankful, Georgie, that you're not going to try & get in the navy just yet. Good boy.

★

Lemberg, France, was, during the war, a tiny, war-torn village, which we affectionately called the "Lemberg Rest Center." For the first time since we went on the front line, we remained in one place for more than a day or two. The front line was about five hundred or so yards beyond, where we manned two foxholes with our Browning .30-caliber water-cooled machine guns, overlooking a valley from atop a hillside. We were on duty for 24 hours and then were replaced for another 24. With this arrangement, we were assured of a "comfortable" place to sleep (on the floor) every other day.

The construction of a typical French peasant house in the small country village was a paradox. The walls were a sturdy one and a half to two feet thick, which theoretically maintained heat in the winter and coolness in the warmer weather. Unfortunately, there was the roof—of flimsy construction with only the bottom shingles secured. The concussion from a nearby exploding shell would precipitate a shower of shingles and reveal the moon and stars, weather permitting. This might have been romantic in warmer weather, but hardly so in the middle of winter. It might be called unwanted air-conditioning.

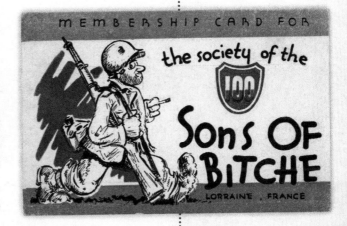

The weather, since we first went on line in November, had been inhospitable and daunting, from the continuous autumn rain to the bitter cold and snow of winter. Snow blanketed the ground when we occupied Lemberg. It was an innocent, picturesque, postcard setting. What we weren't aware of was the insidious and hidden destructive force beneath the snow. When the cover melted in March, there, staring at us innocently, was a field of mines! If we had wandered below our position for even a short distance, we would have found out if there really is an afterlife.

The first day we walked up to our positions in Lemberg, we saw four or five dead German soldiers scattered behind our foxholes. We accepted their presence. That's what war is all about: kill or be killed! We were veterans by then. We hadn't been so nonchalant when we first confronted a dead victim. He was a German soldier and his abdomen had been ripped open.

ABOVE: *A fictitious organization for GIs who participated in the battle for the Maginot Line at Bitche, France. On the back side of the card it said, "Joseph Farris is a legitimate 'Son of Bitche' for his part in the storm and capture of the proud Citadel in the Maginot Line on March 15, 1945."* OPPOSITE: *I tried hard to be part of the family birthday celebrations by being there through my hand-drawn cards. My father turned 47 years old that year.*

His guts were lying in front of him like a large mass of spilled spaghetti. We all walked by the body in silence. We all knew people died in armed conflict, but it hadn't been real to us until then. That image has never left me. We saw many more enemy dead before we saw our first dead American. We passed by, inches away, thoroughly shaken! "Dead American"—the two words somberly made their way back, one to the other. It registered. Good guys died, too!

One of the unfortunate German dead we encountered on our walk to the foxholes in Lemberg was killed as he was answering nature's call and ended up leaning against a tree trunk. I noticed that he had a ring on his finger. As I passed the body a few days later, the ring and the finger were gone. Some GI had a souvenir. Later, when the weather warmed and most of the snow melted, the bodies thawed. The odor was unbearable. We had been urging, without success, the Grave Registration people to remove

Weary U.S. troops take a break in a farmhouse near the French coast town of Les Dunes de Varredille.

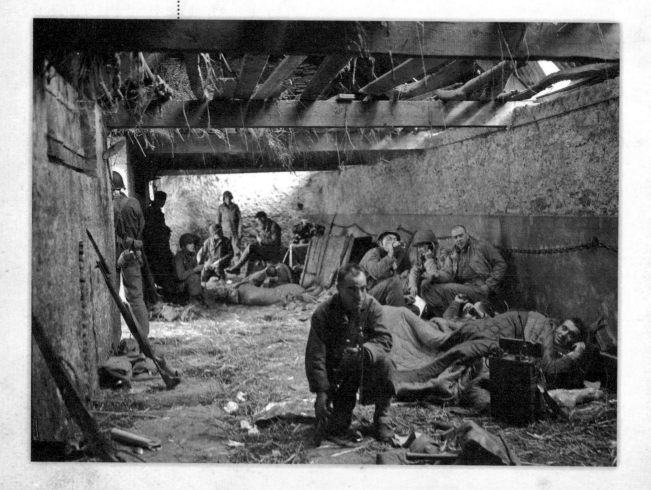

them. They were unable to rouse their courage to approach the front line. We now pressured their superiors, and finally they warily sneaked up at night and removed the bodies.

We had our first contact with the "Moonlight Serenade" at Lemberg. This had nothing to do with Glenn Miller's wonderful tune. It was a tremendous volume of light from huge searchlights behind our lines that were directed so as to reflect off the clouds above and illuminate the enemy in front of us. Because of the tremendous amount of heat generated, the lights were used only 15 minutes out of every hour. When the lights appeared, it was like meeting a long-lost friend, and when they were extinguished, it was like losing one.

There were nights when the darkness was so intense we couldn't see two feet in front of us. We often stood guard with a hand grenade in one hand and a pistol or rifle in the other. A suspicious noise was silenced with a grenade or rifle shot. I was a squad leader by then and would often check my neighboring hole to assure myself all was well. As I approached on one of these excursions, one of the guys in that hole almost blew my head off as he aimed his rifle at me and only my quick action in knocking the rifle out of his hands saved me. I chewed him out with great anger. He wasn't the brightest member of my squad.

We had an extensive communications system and were able to reach almost anyone quickly, even the air corps. One time when I was on duty, I was startled to see off in the distance many Germans lining up for chow. I couldn't believe it! It was a warm, splendid day, and there they were gathered for their noontime meal on an exposed field as though they were at a picnic. I immediately put in a call to the air corps and directed the bombing from my foxhole front-row seat. That put an end to lunch.

Another time, I spotted with my binoculars two Germans standing up in their dugout conversing about the weather or who knows what. I took careful aim, keeping in mind all I had learned in training, and shot. Needless to

Top: Al Bronkow, Edward Gilliam, the author, Joe Stall; bottom: Louis Coxe, Ted Lederer, Bob Mindlin; Lemberg, France, February or March 1945

say, they disappeared from sight. I'm still haunted by my attempted kill and hope my aim was bad and that the intended victim survived. My sorrow was postwar, of course. At the time, they were the enemy whose intention was to do away with me and my comrades, and I felt no guilt. It brings to mind Roosevelt's "I hate war!"

One night, an American patrol ventured down below us with orders to return with at least one prisoner so that he could be interrogated. They didn't get very far, for they walked into a Jerry minefield. The lieutenant who was leading the patrol stepped on one first, and we heard him yell, "Oh my God, I'm hit!" One of the sergeants attempted to go to his aid and also tripped a mine. One of his legs was blown off! The remaining members of the patrol were able to bring him back, but the lieutenant could not be reached. Our very much admired chaplain, Sam Tyler, again displayed his courage by daringly driving his jeep to the very front line and then joining the rescue party in the mine-infested no-man's land. It was a futile attempt on the part of the rescue team, however. Not until this sector had been overrun did we find out that the lieutenant had died and been buried by the Germans.

Company M Morning Report
March 3, 1945
Enemy aircraft active over front line troops.

March 4, 1945
Troops in Lemberg shelled with mortars & 88s. Snow and cold.

Sleeping on the line was quite a problem for "Tex" Oringderff, an ammunition bearer in my squad, and it is doubtful as to whether he got very much of it. He had the distinction of producing the loudest snore in Company M. Every time the Texan attempted to catch some shut-eye, his snore would break the stillness of the night and at times would be a danger of alerting the enemy as to our whereabouts. Whoever was nearest him would nudge him and tell him to be quiet. Some of the guys claimed that Tex snored even while he was awake. What really irritated the likable "Derff," though, was when he was blamed for someone else's snoring. Still, I valued his courage and calmness in battle. One could always count on him.

When we first occupied our positions, we found we couldn't leave the foxholes without alerting the Jerries who were manning 50-mm mortars. They would try to pick us off, and the result was that we were imprisoned in our holes until wiry Sgt. Leonard Ashford decided to put an end to the nonsense. He spotted the cleverly camouflaged enemy observer who was directing the fire and emptied his carbine at him. That took care of him!

We blew our proverbial tops one time when some Army brass left their safe and secure positions to make a rare frontline inspection and issue countless petty orders. We had been on line a considerable length of time, and experience had taught us a lot that wasn't in the books. What really irritated us was the considerable commotion and activity they caused, a gold-plated invitation to the enemy to open up on us. We didn't pay too much attention to their suggestions and stuck with our battle smarts.

There were many startled faces when one day two German soldiers walked, unchallenged, right through our front lines and gave themselves up. They had simply penetrated our seemingly impregnable defenses without alerting any of us. There was hell to pay and considerable review of our situation.

On the other hand, we later heard that three GIs had been killed by their own trigger-happy men. Either they had forgotten the nightly password and countersigns, or else they had been mistaken for the enemy. It didn't matter anymore to the dead men. Friendly fire!

The chicken population soon dwindled to practically nothing, as they became meals for us whenever they had the misfortune to stroll within arm's reach. They helped to offset the monotonous food we were usually served. We did occasionally have hot meals on line whenever the cooks had the courage to bring it to us. I was amused at how fast they scampered back to the comparative safety of their field kitchens.

During the second week of March, we were told that we would be relieved by elements of the 71st Infantry Division and be sent to the rear for a 10- to 15-day rest. How wonderful that news sounded to us, and our morale soared. The advance units of the 71st arrived and made the necessary inquiries and reconnaissance. This was the first time any of these men had been on front lines, and they looked it. The noncoms sported crisp chevrons, and the officers

Louis Coxe, Ted Lederer, and the author, Lemberg, France, February or March 1945. Coxe's father was a colonel and could have pulled strings to get his son out of combat, but Lou felt it wasn't fair. He was a good friend.

displayed shining bars of their rank on their shoulders. It was an invitation to the German snipers to pick off the leaders. We had learned the hard way to not display our ranks.

We went off the lines for our "rest." Some rest! We attacked Bitche, France, and succeeded in taking it as part of the coordinated drive by the Seventh Army. This was the first time Bitche had been conquered in battle.

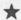

MARCH 6, 1945

Dear Folks—

One of my best buddies here, Joe Stall, sends his love to you all. We both hit this outfit at just about the same time almost one year ago & we've been in the same platoon & together right along. He's a swell kid. It's been snowing a little off and on these past couple of days but there is no snow on the ground to show for it.

I'm going to take an army correspondence course—the USAF 1 on commercial art. It costs us an initial fee of two dollars & that's all for the duration or as long as I wish to keep it up.

I was paid today & I found out that my fifty-dollar allotment doesn't start till next month so you'll receive only twenty dollars for February. I sent thirty dollars however today & you'll receive that besides the twenty dollar one.

One of the fellows in my squad, Bob Mindlin, went to Nancy [France] a few days ago & he got me a pipe from there so until I lose or break that, I'm all set.

MARCH 10, 1945

Dearest Folks—

I wish you could see the mustache that I have been sporting these past few days. If I can get to a photographer I'm going to record it for posterity & forward the results to you. How about that?

We now have a red easy chair in our living room suite. We're sleeping on mattresses too—how's that! And the big punch we have electricity—that is an electric bulb hooked onto a battery. By golly this is as good as garrison. Now

we're working on a deal to get a radio & then we really will be living. We do all right in this man's army for ourselves.

MARCH 11, 1945

Dearest Folks—

I just returned from church services which were held in a small hall. You'd be surprised how much a little close contact with God can lift your spirits. Whenever I feel low, as though everything was happening to me & me only, I quietly say a little prayer. It may not bring any physical change but inside you're a new man.

I can say that I've prayed at least once every day & many is the time it was four & five times that I asked for strength within a few hours.

That is not true only of me—I've heard many fellows say the same thing. I sometimes think that if all people had to get a taste of some of war's hell it would be a different world.

MARCH 12, 1945

Dearest Folks—

Hello, you swell people, how're we all doing? I'm feeling like a million dollars.

My rest period turn has come up again. I'm going to Nancy for four days plus traveling time & I will be leaving in a few days. For that reason I may not write for a period of time of six days so do not worry about it. I'm going to have myself a good time I'm sure of that. I hear that Nancy has been hardly touched by war and is one of cleanest cities in France. There is an art museum there plus movie houses, parks etc. It sounds like a good deal & I'm looking forward to it.

Company M Morning Report
March 13, 1945
Company relieved by elements of the 71st Inf. Div. Troops billeted in Lemberg & Enchenberg, France. Troops in Lemberg & Enchenberg strafed by enemy aircraft.

MARCH 14, 1945

Dearest Folks—

As has been the case lately, there isn't very much to write about. The weather these past couple of days has been swell—nice sunny days—the kind of days that I used to like to go out and wash the windows of the store. That's just

what I'd like to be doing now—peacefully cleaning the windows—peaceful except for the radio which would be blaring away with the Make Believe Ballroom on WNEW or the musical program in the afternoon on WMCA.

Then I would finish, and, Dad, you and I would start rearranging the store naturally. I'll bet that the store is in fine shape now—I know that you painted it over recently.

I haven't yet left for my rest period but it won't be before too long—I'm next on the list in the platoon to go.

We got our PX rations today—no beer—instead fruit juices, peanuts, candy & cookies.

The war news is coming along fine but I don't believe in becoming over optimistic—I've learned that that doesn't pay.

The boys have just gotten a pinochle game together so I'm going to leave you & play a few games.

★ NEAR BITCHE, FRANCE

MARCH 17, 1945

Dearest Folks—

You should see the difference between the craters left by the Jerry 50-mm mortar shells and from one of our 500-lb. bombs. The latter really makes a hole—big enough to drive a couple of 2½ ton trucks into. They also make short work of buildings. I looked up from within one four-story building on the bottom floor and I could see the sky—how about that!

MARCH 18, 1945

Dearest Folks—

The big thing to report is that our battalion—the only one in the division—has been awarded the Presidential Unit Citation for combat action some time ago. As yet I am unable to mention when & what it was all about but when I am permitted to tell you, I'll give you the whole story. All members of the Third Battalion are now entitled to wear a special ribbon on the right breast of the uniform apart from the other ribbons which go on the left side.

France
March 21st, 1945

Dearest Folks —

Here it is the first day in spring
— and a real spring day it is. — The sun
is in all its glory, the birds are singing and
all is quiet except for the test firing of small arm
weapons in the distance.

I received the Yellow-Bole pipe
you sent — it's a sweetheart & thanx a million.
I have all the fellows telling me how to break
it in now.

By the way folks - are you still
saving all my letters — I guess in later years
they'd be interesting to read when I'm home
& settled.

I have sent for a correspondence
course, government issued on Commercial
Art — thataway I can study a little in my
spare time — that's better than jud idling
the time away.

Enclosed is a sketch of a terry hole
in which my squad & myself have been sleeping
in for the past few nights. It's a fine set-up &
quite comfortable altho the bunks are just
a few boards nailed together. It's just about

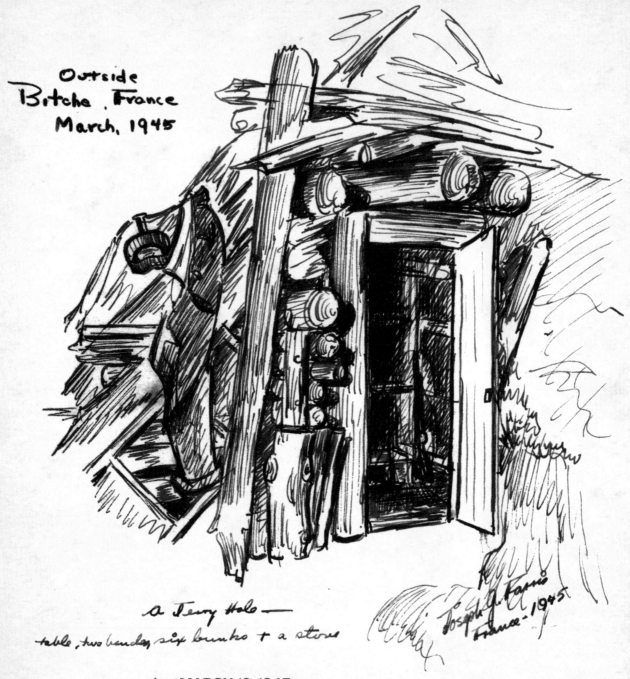

Outside Bitche, France March, 1945

*a Jerry Hole —
table, two bunks, six bunks + a stove*

*Joseph A. Farris
France - 1945*

The comfortable quarters of German troops on line were built for them by slave labor. The Americans, by contrast, were in open, uncomfortable foxholes.

MARCH 19, 1945

Dearest Folks—

Yes, spring is really here—I saw a bunch of fellows playing softball yesterday—that brought me back to the days where the fellows from the corner used to get together for a little spring training—the good ol' Tornadoes. I guess our gang is really split up now & just about all over the globe. I see that every one of us is serving overseas too—how about that?

Slept last night in a Jerry dugout built into the side of a hill & it's the nearest thing to a mansion out in the woods that I've run across yet.

It was completely closed in and was blackout proof. We had six bunks, a table, two benches, and a wood burning stove. I can see why we have so much trouble at times getting the Jerries out of their holes. With dugouts like they have, living in the woods is no hardship.

MARCH 21, 1945

Dearest Folks—

I have sent for a correspondence course, government issued on Commercial Art—that way I can study a little in my spare time—that's better than just idling the time away.

Enclosed is a sketch of a Jerry hole in which my squad and myself have been sleeping in for the past few nights. It's a fine set-up and quite comfortable altho the bunks are just a few boards nailed together [. . .] With three men on the floor it will accommodate nine men because of the triple-deck bunks. There is plenty of wood around to keep the fire going.

Just had a start and almost headed for the hut just now—heard some bursts quite nearby but they were nothing but somebody firing bazookas.

★ STEINBACH, GERMANY

MARCH 23, 1945

Dearest Folks—

Enclosed is a little snapshot that was taken of us a while ago when we fired overhead fire for Co. K—a rifle company which attacked a hill while our machine guns gave them supporting overhead fire. The riflemen in the pic were part of the second wave of the attack. We fired almost ten-thousand rounds that day and previous to that there was a tremendous artillery barrage with plenty of time-fire being used. Time-fire is artillery shells that explode in the air before hitting the ground and the Jerries don't like it a bit. It really sprays the ground beneath. My machine-gun squad is in the upper-left-hand corner—I was first gunner that day. I have an arrow pointing at me—all you can see is my back and right leg and head so about all it is, is a souvenir.

HEADLINES, DE

ATH, AND VICTORY

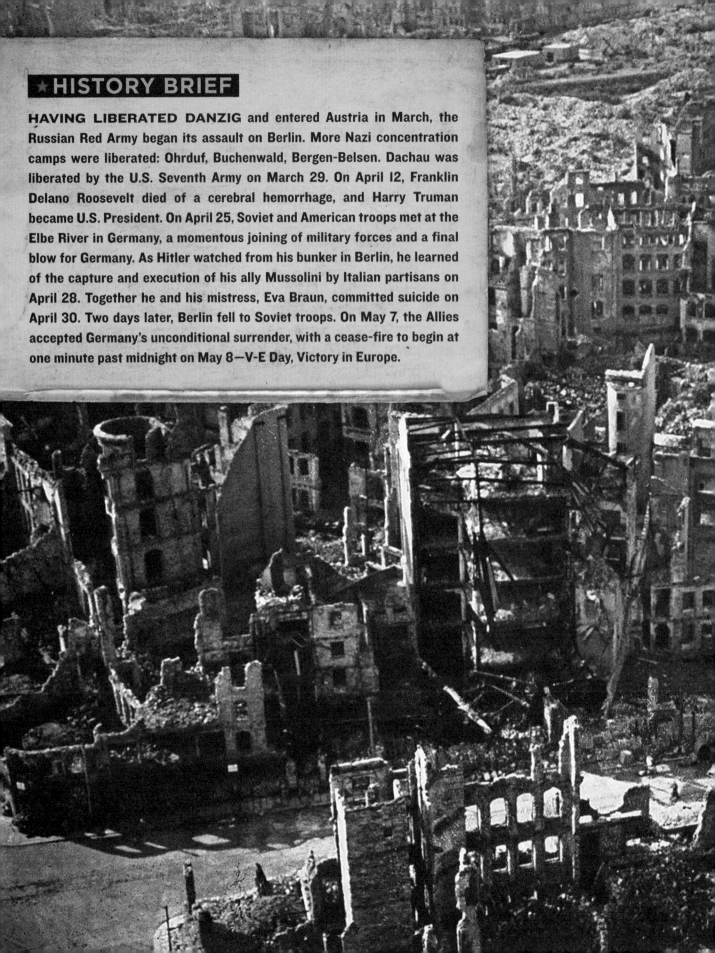

★ HISTORY BRIEF

HAVING LIBERATED DANZIG and entered Austria in March, the Russian Red Army began its assault on Berlin. More Nazi concentration camps were liberated: Ohrduf, Buchenwald, Bergen-Belsen. Dachau was liberated by the U.S. Seventh Army on March 29. On April 12, Franklin Delano Roosevelt died of a cerebral hemorrhage, and Harry Truman became U.S. President. On April 25, Soviet and American troops met at the Elbe River in Germany, a momentous joining of military forces and a final blow for Germany. As Hitler watched from his bunker in Berlin, he learned of the capture and execution of his ally Mussolini by Italian partisans on April 28. Together he and his mistress, Eva Braun, committed suicide on April 30. Two days later, Berlin fell to Soviet troops. On May 7, the Allies accepted Germany's unconditional surrender, with a cease-fire to begin at one minute past midnight on May 8—V-E Day, Victory in Europe.

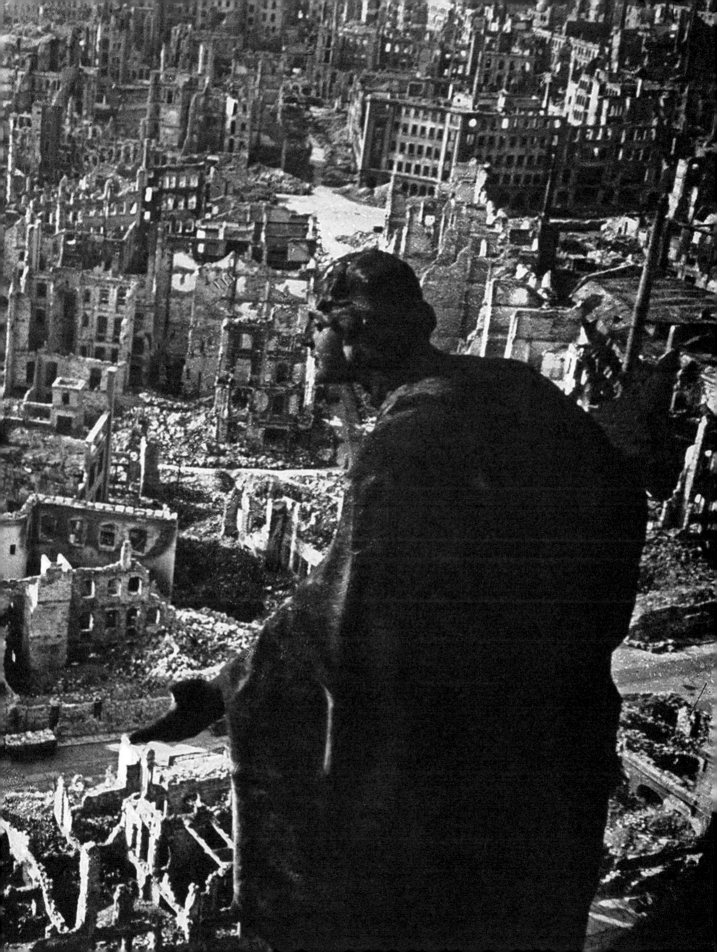

We were now in Germany, a beautiful country that reminded me of New England and made me homesick for the hills of Connecticut. But seeing the bombed and ruined cities quickly brought me back to reality. The damage we saw in Germany was considerably more extensive than in France, where much of our fighting was in the countryside, such as on Hill 578.

It's ironic that, except for the major battle in Germany of the crossing of the Neckar River and some minor skirmishes, most of our combat had been in France, a victim of the German juggernaut. There was a considerable difference between the amicable dealings we had with the French, who couldn't do enough for us, and the watchful eye we had to keep on the Germans. It was impossible to forget that they were the enemy. Of course, the relationship we had with the Germans was one of conqueror and conquered, whereas with the French we were liberators. It is still startling for me to see that after the war, our former enemies, Germany and Japan, have become our friends. The inanity of war never ceases to amaze and depress me. It must be the human condition.

As my letters show, we felt no guilt in taking over Germans' houses when necessary, since we felt our presence was the result of German aggression. I find it interesting how often the rightness or wrongness of human behavior seems to depend on circumstance.

The author's birthday card to his father. PREVIOUS SPREAD: *The view from Dresden's town hall shows the extent of destruction after the Allied bombings on February 13–14, 1945.*

★ HOCHDORF, GERMANY

MARCH 25, 1945

Dearest Folks—

We've been permitted to disclose that we're in Germany now. The big thing that struck us was that the difference between living conditions here and in France is great. The homes here are as good as those in the United States minus a few luxuries. They are well furnished & well-kept.

The houses have running water but no drainage systems as ours. In fact the house that we're now staying in has a faucet & sink right in the kitchen, which wasn't the case in France. The only unusual thing, though, is that the water runs into a pail underneath the sink & has to be regularly taken out and emptied. The bathrooms still are "kaput" & are located outside & pretty bad.

I can't get over how neat & how much better the homes are than those in France. Many have brand-new furniture. The people seemed to have plenty to eat. As we move along in Germany we have the right to move right into a house after giving the people a little time to temporarily move out. Last night we came just in time for supper—potatoes on the stove waiting for us. We are not permitted to talk, except on business, with any of the conquered German people. It is intended to make sure they know who's boss & that they have been conquered.

I had some fresh milk last night, French fried potatoes & a little wine, plus a K ration—not a bad meal. We got the wine that is it was given to us, by the man of the house. We just took a big pail to the cellar & he opened the stopper of his big wine barrel.

My next rest period is due in a couple days & I'll be back in France for a while—at Nancy which is quite a large city—so in case you don't hear from me for a while don't worry.

Included is a medal awarded to German mothers for motherhood for the state.

Company M Morning Report
March 23, 1945
Main elements of Co. left area N. of Bitche on organic transportation at 1830 22 Mar 45 remainder of Co. shuttled. Present location of Co. in Stanbach, Germany.

Company M Morning Report
March 25, 1945
Co. moved by motor to Maxdorf by foot & motor from Maxdorf to Hochdorf.

★ FRANKENTHAL, GERMANY

MARCH 25, 1945

Dear Folks—

This is still the 25th of March—Sunday night & Palm Sunday but it will not be mailed out until tomorrow. Golly but everything is going along

wonderful. The news is very encouraging & everything else seems to be so fine.

In fact right now we have a radio entertaining us—one that we picked up & had fixed by one of the fellows in the battalion. I heard Bob Hope for the first time since I've been overseas. You don't know how swell it is to be listening to a radio again. Those luxuries, which have almost become necessities in the USA, mean a lot more to you when you are away from them for a while. But most of all, I miss all you swell folks of mine and my two kid brothers.

That radio brings civilian life so close to us. Listening to that radio all I have to do is close my eyes and I'm sitting in one of our booths talking to you all—here's hoping it won't be long before that becomes a reality.

Probably be moving early tomorrow so I'm going to sign off and get a little sleep.

Cross of Honor to the German Mother, a civilian award issued by the Third Reich. I brought home one of these crosses but somehow, it has disappeared.

MARCH 26, 1945

Dear Folks—

If you have not already sent the India ink to me do not send any. I have found "beaucoups" (plenty) of ink.

Everything seems so peaceful and quiet with the radio in the background & the fellows all sitting down writing & reading. Reminds me of the nights I used to stay up at night drawing.

MARCH 30, 1945

Dear Folks—

Here I go again taking a crack at this typewriter. I'm starting to get on to it. The main difference between this and our typewriters is that the y and the z are reversed. That's probably because in German the z is used more that the y. There are a few other differences but they don't affect the typist too much.

Well, my rest period has finally come up again after a couple of false alarms. I'll be leaving tomorrow or the day after to Nancy. The first thing that I'll do is get cleaned up and dressed

Company M Morning Report
March 26, 1945
Co. moved by vehicle from Hochdorf at 1830 to new location in Frankenthal, CP located in Frankenthal. Machine-gun platoons guarding I.G. Farbenindustrie (Chemical Works) in Ludwigshafen. Present status of Co.— attached to army task force.

Somewhere in Germany
March 25th, 1945

Dearest Folks —

We've been permitted to disclose
that we're in Germany now. The big thing
that struck us was the difference between
living conditions here and in France is
great. The homes here are as good as those
in the United States minus a few luxuries.
They are well furnished & well-kept.

The houses have running water
but no drainage system as ours. In fact the
house that we're now staying in has a faucet
& sink right in the kitchen, which wasn't the
_____ _____ unusual though
_____ underneath
_____ out and
_____ "kaput"

_____ eat &
_____ in France.
_____ ture. The
_____ As we
_____ the night
_____ ning the

Joseph G. Ferris
Fellbach, Germany
April, 1945

in clean clothing. That will probably also mean an overseas cap. It's been a long time since I wore a hat other than my steel helmet liner.

We really have our electric light system perfected now with two bright lights burning on a big battery down in the basement. We have the radio hooked up on three smaller batteries and the jeep battery. I heard Bing Crosby last night—the first time in quite awhile and he sounds as good as ever. We caught a few bars of Harry James and "Easter Parade"—which is tops as far as I am concerned—play it a couple times for me.

Company M Morning Report
March 31, 1945
Co. relieved from guarding chemical plant at 1200 by units of 103rd Inf. Div. Present location of Company in Frankenthal, Germany.

April 3, 1945
Company motored from Schwetzingen to Mulhouse, remained 6 hours and then motored to Neckargartach to attack enemy on E side of Neckar River. Attack to be carried out after crossing river in assault boats.

★ NANCY, FRANCE

APRIL 3, 1945

Dear Folks—

I'm finally at the rest camp & it's wonderful. From my letters you probably were wondering whether I was ever actually going—well, for awhile I was too, but anyway, here I am at Nancy, France.

You'd never know that it was the same group of fellows who got off the truck as few hours ago, if you were to look at us now. We've showered & had a complete changeover in clothing—brand new, mind you. I really needed that shower as it had been almost a month since I last had an opportunity to bathe.

The food is wonderful. We walk into private mess halls & sit at a table. French waitresses do the rest. They brought so much food the first time that I couldn't finish the plate and it was chicken, too. And then we were told we could have seconds. In fact even on line we're eating much better than we ever were in the States.

We have separate rooms at about five to a room & we sleep on cots with two blankets plus a heavy comforter.

Tonite I took in a movie—one of the latest that I've seen yet. Animal Kingdom with Ann Sheridan—it kind of made me a little homesick.

You can't imagine how swell it feels to be clean! I feel light as a feather & ready for anything.

OPPOSITE: *I drew an inordinate amount of churches. I liked the various shapes and shadows they present—nothing to do with reverence.*

Since I just came in late this afternoon, I haven't had time to explore Nancy but passing thru I noticed it is a big city & not too scarred from the war. In fact there is very little evidence that a war exists were it not for the presence of us G.I.s.

There is a Red Cross here with coffee & donuts—all we want—nearly all the time—all in all, this is paradise.

The war news is progressing wonderfully but I want you all not to let it make you too optimistic—be very conservative in your predictions and then a sudden reverse in the news will not let you down too much. It does look as though the end is in sight over here & I can't think of anything nicer than to have the war end while I'm here in Nancy.

It's good to be able to talk with the people again & be able to smile at the kids & give them some "bon-bon" (candy). In Germany and for a very good reason, we are not allowed to talk or have anything at all to do with the people (and some of the German girls are so good-looking, too). It's a wise policy & maybe we'll be able to show them who is boss.

I may not write for the next four or five days so don't worry—it'll be because I'm in town having a good time and I know that's what you'd want me to do.

Plüderhausen, Germany, May 1945

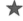

I had originally been scheduled for a furlough in January 1945, but because we were short of men, it was postponed to February. The same thing was true of this furlough as the previous one, and it was canceled and rescheduled for March. Again, they couldn't spare me and I was told it would be in April. This time, I did leave for Nancy, France, for a week or so.

While I was away, my outfit engaged in the severest fighting in the war for us. Regimental headquarters was told to send a battalion to the Neckar River area. The Third Battalion, mine, just happened to be on trucks in

transit and was chosen instead of the Second, the initial choice. The company motored from Schwetzingen, Germany, to Mulhouse, France, remained six hours, and then went to Neckargartach in Germany to attack the Germans on the east side of the Neckar River in assault boats at 3:00 a.m. My comrades encountered much enemy resistance—rockets, artillery, automatic and small-arms fire—from the Germans, who charged our gun positions yelling and screaming, seemingly under the influence of drugs or liquor. Our forces suffered heavy casualties—ten of our enlisted men (EM) and three officers were missing in action (MIA), and we lost three of our machine guns and one mortar. In my absence, my squad was being commanded by Al Brunkow, who had just received a battlefield commission to second lieutenant. He was wounded and captured, along with my machine gun.

Thanks to the fates, I missed this encounter because of the serial postponements of my leave, just as I had been fortunate early in my Army career when I was chosen for the Army Specialized Training Program

Murrhardt, Germany, May 1945. Scenes like this one—and the one opposite—were common throughout Germany at the end of the war.

Company M Morning Report

April 4, 1945

Company crossed Neckar River in assault boats at 0300. Heavy enemy resistance encountered. Casualties heavy. Ten EM & 3 officers MIA.

after infantry basic training at Camp Croft, South Carolina. Back then, many of the troops I had taken basic training with weren't as lucky as I and were sent to Italy where they took part in the Battle of Anzio, including Charlie Hajj, one of my best friends, who sadly lost his life there.

Our company had a first sergeant whom everyone detested. He actually ran the company while the lieutenant in charge occupied himself with the actual fighting plans that were passed down from upper echelons. When he saw me in clean and pressed clothing, after my return from Nancy, France, he tried to intimidate me into changing clothing with him since I "would be going back on line and would soon become filthy again." I was infuriated with his suggestion and managed the courage to tell him to go to hell.

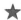

APRIL 4, 1945

Dear Folks—

I took the walking tour of Nancy this afternoon and noted much of the historic points of interest. But the best thing of all is that I met Tony Fiaschetti [a friend from Danbury, CT] in the American Red Cross club in town. And not only that, but tomorrow I'm going to drop over to his battery where there are many other Danbury boys—there are about 30 in his whole outfit—among them Louis Sahely, Harry Ramey, Paul Habib & many others. I'll let you know all about it after I have seen them.

I just noticed a sign that says we can send telegrams home—so if someday you should receive one from me don't let it surprise you. It also says that you may send a telegram to me—from any regular telegraph service. I don't know how long it would take but just in case you ever want to try it—there it is.

APRIL 7, 1945

Dear Folks—

A lot has happened since I last wrote you. The one that will interest you most right now is that I saw twelve or thirteen fellows from Danbury—that's right 12 or 13. And if I had the time and transportation, I could see twenty more.

There are 33 Danbury boys all in this one AA [anti-aircraft] battalion. Some of the fellows I saw & talked with are—Louis Ellis, Gus Pappas, Ed Jocknevich, and George Humeston, an old schoolmate of mine & the one who took me around to see the boys, and I told you I met Tony Fiaschetti, Donald Roth [customers in the store] and many others who you probably do not know.

I couldn't get to see Harry Ramey & Louie Sahely & the others because their batteries were all split up and many miles apart. It was really swell seeing the fellows—the first I've seen since I last saw Tony near Marseilles. I spent nearly the whole day with the fellows. I guess I'm the first home-town fellow they've seen outside of the ones in their own outfit.

Meanwhile, I'm really living like a king here. We don't do anything at all that might resemble work. In the morning a French gal fixes up the beds, sweeps out the rooms & takes care of everything. For our meals we go into small dining rooms holding about 75 seats plus tables & sit down. Then a French waitress brings us the plate full of food. When we want anything, we simply call the maid—how about that? We get butter & marmalade every meal—this morning it was fried eggs sunny side up, my favorite—tomorrow morning it's hot cakes.

There are movies all the time—all kinds of athletic equipment imaginable—radios—donuts & coffee—none of which is any charge at all. This is all a wonderful setup & I can make no squawks about it at all.

I saw the movie Wilson tonite & I think it was a great show—and very educating. I've gone to the movies everyday that I've been here & today I went twice.

I wasn't able to have any pictures taken as the photos would take at least 12 days and naturally I'll not be here by then.

What I miss most of all back here is my mail which I'll get when I get back with the fellows.

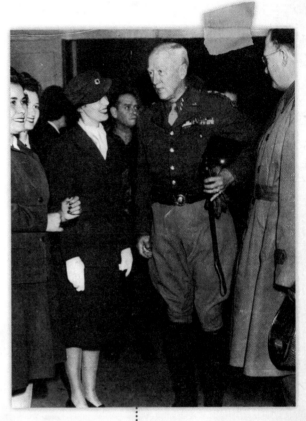

Gen. George Patton may have charmed the fairer sex, but he didn't win our admiration. He had a reputation of promising his troops a rest period in the next town they captured but rarely delivering on his promises.

Company M Morning Report
April 5, 1945
Co. supporting Battalion attack E of Neckargartach. Heavy enemy resistance: rockets, artillery, automatic & small arms fire. Lost 3 machine guns & 1 mortar.

April 7, 1945
Company in defensive positions east of Neckargartach. Troops still receiving enemy artillery and mortar fire.

I didn't mention in my letter that the antiaircraft battery I visited was permitted to track any enemy aircraft but not actually shoot at them. Strange.

★ NECKARGARTACH, GERMANY

APRIL 9, 1945

Dear Folks—

I received a letter from Nickie [Nick Attick, a boyhood friend] & he seems to be making out all right. In fact he expects to go back on line soon. I'm glad that he wasn't hurt too badly.

I received quite a few letters from you—March 22 the latest.

While in Nancy I was almost run over by the vehicles there. It had been so long since I had been in any traffic I was caught by surprise and especially by the sounds of the various horns & the shine of the lights. Up on the front, that is right behind the lines, vehicles are driven at night without any lights whatsoever and the horns are disconnected for fear that they might accidently be hit when absolute silence is necessary.

APRIL 12, 1945

Dear Folks—

The weather has been swell lately—good ol' spring days. I'd like to be walking up Elm Street right now—there's nothing I'd like better to be doing right now. Flowers have been popping out—the trees are green with leaves—and yet this war continues on. Then all I'd need is a big dish of "taboule"!

You should see me walking around with brand-new pants with a sharp crease and a new shirt, also with creases. It actually feels good to be a little "dressed up" so to speak. And I just washed & shaved & combed my hair—all I need now is a big date tonight.

Company M Morning Report

April 8, 1945
Company in same defensive positions E of Neckargartach, Germany. Troops still receiving artillery and mortar fire and occasional sniper fire.

April 9, 1945
Company in same defensive positions. Troops repelled heavy counter attack at 0200 without loss of any men.

April 10, 1945
Company in same defensive positions East of Neckargartach. Troops repelled two counter attacks suffering only one casualty.

I keep getting reports, Georgie, on how big you're getting. I guess I'm going to have to watch my step when I get home & at least I'll have to take up boxing lessons.

My machine gun squad was given the assignment of zeroing in on a particular street in a German town where Nazi troops might attempt to infiltrate. We chose an occupied house after informing an older woman living there that we planned to enter. We went to a room on the second floor and placed our machine gun on a table with the barrel aimed at the road. It's interesting to me that I still remember feeling badly amid the seriousness of our mission about the scratches we were putting on the pristine-looking piece of furniture.

Suddenly there was a knock at the door. I opened it and, to my horror, saw the woman ominously standing there holding a long-barreled Luger pistol. At first, I thought she was threatening me, but I soon realized she was more frightened than I was. She was concerned that we might search the house, discover it, and place her in jeopardy. She handed the Luger to me with great relief to be rid of it, and I was owner of a much prized trophy.

A day or two later, we were going through a burning and battered lumberyard, a very chaotic scene, when a GI popped his head out of one of our tanks and yelled, "President Roosevelt is dead!" I felt as though my own father had died and was bereft with sorrow and abandonment.

Company M Morning Report

April 13, 1945
Company supported Battalion attack through Neckarsulm to Willsbach, with replacements filling out the company.

April 14, 1945
Company moved out to clear out Affaltrach, Eschenau, Weiler Eichelberg. One man slightly injured.

Franklin Roosevelt's death on April 12, 1945, affected us greatly. He was a father figure and helped determine our destiny.

The New York Times.

LATE CITY EDITION

VOL. XCIV—No. 31,856. NEW YORK, FRIDAY, APRIL 13, 1945. THREE CENTS

PRESIDENT ROOSEVELT IS DEAD; TRUMAN TO CONTINUE POLICIES; 9TH CROSSES ELBE, NEARS BERLIN

Franklin Delano Roosevelt
1882–1945

★ GERMANY

APRIL 17, 1945

Dear Folks—

We're still trying to get over the shock of President Roosevelt dying. It happened at a very inappropriate time. It seems now is when we needed him most. I'm sure though that the war will be conducted just as efficiently as it has been.

I was approached by a fellow while I was eating chow & he asked me if I was an Assyrian—how about that!

★ HÖSSLINSÜLZ, GERMANY

APRIL 19, 1945

Dear Folks—

Today was a big day when it comes to receiving packages. I hit the jackpot. I received six packages today all at once, seven copies of the Danbury News-Times & three letters—how about that. I received the jackknife, fork & spoon, fruit cake, writing paper & drawing ink. Thanx a million to you all.

Even though I am physically far away from you all, in spirit I'm as close to you as ever I was & in fact closer. The longer I'm away from you, the more love I have for you. The one thing I want to do most in my life is to show you, Mom & Dad, how much I love you both. I never realized as well as I do now how wonderful you both are. When I get back, I want you both to quit working & take it easy.

Company M Morning Report
April 20, 1945
Company spent night in vicinity of Lowenstein. Moved out into attack through Klaffenbach.

★ KLAFFENBACH, GERMANY

APRIL 21, 1945

Dear Folks—

You should see the house we're in right now—it's really beautiful—one I wouldn't be ashamed to take back to the States were it possible. We took the town this morning and then picked out one of the best-looking houses and set up. It's really a fine-looking house, outside and in.

The weather has been swell as of late and, coupled with the scenery, Germany is a very beautiful country, that is one thing I must admit. This country is wonderful to look at. The hills and rolling valleys make me want to bring out my drawing board and start working—but I guess I shouldn't call it work.

Most of the houses in Germany are modern and usually very clean, the girls are o.k.—makes you sorry that the non-fraternization policy is in effect. The little kids are so cute that it takes quite a bit of control to resist giving them some candy and playing with them.

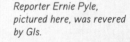

Company M Morning Report
April 24, 1945
In Army Reserve. Troops cleaning weapons and vehicles. Moved by motor from Grossheppach to Waiblingen.

★ WAIBLINGEN, GERMANY

APRIL 24, 1945

Dear Folks—

We really hit the jackpot last night. We slept in a room right next to a bar room. The beer tap was full & the owner was behind it dishing it out to us as often as we wanted some. In fact right now, I have a glass of beer on the table ready for instant action—you should have seen the bed I slept on—reminds me of my bed at home with you.

There was an accordion in the home we were at a couple of days ago—a brand new one. I was starting to get the feel of it, playing songs on it fairly well until we received moving orders. It's a lot easier to play if you've had harmonica experience.

We felt pretty bad when [renowned war correspondent] Ernie Pyle was ambushed & killed the other day—we soldiers have lost two of our best friends in the past few days—F.D.R. and Ernie Pyle.

The more I see of Germany, the more I can understand why Hitler was able to get into power. First of all, when he came into power, Germany was in bad shape so he fed them, gave them work, nice homes to live in & also was then able to convince the people on his military & political ambitions. He drugged the

Reporter Ernie Pyle, pictured here, was revered by GIs.

Sgt. Joseph G. Farris
Co. M, 398th Inf.

"Sorry, Muller, but we don't handle U. S. war bonds."

Reds 10 Miles in Berlin; Flank Capital, Reach Elbe

(Continued from Page 1)
Russians had linked up with Yank forces, but this advance now officially places the distance between the two forces at approximately 20 miles.

and the first shells hurled at Berlin were fired by gunners who defended Leningrad during the heaviest German offensive against that fortress city.

people by giving them their necessities in life. The way we'd put it is—"He's not so dumb."

I'll be glad when this mess is over—I've seen so much suffering, I think I used up my life's quota on it and have seen all I care to see.

Company M Morning Report
April 25, 1945
Company still in Army Reserve. Following training schedule which includes care & cleaning & maintenance of vehicles and weapons, military courtesy and discipline and orientation, including operations of unit since crossing Neckar River. Co. in Waiblingen.

APRIL 26, 1945

Dear Folks—

Enclosed is an issue of the Stars and Stripes, our overseas newspaper.

On the back page of the Stars and Stripes is a cartoon I made while I was in Lemberg, France. I went to the Stars and Stripes office a while back and showed them my work and they accepted the one you see. I'll send the original to you the first chance I get.

Save the paper—this is my first published work even though there was no money involved.

★ PLÜDERHAUSEN, GERMANY

MAY 1, 1945

Dear Folks—

As we have been going through these towns we have been liberating, many people of foreign descent—that is, other than the Germans of whom we have taken as conquered people—never liberated. I've seen many suffering people but in spite of their previous predicament, they are a happy people now that the Americans have freed them from their bonds which the Krauts had on them. They are all along the road, walking toward a rear assembly area where they will await transportation home which may be France, Russia, Poland, Greece or many other places. There was a lot of forced labor used by the Germans for their factories and mines. The refugees were crowded into small living quarters and not given too much to eat. Many had been under the Germans for as much as four years or more. As we pass by them, they all give us the V for Victory sign which it seems they all know. They are a happy lot of people—all of them—they gladly give us their wine.

Company M Morning Report
May 1, 1945
Company moved by motor from Waiblingen, Germany, to Pluderhausen.

OPPOSITE: *I submitted this cartoon along with others to* Stars and Stripes, *our weekly newspaper, with the hope of being invited to be on staff and getting off the front lines. They published this cartoon (my first published cartoon, with no payment), but I wasn't beckoned to their offices.*

In huge type the headline for the Stars and Stripes, the American newspaper put out for the troops was HITLER DEAD. The story underneath said: "Adolf Hitler, for years the master of Germany and the man who set out to conquer the world, died yesterday afternoon, the German radio at Hamburg announced last night. Declaring that Grand Admiral Karl Dönitz, commander in chief of the German Navy, was Hitler's successor, the radio stated: It is reported from Der Fuehrer's headquarters that Der Fuehrer, Adolf Hitler, has fallen this afternoon at his command post in the Reich Chancellery, fighting to the last breath against Bolshevism and for Germany."

Even at the end, the German propaganda machine still functioned, unable to relay the true facts.

The Führer Is Dead

Beginning in January 1945, Adolf Hitler directed Nazi forces from his underground Führerbunker in Berlin. Soviet troops were approaching; defeat must have seemed inevitable. On April 29 Hitler married Eva Braun and dictated his will. On April 30 the two shared cyanide capsules, and Hitler shot himself.

MAY 2, 1945

Eddie, you asked me if a machine gun can shoot one round at a time—well it can, provided you are careful when you touch the trigger. If you just tap the trigger lightly you can get one shoe into the air. Since the rate of fire is 525 rounds a minute maximum, you can see that you have to be very careful when you fire it. Sometimes when the gun isn't in too good firing order, all you can get off is one shot and you have to keep pulling back the bolt. Last winter it wasn't too unusual for the gun not to fire. Many times the water in the water jacket of the gun would freeze and we would really sweat it out trying to get the gun to fire. We eventually used anti-freeze just as you would back home in autos.

The most we have ever fired was back in France one day when we fired 37 belts of ammunition for the platoon—that is four guns firing as fast as they could be operated. There are 250 in a belt which makes a grand total of 9,250 rounds—and that is a lot of lead to have thrown at you. We were firing overhead fire for one of the rifle companies. They were advancing under the fire we were giving them.

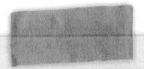

Germany,
May 3rd, 1945

Dear Folks,

Just came back from the first in-
spection that has been held for us since
we first hit combat. Started off good
with no gigs against me. It seemed fun-
ny to stand inspection again after so
long being on the front lines--but it
is a good feeling.

Well the war news looks good--in
fact by the time you receive this the
war over here should be just about over
if not completely. It is a good feel-
ing not worrying what is going to hap-
pen to you tomorrow.

I have been feeling around with
an accordion and have gotten so that
I can carry a tune fairly well. Who
knows maybe my musical whirl is not
over yet. It is very similar to a
harmonica and that makes it rather easy
to play.

Enclosed is a copy of the Stars
and Stripes which I want you to save
for me.

Well chow should be coming up
soon so sign off for now--

Best to all,
Love,

Joe

I attempt to play the accordion in Plüderhausen, Germany, in May 1945 after the European war ended. Someone in our company confiscated the accordion, and when no one wanted it, I sent it home. I still have it.

Usually, though, we were right up there with the riflemen giving them close support all the way. They appreciate us too when they need some fire up there and we gave it to them every time.

Well, today we got the news that old Adolph was dead—that should be just about the end of this mess. We are all praying so anyway.

MAY 3, 1945

Dear Folks—

Just came back from the first inspection that has been held for us since we first hit combat. Started off good, with no gigs against me. It seemed funny to start inspection again after so long being on the front lines—but it is a good feeling.

Well the war news looks good—in fact by the time you receive this, the war over here should be just about over if not completely. It is a good feeling not worrying what is going to happen to you tomorrow.

I have been fooling around with an accordion and have gotten so good that I can carry a tune fairly well [. . .] It is very similar to a harmonica and that makes it rather easy to play.

MAY 7, 1945

Dear Folks—

Everywhere you go around here you see the German people working on their wood supply. Almost all the stoves that we have seen are the wood burning type. In only a very few places have we seen steam heat and it was in factories as a rule. The peculiar thing, to us anyway, is the fact that the women do as much work, if not more, than the men. You see them chopping wood, stacking it, gathering it and feeding it to the stove. In the fields they are right next to the men folk, digging and spading. It seems strange to us since we are accustomed to having the women folk in the home and there only.

Many is the time that we see the lady carrying a suitcase and the man doing nothing, just walking along side her. I guess they don't believe in the walking

on the street side either, in fact, it seems that the custom is just the opposite. Everywhere you see a huge supply of cut wood, usually stacked outside in neat piles.

The German people are as a rule much cleaner and neater than the French people that we have any contact with. I believe that they ate better and lived a lot better than the French. Their homes are a great deal better than the French homes. I think that the comparison is fairly accurate since we have been in both small towns—German and French.

The one place that the Germans are surprisingly bad in is their bathroom. In nearly every home it is kaput. The only way to flush is to run water from a pitcher. Nearly every home has running water right out of a faucet. In France you had to go out to the well which, as a rule, was in the back yard and use the old bucket system.

The German homes almost all contain a radio where in France they were rare. In a good deal of these towns the power system is snafu. Usually it was due to the German army itself since they blew up bridges and dams as they retreated except when we got there just a little too fast for them. We really tore through this last offensive.

During this recent drive we really came through with flying colors. Once there we were the only battalion in three divisions—THREE, mind you, of a total of 27 battalions—to complete our mission according to schedule. We really had to keep going in order to accomplish this mission. We started early one morning and we kept going all that day and all that night until five the next morning. A good deal of the mission had to be walked. Everyone was quite tired when we were finally told that we could stay in that last town we took. While I was in that town I got me what most of the G.I.s were and still are trying to get—a German Luger pistol. Mine is a target pistol and a honey too. I got a chance to fire it the other day and it operated perfectly—no stoppages at all. I hope that I will be able to bring it home with me.

Left to right, top row: Henry Russell, the author, Guido Giannelli, and John Hayes; bottom row: Leland Zeiter and Shelton Oringderff.

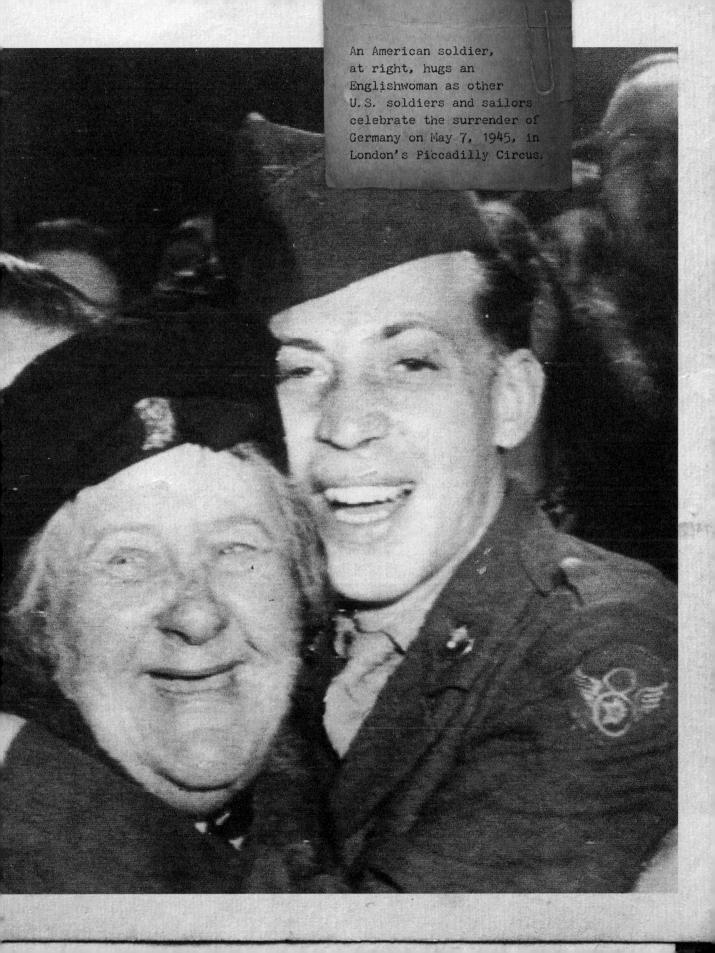

An American soldier, at right, hugs an Englishwoman as other U.S. soldiers and sailors celebrate the surrender of Germany on May 7, 1945, in London's Piccadilly Circus.

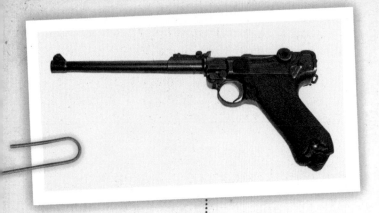

The Luger is a remarkable weapon, and while still in Germany, I used it on a firing range and found it to be as effective as my carbine rifle. When I got home, I broke down the Luger and took the barrel into New York City to find out what kind of cartridge it required. I was firmly told by owner of the weapons shop that I was risking arrest by bringing it in to the city. When I got home, I purchased cartridges for it after registering it at the Bethel Town Hall. After almost 50 years, my wife's discomfort with having them in the house prevailed, and I turned them into police headquarters. They accepted the cartridges with no inquiry or comment.

German Luger pistol. The story of how I acquired the pistol is in my letter of April 12.

MAY 8, 1945

Dear Folks—

Today is the day that so many, many of us have waited for [the surrender of German forces]—officially at 2401 tonight. While the war has been over for me for quite a few days now, I'm gratefully thankful that some of the suffering will now come to an end at long last. This is really an anti-climax since I knew that I wouldn't have to go on line here anymore, as I said quite a few days ago.

We have the lights on here—with no blackout—none at all. It's wonderful too, to see them shining with no worry of some Jerry F.O. [forward observer for mortar or artillery] dropping rounds on us. This is the first time, with the exception of when I was in Nancy, since I've been here that we have been allowed to show light. After an experience we had back in Rosteig, France, no one had to tell us to black out either. We entered this town back in France, vehicles and all. When you take vehicles in, the place should be quite safe. As it was, this town was on the front line and surrounded by high ground on all sides. The Jerries occupied this high ground. Why we went in so high and mighty, I'll never know. Anyway, we weren't in Rosteig but a few minutes after being billeted when the Krauts threw the whole book at us. We were under the tables, in the corners of the rooms—and in all cases on the floor—and there were many prayers said that night. I was no exception. Our building

was hit at least one time. All our vehicles now sport shattered windshields. These resulted from that first night in that town. They threw stuff at us all the time we were there. Just as we came into the town, we saw a woman running around with a lantern blazing away. Whether that was some sort of prearranged signal with the Jerries, no one knows. Anyway, just a little while after we got the works. After that, blackout discipline was something that no one had to lecture us about. We made sure no lights were showing. When we saw any lights, we simply shot them out, especially when the light was civilian. The boys shot out quite a few that night too. After one volley, the offending party is convinced that he is in error. Those lights really look swell.

We have electricity and a radio now—and that is quite as luxury to us—especially after not hearing a radio for so long, no less having electricity.

Right now we are listening to the radio from New York—no—I'm wrong, it is London. We are listening to the crowd celebrating V-E [Victory in Europe] Day. I can just imagine New York—and Danbury, too. I'd sure like to be there helping out.

Celebration in Times Square at the end of the war, May 7, 1945

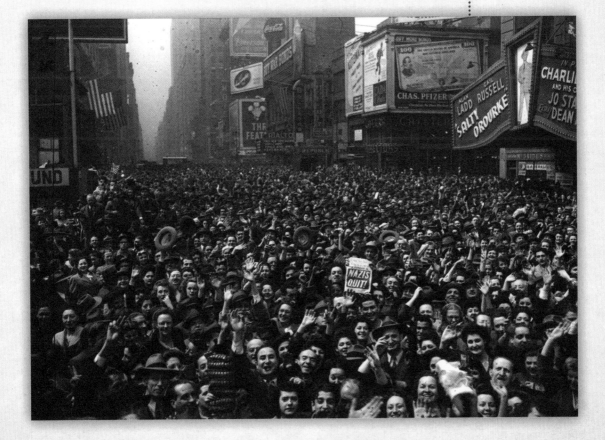

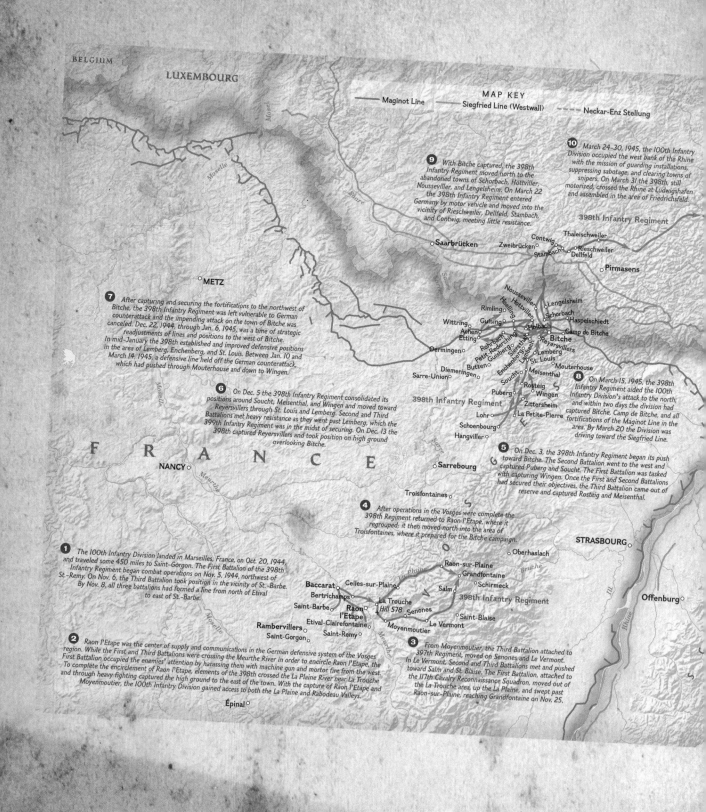

BELGIUM
LUXEMBOURG

9 With Bitche captured, the 398th Infantry Regiment moved north to the abandoned towns of Schorbach, Hottviller, Nousseviller, and Lengelsheim. On March 22 the 398th Infantry Regiment entered Germany by motor vehicle and moved into the vicinity of Rieschweiler, Dellfeld, Stambach, and Contwig, meeting little resistance.

10 March 24–30, 1945, the 100th Infantry Division occupied the west bank of the Rhine with the mission of guarding installations, suppressing sabotage, and clearing towns of snipers. On March 31 the 398th, still motorized, crossed the Rhine at Ludwigshafen and assembled in the area of Friedrichsfeld.

398th Infantry Regiment

Saarbrücken
Zweibrücken
Contwig Thaleischweiler
Stambach Rieschweiler
Dellfeld
Pirmasens

METZ

7 After capturing and securing the fortifications to the northwest of Bitche, the 398th Infantry Regiment was left vulnerable to German counterattack and the impending attack on the town of Bitche was canceled. Dec. 22, 1944, through Jan. 6, 1945, was a time of strategic readjustments of lines and positions to the west of Bitche. In mid-January the 398th established and improved defensive positions in the area of Lemberg, Enchenberg, and St. Louis. Between Jan. 10 and March 14, 1945, a defensive line held off the German counterattack, which had pushed through Mouterhouse and down to Wingen.

6 On Dec. 5 the 398th Infantry Regiment consolidated its positions around Soucht, Meisenthal, and Wingen and moved toward Reyersvillers through St. Louis and Lemberg. Second and Third Battalions met heavy resistance as they went past Lemberg, which the 399th Infantry Regiment was in the midst of securing. On Dec. 13 the 398th captured Reyersvillers and took position on high ground overlooking Bitche.

Nousseviller Lengelsheim
Hottviller Schorbach
Rimling Haspelschiedt
Wittring Gusing Holbach Camp de Bitche
Aschen Bitche
Etting Rohrbach Reyersvillers
Oermingen Petit-Réderching Lemberg
Butten Guisberg St. Louis
Diemeringen Soucht Enchenberg Mouterhouse
Sarre-Union Meisenthal
Puberg Rosteig
Lohr Wingen
Schoenbourg Zittersheim
Hangviller La Petite-Pierre

398th Infantry Regiment

8 On March 15, 1945, the 398th Infantry Regiment aided the 100th Infantry Division's attack to the north, and within two days the division had captured Bitche, Camp de Bitche, and all fortifications of the Maginot Line in the area. By March 20 the Division was driving toward the Siegfried Line.

5 On Dec. 3, the 398th Infantry Regiment began its push toward Bitche. The Second Battalion went to the west and captured Puberg and Soucht. The First Battalion was tasked with capturing Wingen. Once the First and Second Battalions had secured their objectives, the Third Battalion came out of reserve and captured Rosteig and Meisenthal.

F R A N C E
NANCY

Sarrebourg

Troisfontaines

4 After operations in the Vosges were complete the 398th Regiment returned to Raon l'Etape, where it regrouped; it then moved north into the area of Troisfontaines, where it prepared for the Bitche campaign.

STRASBOURG

Oberhaslach

Raon-sur-Plaine
Grandfontaine
Celles-sur-Plaine Salm Schirmeck
Baccarat
Bertrichamps La Trouche 398th Infantry Regiment
Saint-Barbe Hill 578 Senones
Raon Saint-Blaise
Rambervillers l'Etape Le Vermont
Saint-Gorgon Etival-Clairefontaine Moyenmoutier
Saint-Remy

Offenburg

1 The 100th Infantry Division landed in Marseilles, France, on Oct. 20, 1944, and traveled some 450 miles to Saint-Gorgon. The First Battalion of the 398th Infantry Regiment began combat operations on Nov. 5, 1944, northwest of St.-Remy. On Nov. 6, the Third Battalion took position in the vicinity of St.-Barbe. By Nov. 8, all three battalions had formed a line from north of Etival to east of St.-Barbe.

Épinal

2 Raon l'Etape was the center of supply and communications in the German defensive system of the Vosges region. While the First and Third Battalions were crossing the Meurthe River in order to encircle Raon l'Etape, the First Battalion occupied the enemies' attention by harassing them with machine gun and mortar fire from the west. To complete the encirclement of Raon l'Etape, elements of the 398th crossed the La Plaine River near La Trouche and through heavy fighting captured the high ground to the east of the town. With the capture of Raon l'Etape and Moyenmoutier, the 100th Infantry Division gained access to both the La Plaine and Rabodeau Valleys.

3 From Moyenmoutier, the Third Battalion attached to 397th Regiment, moved on Senones and Le Vermont. In Le Vermont, Second and Third Battalions met and pushed toward Salm and St. Blaise. The First Battalion, attached to the 117th Cavalry Reconnaissance Squadron, moved out of the La Trouche area, up the La Plaine, and swept past Raon-sur-Plaine, reaching Grandfontaine on Nov. 25.

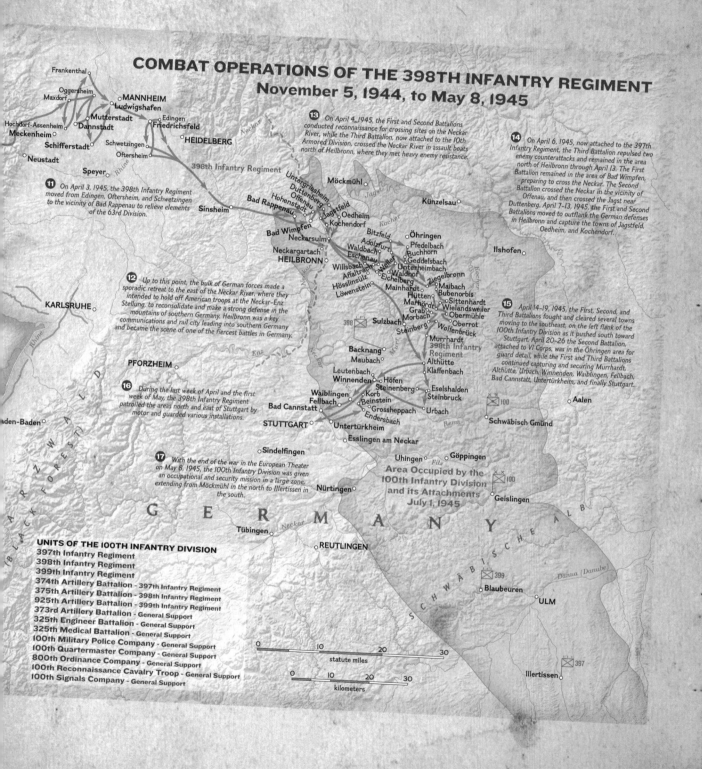

HOT WATER O

UT OF A FAUCET

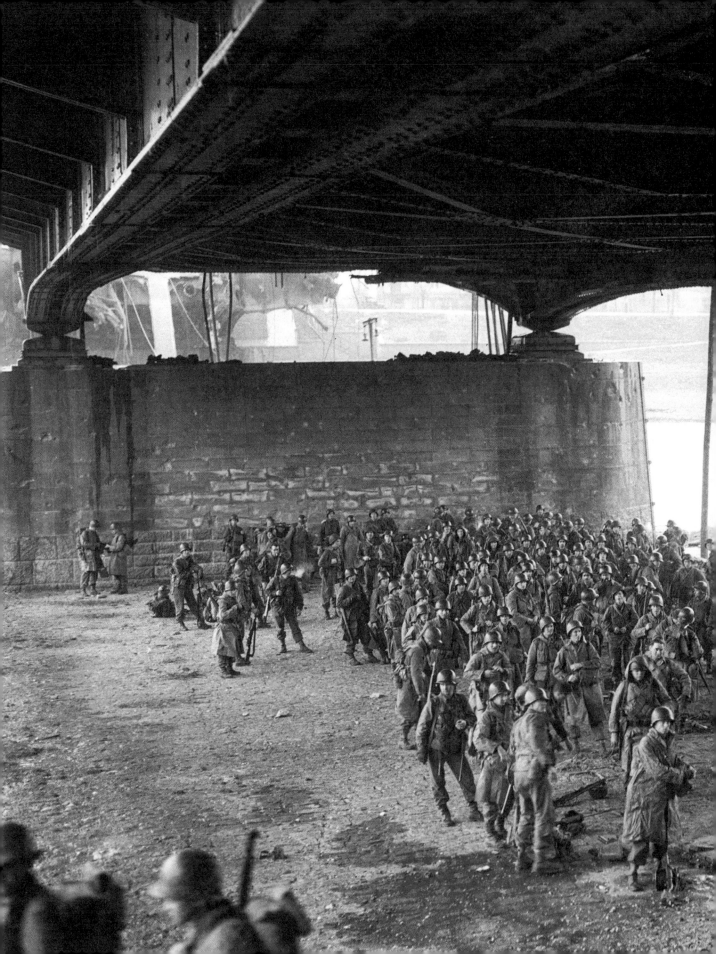

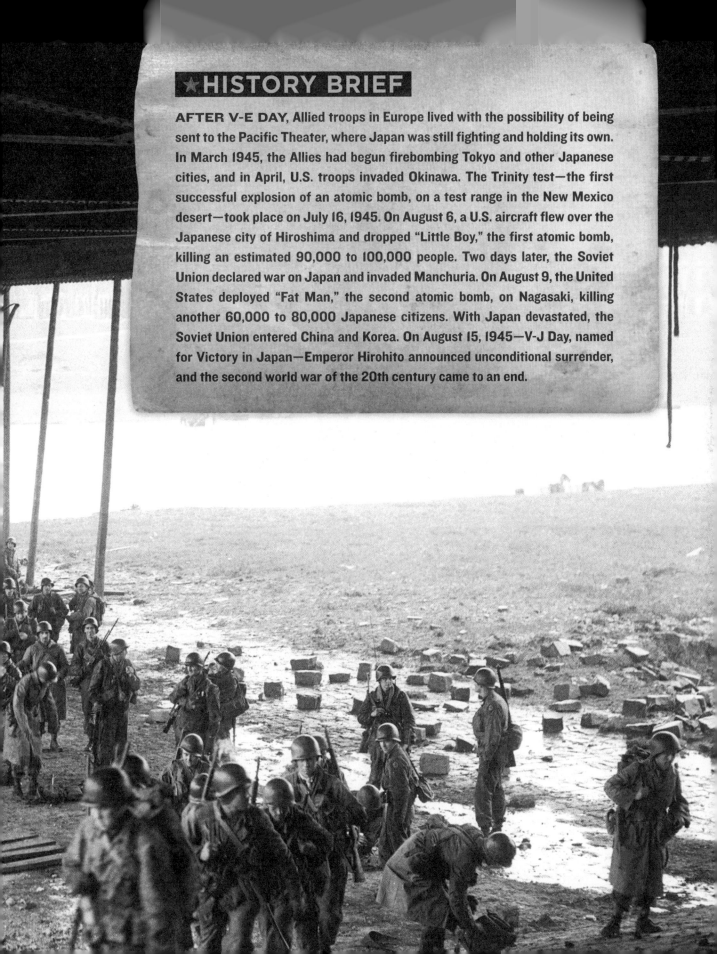

★ HISTORY BRIEF

AFTER V-E DAY, Allied troops in Europe lived with the possibility of being sent to the Pacific Theater, where Japan was still fighting and holding its own. In March 1945, the Allies had begun firebombing Tokyo and other Japanese cities, and in April, U.S. troops invaded Okinawa. The Trinity test—the first successful explosion of an atomic bomb, on a test range in the New Mexico desert—took place on July 16, 1945. On August 6, a U.S. aircraft flew over the Japanese city of Hiroshima and dropped "Little Boy," the first atomic bomb, killing an estimated 90,000 to 100,000 people. Two days later, the Soviet Union declared war on Japan and invaded Manchuria. On August 9, the United States deployed "Fat Man," the second atomic bomb, on Nagasaki, killing another 60,000 to 80,000 Japanese citizens. With Japan devastated, the Soviet Union entered China and Korea. On August 15, 1945—V-J Day, named for Victory in Japan—Emperor Hirohito announced unconditional surrender, and the second world war of the 20th century came to an end.

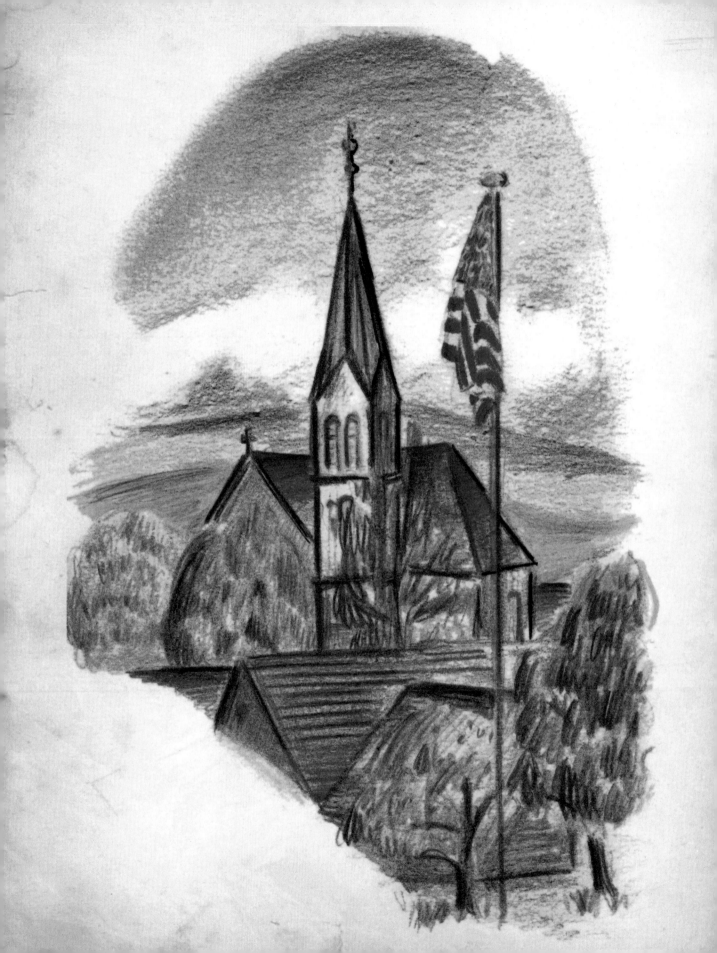

The war was finally over. Hanging over our heads like a specter, though, was the ominous possibility of being sent to the Pacific Theater of Operations to be part of the invasion of Japan. The atomic bombs hadn't been exploded yet. We were scheduled to go to the Pacific to participate in the war against Japan—an event we weren't looking forward to, and our morale was low. When the atomic bombs exploded over Hiroshima and Nagasaki, that threat evaporated and we were able to relax and deal with our new mission—occupation.

I never thought of the morality of the bombing then. To me and my fellow GI's, our main reaction was that we didn't need to invade Japan and thousands of American lives were saved. We had survived the war in the European Theater of Operations and the odds were strongly against our surviving the invasion of Japan too. After the war, I started to have doubts about the bombings. Might we have bombed an unpopulated island as a formidable example to Japan? Was the second bombing of Nagasaki necessary? I'm aware of the arguments that we weren't sure the bombs would explode as planned, that we had only a few available, and why in hell didn't the Japanese surrender immediately after Hiroshima? These questions about the morality of the bombing came much later. My immediate reaction was unequivocally, "Hooray, the war is over. I'll be going home!"

Wernau, Germany, 1945. PREVIOUS SPREAD: *The U.S. Army advances on the university town of Heidelberg after crossing the Neckar River on March 31, 1945.*

★ MURRHARDT, GERMANY

MAY 16, 1945

Dear Folks—

We're getting three hot meals a day—something unusual for us. Many is the day that all we had to eat was one small K ration. The best we ever got was two hot meals a day and a C or K ration for dinner. We got a lot of Spam—when I get home keep that as far away from me as possible!

I believe I told you that I received an army art course the other day—it gives me something to do.

No doubt you have heard & read about the point system the army has adopted for discharge—and you probably noticed that I haven't a chance—not that I ever expected to qualify. I have 37 points—far below the necessary 85—oh well, that's the way it goes.

Company M Morning Report
May 10, 1945
Company moved by organic transportation from Pluderhausen to Murrhardt.

The point system worked something like this: 1 point for every month in service; 1 point for being overseas; 5 points for combat credit such as the Bronze Star or Purple Heart and for each major campaign; and 12 points for every dependent child.

In December 1944 or early January 1945, after the Battle of the Bulge (also known as the Ardennes Offensive), which took place in southeast Belgium, we came under a surprise attack. Members of my platoon and I were playing cards and just relaxing when an explosion took place just outside the building we were in. Glass flew all over the room and one of the guys received a very slight scratch. He reported it to the medics and was put in for a Purple Heart. We all laughed at him and kidded him considerably about the Purple Heart. He got the last laugh, however, when his point total for going home was calculated. The Purple Heart was worth 5 points!

MAY 17, 1945

Dear Folks—

Last night we were discussing some of the various experiences we've ever had

over here. One of the funniest took place as we were flushing out a town we had just captured—by that I mean we were checking for weapons and German soldiers in civilian uniform. Well, as my squad checked one house, the lady of the house came up to us and took us to one of her cellar rooms. There was a big hole in the side of the room and imbedded in the floor was this huge 500-lb. bomb—a dud since it failed to explode. She was practically in tears—then she knocked us over when she said or rather asked us, if we could take it out. We got out of there in a hurry—if we ever moved it there's no telling what could happen—sometimes even the slightest jar will set them off. It really was funny though, her asking us to please take the bomb from her room. I can't blame her for worrying, though.

★ NEAR STUTTGART, GERMANY

MAY 19, 1945

Dear Folks—

Here it is [Saturday]—what would be back home the big night of the week—over here it is just another night to us. There isn't very much we can do—we aren't allowed to speak or in any way fraternize with the civilian population—we don't have movies set up as yet so all we do is listen to the radio. There are a lot of American programs broadcast for us by the B.B.C., the A.E.F. and from Luxembourg. I went for a stroll to the park in town here with a buddy & we had a little talk.

It's remarkable how the women folk work over here. Naturally there aren't many men left—just a few—so the women have to man the farms. In the little towns, farming is a big occupation. Everybody—every single family has a garden—& good sized gardens, too. While in the park tonight we saw five women cutting the park grass—raking it & putting it

Germany
May 16th, 1945

Dear Folks—

Hello everybody, how are tricks? I'm really living the life of riley now & enjoying it. I can appriciate this now after what we went thru.

It's getting warm—kind of reminds me of South & North Carolina. We're going in a little training every morning—in the afternoon clean our weapons, swim-play ball etc. We're getting three hot meals a day—something unusual for us. Many is the day that all we had to eat was one small K ration. The best we ever got was two hot meals

on wagons & taking it away. They handled their pitchforks as well as any men I've ever seen. Wherever we go, we see women, little children, old men—and most surprising—old, old women, grandmothers no doubt—out digging & hoeing big farm fields. Hitler really had them all out working—if people in America saw all this they would realize how much can be done and why Hitler was able to build the huge fighting force he had.

I can't get over how pretty the German girls are and then we think of that non-fraternization policy—that's life!

★ MURRHARDT, GERMANY

MAY 24, 1945

Say Mom, did you get the flowers I ordered last February or March for Mother's Day? I do hope so. I think that I told you that censorship has been lifted over here. I told you we were transferred into the Third Army—well it was a mistake as we're still in the Seventh Army. I see where the First Army is C.B.I. bound by way of the States. No one knows what is in store for us—has us all sweating it out.

There aren't very many of the old boys that came out with us left now. Out of 36 in this platoon, there are 12 or 13 original fellows and not all were with us all the time. We lost three platoon leaders—lieutenants—two killed. The first one, Lt. Gray—you probably noticed the first letters of mine were censored by him—was killed on Hill 578 where a sniper shot him squarely in the head. The other—Lt. Lederer—who was the officer that made me Sgt, was killed fighting on the Neckar River crossing. They were both swell fellows, especially Lederer who was liked a lot by all and was a Tech Sgt when we came over. That's war for you. It's too bad for the Neckar River crossing was the last tough resistance we

Women take turns doing chores at a village threshing machine, August 1946.

met, although in the next two days, I lost two men in my squad, one wounded by shrapnel, the other by a ricochet bullet—but all that is over, thank heaven, so the best thing, I guess, is to forget it all.

You should see the way the people work their cows here—it seems that the German army confiscated all the horses for their horse-drawn artillery etc. The cows pull wagons, plow, and it seems everything else. It's a wonder that they give any milk at all.

MAY 26, 1945

Dear Folks—

We got word that the fellows in this platoon who were captured are all o.k.—six in all. After being captured, they were forced to walk from 350 to 400 miles in less than a month to Austria. After two days there, however, the Yanks armored units caught up with them & set them free. The Jerries didn't exactly mistreat them but they ate very little—one loaf of bread for eight men every couple of days. One of the fellows was able to pay us a visit & gave us the low down. Those fellows are now on their way to the States, as has been army policy.

I see where our [New York] Yankees are in the top spot—how about that!

MAY 30, 1945

Dear Folks—

Well, this now is my 3rd birthday in the army & it wouldn't make me mad if it was my last in the army. Had quite a day—a lot of physical exertion. We had a half hour of close order drill & a half hour of calisthenics, then a three-hour march. This afternoon we had an hour of orientation—the latest war news & then we took on headquarters team in softball.

We had quite a game & lost 4 to 5 after two extra innings. We're shaping quite a ball team together now. In the first game yesterday, I got one hit, two walks, one force out. Today, two hits out of four times at bat.

We have a battalion show tonite—which I want to take in. The Regimental Band will be there.

Lt. Ted Lederer, who was killed in the crossing of the Neckar River on April 3, 1945. His death was a great loss.

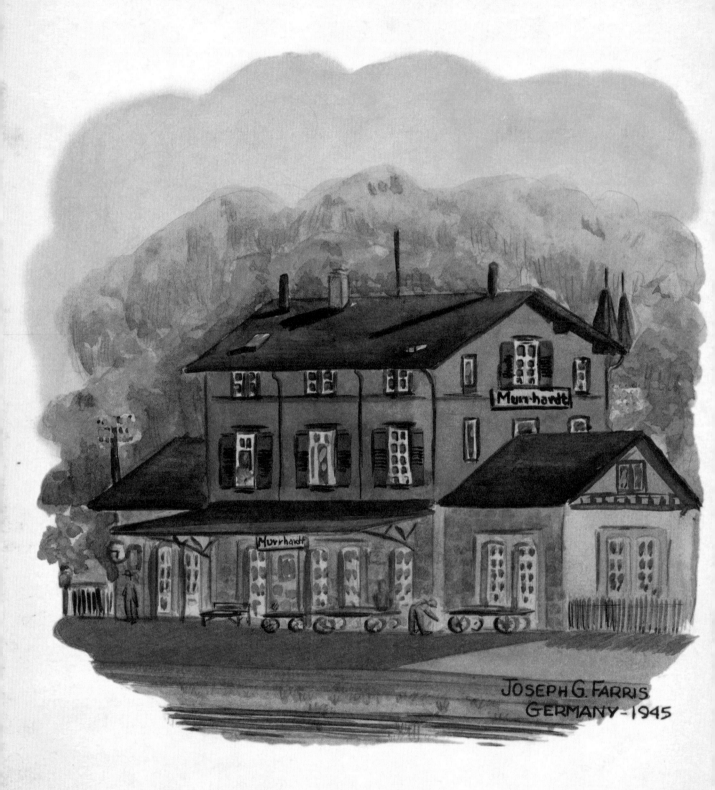

I've been doing a bit of sketching as of late. We have a lieutenant [Bucky Walters] in the company—battlefield commissioned—came over as an S/sgt. He and I get together quite often & do a little sketching. He did my portrait just recently & it came out quite good.

I see that they are having quite a bit of trouble in Syria & Lebanon. I hope they can settle their troubles before too much blood is shed.

JUNE 2, 1945

Dear Folks—

I've really got a fine squad—probably the best in the platoon— "Tex" Oringderff, Victor Tigerman, "Kaufy" Kaufman, Henry Weber, Hubert Roberts & "Willard" Ochs our driver—quite an outfit—good workers & dependable in combat, which means a lot.

We got a platoon leader today & he doesn't look like a bad fellow. We were without an officer more than with once in combat since we've been over here.

Every now and then, we get together for a little song session—a cook in the kitchen with his mandolin, Kaufy from my squad with his harmonica & me with the accordion. Then the boys gather around & croon. We have quite a time, especially when we have some "Schnapps" (German version of whiskey) to brighten up the picture.

JUNE 4, 1945

Dear Folks—

Yesterday a few of us went to Heidelberg, which is about a hundred miles from here, on a sight-seeing tour.

We left about eight in the morning on two and a half ton trucks with the tops wide open. It was a fine sunny day and the ride down wasn't bad at all. We went thru Lowenstein and down to Heilbronn—you'll probably remember Heilbronn—on the Neckar River where we had some of our toughest fighting. We stopped off there to take a look around the area we fought and gave so much to take. The way we approached it was from where the Jerries were—we

ABOVE: *Portrait of the author by Lt. Bucky Walters.* OPPOSITE: *The railroad station at Murrhardt, Germany*

never could have gotten away with that a few months ago. I went by the hole I occupied and took a good look at same. We went to the factory, where the C.P. (command post) was. Then we took a look at the Neckar River. I snapped a few pixs.

We then got on the trucks & were on our way to Heidelberg again. It isn't shattered at all, with the exception of the main bridge that the Jerries blew up a half hour before the Yanks arrived.

The town is noted mostly as an education center & the center of life in peacetime was the university. The school is very plain—not even as elaborate on the outside as our high school in Danbury. The size is about twice as large as our high school and is in the shape of a hollow square. Buildings flank the quadrangle. There are no classes in session now, in fact the G.I. s have taken it over & it is a kitchen, library, sleeping quarters etc. It is a modern building & was financed by an American for a million & a half dollars. The old university building is nearby.

View from the castle in Heidelberg, May 1945

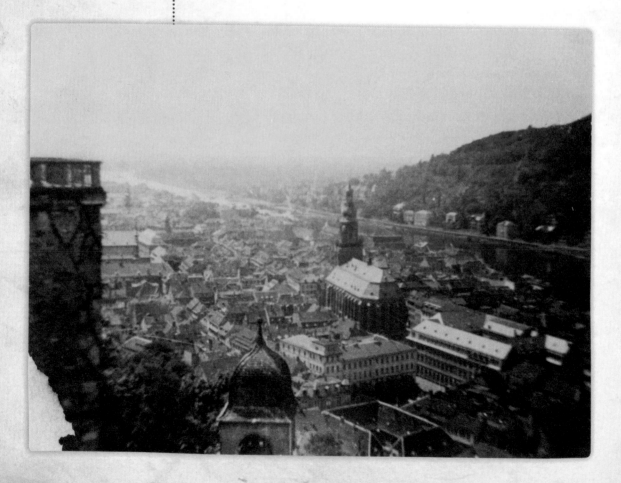

Murrhardt, Germany
June 4th, 1945

Dear Folks —

 Hi you all. how are we all doing?
Yesterday seemed to me very much like a day at
home — the days when we used to get up early
to go to New York — naturally on a Sunday. Yester-
day a few of us went to Heidelberg, which is
about a hundred miles from here, on a sight-
seeing tour.

 We left about eight in the morning
on two and a half ton trucks with the taps
wide open. It was a fine sunny day & the ride
down wasn't bad at all. We went thru
Lowenstein, & down to Heilbronn — you'll probably
remember Heilbronn — on the Neckar river where
we had some of our toughest fighting. We stopped
off there to take a look around the area we fought
& gave so much to take. The way we approached it
was from where the theories were — we never could
have gotten away that a few months ago. I
went by the hole I occupied & took a look at the
same. We went to the factory & the C.P.'s where
(command Post) were. Then we took a look at
the Neckar river. I snapped a few pics.

 We then got on the trucks
& were on our way to Heidelberg again. It

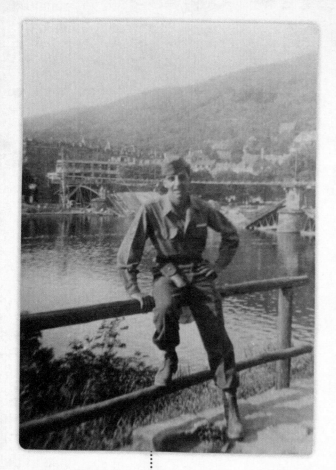

The author in front of a destroyed bridge in Heidelberg, May 1945

We then went up to the castle of Heidelberg—Van Schloss Castle—that is probably the most interesting sight in the famous town. The French destroyed part of it during the 1700s & lightning caused a fire that burned part of it down in the late 1800s. After that the castle was never restored. Our first guide was quite a boy—short, very plump & bewhiskered. He spoke very good English with a German accent. He told us that he had thrice shown the king & queen of England around the castle and when the king was coroneted, he was invited to attend & spent ten days in England as the royal family's guest. He was quite a boy.

The most interesting part perhaps was the huge wine vats. As we descended into the castle, we came upon a huge vat & started to admire the same. The new woman guide then told us to our surprise that this was the smaller of the two—the bigger one was yet to come. A few steps more & we came to the big baby—and big is the word. On top of this monstrous vat was a dancehall, mind you, on the top, big enough to hold twenty couples at one time. The vat would make a comfortable home to live in—were it a house. It had a capacity of 49,000 gallons of wine. Upstairs in the castle was a pump that instead of pumping out water, gave out wine—that's a lot of wine, 49,000 gallons! This is the biggest wine vat in the world & was built in 1751.

Up in the courtyard the view is wonderful—I think the nicest we ever saw. You can see for many miles. Right below us the city of Heidelberg & neighboring towns on the outskirts. Through this all is the Neckar River which must be an average of 50 to 60 yards wide at least.

After a few hours we caught a ride in a truck & took off back to town. There is a Red Cross in the city with all its customary services—donuts & coffee, writing materials & a reading room etc. The best deal though is the free restaurant for GI's where we can get meals to eat & be served by French maids. The government pays the help & provides the food—not bad at all.

JUNE 6, 1945

Dear Folks—

Well, today is the one-year anniversary of "D" Day & it has been declared a holiday for us, so there is no training. One year ago today, I was aboard a train headed for New York City—remember the New York battalion, where members of this division paraded for infantry day. A lot has happened in the ensuing year.

When you next see Tony, the barber, tell him he really & truly may have some competition from me when I get home. I'm getting to be fairly good at cutting hair—how about that! I'm coming along on the accordion & we have songfests almost every night. If possible, I'm going to try & bring the accordion along with me wherever we may go.

I just sent a package to you with the following things—for one, my portrait done in charcoal by this lieutenant friend who is in the Third Platoon—the mortar (81mm) outfit, by the way, I'm in the First Platoon & always have been (the "Fighting First"). The Second Platoon is also a heavy machine-gun outfit—four guns in each of the two platoons & 6 mortars in the Third. Then there is a beauty of a beer mug in the box & also a few copies of American Artist, which I want you to save. So be very careful how you open the wooden box & especially that you don't cut the charcoal drawing. Keep the drawing covered with glass or cellophane so the flies don't get at it.—it came out quite well.

We've got quite a team in this platoon—the best softball outfit in the Company. We beat the Second Platoon 16 to 1 the other day. I got three hits—a double & two singles & no errors in the field. I've been playing second base right along.

★ OBER URBACH, GERMANY

JUNE 10, 1945

Dear Folks—

One thing that we have noticed around here is the absence of billboards dotting the countryside. And I must say, we don't miss them one bit outside of the fact that it wouldn't be home without the roadside advertising.

Regimental cup I "liberated" from a German home (with great contemporary guilt)

You should see the kids around. Man o man, they have enough to start another war in the near future if the opportunity should present itself. They went in all out for the reproducing program that Hitler worked so hard for.

We are now allowed to deal with stores and the like and that goes for beer taverns. Every now and then you get the urge for a beer; and even this German stuff tastes good. It is too weak as a rule. We got five glasses for one mark or, in our money, for ten cents—not bad, hey?

Unterurback, Ger.
June 10, 1945

Dear Folks,

Hello folks how are things coming along? I'm feeling swell and taking life easy, not doing too much.

Enclosed is a watercolor which I like very much and I want you to hold on for me. I don't know who the artist was but it typifies this country swell. It is an original by the way.

One thing that we have noticed around here is the absence of billboards dotting the country side. And I must say we don't miss them one bit outside of the fact that it wouldn't be home without the roadside advertising.

You should see the kids around man o man they have enough to start another war in the near future if the opportunity should present itself. They went in all out for this reproducing program that Hitler worked so hard for.

We are now allowed to deal with stores and the like and that goes for beer taverns. Every now and then you get the urge for a beer and even this German stuff tastes good. It is to weak as a rule. We got five glasses for one mark or in our money for ten cents--not bad hey?

That's about it for now,
Best to all,
Love.

JUNE 12, 1945

Dear Folks—

Just read in the Stars and Stripes that the Third and the Seventh Armies (we are in the Seventh) are to be occupation forces—well, I still don't know if that is going to include us—they could transfer us out very easily and into another army—but that remains to be seen. Occupation wouldn't be too bad and at least it would mean that we probably wouldn't see any action and I'm not exactly craving any more combat—I've seen all I care to see and then a little too much.

BUY WAR BONDS

JUNE 15, 1945

Dear Folks—

Well, we're still taking life easy, not exerting ourselves too much. We've been drilling for a review by our General Murphy, the artillery commander. You'd be surprised at all the work there is behind a military review that may only last an hour or so.

I see where Ike [Supreme Allied Commander Gen. Dwight Eisenhower] has given the o.k. on talking with little kids—I think that was a wise move as it's hard not to speak to a cute little kid. In Murrhardt, living right next to where we were staying was the cutest little girl I've seen since we've been over here. She was given enough candy, on the sly, to start a confectionery store. Well we'll be falling out for drill call in a minute or so—so I'm going to sign off for a while.

It's been about seven hours since I started this and our training schedule for the day is now over—all we have left is retreat formation. We're really garrison now—in the first six months overseas I saluted only three times all together. Officers didn't want to salute near the front line as snipers like to pick off officers. Now saluting is common and very much stressed.

JUNE 17, 1945

Dear Folks—

A couple of the boys received some wonderful news today and man but are they overjoyed—they're going to leave us in a few days and head for the States

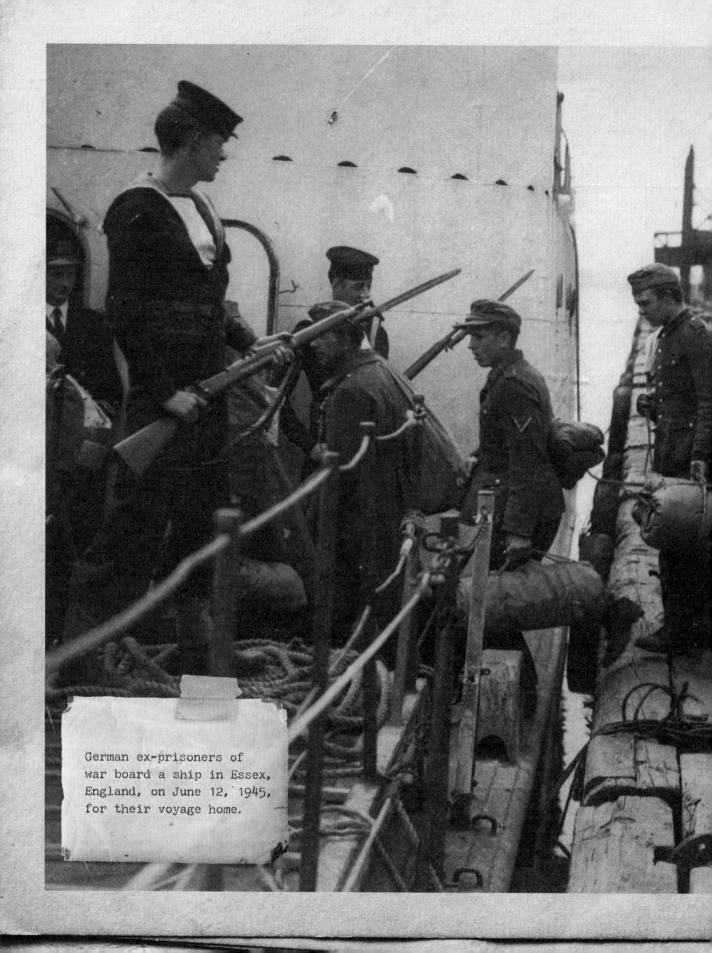

German ex-prisoners of
war board a ship in Essex,
England, on June 12, 1945,
for their voyage home.

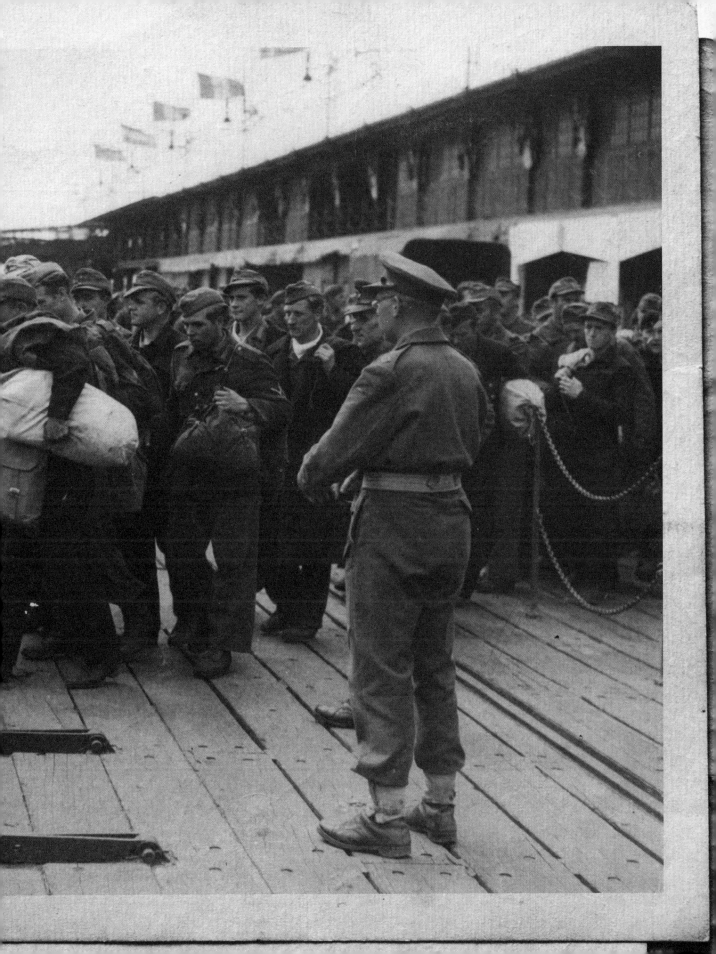

The Scala Theatre in Esslingen, Germany, October 1945. OPPOSITE: Street scene in Ober Urbach, Germany, 1945

to be discharged. They had previous service before joining this division and their total points were over eighty-five. I've never seen such a happy bunch of fellows—one of them is our first sergeant and you should have seen the ol' boy! I know darn well if I was as lucky I'd be just as excited and overjoyed but I and my measly 42 or possibly 47 points are way below 85—oh well, that's the way it goes.

You should see the way people work over here. They're up bright and early in the morning and at work till about 6:30 p.m. I've seen old men and women who must be about 75 years old at least and have to ride to and from their fields on a cart which is almost always pulled by two cows. When they come back from the fields there's no recreation or movies awaiting them like there is for us. I realize that I'm looking at the country after a great war and the men as a whole aren't back to work yet but there aren't even any facilities for movies and such. The radio must have been their sole means of entertainment. Almost everyone in these small rural towns owns a four wheeled wagon and a couple of cows. About all the work they seem to be doing is out on the fields cutting and gathering grass for hay to feed the animals—or else gathering branches and trees for firewood. There is a sawing machine that must be community owned and it makes regular stops at each home to saw wood. Then the people chop it into small pieces and pile it outside. Evidently everyone trusts each other as it's piled right out where it's easy to get at. That's all the people seem to do—cut and gather hay and build a supply of wood. They don't have any such things as an oil stove, hot water heater etc.

There is a bakery where people bring already prepared pastry and pies to have baked much like we bring clothes to a tailor to have pressed.

There is a town crier in all these small towns and he is the principal source of news to the people. He goes around ringing the bell several times and the people stop work, stick their

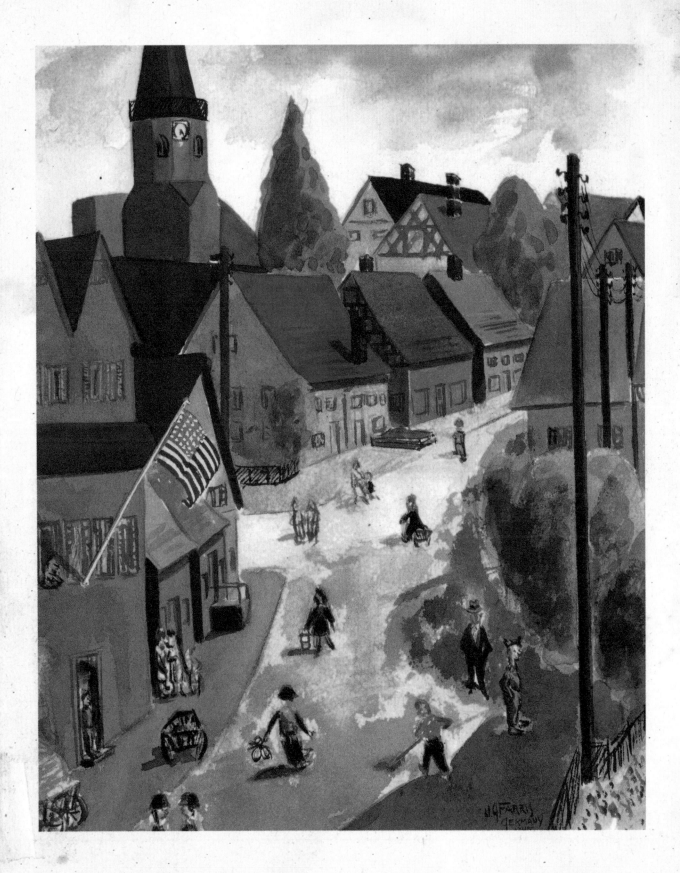

Clockwise: The author, "Doc" Hoover (our very courageous medic), Raymond Young, and Al Kaufman, Ober Urbach, Germany, June 1945

heads out of the window and listen to him give the latest "poop from the group" as we put it. Now the news he gives is the news we feed him.

JUNE 19, 1945

Dear Folks—

I have completed a watercolor of a street in Ober Urbach, which I'll hold onto along with others and bring back with me when I go home.

You should see the bathtubs the people use round here. No one in these rural towns seems to have tubs like we have back home. First of all you have to start a fire in a combination stove and heater tub which looks like a washing machine and then transport the water into a long mummy case affair. There is no such thing as faucets on the tub as back home and hot water at a touch is unheard of. So you have to be a woodsman, pioneer and acrobat in order to take a bath. I must say, though, it is better than France where you went to an establishment, paid a fee and went in and took a shower or bath. In the small towns in France I never recall seeing a bathtub unless they had them camouflaged so that I didn't notice it. No doubt in the bigger cities modern improvements must exist but in our fighting we haven't had too much contact with the big towns.

JUNE 20, 1945

Dear Folks—

Well, we heard some good news yesterday nite—that as things stand now, we will go to the States before going to the Pacific and therefore we will be able to get home on furlough. One caution, though, I think that even you people back home are starting to know the army so we'll not count on it too much but it does look good to see you soon. For that reason, that we may get home, you may as well stop sending packages or not more than the ones that you may be now be making up.

Oberurbach, Germany
June 29th, 1945

Dear Folks,

Well you all the big trip is all over.
I can say that I had or should I say spent the
nicest three days since I've been overseas.
We left for Brussels last Saturday morning
and got there Sunday afternoon. All told
the trip took two days and was roughly about
420 miles one way. We went all the way by
one & a half ton truck and that made the trip
rather rugged but we all agree that it was
well worth while.

We left from Schorndorf and went thru
Stuttgart which was kaput from the many
air-raids that the air corps threw at the
city. The French have taken it over and
when we were supposed to move in, you'll pro-
bally remember they wouldn't move out. For
that reason we have been near it and that is
all. The next big town we hit was Strasbourg
which is on the Rhine river and just inside
the border of France. From then on we could
fraternize with the fair sex and not worry
about about being picked up. We then hit
Saverne where we were able to get a hot
meal which is a lot better than the K rations
they issued to us at the start of the trip.
We reached Metz, France about five that
afternoon and bedded in for the night. If
you'll remember Metz is where Patton had
such a time with the 5th infantry division
eventually taking it after quite a battle.
We got another hot meal and a cot to sleep
on. One thing about the kitchen there, was
that the K-P.s where were Jerries. They
served us and did all the work around inciden-
tal to the kitchen.

And on top of that good news, I was further surprised by being told that I was up for another rest leave—this time to Brussels, Belgium. So I'll be able to see another country before we leave. As for Paris, I've got my fingers crossed that we may pass through there to get on the boat and who knows, maybe even parade there. I can tell you a thing that you probably are aware of and that is that this division has a very excellent record for its combat participation, plus the laurels that we picked up while still in the States. We accomplished quite a bit and especially remarkable was the speed in which we hit the front lines after arriving in France. The first elements hit the line on Nov. 1st. This Third Battalion of the 398th hit the line on a very easy day to remember—Nov. 7th, Election Day. The fact that I'm going to Brussels will mean that I may not have very much chance to write. Now that the war is over here, you won't have to worry about a sudden lull in receiving my letters so don't get alarmed. Back to going home, we haven't been told when or where we will leave from as yet but I have a hunch that we will be home something like in August—I doubt any sooner.

Gen. George S. Patton

JUNE 29, 1945

Dear Folks—

Well you all the big trip is all over. I can say that I [...] spent the nicest three days since I've been overseas. We left for Brussels last Saturday morning and got there Sunday afternoon. All told the trip took two days and was roughly about 420 miles one way. We went all the way by one and a half-ton truck and that made the trip rather rugged but we all agree that it was well worth while.

We left from here and went thru Stuttgart, which was kaput from the many air-raids that the air corps threw at the city. The French have taken it over and when we were supposed to move in [...] they wouldn't move out. For that reason we have been near it and that is all. The next big town we hit was Strasbourg, which is on the Rhine river and just

inside the border of France. From then on we could fraternize with the fair sex and not worry about being picked up. We then hit Saverne, France where we were able to get a hot meal which is a lot better than the K rations they issued to us the start of the trip. We reached Metz, France about five that afternoon and bedded in for the night. If you'll remember Metz is where [Third Army commander Gen. George S.] Patton had such a time with the 5th infantry division, eventually taking it after quite a battle. We got another hot meal and a cot to sleep on. One thing about the kitchen there, was that the K.-P.s ["kitchen patrol"] were Jerries. They served us and did all the work around incidental to the kitchen.

After getting settled in Metz, I shaved and cleaned up and took off for town. Just as I was leaving the building in which I was bunked up in, I met a fellow from Danbury who, to top it off, is in my division in the 325th Medics. I knew him from sight only and as he was passing by, I stopped him and asked him if he was from Danbury—and he told me yes. I talked to him for awhile and found out that he had just returned from Brussels. After that I headed for the main part of the town and no sooner had I found the Red Cross, which is the center of activity for us G.I. s, I ran into another fellow from home. You know him, I'm sure—remember that fellow who came to the store, right after I had completed at Camp Croft. You remarked that he was a very good-looking fellow. His name is Frank Chiarella—you gave him cigarettes and candy, etc. He is now an M.P. [military policeman] after going all thru combat with the Thirty-Sixth Division in the infantry as a rifleman. He is permanently stationed in Metz and most of his outfit is made up of ex-combat men. It was swell seeing Frank—it had been about 22 months or so. I made a deal with him that in case he got home first he would go and see you as he did last time.

We left early the next morning and really made some good time since our pass started at one that afternoon regardless of when we arrived there and we didn't want to waste any time if possible. We passed thru historic Verdun of the last war and on into Luxembourg and then Luxembourg City. This

Two French children celebrate the liberation of their city, Metz, France, with two U.S. soldiers.

American Plainspeak

In December 1944, Gen. Anthony McAuliffe of the 101st Airborne answered a German call to surrender with one word: "Nuts."

On September 11, 1944, British troops enter Brussels, which was set ablaze as Germans fled.

country is a very neat looking state and the people seem to be fairly well off in comparison to some of the towns we passed thru on the way. It started to rain on the way and we had to stop the truck and put the sides down. We passed on into Belgium and soon came to Bastogne. This is where the Jerries received that now famous reply to their surrender demands last winter [during the Battle of the Bulge] of "Nuts!"

There wasn't much left of the destruction of our vehicles to show for the wrath of the German drive. Other fellows passing thru here a few months ago said that there were G.I. vehicles strung out as far as one could see, all in bad shape. When I passed thru all I could see were a few Jerry tanks and such, but very little if any American equipment. Our salvage crews did a good job. We soon came to Namur, Belgium, which is

quite a big city and we stopped an hour or so to gas up. We walked around a little and got a Belgian beer, which wasn't bad at all.

We reached Brussels about 12:30 that afternoon in plenty of time for the start of our pass. We were taken to the Hotel Siru, just recently acquired by us and I must say it was a deal. You couldn't buy better service than was given to us there the minute we arrived till the time we left. To begin with, we didn't even have to walk to our rooms which were on the fifth floor but instead we went up on the "lift" or to us the elevator. To my surprise, I found out that I had a private room and to top it off—a private bath. How about that?—and we were used to about six or seven in one room and not thinking anything about it. The bed was as soft as any I've been in for the past two years except for the time that I spent at home on furlough or leave. The room was overlooking the main or one of the main squares in Brussels and all I had to do was open the window and look out at the streaming mass of people going their way.

The first thing that I did was get a haircut and then a bath. It was just like home—hot water out of the faucet. Then I shaved and was ready to go out and see what the story was around town. The first nights I got myself acquainted with the high points around and took in an army-sponsored vaudeville show. There were more English and Canadians there than there were Americans. The show was a good deal—they had some fine performers participating. I hit the hay about 12 that night and slept thru until the maid awakened me up the next morning. After using a little will-power, I up and dressed and went out to the lift and down to breakfast. The chow was really o.k. and we had no kicks to make about it. I took in a tour given by the Red Cross and saw the highlights of the city. That night I took in what I think is the best movie I've seen since I've been overseas—Roughly Speaking—a swell show. The next day I went out with a girl that works in the Red Cross—Belgian—and we took in the Art Museum which was quite interesting. She knew the museum quite well and was familiar with the paintings—she was a nice kid—cute too. While in Brussels, I went to a dance at G.I. Joes, a snazzy place for us G.I.s where they had a wonderful band and some fine singers. While there, I did the first

dancing in the past eight or nine months and I really did enjoy it. This girl, by the way, could speak near perfect English and did in fact teach it.

I met a R.A.F. [Royal Air Force] fellow—an Englishman naturally, and I had quite a conversation with him about everything that we thought of. He was a very interesting man to talk to—must have been about 35 years old and quite well educated. They have some funny ideas about us and I tried to set him straight on a few things. He taught me quite a bit about the English, the King and his set-up and even about cricket—their game as baseball is to us.

We stopped off in Luxembourg City on the way back and tried to get billets to spend the night but they were all full so we continued on to Metz which was only about 75 kilometers away—or about 45 miles or a little more. I saw Chiarella again while there and then went back to the place we were staying in and went to bed—thought I could use a little rest instead of doing anymore walking. We got up about 8:30 the next morning and headed back here [Ober Urbach]. We arrived here at about 6:30 last night and I came back to my company just in time to be the first one in the chow line as the rest of the company was standing retreat. It is a new ruling now that when retreat is being sounded everybody—including the Jerries—that is the German people—have to stand at attention. I think that it is a good ruling.

So that brings us up to date where I am now—I know that you haven't heard from me for quite awhile but I know that you weren't worrying. By the way the latest rumor has us staying over here till next March—naturally it has us wondering as to what the story is.

JULY 4, 1945

Dear Folks—

Our battalion represented the division in a corps review for Independence Day. This battalion rates best in the division evidently.

The people were lined up on both sides of the street—it was quite a treat for them—probably the only thing that changed their monotonous living. They don't have any movies or newspapers as yet. We looked sharp, at least from what I was able to notice from the ranks—especially good when we passed the reviewing stand. We had a 24 gun salute at exactly twelve noon.

Royal Air Force patch, World War II

Sunday a few of us went to Nuremberg, Germany, and saw Glenn Miller's A.E.F. [Allied Expeditionary Forces] Band—thirty-five pieces at least in the band. We went by truck all the way—a round trip of about two hundred miles all told. Nuremberg is a beat up town, the greater part probably due to the many air raids which were thrown at it and we did get to see the great stadium where Hitler held many of his huge rallies and speeches. I managed to stand and pose where Hitler stood during his speeches.

Glenn Miller's band was still entertaining the troops at this time, but without their bandleader. When the band had flown to Europe to perform in mid-December 1944, Miller flew in a separate plane from the band. It apparently crashed somewhere on its way and was never heard from again.

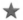

The author, in June 1945, standing where Adolf Hitler delivered his speeches in Nuremberg Stadium

JULY 6, 1945
Dear Folks—
This is probably the last letter I write from this town as it will be a new one tomorrow—nearer to Stuttgart, I believe.
There are a lot of advantages in being a non-com. I don't have to pull any K.P. or any guard duty except for occasionally sergeant of the guard.

★ WERNAU, GERMANY

JULY 8, 1945
Dear Folks—
We have been moved again—this time to a town closer to Stuttgart. We are in a modern factory on the edge of town. At first when we heard that we were to be situated in a factory we thought this was going to be a bad deal. Instead

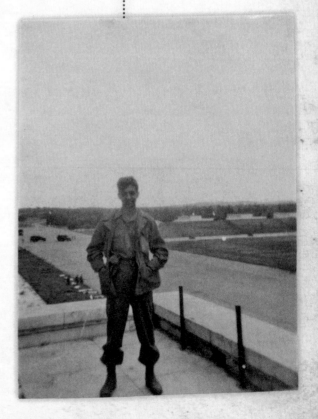

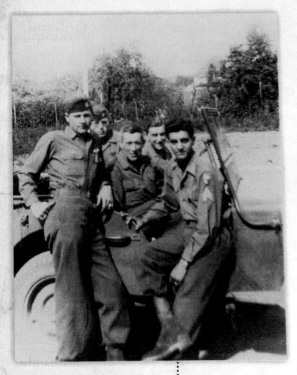

Some of the men in my squad. Each machine gun squad had a jeep to facilitate the movement of the heavy weapons, ammunition, and personnel.

it has turned out to be a fine setup—as good as any we have had yet. The rooms that we're now in were, I believe, previously occupied by German troops who were guarding the building. Everybody has a bed of his own, plus a wall locker. This room that I'm now in had bed space for eight men by using double-deckers, so all we did was take off the top bed and now we're really doing o.k. for ourselves. The mess hall is beautiful—and in the kitchen there are many electric appliances—even an electric dishwasher.

We still haven't heard anything definite on going home or otherwise so we're as much in the dark about the subject as you are. I personally wouldn't mind staying here until near Christmas and then getting home for the holiday—it would be swell to be able to be with you over Christmas and New Year's Day but that still is in the future so I'm not going to worry about it right now.

One of the fellows told me that he has seen my cartoon—the one that appeared in the Stars and Stripes—in a magazine so please keep an eye out for it.

JULY 12, 1945

Dear Folks—

I'm now a non-commissioned officer of the guard, which I'll be pulling quite often now. I have to change the guard every two hours in two shifts of four hours. It's not a bad deal as after I've posted the men I can do as I please—write or read.

Now that we're going to be over here for quite a while, there's a possibility that we may get furloughs. Just in case I can get one and permission to travel where I can go as I please—maybe I can get to Syria [really Lebanon, which didn't become independent of Syria until after World War II]. There isn't too much chance of this as it's so far away but just the same, send me addresses of everyone we know there, or any place else over here. Then I can always have them on hand should an opportunity turn up.

I have your pictures in two small frames with cellophane windows, which I carried every minute I was in combat from the time we hit Marseilles 'til the

war ended. I now have them standing on a shelf above my bed. Every one that looks at the pictures remarks how young you both look, Dad & Mom.

JULY 14, 1945

Hello everybody, how're tricks? I've really got a deal worked up now—I'm working on painting signs and putting cartoons on same. I don't have to fall out for any subjects or drill period, inspections and so forth. It's quite a deal and I'm enjoying doing it—it's a lot better than the stuff the rest of the company is doing.

Back to my job painting signs—not only are we our own bosses, but we even drink champagne while we work. I don't know what a lot of the men are going to do when they get back to civilian life and start ordering champagne over the bar, since they are going to have to have plenty of money to do it. A bottle

J. G. Farris
July, 1945
Warnau, Germany
Rathaus - (City Hall)

of champagne costs us about eighty cents. Naturally it isn't the best quality since it isn't very old but nevertheless, it is champagne.

This is the nearest we've come to army life as it was back in the States. We have rooms with about four men in each, bathrooms all over the place, a beautiful mess-hall, better than any we had in the States, a barroom, barber shop, a laundry service, movies almost every night in one of the towns farther up—Esslingen where there is a very modern theater, the best that I've seen in Germany. One thing though, the owners don't seem to believe in comfort as none of the seats are cushioned enough to be worth mentioning.

Scene of the Allied crossing of the Neckar River in early April 1945

JULY 16, 1945

Dear Folks—

Nothing new has happened. I'm still painting signs and taking it easy. I'm not falling out for any drill at all and that in itself is a swell deal. We're right next to the company bar and occasionally we'll have a beer to give us added inspiration.

Well, the non-fraternization law has been lifted and we now can talk to anyone we please. Everyone's glad that it has been lifted since it was just a pain in the neck anyway.

Yesterday, one of my buddies (Kaufy Kaufman) and I went swimming and where do you think it was? In the Neckar River, which is only about a mile away from where I am. We didn't have bathing suits since at first we had no intention of swimming. One look at the river and we decided we'd have to take a crack at it! So—we went to the side of the river which offered a little seclusion—in the bushes down a hundred yards or so from where the civilians were bathing. We stripped down to our shorts and in we went. It was rocky to beat the band and not too deep but the water was refreshing. There's quite an undertow current in the middle and swimming against it is just like standing still.

I'd like to have my George Bridgman art book so please send it in the next package. We're attempting to start classes of our own for the fellows here and

I'm going to teach the art class. Because of the training schedule, they're going to have to be held nites.

JULY 22, 1945

Dear Folks—

We just finished from quite a grind—for two days, we checked houses in seven towns. We started at four thirty yesterday morning and worked till about seven that night. We left at about eight o'clock this morning and out we went checking houses again. The purpose of it all was to check and see if the civilians had possession of any weapons of any kind and also to check papers to see if we could pick up any SS men, or deserters from our army. We didn't find too much—just a few knives and a little ammunition.

We received our rations today—about ten or eleven bars of candy and fourteen packs of cigarettes per man—these will have to last from two to three weeks—but since I still do not smoke, that is one worry that I don't have.

We ran into an Armenian camp of displaced persons and I was curious as to whether I could understand the language or not. However, all I was able to make out was the Arabic word for soup.

JULY 24, 1945

Hello, everybody, how're we all feeling? Today was a day off for all because of that 48-hour search of all German homes in our area on Saturday and Sunday. During that search, I believe that we saw almost every type of home there is anywhere. We saw some of the cleanest homes and also the exact opposite. Most of the homes do not have modern sewage disposal. Only in up to date factories or new homes do you find the flush toilet which is so common in America. Naturally, the search was in the small rural districts where the main occupation is farming but still I don't

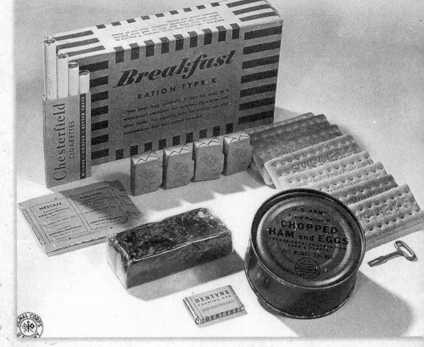

K-rations were designed by Dr. Ancel Keys to meet a soldier's daily caloric needs. The breakfast ration, shown here, included a canned meat entree, biscuits, a dried fruit bar, chewing gum, instant coffee, and a four-pack of Chesterfield cigarettes.

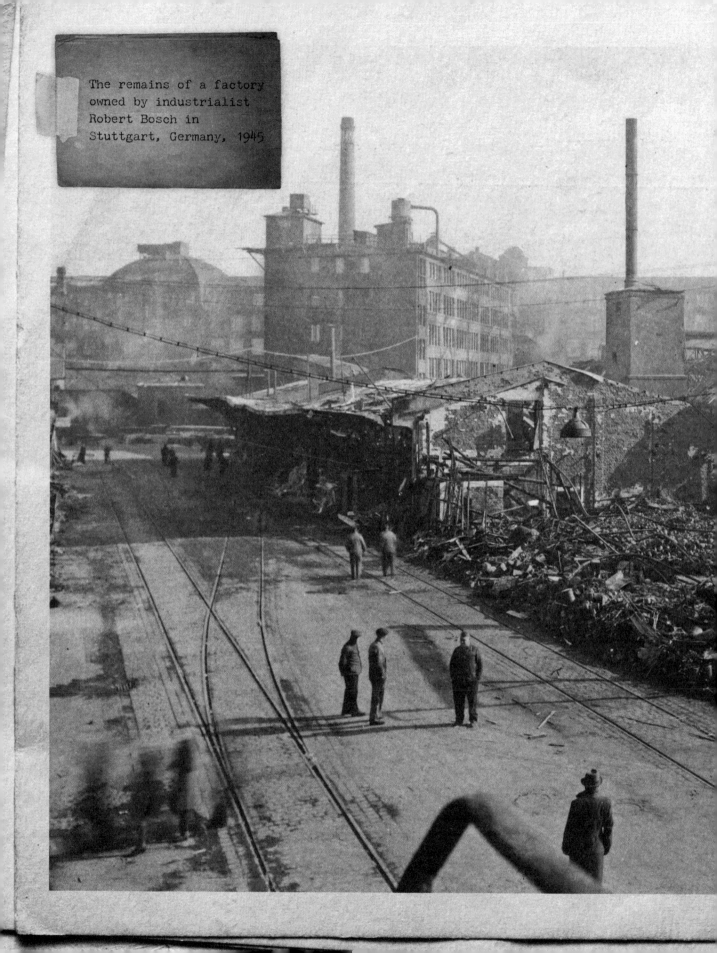

The remains of a factory owned by industrialist Robert Bosch in Stuttgart, Germany, 1945

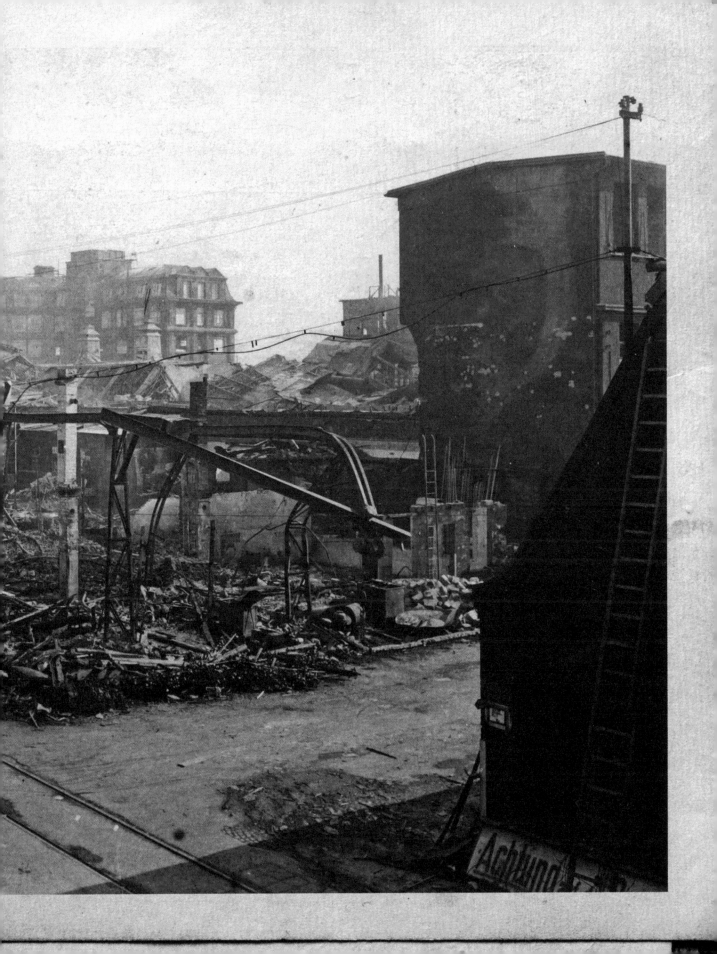

WERNAU, GERMANY
JULY, 1945

I was in a good situation while in Wernau, Germany. I spent most of the time as "artist in residence" along with Bucky Walters. I did drawings and signs on order and became the staff artist for the Blue Times, *the Third Battalion's newspaper. I designed the title and started a cartoon feature called "How 'bout That?" It was short-lived, since I soon left for school at Biarritz, France.*

think that is any excuse for some of the conditions we saw. Since we had to check every single home and some of the people were not home during Sunday afternoon, etc. we had to go through a few homes by way of the window.

We have finished the illustrations for the battalion history of Hill 578 and today Bucky (the lieutenant with whom I was working) and I took the drawings to Kirchheim, which is about five or six miles away, to be reproduced by photography. We have to have the history and the illustrations in to Seventh Army as soon as possible. While at the photographer's shop we happened to start a conversation with a man who owns the shop. He is, it so happened, a very prominent man in the photography field and by looking at several pictures he had on the wall we found out that he had spent much time in Egypt. Upon finding that out, I promptly asked him if he could speak any Arabic and he said that he could. And so we conversed a little in Arabic. I couldn't understand him too well since I guess there is a little difference in the Arabic spoken in Syria and in Egypt but it sounded swell to hear even that little. He told us about some man who used to go to his studio quite often just to talk in Arabic with the photographer. When the man found out the photographer could speak Arabic, he started to show tears; evidently it had been so long since the man had been able to speak to anyone in Arabic.

The photographer said that he liked Egypt much better than Germany. For one thing he said he liked the weather much better—even if the temperature was higher it was always cooler because of the fact that it was much drier. When there is a lot of moisture in the air you feel much warmer than you would otherwise. We are going back for the prints day after tomorrow and whenever we can get a chance we are going to go to him and have our portraits taken. He does a fine bit of work.

Now that the illustrations are all finished I will go back to painting signs for the company along with another sergeant who also has a fine racket, so to speak.

JULY 29, 1945

Dear Folks—

We just lost our regular chaplain recently when he volunteered for the Pacific after a 30-day leave in the States. He did this after he found out that we were to be over here for the rest of the year. He's the type that cannot stay in any one place for any extended period of time. He's a legend in the battalion for all he did while we were in combat. Many was the time that he went on line to bring back wounded men—a task not assigned to a chaplain—and he was always up there when the going was roughest. No one expected him to come through alive because of experiences like this and I'm afraid the same feeling prevails now that he has decided to go the combat zone again.

A couple of us went to Stuttgart yesterday where division headquarters is located to turn in our battalion history of Hill 578. We had prints made of our illustrations and I'll get a set home to you to save for me the first chance I get.

Stuttgart is quite a place, or should I say was quite a place. In order to get to our division, we had to follow a road up a hill, one of many that enclose the city, to what looked like a mansion. Overlooking the city, the damage is lost in the sunlight and shadow combination but the sight is one that I'll long remember—it's really something to see. The city, it seems, started in this huge valley which is surrounded by many hills and as time went by and the city grew, it expanded onto the hillsides. The city seems to be overflowing right out of the valley. The destruction that our air power caused is something that really you have to see to appreciate. There aren't many buildings that escaped our bombs and that goes for everything— churches and all. I can just imagine the sight that beheld the men in the planes as they approached the city—and I don't think that there was very much pin-point bombing either—all it seems the corps did was drop their load of bombs on the town in general.

I've heard a lot of talk back in the States about what a fake the Red Cross was—well, almost any G.I. will tell you he thinks a lot of the organization.

Bombs Over Stuttgart
Germany's automobile center, Stuttgart, was a primary target for Allied bombing missions from 1940 to 1945.

Even many years later, I can remember the chaplain accompanying a squad in the middle of the night on a mission to capture one or more of the enemy in order to get needed information. When the squad members were unable

to discover where they were hiding, the chaplain stood up in plain view and lit a cigarette in order to provoke the Germans to fire at him and expose their location. It worked and the squad successfully completed their job and brought in prisoners. The chaplain wasn't touched! Fortunately, the war would be over in the Pacific before he would get there and have to risk his life again.

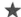

JULY 31, 1945

Dear Folks—

I'm still doing a lot of artwork for everyone. I believe that I told you I'm staff artist for the new battalion paper which is to be put out soon. Evidently, I'm known in battalion, which can mean more artwork and that's a lot better than training.

We've been having a lot of trouble with these displaced persons—Russians, Poles, Italians and others. Now that Germany has been defeated, they feel that they have the right to take whatever they please from the people. Well, you know that the Americans don't operate that way, even though that has practically been the policy of the French and the Russians. The French took everything of value in Stuttgart, for example, but our policy forbids us from doing just that thing. Anyway, irritation keeps on between the former slaves of the Nazis. One case is this factory we are guarding—of great military importance to us. A German foreman from this factory once sent one of the Poles to a concentration camp for some infraction of one of their rules. For this reason, the Poles have been trying to get hold of him to kill and it has become our duty to see that no violence breaks out. When these displaced persons see us they yell out "comrades" and so on, expecting us to allow them to do whatever they please. We have searched them for weapons but they always manage to get some somewhere or other. As these Poles in this particular factory leave for home, they pass the word down to the next group about this foreman and so he's on the spot continually. To complicate the matter, if that's possible, many of these displaced persons do not want to go home for various reasons. Many do not have anything to go home for, while others do not want to go home because their particular section of their country may be occupied by the Russians.

At one camp of these unfortunate people, one of our boys was accidentally shot by some Russians who approached the house that the Americans were sleeping in and upon seeing our boys, who yelled that they were American soldiers—but in German—shot him in the rear of the thigh. These Russians believed our boys were Germans who were determined to prevent them from taking food—so they fired on the G.I.s. Well, our men promptly opened up with their weapons and the next morning we found out that they had killed two Russians. Meanwhile, the G.I. who was injured is coming along o.k. and should be back with us in no time at all. We aren't guarding this camp anymore as some other company has taken over.

All this stuff doesn't reach you, I imagine, as it is a rather touchy subject and can cause international complications. Meanwhile, these people are a big headache to us and until we can get them back where they came from, they will remain so.

AUGUST 3, 1945

Dear Folks—

I've been quite busy, especially since I had a drawing deadline to meet for the battalion paper, of which I believe I told you I'm staff artist. The deadline was to be sometime next week and suddenly word came down that the work

Russian and Polish girls, forced to work in German factories, are liberated from Juchen concentration camp by the U.S. Ninth Division.

had to be in by seven tonight. With a little plugging, I was able to finish all of the stuff. I designed the heading of the paper, which is to appear on all of the issues and also a cartoon, one of which will appear in every issue. Also, I'll illustrate various articles whenever the same warrants it. It's a swell deal and is giving me good experience since art is what I hope to follow when this is all over.

LESTER COWAN presents

ERNIE PYLE'S
"STORY OF
G.I. JOE"

starring **BURGESS MEREDITH** *as* **ERNIE PYLE**

Screen Play by Leopold Atlas, Guy Endore, Philip Stevenson

Directed by **WILLIAM A. WELLMAN**

RELEASED THRU UNITED ARTISTS

AUGUST 7, 1945

Dear Folks—

I've decided that I'm going to devote this letter to the G.I. movie. It started back in Fort Devens, Mass., where my army career started. We couldn't get over the hardship of sitting on hard wooden seats after going to the comfortable movies back home. That was our first contact with the G.I. movie—outside of the hard seat, there wasn't very much difference to those back home. The same was the case at Camp Croft, S.C. At Clemson College we used a civilian theater and the same was the case for The Citadel, S.C. Then at Fort Bragg, N.C., we went to the government-run theater. Up to now it was o.k. The shows were continuously run with no break for changing reels. At Camp Kilmer, N.J., and also Camp Shanks, N.J., the shows were still top-notch. Then came our first encounter with the changing of reels during a break when we hit the boat on our way over to France. Outside of the fact that the pictures were old it wasn't a bad run. Overseas, though, is where we really have seen almost everything that can happen in a movie show. Usually the pictures were run on a projector, the type many people buy for their homes—a good one, no doubt, but not compared to the ones used in theaters. And after each reel the lights had to be put on and the G.I. operator would quickly attempt to put the new reel into motion. The biggest gripe we had on these almost amateurish jobs was not the fact that the reels had to be changed, but the fact that the film was sure to snap a few times every reel or else the sound wouldn't be coordinated with the persons speaking. We've seen shows in

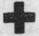

AMERICAN RED CROSS

Frankfurt, Germany
Aug. 10th, 1945

Dear Folks—

Hello everybody how is we doing? If you've looked above you'll notice that I'm writing this from Frankfurt. I'm on my way to Biarritz, France to go to school for about two months. I'm going to study something along an art course — I'm not exactly sure as to specifically what, but regardless of what it may eventually be it's going to be a swell deal. In case our outfit should leave before our course is completed we are supposed to be called back. However the war may be over as

FORM 539 A

almost every imaginable place—under the stars back in basic training, and over here in old barns, gyms and so on. But the G.I. has to have his moving pictures and we were quite lucky in that we saw one every now and then, even during combat. Whenever the film breaks, as it's almost sure to do, the fellows all give out with a big groan and start yelling and hissing. The theater in Esslingen is a good deal and it's just like going to a movie back home.

★ FRANKFURT, GERMANY

AUGUST 10, 1945

Dear Folks—

If you looked above, you'll notice that I'm writing this from Frankfurt. I'm on my way to Biarritz, France to go to school for about two months. I'm going to study some thing along [with] an art course [...] In case our outfit should leave before our course is completed, we are supposed to be called back. However the war may be over as you read this—we've heard many rumors to that effect. At least I hope so.

By the way, I was put in for staff-sergeant just before I left. I don't know what my going to school will mean—whether the rating will go through or not. [Everything was in flux, and I wasn't sure if my possible promotion would be lost in the bureaucracy.]

I'm not sure if we'll pass through Paris on the way to Biarritz or not, but I've got my fingers crossed. Biarritz is on the western coast about fifteen miles from the Spanish border. In peace time, I believe, it was quite a luxurious summer resort, so our accommodations should be top-rate.

GI Universities

Biarritz was one of three locations where the Army offered college courses to soldiers on their way back home.

★

When the United States exploded the atomic bombs over Hiroshima and Nagasaki, Japan, on August 6 and 9, 1945, respectively, the threat of our being shipped off to fight in the Pacific evaporated, and we were able to relax and deal with our new mission. I was riding in the back of an Army truck with some of my fellow soldiers and glancing at the August 7 edition of *Stars and Stripes*. In a small box on the front page was an item that we had dropped an atomic bomb with the strength of 15,000

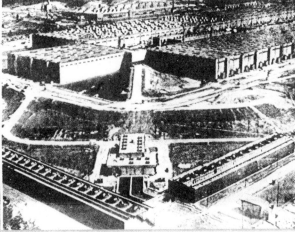

An Independent Newspaper for All the People

CIRCULATION: July Average: Daily 569,159; Sunday 1,102,515

TUESDAY MORNING, AUGUST 7, 1945
Copyright, 1945, by Tristate Publications, Inc. Vol. 233, No. 38

abdefgh

THREE CENTS

Atomic Bomb, World's Most Deadly, Blasts Japan; New Era in Warfare Is Opened by U. S. Secret Weapon

Today

Key to Atomic Power
Must Help Mankind
Trusteeship Set Up
Bar to New Wars
World Balance Upset

By Alexander Kendrick

Inquirer Washington Bureau

WASHINGTON, Aug. 6

HOW to control atomic power, the greatest force for both war and peace ever placed in the hands of mortal men, automatically becomes the topmost problem of this Nation's Government, its military leaders and its scientists.

For the revolutionary aspects of atomic energy are such that they unceremoniously upset the whole balance of world political, economic and military power, and present the key to the future development of all industry and agriculture.

The control of the world's chief source of energy it is not so much to say, makes the United States, Great Britain and Canada a triumvirate in full charge of the harnessing of the

Bong Killed Testing New Jet Plane

Leading Air Ace Burns to Death In Crash on Coast

BURBANK, Calif., Aug 6 (UP)—Major Richard Bong, America's greatest air ace, died today in the

flaming wreckage of a jet-propelled fighter plane which crashed while he was testing it.

Only 24 years old, he wore 36 decorations, including the Nation's highest award, the Medal of Honor. He had survived countless air battles and shot down 40 Japanese

MAJOR BONG planes without a scratch

The knowledge he gained in those battles was too valuable to risk, so

Terrific Missile Unleashes Basic Force of Universe

Text of President Truman's Announcement on Page 3, Other Stories and Pictures on Page 2, 3, 4, 5 and 12.

By JOHN C. O'BRIEN

Inquirer Washington Bureau

WASHINGTON, Aug. 6.—A terrifying new weapon—an atomic bomb with a destructive force that staggers the imagination—has been loosed upon Japan, President Truman revealed today.

Called the greatest achievement of organized science, the explosive crashed with annihilating force Sunday on Hiroshima, Japanese army base with a population of 318,000.

EXCEEDS 20,000 TONS OF TNT

Developed at a cost of $2,000,000,000 by the Army with the assistance of American and British scientists, the new bomb, which harnesses the basic power of the universe (the force from which the sun draws its power) has more power than 20,000 tons of TNT and

tons of TNT on Hiroshima. I was startled and yelled out, "The war is over!" It seemed as if the *Stars and Stripes* hadn't realized the significance of the event and treated it as a minor event. The next day's edition splashed the news in large type over the entire front page.

I never thought about the morality of the bombing then. To me and my fellow veterans, our main feeling was that we didn't need to invade Japan and that many American lives were saved. After the war, I began to have doubts about the need for the bombings. The estimates run from 75,000 to 180,000 dead in Hiroshima alone. Might we have bombed an unpopulated island after alerting the Japanese of the terrible destruction they faced if they didn't surrender? Was the bombing of Nagasaki and its estimated 60,000 to 80,000 dead necessary? Nevertheless, my main feeling at the time was, unequivocally, "Hooray, the war is over, and I'll be going home soon!"

Hiroshima, Japan, was struck by an atomic bomb on August 6, 1945, killing upwards of 70,000 people. A second bomb was dropped on Nagasaki three days later, effectively bringing the war in the Pacific to a close.

CHAPTER EIGHT

E THIS IS THE ARMY

★ HISTORY BRIEF

BY THE END OF WORLD WAR II, as many as 60 million people had died, the majority of them civilians. U.S. losses were grave—405,000 servicemen and women died—but were proportionally fewer than those suffered by any other combatant nation. As early as 1943, the U.S. War Department had begun making plans for the demobilization of U.S. soldiers in Europe after the war. One element of this was to provide educational opportunities in Europe for GIs who would be returning home, perhaps to American universities or jobs, or to other roles in the military. After V-E Day, in the summer of 1945, schools run by the U.S. Army opened in Biarritz, France; Shrivenham, England; and Florence, Italy. Each enrolled 4,000 GIs in two-month courses of study in the soldier's chosen field. A short-term enterprise, designed also to give Europeans an interest in an American college education, the GI universities closed their doors in March 1946, less than a year after opening.

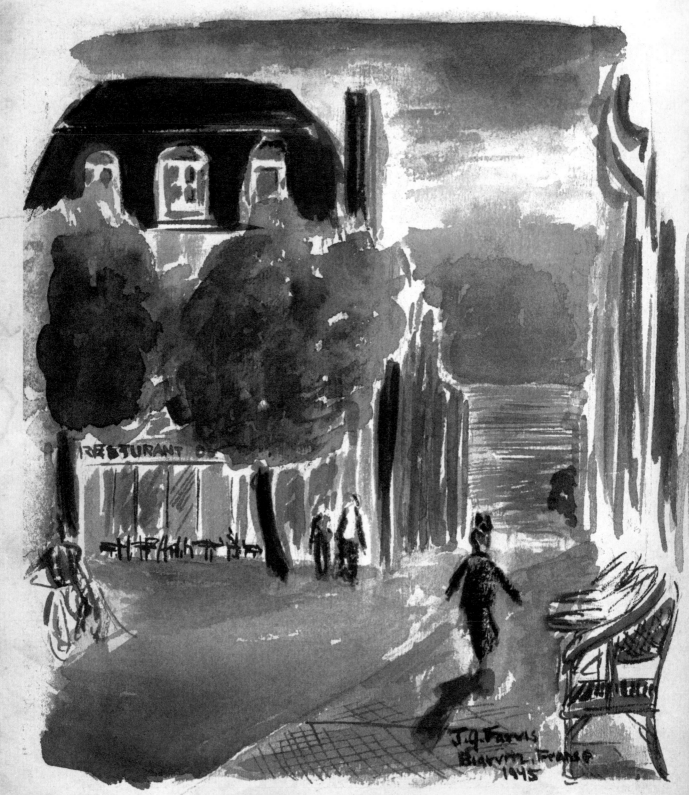

RESTURANT

J.G. Farris
Biarritz, France
1945

ATLANTIC OCEAN

★
**AUGUST 1945
THROUGH
JANUARY 1946**
★

When the war in the Pacific was finally over, our main concern became when we would be sent home and discharged. The rumor mill was at full steam as to what the division would be assigned to do and where, how the point system for being sent home would change, who would be assigned to occupation duty, and so on. While I was waiting for my fate to be decided, I decided to take advantage of whatever sightseeing experiences would be offered, and I did. I went to Brussels, Nice, Switzerland, Heidelberg, Lourdes, and a number of other places on day trips.

Drawing has always been a passion for me and I drew before, during, and after the war whenever I had the opportunity. I also maintained a steady stream of letters home, many of which are part of this book. I was fortunate to be chosen to go to Biarritz Army University on the southwest coast of France for eight weeks of study. I was part of the art program, my first formal training in the subject. I didn't know what part of the art world I would attempt to make a living in, so I decided at Biarritz, and later in art school in the States, to get a good education in all phases of art: drawing, illustration, painting, design, art history, and so on. However, becoming a civilian again was one of my great wishes at that time.

Biarritz, France, August or September 1945. PREVIOUS SPREAD: *People pay their respects during the burial of Gen. George S. Patton, Luxembourg, December 1945.*

★ BIARRITZ, FRANCE

AUGUST 14, 1945

Dear Folks—

Don't be surprised at anything I may write these next few days—this is all like an unbelievable swell dream. As you've probably noticed from above, I'm at Biarritz, France—about fifteen miles from Spain and on the Atlantic coastline.

I went up to our battalion bulletin board today & staring me in the face was a sign or should I say a news bulletin. It said, "The War is Over—official." Man, but that's wonderful news—no longer do we have to sweat out going to the Pacific—now it's sweating out going home—I don't know how long it'll be.

This place is wonderful—no kidding—I'm here for eight weeks & I'm going to study some form of art and also I believe I'm going to study the principles of photography—how to develop and print and enlarge etc.

AUGUST 17, 1945

Dear Folks—

Well, I'm all set to start school this coming Monday. All the preliminaries are over—my schedule has been made out & I'm raring to go.

We left Stuttgart last Friday morning & went by truck to Frankfurt, Germany—about a five-hour trip in the rain. Being ranking non-com, I was in charge of the group of twenty men from the 100th. I don't know how come I was so lucky. Out of 15,000 men in the division, twenty one were picked & I was fortunate to be one of them. We are on detached service & as things stand now, we are to report back to our outfits at the completion of this eight week course.

They really put me out on a limb when we left Stuttgart. My orders were to report to the Railway Transportation Office & from then on, I was on my own.

I had to find a place to eat and sleep for the men. Fortunately we found a transient mess where we found bunks and chow. The next morning we were to be on the train at 0900 when it pulled out. At 0700 I found out that the

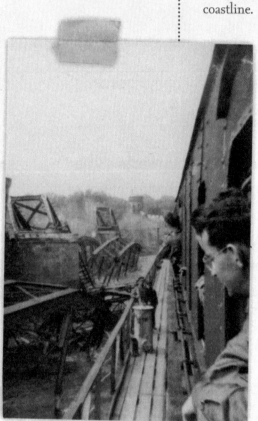

Wreckage observed on the way to Biarritz, France, August 1945

Biarritz, France
August 14th, 1945
Time: 2315

Dear Folks —

Don't be surprised at anything
I may write these next few days — this
is all like an unbelievably swell dream.
As you're probably noticed from above,
I'm at Biarritz, France — about
fifteen miles from Spain & on the
Atlantic coastline.

I went up to our battalion
bulletin board today & staring me in
the face was a sign or should I say
news bulletin. It said "The War
is Over" — "official". Mon. but that's
wonderful news — no longer do we
have to sweat out going to the
Pacific — now it's sweating out
going home — I don't know how
long it'll be.

This place here is won-
derful — no kidding —. I'm here

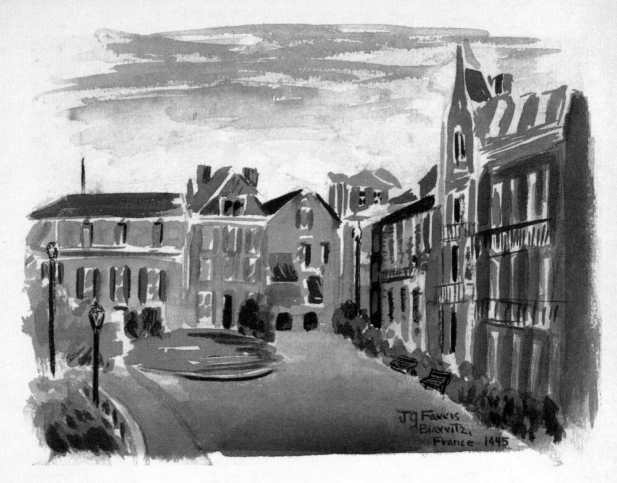

Place de l'Atalaye, Biarritz, France, August 31, 1945. The Family Hotel was the yellow building, third from right, overlooking the ocean to the left.

truck & driver had not waited the previous night and took off without saying anything and he had our K rations so I had to dig up a truck to get us to the station and from there on, everything clicked.

The train ride was long and dirty. The coaches (no Pullmans at all) had wooden seats and were rough to travel on. The first two nights, we crawled along the track. We'd move a bit and then stop awhile. It was that way all the way to Paris .We passed on through the outskirts of Paris. We could see the big tower [the Eiffel Tower]. From Paris to here we made swell time. All told it took three days and two nights. We arrived in Biarritz at about 8:30 Monday night & were the first group to come to Biarritz (pronounced Be-ritz). There are going to be around 4,000 students from all over the E.T.O. [European Theater of Operations] attending this opening of the university.

The courses I'm going to take are 1. Elementary oil painting—something I haven't fooled around with too much; 2. Life drawing & painting; and 3. Elementary photography, where I'm going to learn the principles of photography and how to develop & print film. I'm going to have six class

hours a day, five days a week and it all starts this coming Monday.

Biarritz is a resort town that is among the best. I'll send you postcards of the scenery and you'll see how really nice it is here. The rich of France are the visitors here, and these Frenchmen are entirely a different set from the ones I saw in the small villages while we were fighting.

I still find it hard to believe that the war is completely over. I realize that a lot remains to be done as yet, but at least the men won't be foolishly dying anymore! And that's all I make war to be—foolishness! One instant we're fighting the people and the next we're associating with these very same people. It doesn't make sense but it's over and that's what counts.

I don't know how long it will be before I'm discharged, but I'm convinced it will be quite a while yet. Now, I'm sweating out being caught in the Occupational Army although I'm hoping there will be a sufficient amount of men below my point score to take care of that. I believe I now have 47 points with possibly 52—officially I have 42 points but I believe we were awarded another battle star—three in all now so that'll up the total to 47.

I'm in a fine hotel—"The Family," which is on high ground overlooking the ocean. I'm sharing the room with another G.I.—an M.P. to top it off—who's been over here for quite awhile. It's a big room with two beds—really soft and the best I've been on since I was last home on furlough. We don't even have to make up the beds in the morning—a maid takes care of that. We eat in another hotel—"The Angleterre" which is about 300 yards away. There we eat cafeteria style. There are waiters all over the place bringing us coffee—and whatever we want. The bread is prima (German for "extra good")—a French style and beats the G.I. white bread. It's something like Vienna bread.

Cecil Thomas and the author, September 1945. ABOVE: *My makeshift calling card.*

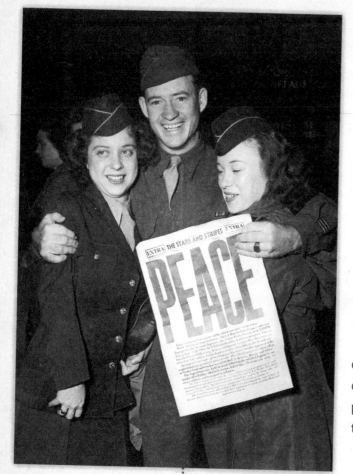

I was interested in a basic art education. It might be described as "academic," which is somewhat of a derogatory term today, but it has served me well during my career. I'm capable of drawing and painting quite realistically when needed and still feel free to be experimental and to use distortion and abstraction to advantage. Cartooning, which I love, has been my bread-and-butter work and has given me the opportunity to draw constantly. Concurrently, I've painted and made sculpture. My painting has gone through many phases, perhaps to my commercial disadvantage, but I enjoy changing directions whenever I feel the desire. I've never been bored whether drawing or painting and enjoy looking at a blank piece of paper or canvas and letting my subconscious take over.

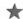

ABOVE: *News of the Japanese surrender is met with smiles and embraces on the evening of August 14, 1945.* OPPOSITE: *The crowd raises two soldiers on their shoulders during a V-J Day celebration in Times Square, New York City.*

AUGUST 17, 1945

Dear Folks—

Well, here it is V-J [Victory over Japan] Day—the one we've waited so long for. It's still hard to believe it's here. We fell out today for a parade because of the day and let me tell you almost every organization in Biarritz must have been represented. We had quite a time marching to the French band whose cadence is much faster than what we are accustomed to. We marched along ocean shore and on up to the memorial honoring France's Unknown Soldier. There, ceremonies were held and the mayor of Biarritz had his say and we thought he'd never stop. It was in French, by the way and didn't mean much to most of us. Then a French general and our one-star general-commandant of the University of Biarritz General McKluskey spoke. Meanwhile, many organizations placed their wreaths alongside the monument. After awhile everyone had finished and it was all over until next year, the first anniversary.

I've been quite lucky in the army—first ASTP and now this. Many fellows feel army life has been a great waste of time to them, but I differ. I wouldn't trade the experiences and travels I've had for a million dollars. I've learned a lot and also matured quite a bit. In other words, I don't think anything could stop me now and I don't scare easily or excite at the slightest little thing.

Everyone is wondering how long it will be before he or she gets that longed-for piece of paper—a discharge. I've got my fingers crossed. Since I'm not married and have no children, many fellows have the jump on me. A couple of men who joined our outfit last April have over fifty points—three children—although they've been in the army less than a year.

By the time school is over in October, I'll have had twelve-plus months overseas—not too long compared to many men but too long as far as I'm concerned.

V-J Day
On August 15, 1945, six days after the U.S. dropped a second atomic bomb, Japan surrendered. Generals met on the U.S.S. *Missouri* on September 2 to sign surrender documents.

AUGUST 22, 1945

Dear Folks—

Well, school started here and once again I'm a school boy—it's swell to be going to school again, especially with courses I want. My first course at eight in the morning is elementary photography—an hour Monday, Wed. & Friday, & two hours Tuesday & Thursday when we work in the laboratory doing experiments on photography. The second class I have each day is life drawing & painting, and last, in the afternoon, is oil painting. The latter two are two hours each day. I don't have very much homework & so this isn't bad at all.

We had quite a model today in the life-drawing class—an old boy about 75 years old. He came complete with his harp, which he played continually while we were sketching him—near the end of the class, he played a different piece for us. He was a good character study.

We G.I.s now stationed in France are going to receive 850 extra francs a month from the French government in order to make up a little for the inflation of prices in France.

AUGUST 26, 1945

Dear Folks—

We've completed one week of school already and now we have seven to go. It felt swell being a schoolboy again and especially in a fine setup as this. It's hard to believe that this is still the army—about the only thing missing to make this any college back home is the flashy wardrobe that is a part of college life—at least in the movies.

There are fellows here from practically every outfit in the E.T.O.—there's a wide assortment of patches and it looks good. I believe I told you that there were 21 men from the 100th Division. All told, there are about 4,000 students plus the permanent station complement of about 1,500 G.I.s.

Tickets to a bullfight, a popular excursion for soldiers

You should hear the way our popular music has taken over in Europe. All the bands around are attempting to imitate our popular American band style. They have the latest hits here too and some of the bands sound o.k. I won't forget the crackerjack outfit in Brussels—they were darn good. You see small three and four piece orchestras in the cafes here as back home. The girls are even learning to jitterbug.

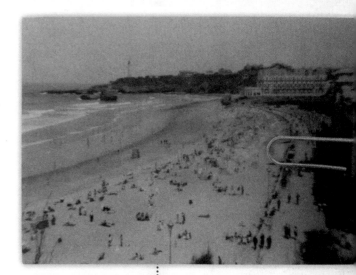

SEPTEMBER 5, 1945

Dear Folks—

A few days ago I submitted a cover design to The New Yorker magazine—if it isn't suitable I'm having them return it to you instead of coming all the way back here—so don't be surprised should you receive a large envelope addressed to me.

I graduated from art school in 1951 and then started my art career. In my beginning years, I did illustration for publications, book jackets, and book illustrations before I went into cartooning full-time. My first cartoon sale was for $10 to a publication called the *Victorian*. I didn't realize it then, but it was a conservative Catholic magazine. There was a risqué drawing in my submissions, and I was sternly reminded it was a *religious* publication! That was my first and last sale to the *Victorian!*

I started selling to various magazines, and finally in 1957 I sold my first drawing to the *New Yorker*. Little by little, my *New Yorker* sales increased until I was finally offered a contract. For cartoonists, the *New Yorker* was and is the pinnacle of the profession. The middle years of the 20th century were known as the golden years of cartooning.

Most of the magazines in New York City that used cartoons opened their offices on Wednesdays for visits by cartoonists. They would look at our work and hold those cartoons that interested them for later meetings when they decided what to purchase. Wednesdays were also social events and offered cartoonists companionship at the various stops and at lunch. It was

The beach at Biarritz, France, where I was stationed from August 12 to October 17, 1945

a pleasant break from the isolation of our studios. It was a wonderful time for cartooning until the advent of television, which was quite detrimental for magazines and consequently for cartooning because of the major loss of advertising. There aren't many magazines for cartoonists now compared to the height of cartooning.

SEPTEMBER 9, 1945

Dear Folks—

We just came back from the bullfight in Bayonne, which is a fifteen-minute ride from here. We left here about two in the afternoon and took a train to Bayonne. It had been raining off and on all day so we took along our raincoats—folded up into a neat little bundle and tucked it under our arms.

We had bought seats for 299 francs—$4— which were the lowest priced tickets— and all the seats were reserved. The gates opened at three and after buying a few glasses of wine, we went in and made ourselves comfortable on concrete seats. It then started to rain—a slight pause— and rain again—so we just threw our raincoats over our heads and listened to the patter. Promptly at five o'clock, the show began at the correctly scheduled time.

The arena in which the bullfights are held is circularly shaped around an enclosed ring. This place in Bayonne, held at the most, about 15,000 capacity. The bulls are locked in stables which have entrance into the arena and are located under the stands. The mayor of the town is in charge of the entire event & upon his signals, the various

stages of the fight progress. It's all a very gay and colorful sight to behold. The torero is the most important man and he leads a team. He's brightly dressed in a gold-lace-type suit—very flashy and his assistants usually in silver or gray.

At five o'clock, the band blares away and the entrance gate swings open and the bullfighters—the toreros, the matadors and the picadors and all the rest march into the arena in great pomp and ceremony. They marched toward the mayor. Seven bowed. The fight was ready to start. The side entrance opens up and out comes the bull. The torero and his aides, with just a big cape with his arms at his side, have the bull brush up against his side. Whenever the torero does this he is usually applauded by the audience. And the crowd at a bullfight can make any Brooklyn bunch look silly. They go wild at the bullfight—whistling is a way of booing and you should hear them whistle!

Many G.I.s left early because of the rain and also because the fight is so bloody. I can see why it's not allowed in the States but the people here go for it in a big way. Someone said the winner, no doubt the second torero, would receive one million francs. Theirs is a dangerous occupation.

By the way, my promotion to staff sergeant came through.

French Bullfights
Bayonne, three miles from Biarritz in Basque country, is France's bullfighting capital.

Bullfight at Bayonne, France, on September 8, 1945

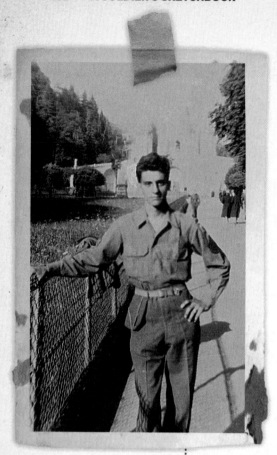

Author at Lourdes, France, September 1945. I took advantage of any opportunity to go on trips and explore significant and interesting sites, such as Lourdes in southwestern France.

SEPTEMBER 13, 1945

Dear Folks—

We're coming along fine in the oil-painting classes and I like using oils very much. This is the first I've fooled around with oils and I think I'm coming along o.k. We have all kinds of trained fellows in these art classes and some have made their living at it in civilian life. Others have attended various schools.

We went to St-Jean-de-Luz, a few days ago to do a little sketching. It is about nine to ten miles south of here, very near to the Spanish border. It's also along the shore and quite an attractive place.

SEPTEMBER 17, 1945

Dear Folks—

Early Saturday morning, one of the fellows in my art classes and I left by train to Lourdes—150 kilometers—roughly 100 miles. Since it is off limits to leave Biarritz without passes, we didn't tell anyone or attempt to get a pass.

We got into Lourdes at about 11:00 o'clock and were on our way to see this famous city of religious interest...

We joined a tour run by an American Catholic chaplain. First we went into a building which had a big panorama painting of Lourdes as it was in 1858 and the chaplain explained it. Then we went to the museum of belongings of [St.] Bernadette and spent a little time there. From seeing her gloves and shoes, it's apparent that she was very small in size. We then went to the house where she was born. It was a converted mill and very small. We didn't go into this house since it was still owned by her family and private. We then went to the house where she lived for a while and which had been given to her father by the town clergy so Bernadette could attend the nunnery and become a nun. Bernadette's sister-in-law lives there now and runs a souvenir shop where I bought some of these cards I have.

The next day we went to see the large church built near the Grotto where Bernadette saw the Apparitions of the Holy Virgin. It's a beautiful sight—I couldn't get over it—no kidding. More important was the Grotto where Bernadette saw the Apparition. She had dug in the ground at the direction

of the Holy Virgin and found a spring which is running to this day. Since that time, countless miracles have seemingly been performed on crippled people attending Mass there who then walked away physically sound. There are crutches—over a hundred easily, hanging up to the left of the Grotto. These belonged to former crippled people who were cured there. Everyone there drinks of the water and some are bathed in it because of its supposedly held holy powers.

It was really something to see the crippled there hoping that some such miracle would heal them. Fred Suite, the fellow who lives in the iron lung in the States supposedly came to Lourdes every year.

Virgin Rock of Biarritz
Napoleon III had a walkway carved through this seaside rock, a tourist destination to this day.

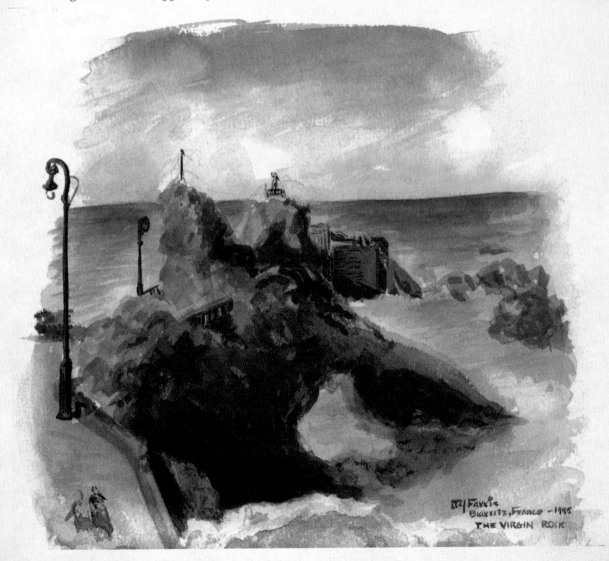

BIARRITZ, FRANCE – 1945
THE VIRGIN ROCK

Art Beat

The 1940s saw a rise in the regard for photography as a visual art. The New Bauhaus approach of Chicago's School of Design influenced courses taught to soldiers and veterans.

One thing we noticed about it all was how commercialized the whole thing has become. I never saw so many souvenir shops in one town. The whole thing, to some people, has become a way of making a living.

We arrived back here at about five yesterday—everything had panned out o.k. and we've seen another place of interest. Even though Lourdes means more to those of the Catholic faith, I think it was worth seeing.

SEPTEMBER 19, 1945

Dear Folks—

Everything is going along swell and it looks like you're going to have an artist in the family—and I hope, a successful one.

I just assumed I would be successful. I certainly was unaware of how difficult the creative professions are and in my ignorance plowed ahead. The first years were quite a struggle, but I was determined and put in many 12 or more hour days before my efforts finally bore fruit.

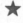

SEPTEMBER 21, 1945

Dear Folks—

School is coming along swell and I'm really learning quite a bit—especially about oil painting and a lot about photography. When I get home, we'll be able to develop and print our own and before long I'm sure the whole family will be doing it. Golly, but I can hardly wait until I do get back with you—it makes my blood tingle to think about it. I can imagine the feeling of being home again, free and safe. I'm not one bit sorry for all of this though. I've really learned plenty, mostly by experience. I think you'll find that I haven't changed very much and where I have, for the better.

I carried a 127 point-and-shoot camera like this one throughout Europe.

SEPTEMBER 23, 1945

Dear Folks—

We saw a newsreel, the first in a long, long time—of the States when the Japs threw in the towel—man, oh man, I'd have sure liked to have been home for it. Later in the newsreel, one of the government officials was shown giving a speech, saying, "We want speedy recovery, we want this and that" and so on. Suddenly a G.I. yelled out "We want a discharge!" We were laughing so much, I thought the house would come down. You can't beat a G.I.

I said in my last letter that I had 49 points—well, the army has become generous and made it 50 points. If they discharge all with two years of service, I should be set with my 29 months. It sure has been a long time hasn't it, but in a way, I guess it passed by pretty fast. I don't have much hope of being home for Xmas but I should be able to spend my 22nd birthday with you all.

SEPTEMBER 25, 1945

Dear Folks—

My roommate left last week, and I've made a studio out of this place. There are drawings and paintings all over the room, watercolors, and what not. I warn you now, when I get home, you'd better have a studio for me or else, Mom, you'll be picking up my stuff. I think I'll do a little daydreaming—I want a room with big windows, facing north—the reason for north is that the light is more consistent from there. And also those daylight fluorescent lights like we have in the store. How 'bout that? I sure liked staying up late in the kitchen, with the radio on and drawing or painting. I really feel that I'll be able to make good in the art field and I'm working with all my might toward that end. I could have made these two months a snap and a fine rest, but I decided to get as much out of it as possible. I feel that if I work hard, especially the first years, I'll get up there. And I'm doubly lucky in that I've got such swell folks as you.

As I was sketching, workmen were tearing down the building behind this hotel, and a couple saw me in my window and yelled to me indicating they wanted to pose for me. So I was naturally glad to have someone [stand] still long enough to make a sketch and one of the fellows stopped working and posed for me. I got a big kick out of that.

Construction viewed from my bedroom window in Biarritz, 1945

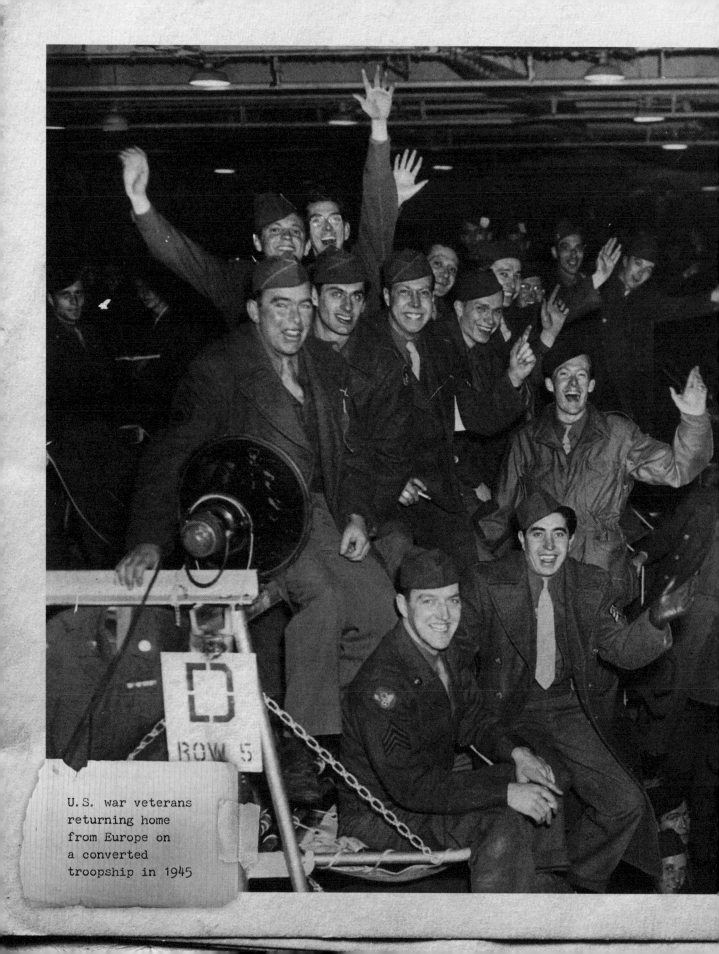

ROW 5

U.S. war veterans
returning home
from Europe on
a converted
troopship in 1945

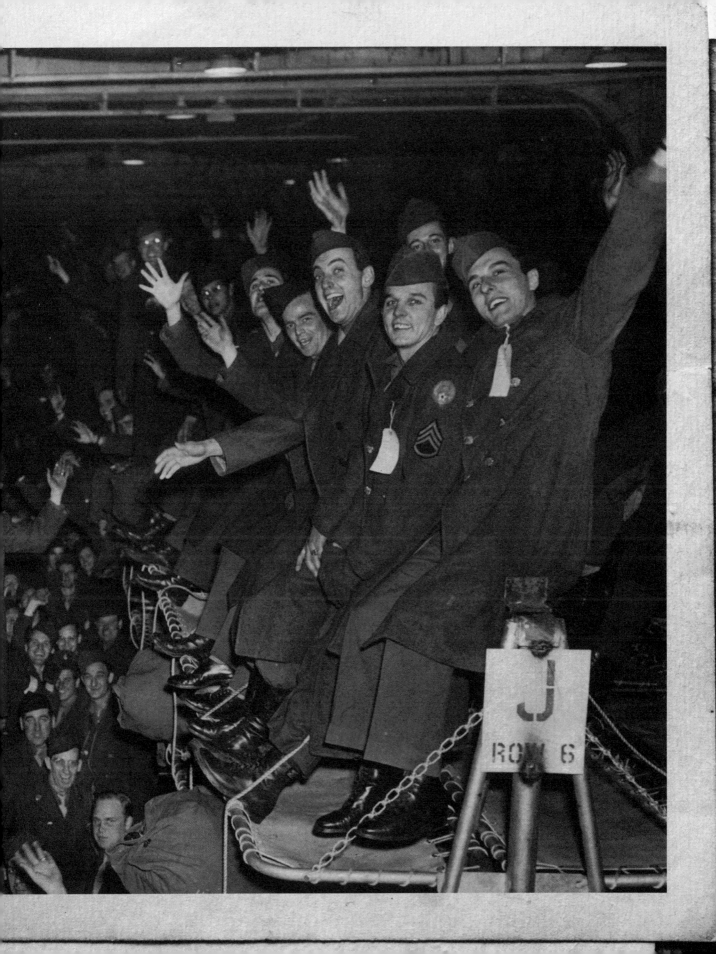

OCTOBER 6, 1945

Dear Folks—

One year ago today, we left New York for parts unknown, after boarding the night before. A lot has happened in this past year—more than I'll probably see for the rest of my life.

This last week coming up will be devoted mostly to taking exams and various ceremonies, such as receiving our diplomas and such. This has been a swell deal and a chance to really learn plenty. I think I've improved a hundred percent in my artwork since the first day. Now when I get back to Germany, I can carry on by myself.

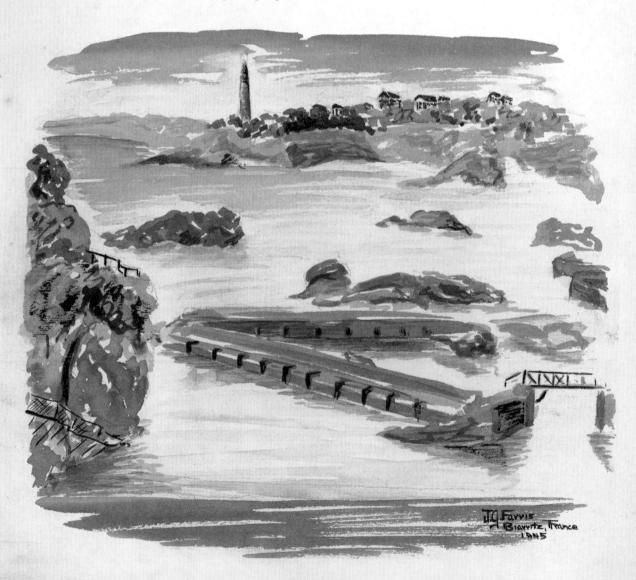

OCTOBER 14, 1945

Dear Folks—

This will be the last letter from Biarritz as we'll be leaving at nine tomorrow morning on our way back to Germany. From letters I've received from the fellows, I see that there are going to be faces there new to me. Many of the old men have already left since they've got enough points.

★ ESSLINGLEN, GERMANY

OCTOBER 23, 1945

Dear Folks—

I'm "home" at last back at the company—by name only though. There are only about 30 men left in the company now and one or two other fellows and I are all from the First Platoon. Fellows below 45 points, and there were many in the low 40s, were shipped out to occupation units. It seems a pity too, for many of them went all through combat but fell short of the 45 point mark. Also men above 60 were shipped to closing out units in France and Berlin.

The division has been alerted to leave in the early part of December but that was before all the delays popped up. No telling if it will be on my time or not. No one knows what the minimum score to go will be but it's somewhere from 55 to 60. When I came back I found out I had an additional 5 points for a total of 55. Here's the breakdown:

24 points for months in service
8 points for overseas service
10 points for two battle stars
8 points from VE to VJ
5 points for Bronze Star medal
55 points total

Long Path to Peace

The Potsdam Agreement, August 1945, ordered demilitarization of Germany, but peace treaties were not signed between the U.S., other Allies, and Germany until 1947.

I must almost have been driven crazy with my preoccupation with points. We kept receiving mixed information, so my total points seemed to fluctuate continuously. It indicates how anxious we were to go home.

★ WERNAU, GERMANY

OCTOBER 30, 1945

Dear Folks—

It's back in Wernau again where the company was when I left for school. A few days ago the company had less than thirty men on the roster—now the men are starting to come in and already we are coming close to a hundred men and the company will probably continue to grow. The division is still slated to go home in December and as things stand now the minimum score to make the trip is going to be 60 and since I've only got 55 it doesn't look so good but there is always the possibility that they may lower it. If it weren't for all the delays that have popped up there wouldn't be much doubt about getting home for Xmas—and the men over here are really sore about those longshoremen striking even though they may have a legitimate squawk coming—at least they could have waited until the men were shipped home—or maybe that was their strategy—they may have figured that if they struck now that the owners wouldn't dare turn their demands down. The whole thing is snafu, I guess.

When the company got ready to move down here again they decided to take over the same houses we had before and not use the factory since it was too cold there and to heat it up would take up too much coal. Well, when we told the people that they would have to move out to make room for the soldiers, they all had a hard luck story to tell us—no one wanted to move out naturally, but the way we feel about it is that if it wasn't for them we wouldn't be over here anyway. We looked for different houses but these were the best we could find and our policy is to give the men the best houses possible so we told them that they would have until one o'clock this afternoon to be out and let it go at that. It was a lot easier to take over a house during the war since no one dared say anything and also the fellows didn't have much sympathy for the Jerries anyhow. After actually sleeping in a hole, we couldn't stand for much talk but now that the war has slipped away, our grievances aren't so fresh in mind. I know it is a hard thing to have someone say to you that you had two hours to move out of your house to make room for some soldiers of an enemy power but again—they asked for it and we gave it to them.

Docks Shut Down
Longshoremen at the Port of New York struck in October 1945, closing the waterfront for more than two weeks.

NOVEMBER 4, 1945

Dear Folks—

No doubt you are wondering what comes off here—every letter I tell you that I'll be shipping out any day now—I'm just as puzzled as you are as to what is holding up my orders. I've been sweating them out now for almost a week and a half and still no news. It can't be much longer since they'll be leaving for the port before too long. There have been rumors that the Eighty-Fourth Division is going to take home men with point scores from 50 to 59—I've got my fingers crossed and sure hope that it is true.

Meanwhile I'm just taking it easy and doing as little as I can possibly get away with so that I can spend my time sketching, painting and reading.

NOVEMBER 9, 1945

Dear Folks—

Well, I'm still in the good ol' Hundredth, but it won't be long now before we fellows with less than 90 points ship out. In fact, I almost shipped out this past Monday to the 78th Div. in Berlin. Whatever outfit I do eventually get in, I have hopes of getting some kind of deal where I can use my art training to advantage.

We're not doing much meanwhile—there is German class going on with an English speaking instructor, which I'm taking in. I just finished a big mural—in cartoon style in the mess hall. It's about 25 to 30 feet long and I made it primarily of colored cardboard and did a little lettering. It took about two days of steady work to finish. On the side, I've been doing some charcoal portraits of the boys—similar to the one I set home, which Bucky Walters did of me.

I've just about become resolved to the fact that I'm going to be over here until at least February and maybe even longer, so don't expect to see me before then. No doubt you've heard that fellows between the point scores of 45 to 59 would be used for a close-out force. Even though fellows with 50 points can be discharged, either now or in the future, that ruling is only going to be to the advantage of fellows already in the States.

We were interviewed today by our company officers as to whether we wanted to re-enlist or not—when I was asked if I was interested or not, I

laughed—things will really have to be tough before I sign my name on any enlistment papers. Only two fellows, both of them new men, have signed up and everyone else didn't waste any time saying "no."

By the way, Georgie, you said some time ago that the cover design I sent to The New Yorker had been returned—well, how about sending me the letter or whatever comment they made on it. Do not send the painting though.

Two *New Yorker* Covers
Some 35 years later, Joseph Farris's art appeared on the cover of the *New Yorker*, in 1982 and 1983.

NOVEMBER 11, 1945

Dear Folks—

If you don't hear from me for a while it will be because I'm on pass to the Rivera in southern France. I'll try and write whenever I can but naturally when I'm traveling that's out. The pass lasts, I believe seven days plus traveling time. So if we go by train, the whole thing should take about two weeks all told. I guess I have no kick coming at all—the breaks have been coming my way and I aim to take advantage of same. The Rivera and Biarritz are the resort places of France—the Riviera, though, is probably even better known than Biarritz.

There are now only about ten or eleven old men in the company and all have, as I previously told you, less than 60 points. By going on this pass, I'll probably be in the company that much longer—it really doesn't make much difference when we ship out, in the long run so most of us aren't worrying about it.

I'm sergeant of the guard tonight and just finished making out the guard roster—and will have to get up early tomorrow to awaken up some of the boys—four of who are shipping out to the 78th Div. so this is going to be it for a while.

NOVEMBER 28, 1945

Dear Folks—

I'm still waiting for the transfer to come through—should be today or tomorrow at the latest. I'm the only fellow left with below 56 points, the others having shipped out last week. I don't have any idea as to where I'll eventually wind up, but I'm just about used to moving around by now. It's hard saying goodbye to all your buddies but it won't be the first time. There are only six of the old fellows with enough points to go home with the division. The chances

are that even if I did stay with the division, I wouldn't be home for Xmas—it looks as though [I] will get home about a week or two late for the holidays. I'm counting on being home with a Mister in front of my name by March, and any sooner will be just that much better. It's not a question of shipping anymore—now it's a question of when they will not need us anymore for the close-out force.

I'm sure that when I do eventually get home, I'll not take so much for granted as before. I always knew that you folks worked hard but I guess never how hard. First I found out how much I depended on you mom—that started in Fort Devens the first day that I entered the army. From then on, it was question of doing my own wash, sewing, bed-making and what not. I missed your swell cooking and everything that you did for me. Naturally, I missed you as much, Dad, but it wasn't until I came overseas and got responsibility of my own that I could really appreciate what you were up against. In the store, it was for you to worry about paying bills, feeding us all and a lot more—I had to worry about the men under me—if they felt o.k.—that the machine gun was in good shape, that the ammunition was fit for firing and similar things along that line. But it was responsibility just like you've been up against these many years. No kidding, Dad and Mom, I really and truly appreciate what you've done and I hope that I can in some way do my part for you. In comparison to the age of most of the fellows' folks, you two are kids far and away. No kidding, I'm glad that you're both still young—I've much to be thankful for.

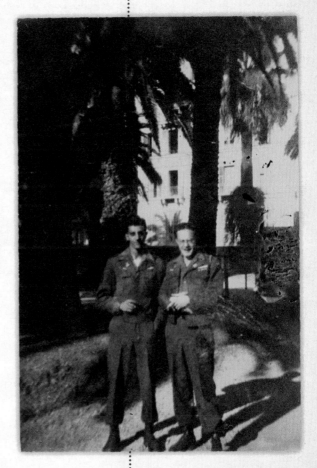

You kids don't know how much I miss you both—when you said in your letter, Georgie, that Eddie was attending dances, it struck me all of a sudden that you're both grown-up already. I'll bet that I'm going to be the shrimp of the family—man but time really does whiz by.

The company is now at Esslingen receiving the Presidential Unit Citation cluster to the one we receive for Bitche. This one is for the Battle of Heilbronn, where the Third Battalion acted as point for the division in crossing the Neckar River. It's ironic that out of all the men

The author and "Kaufy" Kaufman in Nice, France, November 1945

COMPANY M
398TH INFANTRY

Wernau, Germany

November 28th, 1945

Dear Folks,

I'm still waiting for the transfer to come through--should
be today or tomorrow at the latest. I'm the only fellow left with
below 56 points, the others having shipped out last week. I don't
have any ideas as to where eventually I'll wind up, but I'm just
about used to moving around by now. IT's hard saying goodbye to
all your buddies but it won't be the first time. There are only
six of the old fellows with enough points to go home with the
division. The chances are that even if I did stay with the
division I wouldn't be home for Xmas---it looks as though it will
get home about a week or two late for the Xmas holidays. I'm
counting on being home with a Mister in front of my name by
March, and any sooner will be just that much better. It's not a
question of shipping anymore ---now it's a question of when they
will not need us anymore for this close-out force.

I'm sure that when I do eventually get home I'll not take so
much for granted as before. I always knew that you folks worked
hard but I guess never how hard. First I found out how much I
depended on you mom--that started in Fort Devans the first day that
I entered the army. From then on it was a question of doing my
own wash, sewing , bed-making, and what not. I missed your swell

now out on the field receiving the citation, not one those representing this company was actually there at the time. Those men are scattered all over the world right now. Those that were captured (the whole first section, which I am now in charge of) are either dead or at home and then many have gone home on points and the others are in other outfits for lack of enough points. The cluster came through about two weeks ago or so—if it only counted for some points, it would be a deal but it is just a ribbon.

DECEMBER 2, 1945

Dear Folks—

Just returned from church services in Plockington, a bordering town of Wernau. I'm really getting lazy and I had all I could do to get myself out of bed this morning—in fact, it seems, every morning. As you've probably noticed by the return address, I'm still with M Company but my transfer should be coming through the first of next week. I've been living out of my duffle bag ever since I arrived back from the Riviera, since the company clerk told me that it would be only a matter of days before I'd be on my way. As it is now, I'm the only fellow under the point score still around, the other fellows having shipped out last week while I was still away. The division will be leaving this area on or before the 15th of the month for the port—I'd sure have liked to be one of the fellows going with it, but my day will come.

DECEMBER 7, 1945

Dear Folks—

This will be my last letter from the 100th Division and from Wernau. My transfer came through today and I'll be leaving tomorrow morning to the 253rd Combat Engineer Battalion—well, Dad, it looks as though I too am going to be able to say that I was an engineer too—although it's being an infantryman that I'm proud of, naturally, the most. I don't know anything about the outfit as yet but I'll give that poop to you tomorrow night, if possible, when I arrive there. Don't write until I send you my new address, which should be tomorrow. It's going to be hard leaving an outfit in which you've served nearly two years but I'm not the only one that has had to do that.

The Bronze Star medal

★ SCHWETZINGEN, GERMANY

DECEMBER 11, 1945

Dear Folks—

As I write this, I still don't know what I'll be doing but I'm going to try and get into some kind of art job.

We're stationed in a former Panzer outfit camp—it's a swell deal. Out of all the men who left the company and battalion, I think that we received one of the best deals. This post is out of town but we have everything we need—movies, a club, library and so on.

Here we are considered high pointers. The 55 point men will be leaving in about 9 or 10 days and I believe we'll be leaving soon afterwards—transferring into a home bound unit. The rumors sound swell, but until the day I board that boat at the port, I'll not put too much faith in the rumors.

DECEMBER 15, 1945

Dear Folks—

I've been assigned in the depot. I'm in the plumbing section—parts pertaining to plumbing. There are three G.I.s there plus German civilians and PWs (prisoners of war) who do the actual work. All that I've done is sit near the stove and read or play cards—what a deal.

I had a discussion with one of the German civilians who works there and can speak English. He was formerly a grammar school teacher but was thrown out for having affiliated with the Nazi Party. I'm convinced of one thing—these people have been under a clever and well-planned blanket of propaganda. They earnestly believe Germany was right—justified in most of the things it did. Since I haven't been in a position to be too well informed about the pre-war politics over here, I tried, or should say did not let him involve me too much—I wanted to see first-hand what they thought and why. He burned me up a bit but I tried to hold myself. Today came the turning point. Evidently the PWs yesterday had been forced to stand in the cold for quite awhile and this former teacher remarked that it was indecent of the Americans. Well, it developed that the reason the PWs had to stand out there was because four of them had escaped over the fence at the depot. I really let steam off this time and told him what the score was—man, was I sore.

Panzer Camp

By 1945, the U.S. Army occupied the barracks where Nazi Field Marshal Rommel and his panzer- or tank-divisions had trained.

He shut up tighter that a clam and has been reluctant to say anything more. These damn people are no good—they have been fortunate to get off as easily as they have and as for the PWs—they've got a lot more freedom than they'd probably have given to us had the tables been reversed.

★ HEIDELBERG, GERMANY

DECEMBER 24, 1945

Dear Folks—

One year ago tonite, I was in Legeret Farms, France, which is near Bitche. We had just been relieved after that rough battle for the pillboxes, for which we received the Presidential Citation. Some fellows had decorated a Xmas tree with some trinkets from a nearby house. Everyone was quite sad although, some fellows did attempt singing Xmas hymns.

We were in former French army barracks with the line about a thousand or so yards away. The Jerries, every so often, would throw stuff at us to make sure we didn't forget there was a war on. Many of us had received Xmas packages so there was plenty to eat around. There wasn't very much being said and nearly everyone was writing home and wishing that they didn't have to—that they could say "Merry Christmas" in person. Most of the fellows didn't even stay up till midnight—most of us had to go out the next day—Christmas—and relieve those men out there. In the platoon, we were in bad shape as far as men go—I don't think we had more than ten men—we had lost quite a few at Bitche.

Everything is looking rosy now, one year later, and all we're sweating out now is going home.

★ STRASBOURG, FRANCE

DECEMBER 27, 1945

Dear Folks—

In a previous letter, I told you that I was trying for a Paris pass—well, today I had my choice—a pass to Paris or Switzerland and I choose the latter. This Swiss deal is supposedly one of the best and I'm now on the first leg of the journey. This was the fastest I've ever received a pass—I asked for it late this morning and was on the way at three o'clock. We left Mannheim at about four o'clock, passed through Heidelberg, Karlsruhe, Kehl and arrived here in Strasbourg a little after 2300. The Rhine River separates France and Germany here at Strasbourg and this was one of the many times I've crossed it here.

The train we came down on wasn't bad considering some of the previous ones we've ridden on. We came down third class—which meant hard wooden seats, but we're used to that by now. Being a leave train, it didn't have a very high priority and it took us a lot longer than it would have by vehicle.

We're staying here overnight and shoving off at 10:15 tomorrow morning for Mulhouse where we will leave on a Swiss train for the beginning of our tour. There we'll have our money changed over to Swiss francs—that is up to a certain amount—something like thirty-five dollars for quarters, food and transportation and about forty-five dollars for spending—otherwise the G.I.s will buy the country out. That's about the works for tonight.

★ MULHOUSE, FRANCE

DECEMBER 28, 1945

Dear Folks—

We pulled in here at about one o'clock this afternoon and went through our processing such as signing up for tours, changing from German marks to Swiss francs and being oriented on how to act in Switzerland. Right now in my wallet, I have German marks, French francs, plus some American coins which I've carried with me since I left the States—all kinds of money.

They're really working on the black market in Switzerland and it looks as though they've got it fairly well licked. We can take only so much G.I. clothing and rations—cigarettes and candy. We were told that we would be inspected before crossing the border.

OPPOSITE: *The postcards on this and the following page are of St. Jean de Luz, a beautiful seaside resort not far from the Spanish border and south of Biarritz, where I went to school.*

You may have heard of the currency control books they've got out now to curb the black market. We can only send home or transfer to other currency what this card says and the only thing we can get on that card is what we're paid or receive by money order from home. Some fellows have hundreds of dollars worth of German marks which they cannot send home because their cards do not have the necessary credit.

These past couple of days I've been planning on calling you from Switzerland, where it can be done. Because of the fact that we can only spend so much there, I'm going to attempt to reverse the charges. I can imagine how surprised you'll be, if I can get it through, when you hear the operator say deposit fifteen dollars but I'm sure it'll be worth it. Please take the money out of what I'm sending home to you.

Currency Control Books
These books tallied military income in an effort to control postwar black market currency exchange.

★ LUZERN, SWITZERLAND

DECEMBER 30, 1945

Dear Folks—

We arrived in Basel, Switzerland, about nine yesterday morning, where we went through customs and had our baggage checked. We left Basel at eleven and arrived here for lunch. The fellows I'm with and I went on a tour to Engelberg where we rode one of those cable cars you've probably seen pictures of, up to 6,000 feet where we were to look at the valley—supposedly a beautiful view. However it was snowing like mad up there so we went into the hotel located there and had a cup of coffee and bought a couple postcards.

By now you've received the cablegram I sent last evening telling you to call me. I've got my fingers crossed hoping that you can get it through. I couldn't call from here and reverse the charges so the cablegram was it. I hope it didn't worry you.

The beach and casino at St. Jean de Luz. I bought this postcard and the one on the preceding page while I was on leave there.

DECEMBER 31, 1945

Dear Folks—

This is a touch of heaven! We pulled into Arosa yesterday night and were assigned hotels—and lo and behold, there were six men assigned to the Tschuggen Hotel and my two buddies and myself were among the six lucky men—this is one of the ritziest hotels in Switzerland—something like our Waldorf-Astoria in New York City. Last night we went dancing and had a wonderful time. The people got a big kick out of my teaching one of the girls how to jitterbug—she was coming along o.k., too.

Everyone treats us swell—after all only six G.I.s in an entire large hotel. We've never had it so good in the army, believe me.

Today we decided that we'd learn how to ski and so off we went down town (and actually down—we're on a hill about a mile above town) and we rented the necessary ski equipment. We left the hotel after lunch and headed toward the skiing area. Being carefree fellows, we decided to attempt to ski over there, so on the skis we went—I stood up and went downhill about 5 yards and over I went sprawling on the ground. The next fellow tripped over me and the other buddy over him. We then decided to take them off and walk over.

We never laughed so much as we did at the ski area. We hit the snow every few minutes but gradually we got so that we could ski longer and higher distances.

Skiing is beaucoup fun and in three days we should be o.k. We ended up skiing down to the town from the ski slide—over a mile although we hit the ground every now and then. We had a great time, in fact in the short time we've been here; we've had the best time since being in the army.

I was told today to expect your call after midnight tomorrow night—I'm sure looking forward to it.

Arosa, Switzerland, January 1, 1946. In late December I had a choice of visiting Paris or Switzerland and chose the latter. I skied for the first (and last) time and spent New Year's Eve there.

AMERICAN LEAVE ACTION

Room No.

336

Your Hotel in **AROSA**

Tschuggen Grd. Hotel

DATE

Arrival

Departure

JANUARY 1, 1946

Dear Folks—

Well, we're starting on a New Year—and a lot happier time it was last night in comparison to one year ago. The hotel held a New Year's party and we were guests of the night. We all had a swell time although we didn't get too lit up. There were a couple of Americans here on business and we all sat at nearby tables.

Today we managed to get up early enough before lunch to ski for about an hour and also again this afternoon. We're getting so that we can handle ourselves o.k. We were skiing down a hill about 300 yards long without falling. This has been just about the first real exercise I've done and I'm a little stiff, but I never felt so good. The Swiss people got a big kick out of the G.I.'s attempt at learning to ski. The people here are all nice to us and very friendly. Most of them here are from the rich clique.

The author trying skis for first time in Arosa, Switzerland, December 31, 1945

JANUARY 2, 1946

Dear Folks—

Your call came thru about two this morning, which was just about right for me. I was up till almost one anyway at the dance and so didn't have to wait too long.

I couldn't hear you too well, but just the same it was swell hearing your voices again.

We put in about an hour of skiing this morning and another two hours this afternoon. We kept gradually going higher and higher and we've reached about half way up to the top where the ski lift goes. I never realized skiing was so much fun. You should see the kids here—I bet they're born with a ski on each foot. Not only kids ski though, even the older people—in fact everyone does.

We've got a swell bunch of fellows on this tour and the Swiss guide is also a prince. He's young like we are. There are three fellows from the same hotel I'm in, counting myself and we've had a wonderful time together.

★ STRASBOURG, FRANCE

JANUARY 5, 1946

Dear Folks—

We're now back where we started from—Strasbourg. We arrived in Mulhouse at one, left at two and arrived here at five (1700). We leave here at one-thirty in the morning on our way back to Mannheim. Everything's going along swell—we hated to leave Switzerland, but those of us who are waiting to go home have that sentimental journey to look forward to. What a big difference between eating chow in Switzerland and here. There we just walked into the dining room where we were promptly and courteously waited on. Now that we're "back in the army" again, we started off by standing in the always long line and, when we finally succeeded in reaching the chow, by having it thrown on our tray or mess kit. I don't mind that so much but when those serving it to us get a big kick out of it, it's quite a deal.

★ MANNHEIM, GERMANY

JANUARY 6, 1946

Dear Folks—

We're back in Germany again and about ready to shove off for the port (fingers crossed). We're in the processing stage right now and raring to go. That Swiss furlough worked out just about right in killing time.

JANUARY 8, 1946

Dear Folks—

Today as I was waiting in the orderly room to check over my service records, one of the fellows walked up to me and said "Are you Syrian?" When I replied that I was [as noted earlier, we are Lebanese, but Lebanon was then part of Syria], he came out with "kiefak" [hello]—and I returned "mnieh, kiefak int?" [Well, how are you?] Very intelligent conversation. We must have looked funny and also sounded the same. We were in a crowded tent speaking in Arabic. He lives in Brooklyn and it turned out that he had been in

Phone Calls From Home
The first transatlantic phone call was in 1927. War advanced cable technology.

Danbury many times and knew quite a few people we know—Abdel Noor—Chick Dewan. His name is Freddy Assey. Now I can share my desire for "taboule" and "fattoush" with him. He's in the same company I'm in. That little bit was the first Arabic I've heard since leaving you on the 12-hour pass I had from Camp Kilmer.

The way everything's leading up to now, provided we have no unnecessary delays, we should be civilians before the end of this month.

★ BREMERHAVEN, GERMANY

JANUARY 15, 1946

Dear Folks—

We're now ready for the long-awaited boat ride to—home. All we're now awaiting for is the boat itself. Before we left Mannheim, there were a lot of rumors concerning the Europa—the former German luxury liner being in port. Well, we arrived here last Friday afternoon. There was one Liberty ship (capacity 500), which could transport troops to the States. Since then, a few others have come in but since we're fifth on the priority list, we're still sweating it out.

One of the hangars has been remodeled into a Service club called "Radio City." The main objection to it is the fact that there are too many G.I.s and everything is—stand in line.

When we first hit the port, we immediately became conscious of the ocean breeze and by golly, it really can exert itself—almost blows you over.

I haven't met anyone I know here as yet and that's about the first time I've missed [seeing people I know]. I don't expect to meet any buddies from Danbury as probably most of them are already home, but there are many fellows I've met in the army that I could run across.

JANUARY 18, 1946

Dear Folks—

There is a large bulletin board in the hallway of our mess hall and on it is placed the list of incoming boats, tentative incoming and leave dates and the units to leave with the ship. Well, today I saw our unit on the board—we're

scheduled to leave the 29th of this month on a victory ship which has a capacity of approximately 1,500. As I have been constantly telling you, that doesn't mean too much—fate doesn't recognize dates.

Meanwhile, all I've been doing is reading, playing casino or pinochle, ping pong and sleeping. The movies change nightly but the sound isn't very clear. I had my first American ice-cream sundae in the ETO the other day—ice cream topped with marshmallow.

The fellows are all getting quite impatient waiting around. Back in Mannheim we were all under the impression that within a very few days after our arrival here, we'd be on our way home. Evidently, the army is in no hurry to send us out—they must plan to spread the shipments over the month. One big ship would clear this area pronto. There were beaucoup rumors about the Europa arriving here but all that's faded away.

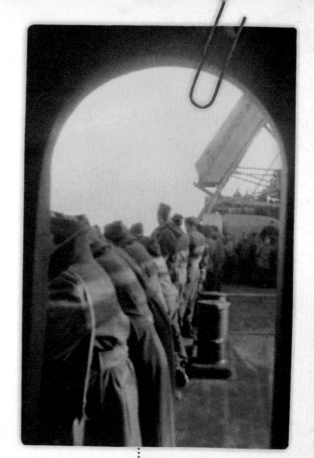

JANUARY 23, 1946

Dear Folks—

There are a bunch of bitter men here waiting to go home. This morning we read in the Stars and Stripes that they're turning loose many troopships since they have more than needed. A couple of hours later we found out we were to be yet back another week before shipping—that'll make a total of FOUR weeks waiting at the port alone for a boat home, while in the paper it said there are more boats than are needed—man but it will be good to get out of this army! It all boils down that they're in no hurry to send us home.

The fellows were so burnt up that a petition has been made up and signed by nearly everyone. It's going to be forwarded to the big G.I.s. I believe that one's going to be sent to Truman, too. It was easy getting into this army, but getting out is a real problem, it seems.

It's getting really boring waiting around. The entertainment facilities are very little to accommodate the 7,000 men at the port.

In case I don't write anymore, I'll try and send you a cablegram right before we ship.

On board the ship Norway Victory, *homeward bound. When I boarded the* Norway, *I remembered the seasickness I had endured on the way over and was determined not to get seasick again. After all, I told myself, it's all in the mind. We must have been out for no more than 30 minutes, and I was at back the rail.*

★

That was my last letter home. I left Bremerhaven, Germany, with nine hundred other GIs on the S.S. *Norway Victory* on January 31, 1946. The trip home took 17 days. During the passage home, we became aware that the *Queen Mary* had made several trips home. We were told they were full of war brides, which bristled most of us because of our discomfort aboard ship and the length of our voyage.

Our boat developed serious leaks and had to dock for repairs in the Azores, where there was an American presence. It was estimated that we would be there three days, so the 900 men aboard were divided into three groups, one to go ashore each of the three days. I was in the second group. The first bunch went ashore and created such havoc that the rotation was canceled, so I can't say that I landed at the Azores.

We arrived at the harbor in New York City on February 16. We were quite moved to see the Statue of Liberty, and I suspect a few tears were shed. By the time we arrived back in the States, the time of triumphant welcoming parades had passed, and we were greeted only by a small tugboat. No fireworks, sirens, or whistles—well, maybe a tugboat did greet us with a whistle or two.

We were then sent to the Fort Dix (New Jersey) Separation Center. I recall the pleasure I had when I first went into a nearby diner and heard the waitress speak English. That was a great day.

★

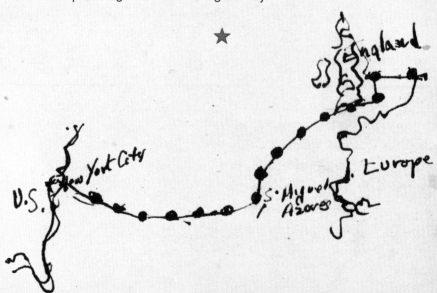

Map that I sketched on the way home. Each bullet represents a day. OPPOSITE: *My honorable discharge papers.*

113 863

Army of the United States

Honorable Discharge

This is to certify that

JOSEPH G FARRIS 31 333 428 STAFF SERGEANT

COMPANY M 398th INFANTRY

Army of the United States

is hereby Honorably Discharged from the military service of the United States of America.

This certificate is awarded as a testimonial of Honest and Faithful Service to this country.

Given at SEPARATION CENTER
 FORT DIX NEW JERSEY

Date 21 FEBRUARY 1946

L R WALKER
LT COL. AC

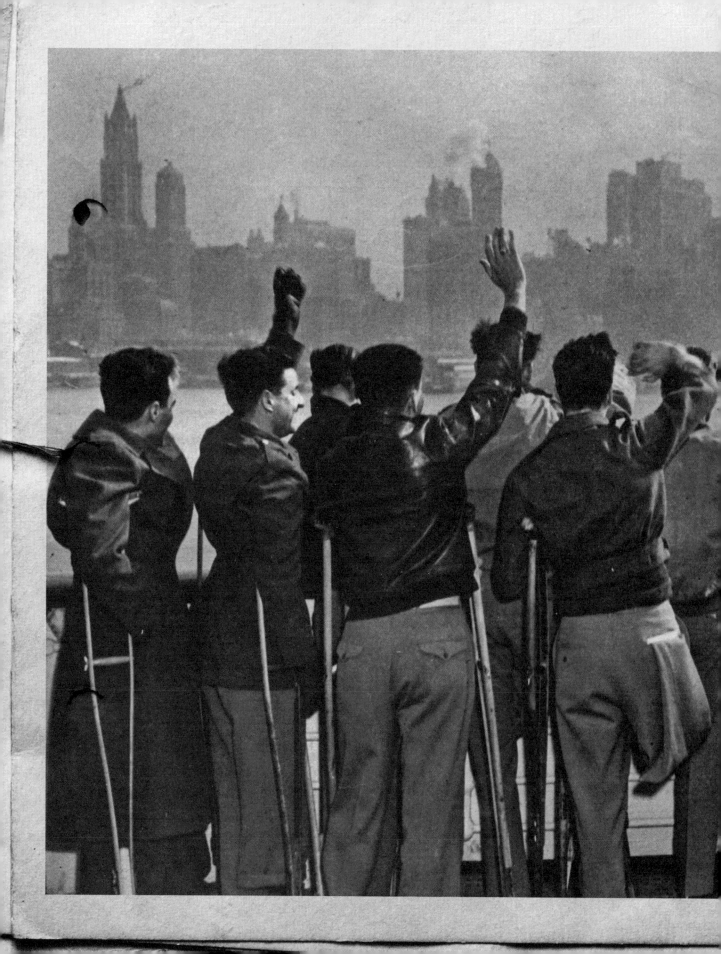

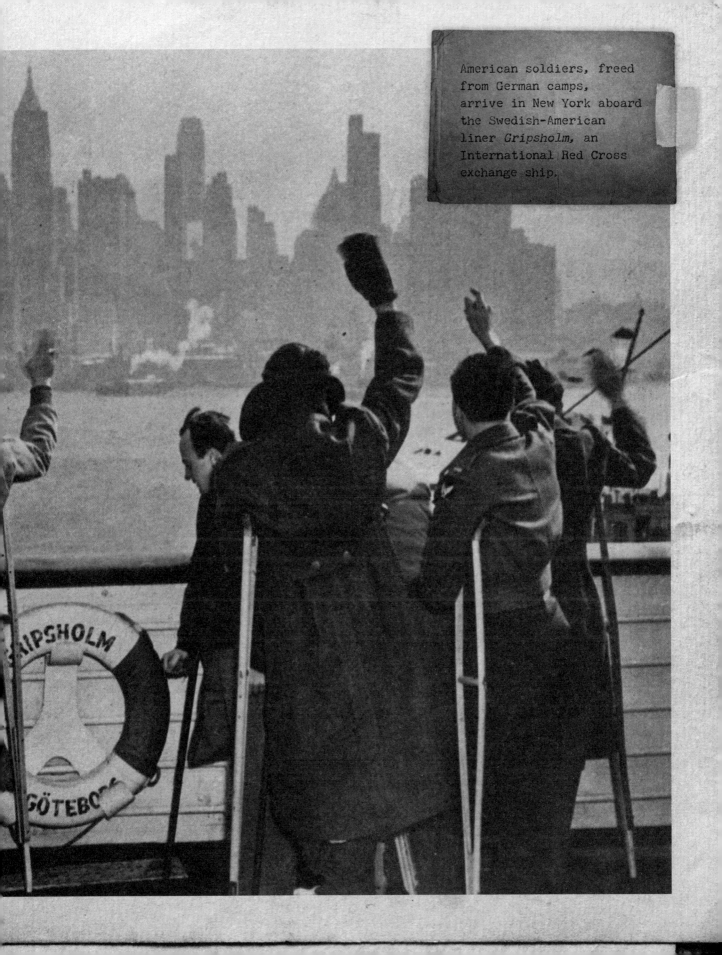

American soldiers, freed from German camps, arrive in New York aboard the Swedish-American liner *Gripsholm,* an International Red Cross exchange ship.

"Surely, as the world's only superpower, we're entitled
to a little mischief now and then."

★ EPILOGUE ★

I was discharged from the Army on February 21, 1946. I was 21 years old. My transition from Army veteran to civilian life was fairly seamless, and I am fortunate that I didn't suffer any of the mental or physical problems recognized today in so many veterans. It's fairly safe to say, though, that knowing any day might be my last isn't a common circumstance for your typical 18-year-old.

I entered the Army a very naïve young man and left a battle-hardened naïve young man. I had much to learn about life, but my experiences serving my country gave me insights that helped me develop into who I am today. The man in my letters seems, at times, a stranger. Looking back through these letters, I find it difficult to get a complete grasp on all that I experienced and lived through. Instead of going to college, I was drafted to serve my country. I didn't have the faintest idea what I was in for. I soon found out.

The war was my first experience of being in foreign lands, and my deep curiosity about things was an education that I treasure to this day. I had never been in a home without electricity or running water. I had been unaware of dirt roads, the pooling of human waste under the front of houses, or the lack of sanitary facilities. I did find out, however, that it is possible to live well and comfortably without all the conveniences we think we must have. I soon realized that people had different beliefs, morals, and standards and that I wasn't always right.

Cartoon from the New Yorker, *May 31, 1993*

My painting "Cocktails," protesting the Vietnam War in 1966. It won the Emily Lowe Award competition and led to a one-man show at the Ward Eggleston Gallery on Madison Avenue in New York City.

The greatest awareness I discovered in combat was how tenuous life could be. At 18, most young people think they are immortal. I quickly learned that I was quite mortal, but also responsible, dependable, and perhaps even courageous. I also discovered the meaning of fear.

We have all heard men and women say that they would gladly die for their country. But I can't honestly say that I've ever heard a GI say that. Most of us felt that we had no choice but to protect our families, our homes, and our way of life and that our service was justified. While some did everything they could to be sent home, most of us did not and served well.

President Roosevelt famously said, "I hate war." If I ever doubted that sentiment, my participation in World War II certainly brought me around. At the beginning, I had considerable hostility toward the Germans for starting the war, and I tried actively to kill them before they killed me. I

felt no guilt when we forced German people to leave their homes so that we could occupy them. My rationale was simple: "I wouldn't be here if it weren't for you." In spite of my feelings then, I hope that I didn't kill anyone. I'll never know.

My career as a cartoonist and painter has been very satisfying. The highlight of my work has been what I have done for the *New Yorker*. While I'm not a political cartoonist, I haven't shied away from commenting on current affairs. One of my collage paintings, which I named "Cocktails," was my angry response to our involvement in the Vietnam War. In the painting, I used missiles, bombs, distorted faces, and other devices to show the horror of war. It graphically described my distaste for the conflict.

Many Americans, including myself, didn't accept the Domino Theory—that if Vietnam fell to communism, other Southeast Asian nations would follow. Time proved the theory wrong. And, before the conflict was over, more than 58,000 Americans were killed, and nearly five million Vietnamese soldiers and civilians were killed or wounded. What a horrible price to pay.

My drawings and letters show a different war. World War II has often been described as a "good war," if any war can be good. We were attacked, and we successfully responded. I can't say that I wouldn't rather have been home furthering my education, but I did feel duty bound to do my best to help end the war. Like my peers, I bitched about incompetence, the fact that we were almost always in the dark about what was happening, the discomfort of always being cold and wet, and countless other complaints. It spite of all this, most of us sucked it up and did what we had to do. We were proud of our service.

"*If you start granting amnesty to people for following their conscience, pretty soon everyone will be following his conscience.*"

Cartoon from the New Yorker, *March 10, 1973*

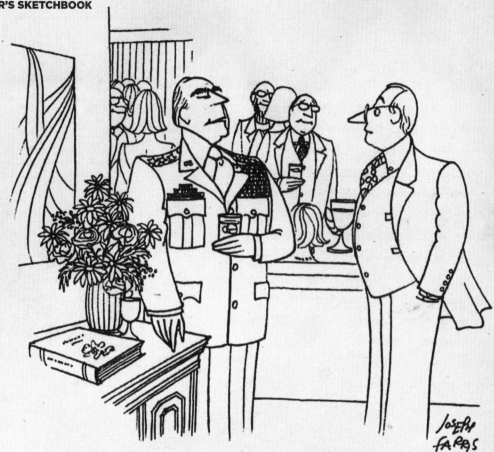

*"I'm absolutely against total war, but then
I'm not for total peace, either."*

Unlike the strong perspective I offer in my painting "Cocktails," my letters and drawings during the war were frequently reportage. They were my lifeline to home, and mail call was one of the most anticipated of events. Unlike today, an era of email, instant messaging, and videoconferencing, it sometimes took weeks to exchange letters. We would have been amazed at the contacts with home that today's service members have. Back then, I always had pen, pencil, paper, and watercolors available to record events and locations, and I was able to store them in my squad's jeep when we were in actual combat. My drawings were, in a sense, my future. At the time, I knew that someday the war would be over and I would be able to follow my desire to be an artist.

World War II was an extraordinary experience and a defining moment in my life. I matured quickly and found out what is really important. Even though I'm basically a serious person, it helped me flow with the current of life and develop a sense of humor—something I very much value. My life has been a marvelous dance—exuberant, sad, wonderful, and gratifying.

Cartoon from the New Yorker, *July 16, 1984.*
OPPOSITE: *Cartoon from* Reader's Digest, *November 2006*

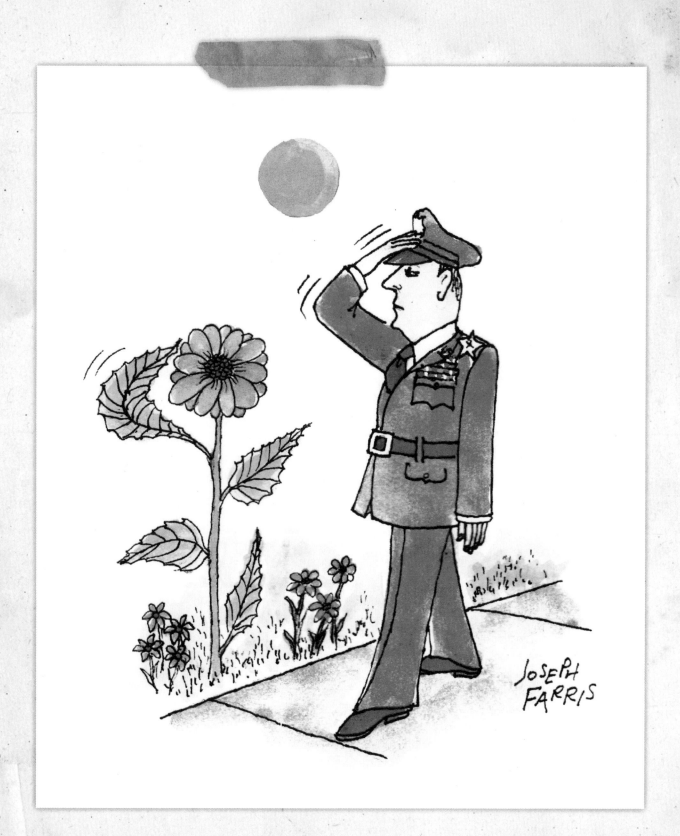

ABOUT THE AUTHOR

Joseph Farris is an internationally published cartoonist whose works have appeared in the *New Yorker* and many other major publications since 1957. His numerous books include *Phobias and Therapies, A Cog in the Wheel,* and *They're a Very Successful Family.* Farris's work is in the private collections of President Jimmy Carter and Paul Newman, among others, and many of his *New Yorker* cartoons are in the permanent collection of the Morgan Library and Museum in New York. He is also a painter. He lives in Bethel, Connecticut, with his wife, Cynthia.
www.josephfarris.com

ACKNOWLEDGMENTS

First of all, I thank my brothers George and Edward Farris for taking the time and perseverance to preserve the letters, drawings, paintings, and other materials that would become this book. My wife, Cynthia, read my added material with an editor's eye, offered helpful suggestions, and was extremely patient with my preoccupation with the memoirs. She has my love and thanks. My grandson, Paul Andersen, has been my personal computer techie. With his help, I've been able to expedite my memoirs. All I had to do was call him when I had a problem, and voilà, Paul was at my side solving it—thanks, Paul.

I thank my two editors, Richard Fumosa and especially Garrett Brown, for helping me clarify what I was trying to say and in the placement of the material. They made suggestions on my contemporary writings that expanded on what the letters could not say because of censorship. I thank my stepson, Michael Aron, who contributed to the cover design process; Carl Mehler and Greg Ugiansky, for their marvelous maps; and Kat Irannejad, Rob Waymouth, Meredith Wilcox, and Alexa di Fazio, who so ably helped on the images. I have great admiration for Melissa Farris—sadly, no relation, but forever a "cousin"—for the design and layout, which greatly enhances the book's appearance.

And as they say, last but not least—in fact, first—Susan Tyler Hitchcock. I put the scrapbook together for my family with no thought of publication. When Susan saw the scrapbook, she immediately said, to my great surprise, "This should be published." Because of her, it has been. She kept a loving editor's eye on the whole project. Many thanks, Susan!

MAP BIBLIOGRAPHY

JOSEPH FARRIS AND HIS WORLD WAR II TRAVELS, PAGES 16-17: map, "Central Europe and the Mediterranean as of September 1, 1939" (Washington, D.C.: National Geographic Society, 1939); map, "Atlantic Ocean" (Washington, D.C.: National Geographic Society, 1939). **EUROPE ON OCTOBER 20, 1944, PAGE 87:** War Department General Staff, *Atlas of the World Battle Fronts in Semimonthly Phases to August 15, 1945: A Supplement to the Biennial Report of The Chief of Staff of the United States Army, July 1, 1943, to June 30, 1945* (Washington, D.C.: War Department, 1945); map, "Central Europe and the Mediterranean as of September 1, 1939" (Washington, D.C.: National Geographic Society, 1939). **OPERATIONS IN THE VOSGES, PAGE 96:** map, "The Battle of the Vosges Mountains 100th Infantry Division," prepared by G-3 100th Infantry Division, Bert Schuman (1945); report, "Operations of the 397th Infantry Division, 100th Infantry Division: Original Monthly Narrative Report Submitted by the Commander, 397th Infantry Regiment during WWII" (November 1944); report, "Operations of the 398th Infantry Division, 100th Infantry Division: Original Monthly Narrative Report Submitted by the Commander, 398th Infantry Regiment during WWII" (November 1944); report, "Operations of the 399th Infantry Division, 100th Infantry Division: Original Monthly Narrative Report Submitted by the Commander, 399th Infantry Regiment during WWII" (November 1944); 397th Infantry Book Council, *Regiment of the Century: The History of the 397th Infantry* (Stuttgart, Germany: Union Druckerei GMBH, 1945); Bernard Boston, *History of the 398th Infantry Regiment in World War II* (Nashville, Tennessee: The Battery Press, 1982); Frank Gurley, ed., *399th in Action with the 100th Infantry Division* (Mercersburg, Penn: Aegis Consulting Group, n.d.), available online at www.marshallfoundation.org; and maps, "Carte de France 1:50,000," volumes XXXV-16, XXXV-17, XXXVI-16, XXXVI-17, XXXVII-16, and XXXVII-17 (Luneville, France: Institut Geographique National, 1957). **MAGINOT LINE, PAGE 123:** map, "Central Europe and the Mediterranean as of September 1, 1939" (Washington, D.C.: National Geographic Society, 1939); Jean Puelinckx, Jean-Louis Aublet and Sylvie Mainguin. Index de la Ligne Maginot & Co. (2002-2011), available online at www.fortiff.be/maginot, accessed April 1, 2011; map, "Ligne Maginot," available online at www.attila-77250.fr, accessed April 1, 2011. **THE ATTACK ON BITCHE, PAGE 127:** map, "The Battle of Bitche," prepared by G-3 100th Infantry Division, Bert Schuman (1945); map, "Carte de France 1:50,000," volume XXXVII-13 (Luneville, France: Institut Geographique National, 1939); and sources provided above for pages 96 and 123. **COMBAT OPERATIONS OF THE 398TH INFANTRY REGIMENT, PAGES 206-207:** Neil Short, *Germany's West Wall: The Siegfried Line* (London: Osprey Publishing, 2004); and sources provided above for pages 96 and 123.

A SOLDIER'S SKETCHBOOK
Joseph Farris

Published by the National Geographic Society

John M. Fahey, Jr., *Chairman of the Board and Chief Executive Officer*

Timothy T. Kelly, *President*

Declan Moore, *Executive Vice President; President, Publishing*

Melina Gerosa Bellows, *Executive Vice President, Chief Creative Officer, Books, Kids, and Family*

Prepared by the Book Division

Barbara Brownell Grogan, *Vice President and Editor in Chief*

Jonathan Halling, *Design Director, Books and Children's Publishing*

Marianne R. Koszorus, *Design Director, Adult Books*

Susan Tyler Hitchcock, *Senior Editor*

Carl Mehler, *Director of Maps*

R. Gary Colbert, *Production Director*

Jennifer A. Thornton, *Managing Editor*

Meredith C. Wilcox, *Administrative Director, Illustrations*

Staff for This Book

Garrett Brown, *Editor*

Melissa Farris, *Art Director*

Rob Waymouth, *Illustrations Editor*

Linda Makarov, *Designer*

Gregory Ugiansky, *Map Research and Production*

Clifton Wiens, *Contributing Writer ("History Briefs")*

Kat Irranejad, *Contributing Illustrations Editor*

Judith Klein, *Production Editor*

Lisa A. Walker, *Production Project Manager*

Marshall Kiker, *Illustrations Specialist*

Manufacturing and Quality Management

Christopher A. Liedel, *Chief Financial Officer*

Phillip L. Schlosser, *Senior Vice President*

Chris Brown, *Technical Director*

Nicole Elliott, *Manager*

Rachel Faulise, *Manager*

Robert L. Barr, *Manager*

The National Geographic Society is one of the world's largest nonprofit scientific and educational organizations. Founded in 1888 to "increase and diffuse geographic knowledge," the Society works to inspire people to care about the planet. National Geographic reflects the world through its magazines, television programs, films, music and radio, books, DVDs, maps, exhibitions, live events, school publishing programs, interactive media and merchandise. *National Geographic* magazine, the Society's official journal, published in English and 33 local-language editions, is read by more than 40 million people each month. The National Geographic Channel reaches 370 million households in 34 languages in 168 countries. National Geographic Digital Media receives more than 15 million visitors a month. National Geographic has funded more than 9,600 scientific research, conservation and exploration projects and supports an education program promoting geography literacy. For more information, visit www.nationalgeographic.com.

For more information, please call 1-800-NGS LINE (647-5463) or write to the following address:

National Geographic Society
1145 17th Street N.W.
Washington, D.C. 20036-4688 U.S.A.

For information about special discounts for bulk purchases, please contact National Geographic Books Special Sales: ngspecsales@ngs.org

For rights or permissions inquiries, please contact National Geographic Books Subsidiary Rights: ngbookrights@ngs.org

Library of Congress Cataloging-in-Publication Data

Farris, Joseph.
 A soldier's sketchbook : from the front lines of World War II / Joseph Farris.
 p. cm.
 ISBN 978-1-4262-0817-1 (hardback)
 1. Farris, Joseph--Correspondence. 2. World War, 1939-1945--Personal narratives, American. 3. World War, 1939-1945--Art and the war. 4. United States. Army. Infantry Division, 100th. 5. World War, 1939-1945--Campaigns-- France. 6. World War, 1939-1945--Campaigns--Germany. I. Title.
 D769.3100th .F37 2011
 940.54'1273092--dc22

 2011012582

Printed in China
11/RRDS/1